ShelleyArt

SERIOUS ART

SERIOUS ART

SERIOUS ART

John Passmore

Open Court
La Salle, Illinois

Published by arrangement with
Gerald Duckworth & Co. Ltd., London.

© 1991 by John Passmore

First printing 1991

Library of Congress Cataloging-in-Publication Data

Passmore, John Arthur.
 Serious art / John Passmore.
 p. cm.
 Includes index.
 ISBN 0–8126–9181–4 (cloth). — ISBN 0–8126–9182–2 (pbk.)
 1. Arts. I. Title.
NX620.P37 1991 91–20956
700′.1—dc20 CIP

Printed and bound in Great Britain

Contents

And we may further grant to those of her defenders who are lovers of poetry and yet not poets the permission to speak in prose on her behalf; let them show not only that she is pleasant but also useful to states and to human life, and we will listen in a kindly spirit; for we shall surely be the gainers if this can be proved, that there is a use in poetry as well as a delight.

Plato, *Republic*, book 10

Preface

This book began in Princeton, New Jersey, where I delivered in 1972 the Gauss Seminar. I am grateful to Princeton, not only for extending that invitation but for making possible the discussion which followed the lectures, at that stage only two in number. Equal gratitude is due, for these same reasons, to Clare Hall, Cambridge, England where I delivered in 1980 the Tanner Lecture on *Art and Truth*. Sections of that lecture are used in the present volume and are republished by permission of the University of Utah Press from *The Tanner Lectures on Human Values*, vol. 3 (Salt Lake City and Cambridge, 1982). The generosity of the Tanner Trustees thus extends even beyond their original, almost overwhelming, financial support. The leading ideas in my chapter on morality were first developed in a Comte Memorial Lecture at the London School of Economics, in 1983.

Since my official retirement in 1979, the Australian National University has offered me hospitality, first as a University Fellow and thereafter as a Visiting Fellow in the History of Ideas Unit. I am grateful not only to the University but to the Head of the Unit, Professor Eugene Kamenka, for his support and encouragement over those years. Mrs Wendie Hare confronted with patience, care and tolerance, the task of transferring this book, through many revisions, on to disk. No one else has seen it except my wife, who has suggested a large number of corrections and revisions. For the last seven years I have spent some months at McMaster University, Canada, as Visiting Distinguished Professor and General Editor of the Bertrand Russell Editorial Project, where the resources of the Mills Library have been accessible to me, not to mention, through the help of my friends there, the theatre festivals at Stratford and Niagara-on-the-Lake.

Some Preliminary Explanations

As everybody knows: 'Qui s'excuse, s'accuse.' Add to that the sufficiently familiar fact that 'qui s'explique, s'excuse' and it does not require much logical perspicacity to conclude that 'qui s'explique, s'accuse'. So these remarks could equally have been entitled *Preliminary Self-accusations*. But preliminary to whom? To the reader, certainly, but not to the author, who could not have anticipated them before he completed his book. Read this then, if you like, as *Self-accusatory Afterthoughts*.

Some forty years ago an article of mine appeared in *Mind* with the title 'The Dreariness of Aesthetics'. It became somewhat notorious. (What an opportunity to reviewers: 'Having argued that aesthetics is dreary, he has now written this book in order to prove that in at least one instance he was right.' In fact, however, this is not a contribution to aesthetics as I there defined that field.) One thing I said in my article was that philosophers should not write about the arts unless they had a more than casual interest in them. Do I fit this bill? I am not a practitioner in any of the arts and that fact makes me uneasy. Only in the case of literature, furthermore, have I had any specialist training, lectured on it or written criticism. I had a first class honours degree in literature, my first publication, in 1934, was a pamphlet on T.S. Eliot and I lectured quite a little, although officially I was a philosophy teacher, on poetry, American novelists, the film and the principles of literary criticism. That, however, was for the most part fifty years ago. These, again, are sobering reflections.

Then have I at least read very extensively in art scholarship and criticism? Quite a lot, certainly, over time. But as the author of considerable books on the history of philosophy, on environmental problems and on teaching, it will be obvious that I must have spent much of my time reading elsewhere. Given the range of this present volume, the reading for it should have been unremitting. Every week, several books are published which I ought to have read. If this book contains no bibliography that is partly in order to conceal the extent of my ignorance.

Only partly, however. For the fact is that many of the ideas discussed in this book come from disreputable sources – comments in the foyers of cinemas, remarks on the radio, newspaper observations. For the same reason I have not cited sources, in marked contrast with my earlier writings where I religiously did so, at a time when, in the world of

philosophy, this was as unfashionable as it is now fashionable. That decision was not made out of a perverse desire to swim against the stream, but simply to mark the fact that this is not a scholarly work. In some ways, indeed, it is the work of an amateur.

What could be more self-accusatory than the admission that this is an amateur's book, written by someone who is moving outside his 'field'? I can offer only a very slender justification. An 'amateur', of course, is etymologically a lover. All my life, I have loved the arts; I have spent an enormous amount of time, and still do, reading literature, looking at buildings, sculptures, paintings – especially in Europe and Japan – going to the theatre and the cinema, opera, ballet and concerts. This is a book written by somebody, trained in philosophy but in the arts no more than a spectator, who loves the arts and hates what he takes to be confused and damaging thinking about them. I do not call that a self-accusation.

Canberra and Hamilton, Ontario
April 1990

1

The Problems Before Us

Several of Mondrian's relatives were painters or draughtsmen. One can be reasonably confident that they took their work seriously, with Netherlands conscientiousness. But such a measure of seriousness was far from satisfying Mondrian. None of them, he complained, 'would have agreed to sacrifice anything at all for art'. Surely, one naturally objects, conscientiousness inevitably entails a degree of sacrifice – the sacrifice of easy ways out and quick returns. In Mondrian's eyes, however, nothing short of a total devotion, excluding all other loves, could do justice to what art demanded and deserved. It was not, indeed, 'anything at all' but *everything*, as the constriction of his own life amply illustrated, which ought to be sacrificed for art's sake.

This cannot be dismissed as Continental excess. Even in England, for a century and more, artists and critics taught us to regard such fanaticism, and the mode of life which it is used to justify, as entirely normal. As Jack Tanner puts it in *Man and Superman*: 'The true artist will let his wife starve, his children go barefoot, his mother drudge for his living at seventy, sooner than work at anything but his art.' In Romanticist-inspired hagiographies, the modern equivalents of Foxe's *Book of Martyrs*, the artist must not only suffer but be a source of suffering, confirming his genius by a life lived in exile, actual or spiritual, by his total indifference to the responsibilities inherent in everyday human attachments. 'Ce monstre inhumain, c'est moi-même.'

One might be reminded of the desert anchorites. Indeed, in his pioneer study of the symbolist movement in literature, Arthur Symonds made just this comparison: 'The artist,' he wrote, 'has no more part in society than a monk in domestic life: he cannot be judged by its rules, he can be neither praised nor blamed for his acceptance or rejection of its conventions ... It is the poet against society, society against the poet, in direct antagonism.' But the anchorites, or so they believed, were obeying divine injunctions. Without agreeing, we can still find their ruthlessness intelligible in relation to the end of which they were in search, as we might find intelligible the ruthlessness of a convinced revolutionary. What is there about art – the painting of canvases, the shaping of stone,

the ordering of notes, the telling of stories – which could possibly justify such sacrifices, such ruthlessness?

That question has not lacked answers. Shelley's *A Defence of Poetry* will serve as a leading example:

> Poetry is indeed something divine. It is at once the centre and circumference of knowledge; it is that which comprehends all science, and that to which all science must be referred. It is at the same time the root and blossom of all other systems of thought; it is that from which all spring and which adorns all.

If this be so, then, certainly, poetry would justify any sacrifice of oneself or others. In a cool hour, however, can we really bring ourselves to believe that poetry 'comprehends all science' or is 'the root and blossom of all other systems of thought'?

Such inordinate claims are still being made, not only for poetry, a word which in any case Shelley is using very broadly, but for art as a whole. Consider this dithyrambic utterance: 'The artist's vision, both analytic and panoramic, makes perceptible at once the parts and the whole. Through art, man can discover the fundamental forms and processes of his universe and can give them new energy and function.' One's natural rejoinder is that science, not art, is our recourse when we seek knowledge of 'the fundamental forms and processes' of our universe and that it is technology which gives them 'new energy and function'.

'There's nothing like leather.' Perhaps we should set aside these pronouncements, coming as they do from artists and critics, as nothing but a cobbler-like enthusiasm. Yet philosophers, with no such occupational prepossessions, have also proclaimed that 'there's nothing like art'. So the preface to a quite unpretentious philosophical introduction to aesthetics, R.A. Sharpe's *Contemporary Aesthetics*, lays it down, with no sign of hesitation, that 'nothing equals the value and importance of the arts'.

No doubt, one might slightly extend the cobbler analogy to cover this case, too. For whereas most Anglo-American philosophers are accustomed to think of aesthetics as a distinctly marginal inquiry, it is in that preface taken to be the main trunk of philosophy, to which the various branches of philosophy must be subordinated. So we are told, for example, that 'the study of ethics and politics is important mainly because it examines issues that arise from our need to construct a society sufficiently stable for the arts to be cultivated in decency and leisure'. On some of the views we shall later be considering, art deserves to be taken seriously only in so far as it strengthens social solidarity, but on this view society itself is to be judged, mainly, by its capacity to supply the conditions necessary for the cultivation of the arts. Forced to choose, many of us would no doubt prefer the second to the first of these

alternatives. Not being forced to choose, we boggle at the 'mainly', conceding only that *one* criterion of a good society is that it provides the conditions necessary for the cultivation of the arts and, this much more dubiously, that *one* possible reason for paying attention to moral and political philosophy is that they help us to see this.

The effect of such inflated claims is to make us suspicious. Do they flow, perhaps, from deep uncertainties? When we turn to the writings of critics, such suspicions may be confirmed. Rarely, except in relation to that other suspect activity, theoretical sociology, do we meet with obfuscation on so grand a scale. In his study of Apollinaire, Francis Steegmüller ascribes to that influential poet-critic's *Méditations Esthétiques* the introduction of 'the turgid, pseudo-metaphysical style' which is so characteristic of avant-garde art criticism; the cubists themselves, he suggests, welcomed their metaphysical halo as, in Braque's words, a way of 'bamboozling' people – although they knew full well that Apollinaire's rhapsodies had nothing to do with their actual activities as artists. But Sir Joshua Reynolds was already complaining that 'it has been the fate of the arts to be enveloped in mysterious and incomprehensible language'. And W.S. Gilbert directed his shafts at 'transcendental shams' well before Apollinaire wrote. Nor was this in a spirit of mere Philistinism. Among literary critics, Frank Kermode is by no means the worst offender and his *The Sense of an Ending* has a genuine and important theme. But confronted, for example, by Kermode's comment on Yeats' *Byzantium* – 'to speak humanly of becoming and knowing is the task of pure being' – even the reader inoculated by much study of bad philosophy calls a halt. As for music, it is easy to sympathise with a reviewer when he tells us that 'Even sensible people when they talk about music seem to go soft in the head. A sickening and sycophantic reverence creeps into their discourse, and it becomes apparent that music is now a religion, with musicians its ministers by divine calling.'

Hilton Kramer has described the hullabaloo which broke out at a meeting of New York art critics when it was suggested that they might learn to write more clearly. 'I doubt,' he writes, 'if a greater degree of moral indignation would have been aroused by a debate on censorship or a witch-hunt.' Indeed, to ask for clear writing was felt to be not only a sure sign of 'philistine' or 'middlebrow' taste but actually the exercise of a *kind* of censorship, a kind of witch-hunt. (The critics in question all had government grants.) 'All this talk about good writing sounds very fascistic to me,' one critic was moved to remark, characteristically ignoring the fact that fascist writing was notorious for its turgidity whereas the warmest advocates of clear writing, from Locke to Russell, were also enthusiasts for liberty and toleration. One suspiciously remembers Lord Darlington in *Lady Windermere's Fan*: 'Nowadays to be intelligible is to be found out.'

The situation is made the more puzzling by the fact that art is so often

dismissed, at the opposite extreme, as a wholly trivial pursuit, idling disguised as a serious occupation. Even James Joyce was once moved to consider, in a letter to his brother, whether 'after all, men of letters are no more than entertainers'. Yet he, of all people, needed the elevated vision of the artist in exculpation of his life of sponging contemptuousness. If Flaubert at one time tells Louise Colet that she does not have the religion of art, even he at another time suggests that 'art' may be 'no more important than ninepins'.

It is not, of course, a fatal objection to the seriousness of a form of activity that able and intelligent men and women can see no reason for taking it seriously. So much is true for every form of activity which asks to be taken seriously, whether it be art, science, philosophy, the cultivation of personal relations, religion, sport, politics, the pursuit of power or the pursuit of money. Such an activity will be dismissed by some as perfectly pointless, be engaged in as 'only a game' by others, be a serious 'labour of love' only for a few. What is so striking in the present case is rather the immensity of the claims which, as we have seen, have been made on behalf of art, claims so remarkable that if they are justified, no university, no intelligent person, could fail to revere the artist and the critic above all other human beings.

Of course, to take art seriously is by no means to be committed to such extraordinary claims. But at least this much is now commonly taken for granted: that serious art is deserving of public subsidy, sometimes quite heavy subsidy, that it is perfectly proper for individuals to be paid out of public funds not only seriously to engage in the practice of the arts but even in the critical study of them. This is not because they are presumed to have a function in strengthening religious or political solidarity; indeed, in western countries – and even in eastern Europe, although it was for long kept from public view – much subsidised art and subsidised criticism bites the hand that feeds it. It claims to be of such a character as to justify being supported even under these circumstances.

Looking around at our ever-expanding galleries, our libraries, our university departments of literature, music, fine arts, our critical journals, we might feel assured that these claims, at least, are fully recognised. That would be, I think, a complacent error. There is many a university in which departments of literature and fine arts, although tolerated, are secretly despised, as consolations reserved for the weak-minded, providing them with a 'soft option'. The views Hegel felt it necessary to begin his *Aesthetics* by disputing – that art is at best a form of tranquilliser, enabling its votaries to kill time in an entertaining fashion, time which vice might otherwise occupy – such views are by no means dead, even if they are now more likely to be whispered in private than pronounced in public. Echoes of George I's 'I hate all Boets and Bainters' reached us, not very long ago, from the highest office of the United States, if only as a private verdict made public by inadvertence –

much as men once whispered their religious scepticism an
sometimes overheard.

The comparison is in fact a significant one; given its instituti
status, who could have anticipated the rapid collapse of Communism o
so much of the Western World? Public support for an activity which ha
articulate and entrenched defenders is often a great deal less substantial
than it superficially appears to be, as Nazi Germany should have
demonstrated to us once and for all. What Trilling has called 'the pieties
about art to which most of us have been bred', may turn out to be no more
secure than the moral, the political, the religious pieties to which, also,
most Western democrats were bred.

Art, it might be replied, has always been with us; it will persist, even if
critics pass away. Particular forms of art may only be cultivated in
particular societies – sculpture, for example, only in *certain* African
countries – but there is probably no society from which art is totally
absent. Hegel has nevertheless notoriously suggested that 'art,
considered in its highest vocation is, and remains for us, a thing of the
past'. Many others, from Keats on, have feared that poetry, at least,
would eventually be destroyed by the rise of science. 'Whether literature
is a thing of importance, whether it is still even now, and will continue to
be in the future, a thing of importance is,' Ionesco more recently wrote, 'a
tormenting question.' Adorno has questioned whether serious art is
possible after Auschwitz and has also suggested that music came to an
end with the Vienna School of New Music. Others have argued that, at
the very least, many art forms, including some like the lyric which have
been particularly valued, no longer have, or will come not to have, any
place in the serious art of a more communal society or – a view we shall
later consider in some detail – that the art of the future will be so greatly
superior to the art of our times that what is now regarded as serious art
will then be dismissed as trivial.

There can, of course, be different views about what constitutes
'seriousness' or 'importance', as there can be about what constitutes 'art'.
In a post-Collingwoodian manner, if with a rather different final
intention, let us distinguish between entertainment art, telic art –
Collingwood's 'magical' art – and serious art. Entertainment art counts
among its members those films, novels, poems, television shows, plays,
music, sculptures, ballets, for which it is only claimed that they are
enjoyable to hear, or read, or look at, as an escape from care, from caring
about, from taking things seriously. They succeed, as such, if in fact they
offer us an enjoyable interlude from care, they fail if they are boring or if
they remind us of our responsibilities, increasing rather than
diminishing our anxieties.

In our own times, entertainment art is often designed to create a high
level of excitement; indeed, critics sometimes see this as its natural form.
Nevertheless, slow-moving leisurely novels, in which nothing is

unfamiliar, paintings of quiet country scenes, music which is quite unobtrusive, reminiscent buildings, all still have their devotees. To use the not completely irrelevant language of drug-takers, entertainment can be a 'downer' as well as an 'upper'. As the pattern of care shifts, so does the pattern of relief from care; in an age which feels itself helpless in the face of violence, counter-violence, which at a different time would create anxiety, may serve to relieve it.

Telic art, in contrast, is successful as such only in so far as it increases, or at least helps to sustain, the degree to which its recipients *care about* some political, religious or social objective or feel a stronger sense of solidarity with a particular group, an enthusiasm for its way of life. One can include under this same heading the use of arts in advertising, to get us to buy something or to join something. Indeed, such advertising often plays upon group-solidarity, strongly suggesting that a particular product 'goes with' a certain kind of group-membership. In any case it tries to persuade us that there is something missing in our lives, to create, while indicating a way of relieving, a form of anxiety.

To achieve its ends telic art can make use of the techniques of the entertainer, as when the Salvation Army asked why the devil should have all the best tunes and promptly took them over, or an advertiser uses the tricks of – indeed sometimes suggests tricks to – the Hollywood film-maker or a telic cartoonist uses comic-strip devices. But if, as sometimes happens, we recall the entertaining advertisement while not remembering what it sells, if we listen with pleasure to a Salvation Army band or a hot-gospeller or chuckle at a political cartoon without its in the slightest degree either modifying or strengthening or confirming our religious or political attitudes in the desired fashion, it fails as telic art, however successful it may be as entertainment. It is as if we could find some way of extracting the sugar from a pill without swallowing it; meant to disguise the real taste, for us it becomes the real taste. For all that telic art may promise that relief from anxiety which it actually gives us when we receive it as pure entertainment, unlike entertainment art it *succeeds* only by imposing on us a measure of responsibility, whether to act or to acquiesce or to desist from acting.

In what serious art consists and whether, indeed, there is any such thing, is a question we can settle only at the end of our inquiry, not at its beginning. One definition of serious art, offered by Agnes Heller and Ferenc Feher, although not under that name, describes it in the first place as 'a particular activity oriented towards beauty and its objectification'. That positive characterisation we shall later be questioning as either false, since in ordinary senses of the word there is a great deal of serious art which is by no means 'beautiful' or, alternatively, as so redefining beauty that statements relating it to art come out as being tautological. The next stage in the definition is, however, more interesting: 'this activity has an independent function, that is, it is not a

by-product of other types of activities, not a mediating vehicle of various ideologies, not a maid-servant of theology and religious belief, and not an articulation of communal self-consciousness, but independent of these (though perhaps expressive of some of them) it is a self-reliant activity.' In essence, this is a negative definition. Let me say, in the same spirit, that serious art is art which can be successful even if it does not succeed when it is considered as telic art or as entertainment art. Definitions, Aristotle once remarked, are the beginning and the end of an inquiry. This will be our beginning definition. Perhaps we shall do better at the end of it, perhaps not.

The classification with which we are working is not, it should be observed, into mutually exclusive classes, in the manner of biological species. Think of it, rather, as like the classification of human beings into such classes as the amusing, the influential, the wealthy Some people fall into one and only one of these classes, others into several of them. They can cease over time to be a member of one class while not ceasing to be a member of another class; they can pass themselves off as being members of a class to which they do not belong; we can come to recognise, of ourselves, that we had mis-classified them. Criteria can shift over time or from classifier to classifier. A man invited to dinner in one social group because he is 'so amusing' might be ignored by another as a bore or a boor. An 'influential' person in the academic world can be quite without influence in the world of affairs; 'wealthy' is obviously relative. Nevertheless, such expressions serve us quite well as classifiers and enable social theorists to write books on 'power' or 'wealth' and the connexions between them.

In one important respect, however, we might turn out to be rather better off than this analogy would suggest, namely in respect to relativisation. To be sure, both entertainment and telic art have relativised aims, just as 'wealthy' and 'influential' are relative. The entertainer would no doubt like to attract, and sometimes does attract, very large audiences. Nevertheless, it is no objection to an entertainment that by its very nature it will entertain only those who belong to a particular group in a particular place at a particular time; that is only to be expected. Telic art is rather different, in so far as some religious and political groups lay claim to universality and will regard themselves as fully successful only when the whole world listens to their message and lives by it. Nevertheless, if paintings of God confirm Christians in their faith it is not regarded as an objection to them that they create revulsion in Jews or Muslims or, if the same condition is fulfilled, to martyrdom paintings that they repel the sensitive. In fact telic art of a religious kind is commonly tailored for particular audiences, who are willing to accept a particular type of representation and respond to it in the desired fashion.

In contrast, it is generally taken to be characteristic of serious art that, even if its audience be small, its appeal cuts across spatio-temporal

borders and cultural periods. So, on this view, the artistic seriousness of West African sculptures comes out in the fact that neither their distance from us in space and time nor our substantial ignorance of the culture out of which they grew prevents us from recognising their quality as works of art. Critics have described works as 'immortal' or as possessing 'universality' as a way of stressing this point. Of course, they will grant that some preparation may be necessary, even learning a language in the case of poetry, before one can fully recognise the seriousness of a work. The fact remains that works are now held up for our critical consideration which have lost whatever magical powers they once possessed and are too demanding to be merely entertaining. It would seem, then, that serious art, unlike telic and entertainment art, is absolutely so.

That this is *in fact* the case is not, however, something we can begin by taking for granted. We do well, in principle, to be suspicious of such words as 'immortal' and 'universal'. Perhaps they are simply attempts by Western civilisation to suggest that what it values has a peculiar metaphysical pre-eminence, a freedom from the normal eroding effects of time and the particularising effects of culture. 'All the epithets of immortal, timeless, self-sustaining and autonomous,' so Barzun sums up, 'are but brave lies when they are not partisan publicity.'

A 'serious' work, on some Marxist views, is rather like that kind of telic art which disguises itself as pure entertainment; it is a work which conceals its telic nature by pretending to a universality it does not possess, thus masking its character as cultural imperialism – or should I now say 'hegemony'? This may not be deliberate, not calculated in the sense that the entertainment in a telic advertisement is calculated. A work of art can be unconsciously telic, having so absorbed the ideology of a particular culture as not even to realise that it is ideology. Although West African sculpture, it would then be argued, has lost its original telic power, it is not that in exhibiting it in art galleries we have come to see that it is serious art. Rather, such exhibition is a gesture of appeasement; the work now helps us to conceal from ourselves our involvement with colonialism. It is still telic art but what it fortifies is not the solidarity of the society for which it was created but rather the pseudo-liberal solidarity of the artistic arm of the bourgeoisie.

At least temporarily we shall have to leave this issue open, without assuming, then, that our proposed classification is at a crucial point not relativised. We may, or may not, finally be able to resist the suggestion that what is generally regarded as 'serious' art is simply art which a particular group happens to find more entertaining than popular entertainment or takes to be non-telic only because it supposes itself to speaking for 'humanity as a whole', admiring an art which is 'above the battle', when in fact it is simply acting as a particular arm of a particular class.

What is more immediately necessary, however, is to make a few

elucidatory remarks about the use of the word 'serious'. The first relates to what has already been said about the classification of which this forms part. Much of what we now regard as serious art – all of it, indeed, until relatively recent times – was designed either to entertain or to achieve some religio-politico-social end or, as in the case of *The Magic Flute*, with both these purposes in mind. Artists have had to live. They have had to entertain, whether a particular patron or some wider audience; they have been called upon to fortify certain kinds of solidarity. In addition, they have themselves often had strong personal convictions; they have sincerely wanted to assist in the winning of converts or the strengthening of the convictions of the already converted – not necessarily, but then dangerously, the convictions of their patrons, as in the Mozart case.

When we say of a particular work that it is a serious work of art, we are not necessarily denying that it was designed to, and may still, entertain or that it was designed to, and may still, serve as propaganda. Matisse once wrote as follows:

> What I dream of is an art of balance, of purity and serenity, free from disturbing and engrossing subject matter, which would be for every mental worker, that is, for the businessman as well as for the man of letters, like a palliative, a mental soother, something similar to a good armchair that does away with the strain of his physical fatigues.

There could scarcely be, in the last part of this statement, a better description of 'downer' entertainment art. It does not follow that Matisse produced no serious art, as the more puritanical critic might presume.

Artists commonly have mixed motives and this works both ways. As very obviously in the case of D.H. Lawrence's novels, an artist may have telic motives intermingled with more purely literary motives. But equally, ostensibly setting out simply to amuse or to create a specific social effect, artists may in fact devote themselves to their work in a fashion which goes quite beyond, and may even tell against, the satisfaction of those motives. The novel designed as entertainment may be too darkly penetrating to be taken in that way, the musical work may be elaborated in a manner too complex to enable it to be dismissed from the mind, the religious painting – say of Magdalene – may come out as secular. *The Magic Flute* will sufficiently illustrate the ways in which the attempt to entertain, to influence politically, and to compose serious music can pull against one another, so that a satisfactory performance of that work is almost impossible. But *The Marriage of Figaro* brings it off.

At a performance of Handel's *Messiah*, some members of the audience may simply be entertained, some may find their religious convictions fortified, some may listen to the work as serious music. We are not rejecting the first two possibilities when we say it is a serious work; what we are saying is that if it comes to fail in these respects that would not

demonstrate its failure as a serious work of art, any more than its success in these respects is enough to demonstrate its lack of seriousness. There are good reasons for taking Bergman's box-office success *Smiles of a Summer Night* more seriously than *Through a Glass Darkly*. One may completely detest, considered as telic art, Riefenstahl's *Triumph of the Will* and yet appreciate its qualities as a film. (Although, to be sure, some will deny that anything can 'come through' from such a film which is not telic; others will assert that so 'impure' a work could not possibly be serious or, indeed, be properly describable as a 'work of art' at all. Trouble lies ahead.)

A second point is that although there is no novelty in using the word 'serious' to describe a particular class of works of art, it can easily mislead. As the primary use of 'serious' dictionaries tend to give 'thoughtful', 'earnest', 'sedate', 'not given to frivolity'. To describe certain artists as 'serious' might then suggest that they resemble Mormon missionaries or Scottish bankers and that their works resemble religious tracts or annual reports – highly implausible analogues. Telic writings often satisfy this definition, but one of the things serious artists have not infrequently tried to bring out is the importance of not being earnest, sedate, humourless, an enemy of cakes and ale. With his target Prussian censorship instructions, the young Marx wrote that 'the greatest seriousness is the most ridiculous thing'; in the same spirit Sartre attacked 'les sérieux'. But the artist can only prick the bubble of solemn idiocy, can only destroy the pretensions of 'les sérieux', by displaying, like the great comic writers, the sort of seriousness which is not incompatible with play, the sort of seriousness one finds in Molière, in Chekhov, in Mark Twain, in Faulkner, in Thomas Mann. The Dada movement fought against a seriousness which had petrified into solemnity. But Dada succeeds only when it is something more than penny-whistling in a church. Both all play, and no play, makes the artist a dull boy.

Taking another look at the dictionary, we find there a second group of meanings – 'important', 'demanding thought', 'not slight or negligible'. That is the sense in which 'serious' is commonly used to characterise certain works of art as opposed to those that are 'trivial', 'superficial' or 'inconsequential'. Serious art deserves close attention over periods of time, it is not just what Hegel called 'fleeting play'. Often highly comic, like *Ulysses* or *Lysistrata*, it is still far from being 'slight' or 'negligible'; critics claim importance for it.

So have we answered the question in what serious art consists simply by looking up a dictionary? That would be nice and easy. The only trouble is that from certain standpoints both entertainment art and telic art can be important, can demand thought, can be by no means slight or negligible.

Entertainment art can be extremely profitable; that at once, in our society, removes any suggestion that is is 'slight or negligible'. Apart from

that, entertainment art is socially 'important' as the 'circuses' element in 'bread and circuses'. By consolidating generations, as rock music does, it can assist the processes of commercial exploitation. Much entertainment rests upon considerable skills – it is not easy to make a James Bond film – and it may even call upon its audience to think, as a good detective story does.

As for telic art, that has been more obviously 'important' in the vast majority of societies, perhaps all. It is a powerful weapon of social control, often calling upon great skills, even when it does not issue in works of art one might also characterise as 'serious'. If it be true, as a film critic has argued – along, of course, with many others – that 'to be political is the only way to avoid the trivial' then indeed only telic art can be serious. (One is tempted to reply that politics is the flight from seriousness into faction, but must learn not to respond to an exaggeration with a counter-exaggeration.)

The dictionary definition, then, while it points to characteristics which art must possess if it is to be serious does not do so in a way which at once makes it plain how serious art differs from what is, from certain points of view, 'important' entertainment or telic art. How to make that distinction is a problem which still lies ahead. I should perhaps add that judging a work to be serious is not the same thing as valuing it highly. A light novel can properly be described as 'splendidly entertaining'; it can be highly valued, that is, as entertainment in contrast with some other work which is 'only mildly entertaining' or 'falls completely flat'. Similarly a telic work can be 'very effective' or 'miss its target'. A serious work can 'not come off' or 'fail to convince'.

Nevertheless, there is a certain connexion between judging a work to be serious and evaluating it; to call it serious is to judge it worthy of being considered as a candidate for a special kind of critical examination, in terms which would be inappropriate to what is purely a work of entertainment. (We are not yet in a position to say what these terms might be.) If we finally decide that the French 'new novel' or a certain type of experimental film is 'nothing but a highbrow game' we are at the same time altering our categories for judging it. Then it is enough to find it 'amusing' or 'boring' and to be quite indifferent to the fact that other readers, other viewers, are amused where we are bored, bored where we are amused, as we cannot be indifferent to the fact that they dismiss as 'trivial' what we regard as 'serious'.

One might be supposed, however, to be embarking on an impossible task in trying to establish that a particular form of activity is intrinsically worthwhile or that the products to which it gives rise are intrinsically worthy of devoted scrutiny. Some human beings, it might be thought sufficient to reply, find the artistic life worthwhile, they take it seriously, they make sacrifices for it and call upon others for sacrifices so that they can do so. Some other persons dedicate their lives to the detailed analysis

and scrutiny of works of art. What more need be, or could be, said? Did I not myself earlier remark that 'it is not a fatal objection to a form of activity that able and intelligent men and women can see no reason for taking it seriously'?

Our very vocabulary discourages so lazy a scepticism. We have at our disposal words like 'pedantic', 'academic', 'scholastic' – in its dyslogistic sense – 'snobbish', 'pretentious' and then, in another group, 'dilettante', and when spoken with a sneer, 'amateur'. The pedant, the snob, it would be natural to define by reference to the fact that they take seriously what does not deserve to be taken seriously; the dilettante, the amateur, as failing to take seriously what deserves to be taken seriously. An activity, we normally suppose, can be 'a trivial waste of time' – whether in itself or for certain of its practitioners – however seriously they themselves may take it.

How could we hope to persuade either the critics of art or art critics that activities which they condemn as trivial are worthwhile or an activity which they take seriously is trivial? There are two procedures which, in principle, we can adopt. We might try to get them to look more closely and carefully at the activity in question, both in itself and as an alternative to other forms of activity – in the expectation that when, under our instruction, they do this, its relative triviality or its seriousness will gradually become apparent to them. Satirists, moralists, prophets have often proceeded in this way; they have sought to show us that an activity, a way of life, is trivial by exposing it to our inspection in greater detail or by so characterising it that its triviality, or its relative triviality, will, they believe, at once become apparent. Swift is a striking case in point. It is one of his persistent objectives to get us to see that some form of activity which we are accustomed to take seriously – whether it be science or politics or theological controversy – is in fact trivial. More succinctly, Oscar Wilde does the same thing when he describes fox-hunting as 'the unspeakable in full pursuit of the uneatable'. On the other side, a bottle-top collector may persuade us that there are facets of that activity which had not occurred to us and which rebut the accusation of triviality.

Alternatively, we might proceed by drawing analogies. Taking as our departure some form of activity which our disputants grant to be worthwhile we then try to show them that if it is properly to be accounted worthwhile, then so is the activity to which we are now drawing their attention. Thus, for example, Leonardo da Vinci argued analogically that anyone who takes either science or poetry seriously must, in consistency, also take painting seriously; Plato that rhetoric, far from being a form of wisdom, is analogous to cookery. Of course, neither method is certain to achieve its ends; there are not, I fear, any self-evident propositions from which we can deduce the conclusion that an activity is trivial or serious. If, as Ecclesiastes tells us, 'all is vanity', then we have no starting point

for the analogical procedure. But in some cases we can reasonably hope to persuade. Otherwise, the present inquiry would indeed be 'vanity and vexation of spirit'.

With these reflections in mind, let us look more closely at exactly what artists and critics have meant when they expressed the fear that the arts, or some of them at least, might pass away, and how Hegel came to assert that 'in its highest vocation' art is already a thing of the past. It is not, usually, that telic or entertainment art might vanish from the scene. In some societies, admittedly, they have been rigidly confined. That is itself a tribute to their importance, from certain points of view. Entertainment has been condemned just because it offers escape, relieves anxieties, whether about one's own salvation or the salvation of one's social group; telic art has been forbidden when it does not serve the interests of the controlling social groups. One does not have to look to the USSR or to China or back to Plato's ideal Republic for examples of such phenomena. The rigid censorship in many Western democracies in the middle decades of the twentieth century was directed as much, in a puritanical spirit, against popular entertainment as against novels or films with a Marxist bent. But although some Utopians have hoped that in an ideal future society there will be no need for either entertainment or telic art, the first being seen as vulgar, unworthy, the second as unnecessary in a society where all hearts beat as one, few artists or critics fear for the future of such long-lived human activities.

They are afraid, rather, that these will be the only forms of art to survive and then in a form so primitive as not to allow of the possibility of their also being serious art. Collingwood expressed this fear, and that is what has happened in Huxley's *Brave New World*, with its remarkably accurate prophecy of certain contemporary forms of entertainment. Telic art in the form of national or political anthems, political posters, cartoons, architecture designed to create respect for the powerful, paintings, murals and sculptures of 'heroic' persons and events, is unlikely ever to pass away. Neither is entertainment art, in however confined a form, even confined as it was in Puritan England.

The fears I have been describing, that serious art might be submerged by a wave of entertainment and telic art, of a trivial kind, are typical of modernism. It tried to overcome these fears by producing works of art – culminating in minimalism – which had no possible value as entertainment and which had to be appreciated as ends in themselves, as possessing, in the Kantian phrase, 'finality without purpose', since they were totally incapable of serving any social cause. Post-modernism is quite different in its attitudes. There is certainly such a thing, it would agree, as 'pure entertainment' which can, of course, be seriously analysed to see what makes it successful but which no one would take seriously as art, and there is certainly a purely telic art, of which the same is true. It may nevertheless be a mistake, post-modernists argue, to assume that a

serious artist ought to set out to produce a work of art which is purely serious, which no one could possibly use as a vacation or interpret in a telic fashion.

The attempt to do this, as they see the situation, particularly when seriousness is puritanically interpreted as implying freedom from sensuality or as identical with the attempt to solve purely artistic problems, actually makes it more difficult to prevent serious art from being overwhelmed by purely entertainment or purely telic art. Serious art has indeed, on the post-modernist view, made a eunuch of itself, losing its virility in the attempt to retain its purity, with no function except in a harem of critics, cut off from the broader world. So, at least in some of its forms, post-modernism sets out to revive a kind of art which is serious art without at the same time spurning entertainment and social function – in architecture emphasising both livability and decoration, in painting reverting to representation, sometimes in a neo-expressionist manner, in music often incorporating the rhythms of popular music or at least making use of traditional musical tonality. If post-modernism fears for the future of serious art, this is only in so far as that future is threatened by twentieth-century varieties of modernism.

Hegel's case is rather different. For him the changes which take place in the ambitions and the seriousness of art do not allow of reversal. They are bound up with changes in the history of human culture as a whole. His philosophy of art, at the point now immediately relevant, is so intimately connected with his metaphysics and his philosophy of history, to say nothing of what was happening in the art of his time, as not to admit of brief description. But one point is clear: if, as he tells us, art is in its highest vocation a thing of the past, this is not because artists have gone astray, taking a path from which they can, in principle, be turned back. Rather, it is because the human spirit, through the development of religion and philosophy, has achieved a depth of reflection such that art can no longer fully satisfy its needs. For the Greeks, the gods could be represented in a sensuous human form, as perfected human beings, and that was a quite adequate and complete representation. With the rise of Christianity, that came to be impossible, so far as the central tenets of Christianity are concerned. It is impossible to sculpt the Trinity or, even, the Incarnation. (An occasional painter has tried to paint the Trinity but cannot do so without simply painting three distinct objects and symbolising one of them as a dove.) Even less can painters or sculptors depict the Absolute. In consequence, 'We have got beyond venerating works of art as divine and worshipping them'

There are many different ways of reacting to these Hegelian pronouncements. Let us look briefly – some of the issues involved will be more fully considered later – at what I shall call the 'secular' response and the 'quasi-religious' response. The secular response is happy with the fact that art is no longer venerated in a religious sense, worshipped. That,

as Edgar Wind observes – discussing Hegel – we feel no inclination to kneel before Manet's painting of *The Dead Christ with Angels*, and are not meant to do so as we were before Mantegna's painting of the same subject, it sees as showing that art has at last become serious, for and in itself, not as telic art. In that sense we can now, on the 'secularist' view, look at Mantegna as he ought to be looked at, something his contemporaries found it much harder to do, we can look at his painting simply as a painting, just as Manet wanted us to do with his painting.

The kind of art we see people kneeling before in Roman Catholic Churches or kissing in Orthodox Churches, the shrines at which they cross themselves as they pass, are very seldom, the 'secularist' will point out, of any artistic interest; one may well doubt whether anyone in fact knelt before Mantegna's painting, particularly if there were a sentimentalised Virgin Mary nearby. Whereas a person can simply be carried away, in a fashion which is essentially orgiastic, by a hymn or a patriotic song, we now realise, on the 'secularist' view, that we have to keep a certain distance from a piece of music, to regard it thoughtfully. Worship is servile, a matter of faith, artistic appreciation is critical. Far from it being the case, then, that the growth of reflection has displaced art as a serious pursuit, reducing it to what Wind calls a 'splendid superfluity', art, on this view, has been strengthened as a serious pursuit, has fully found itself as such, only through the rise of reflection. Indeed, it may even be argued, only after the rise of reflective criticism can we think of serious art as even existing.

Somewhere within this congeries of views, we may eventually come to rest. For the moment, let us look at the second reaction. This is to say that although, to be sure, serious works of art can no longer be venerated or worshipped as divinities or even – as Roman Catholics maintained against the iconoclasts – as aids to devotion, they can properly be venerated simply for what they are: worlds created for us by artists, worlds we accept because we have faith in the artist. Much art theory, written from this point of view, sounds very like theology. That is now a sufficiently familiar point. Max Weber long ago argued that art, in advanced bourgeois societies, served as a substitute for religion. It naturally, therefore, in the Western tradition looked for a theology and as naturally stole it from a Plato who would have refused to lend it.

Once again we arrive at a view which makes us suspicious. To take the arts seriously, are we really bound to venerate them in a quasi-religious way? (The more revolutionary artists of our century – Dadaists and the like – often set out to 'desanctify' art. But they did so in a way which still presumed that seriousness and sanctity are the same thing.) Is there something, anything, other-worldly about that Monet we have just been looking at, that novel by Turgenev we have just been reading, that poem by Philip Larkin, that statue by Rodin? A sense, to be sure, of being in the presence of something we could not possibly create ourselves, an

admiration for a work that is clearly to be taken seriously. But a sense of having moved into a different world? And if this other-worldly seriousness, or any other inappropriate sort of seriousness, is sought for in works of art might that not affect not only the tone of criticism, forcing it into the obscurity we have already noted, but the ambitions of artists themselves, seeking the wrong kind of seriousness for their particular kind of art – especially in our theory-minded age in which **art criticism** and even art itself have come to be, to a large **degree, an** academically-oriented pursuit? A suspicion that this might be so is one good reason for inquiring into what constitutes artistic seriousness.

If there were abroad a general sense of satisfaction with the art of our time, that suspicion might be set aside as absurd. But such is not the case. The often bizarre inventions of post-modernism – as when the building housing London's breakfast television station has its roof covered with egg-cups – themselves suggest as much. So do the judgments of critics.

It is now by no means uncommon to find it argued, even by those whose musical tastes are, in relation to the music of the past, austere, that some kinds of 'popular' music are more likely to have a future as examples of serious music than what is commonly called 'contemporary music'. As for painting, consider this judgment by a modernist critic, Barbara Rose:

> The art currently filling the museums and galleries is of such low quality generally that no real critical intelligence could possibly feel challenged to analyse it ... There is an inescapable sense among artists and critics that we are at the end of our rope, culturally speaking.

Or another painter and critic, Peter Fuller:

> I feel that we are living through the epilogue of the European professional Fine Art tradition – an epilogue in which the content and subject-matter of most art is art itself.

It is against a background of uncertainty, then, that one asks the questions I have been asking. Pressures from populism, with its contemptuous dismissal of all distinctions as elitism, pressures from Marxism – the two sometimes converging, sometimes diverging – a persistent unease about the Freudian doctrine that what passes as self-sacrificing devotion to art is nothing but a circuitous route to fame, power and sex, could be successfully resisted by a self-confident modernism. Now, however, the immune system of the arts has been weakened by internal disorders, by a growing suspicion, within the arts themselves, that they have come to be trapped in an Alexandrian web, in the process losing contact both with the life around them and with their historic roots, their traditional reasons for being. (Some philosophers, some historians, feel that way about their own subjects.)

The tendency of recent critical reflection, at least in relation to literature, has been to treat works of art symptomatically, whether, in some quarters, as illustrations of, or clues to, the customs and 'mentality' of a certain period or, in other quarters, as exemplifications of ways of using types of code. In neither case are the distinctions I have been making at all relevant. Popular entertainment or telic art can give us better clues to what is going on at a particular time than serious works, Jacobean plays about city life than Shakespeare's sonnets. As for codes, any reading of structuralist criticism will soon reveal that detective stories, thrillers, are the favoured examples, just as if one wants to grasp the codes of a revenge tragedy it is better to read Kydd than Shakespeare. So the task I am undertaking is in certain respects totally at odds with most of what is going on in contemporary theorising. Not, however, with everyday practice in reviewing. For the reviewer cannot avoid those discriminations which so many contemporary 'theorists' are intent on repressing, one of the most important of which is the discrimination involved in distinguishing the serious from the trivial. Neither can such discriminations be avoided by anyone deeply concerned with the question why and how societies should subsidise the arts or universities should devote attention to them, except in departments of sociology and semantics.

2

Art and Artists

What is this 'art', the seriousness of which is in question? Not so long ago this was – at least on a certain interpretation – an easy question to answer. From the eighteenth century on, critics and artists largely agreed about what kinds of activity constituted the arts and what works were the leading examples of the kind of art which, even if it was originally designed as entertainment or telic art, had the sort of seriousness of which we are in search. Now the situation has changed. As Adorno begins his *Aesthetic Theory* by remarking:

> Today it goes without saying that nothing concerning art goes without saying Everything about art has become problematic: its inner life, its relation to society, even its right to exist.

True enough, in his 'Modernity: an Incomplete Project' Habermas responds that this calling into question of art is already, rather than art itself, a thing of the past, having turned out, he suggests, to be nothing more than 'a kind of nonsense experiment'. That is particularly true, he argues, of attempts to blur the distinction between works of art and everyday artefacts, conscious staging and spontaneous excitement, 'to declare everything to be art and everyone to be an artist, to retract all criteria'. These 'nonsense experiments', he goes on to add, have had the long-term effect of reinforcing the conservative attitudes they set out to destroy, they 'have served to bring back to life ... exactly those structures of life which they were meant to dissolve'.

This is a comforting doctrine in some respects – in some respects, only, since the new conservatism in arts threatens to be as dreary as the new conservatism in politics, morals, religion. But it ignores the effect of cultural lag. Our media, our Arts Councils, our tertiary institutions, are still heavily stocked with 'soixantehuitards'. Hilton Kramer has been led to remark of the United States, in particular, that 'the sixties movement is now on the inside, running or advising the bureaucracy'. That phenomenon is by no means peculiar to the United States. So to thrust aside the 'nonsense experiments' of the sixties and seventies as now being

something one can safely ignore would be to misjudge the cultural scene. As well, it would fail to take into account the genuine grounds for dissatisfaction out of which those 'experiments' arose, dissatisfaction with artists who, in minimalism, had carried Apollonianism to its extreme point, bent on disguising their Dionysian roots.

To revert, keeping these considerations in mind, to our original question 'What is art?', we must first observe that this is not one question but three questions. The first we might call 'horizontal', what kinds of human activities to describe as 'artistic', with 'artists' as their practitioners and 'works of art' as their products – whether, let us say, photography counts as an art, photographers as artists and photographs as works of art. The second question is vertical, whether only some practitioners, some activities, some products count as artists, as artistic, as art, within each of these horizontal categories, whether, say, an amateur water-colour counts as art. The third is ontological, precisely what kind of thing – whether a physical object, an interpretation of a physical object, or a state of mind – we have before us when we characterise a work of art. These three questions, however, are not on the same footing. How we answer the first two is in large part a matter of making a decision, although not in a quite arbitrary fashion, whereas in the case of the third question the problems we meet with are of a purely philosophical kind.

First for the horizontal question. To be entitled to call oneself an artist is nowadays at once to be in a position to make certain claims upon society: to demand respect, to enjoy certain special liberties, to be granted subsidies from organisations set up to support the arts, to have access to the space or the time devoted to arts in the media, to be appointed to universities as visiting artists, to be represented – at least in the case of some arts – in art galleries. So it is not at all surprising that the practitioners of certain activities, not previously carrying these privileges, should fight for the right to be regarded as artists, precisely as Velásquez sought for recognition, as being something more than a tradesman, in seventeenth-century Spain.

We cannot hope to settle this point, whether they have the right to be thus regarded, simply by appealing to ordinary usage. For that usage is extraordinarily variable. In its narrowest sense, 'art' includes only painting, such similar activities as engraving and print-making, and perhaps sculpture. No composer, writer, architect, or novelist would fill in 'artist' under the heading 'occupation' on an official form; to tell a customs-officer that one's luggage contains 'works of art' because it contains musical scores or poems would be foolishly provocative. Not only that, books bearing such titles as *The History of Art* and indeed most books which profess to be about the arts, unless they are written by philosophers, confine themselves to the purely visual arts. Visiting a traditional 'art gallery' that is all one expects to see; if books are to be

found there, they will be books on art, in its narrow sense, or, perhaps, illustrated books.

At an opposite extreme, William Morris once asked: 'What is an artist but a workman who is determined that whatever else happens, his work shall be excellent?' Composers, poets – Eliot, after all, once praised Pound as 'the better workman' – are all, on this view, artists, provided only that they seek to do excellent work, but so also are carpenters, gardeners, stonemasons. This was by no means an arbitrary re-definition on Morris's part, although it was, of course, an attempt to secure greater respect for a class of workmen who were not, on his view, sufficiently regarded by his contemporaries. Like many another reformer, Morris saw what he was doing as a restoration, not as an unprecedented and arbitrary innovation – a return to that broader concept of artist which did not wholly distinguish between artist and artisan. Velásquez, on that view, was wrong to demand a superior status.

When Morris wrote, the older use of the word was not entirely dead, as, indeed, it still is not dead. Nevertheless, even in England, painters, sculptors, architects had largely succeeded in their fight to separate themselves from 'mere workmen', if only after a long struggle. Painters were no longer members of the Painters-Stainers Company, denominated 'face-painters' alongside 'coach-painters' and 'house-painters'. More slowly in some countries than in others, they had managed to secure a place for themselves within a charmed circle, originally containing only poets and musicians, later to be joined there, somewhat more tentatively, by architects and later still by novelists, choreographers, film-makers and photographers. It is this intermediate sense of 'art', 'artists', 'works of art', between the very narrow and the very broad, that now concerns us. It is sufficiently familiar, even if, as I have suggested, by no means the most common usage.

Morris, of course, is attacking the whole concept of a charmed circle, the primary object of which is to draw a line of demarcation between artists and those other productive workers who cannot properly be so regarded. His type of view has in recent times come to be very influential, according as it does with contemporary populism, the attack on elitism, the demand for 'social justice', with critiques, even, of sexism and racism, in so far as particular crafts had been particularly cultivated by women or by members of certain 'racial' groups. When Habermas condemns as 'nonsense' the refusal to differentiate between works of art and artefacts, it is plain what he has in mind. Not so clear, however, is whether this sort of 'nonsense' has in fact now been abandoned or whether it can properly, without further argument, be rejected as such.

When I spoke above of 'traditional' art galleries it was to differentiate them from those many modern galleries – not necessarily galleries of modern art – in which one now finds silverware, fashions, typewriters, teapots, all of which would once have been segregated to museums of

'applied art' or *Kunstgewerbe* or *arts decoratifs*. They may also include animal or human figures which, until quite recently, would have found their home in ethnographical museums, considered as fetishes rather than as wooden sculptures.

In this last, ethnographical, case the argument is reasonably straightforward, namely that although these objects were originally created – like so much Western art – to fulfil magical functions, they can nevertheless be taken seriously as sculpture, just as aboriginal painting can be taken seriously as painting and aboriginal music as music. (It does, however, tell against the view that only *professional* artists can produce works of art, although the older view that in 'primitive' society no one was singled out for artistic skill has now been abandoned.) Something similar happened rather earlier in the case of Oriental arts. Even if uneasiness about charges of 'racism' has sometimes precipitated such changes it does not wholly account for them. Such problems as still arise are vertical, not horizontal: which particular examples of what is generally granted to belong to traditional art forms are worthy of being included in an art gallery or publicly performed.

The case is quite different when a particular kind of activity – let us say, industrial design – which has traditionally not been part of the charmed circle is clamouring for admission to it. The argument for granting admission commonly takes the following form. First it is presumed that certain kinds of activity, already forming part of the charmed circle, are indisputably artistic; secondly, it is argued that the activity now demanding admission is, in central ways in which those arts can achieve excellence, analogous to them; thirdly it is claimed that it, too, can achieve excellence in these ways.

Why not say, more simply, that there is a kind of excellence peculiar to the arts and that any form of activity which can achieve this kind of excellence is an art? The answer to that question we are not yet in a position to give. Let me for the moment say only that sensible debate about whether a form of activity can properly be regarded as an art does not have to rely upon the very bold assumption that there are excellencies peculiar to the arts and has traditionally not done so. It has relied, rather, on the much more plausible doctrine that the arts have overlapping excellencies.

In the beginning, as I said, there were poetry and music, linked as song. (It was left to the purists of a later generation to argue that poetry and music were so different from one another that song, as a serious form of art, could simply not exist.) Notoriously, those arguments which were adduced in favour of the admission of painting to the charmed circle made use of the maxim 'Ut pictura, poesis'. Drama could find a place as poetry when poetic drama was the usual form and prose drama could enter by clinging to its coat-tail, eventually, after much hesitation, carrying the novel with it. Architecture was in medieval times considerably more

important, socially, than painting, but the architect's character as 'master mason', as later his character as engineer, has always raised doubts in some quarters about the suitability of taking architecture to be an art. Still, the close relationship between painting, sculpture and architecture, with Michelangelo and, later, Bernini, engaged in them all, helped to bring out the way in which a concern with formal spatial relationships runs through all three of them.

Nearer to our own time are the cases of photography and film. Their admission to the charmed circle has been bitterly contested, and sometimes not even sought by their practitioners. In part, as earlier in the case of the novel, the feeling was that both photography and cinema were so largely committed to entertainment that it was ridiculous to take them seriously; in part the objection was that they were both of them methods of mechanical recording.

Although superficially what came out of them was in some ways analogous to what came out of the artist's studio – note, indeed, the expression 'film studio' – their kind of excellence, so it was argued, was quite different, since their object, its critics claimed, was simply to create a total record of what was put in front of the camera and their product was to be judged wholly by its success in these terms. The dispute is not over, but I think we can fairly say that film and photography have by now shown that this is not the case and have entered the charmed circle. The debate now turns around certain kinds of what have traditionally been distinguished from the arts as crafts – furniture-making, for example – and certain products of the designer's inventiveness – typewriters, let us say – where the analogy advanced is with a particular subspecies of sculpture, abstract sculpture. (It is often the case that the analogy, in such cases, is only with a sub-species.)

To fight out in turn all the demarcation issues which have arisen or could arise would be a lengthy and tedious affair. But otherwise how are we to protect ourselves against those who protest against any generalisation we make about the arts by saying, 'But that does not apply to art X', where X is the name of some form of activity the status of which as art is disputable? We shall have to take up that issue as it arises. Perhaps we shall find that we are not making any broad generalisations about serious art as a whole, as distinct from particular forms of serious art. If the problem does arise, we shall fight it out when it does so, using the criteria suggested above.

Is it not preposterous to leave what would seem to be so central a question – what counts as one of the arts – simply hanging in the air? That is the way it has been in the past and the way it is best to be in the future. A formal definition of the form 'Nothing counts as a work of art unless ...' sounds as if it would be something useful to have. But any such definition, had it been arrived at before the Renaissance, would probably have still left us thinking of only poetry and music as arts. The analogical,

chain-link approach suggested above is both a realistic account of what actually happens and allows a degree of elasticity while not entirely leaving the gates open. It is powerful enough to rule out Marcel Duchamp's view that anything was a work of art if he said so, but it still allows the possibility of admitting previously excluded forms of activity to the charmed circle.

One of the most thorough-going attempts to draw a sharp distinction between art and craft which would settle once and for all the question what belongs to which class is in Collingwood's *The Principles of Art*. That bears out our suspicion about such projects. As his example of an art, Collingwood takes poetry. There the analogy with the crafts is at its slightest, even if we reject the view that poetry is an effusion involving no skill – which is by no means, of course, Collingwood's view. But if Collingwood had been in a position to arbitrate when there was some question whether sculpture should be accepted as an art, his answer would have had to be 'No'. He asserts it to be peculiar to the crafts that the craftsman has to think out exactly what he is going to do before he does it, that the end was thought out first, most commonly by someone else, that the raw material is available before the work is done, that the maker is dependent on the skills of someone else. To be sure, none of these things are true of someone composing poetry or music. The medieval sculptor, however, had to think out how to fit his sculpture into a particular niche; he was told what purpose he had to satisfy; the raw material was available as stone before he began; the sculptor was dependent on the skills of the mason. Are we really prepared to say that sculpture became an art only when sculptors were free to let their material take whatever shape emerged from beneath their hammer? Although Collingwood might do so, for his own special purposes, this is certainly a highly implausible position.

At the opposite extreme, Adorno, in the course of opposing, as I have done, the attempt to find a definition of art which would exclude in advance, insists on the usefulness of leaving the concept elastic. 'Art,' he writes, 'has a changing scope and it may be just as well not to try to define sharply what's inside it and what's outside of it.' However, he goes on to add, as I did not, that although, for example, the question whether film is an art is 'instructive', all the same 'it leads nowhere'. This, I have indeed suggested, is not true. At the practical level, it helps film-makers to make certain kinds of demand on society. At the theoretical level, it can help us to see something about both films and those arts with which an analogy is claimed. Certainly, however, such discussion neither has to deploy, nor can it be expected to give rise to, a definition of the arts as a whole.

We have dismissed two views as unacceptable. The first is that when the question is whether a kind of activity counts as an art this can only be settled by an arbitrary fiat, the second is that there is some formal definition which need only be wielded to rule out any pretender to artistic

status. How are we now to proceed? Defying Plato's constant objections to this kind of procedure, I propose to talk about the arts which are now generally included within the charmed circle, on a reasonably generous interpretation which permits the inclusion of film, photography, ballet, without offering any formal definition.

We have still another terminological problem to meet, a second way of interpreting the question 'What is art?' Sometimes the phrase 'work of art' is used in such a way that the adjective 'serious' before it is redundant; perhaps, even, so that 'good' is redundant. To say of something that it is a work of art is then automatically to deny that it is trivial; 'trivial work of art' comes to be a contradiction in terms. So someone, having said of a novel, 'I greatly enjoyed it,' might go on hastily to add, 'Of course, it's not a work of art.' This, as the point is usually put, is the 'evaluative' use of the phrase 'work of art'. The work in question is clearly a novel – that is not being denied – and novel-writing, as is also not being denied, belongs to the charmed circle, and yet the conclusion is not allowed that this particular novel is a work of art.

It would seem, then, that as well as distinguishing horizontally between novel-writing and such forms of writing as précis-making which are not included in the charmed circle, we might also wish to distinguish vertically within the class of novel-writers between those who write works of art and those who do not. When we differentiate between 'poetry' and 'light verse', between a 'painting' and a 'daub', or between, in the manner of some lending libraries, 'literature' and 'fiction' we are making such vertical distinctions. A composition may be dismissed in the same spirit, with 'That's not music'; a film with 'That's not cinema'; a building with 'That's not architecture.' In each case the dismissal-phrase could be spelt out either as 'That's not good …' or 'That's not to be taken seriously as …'. More often, perhaps, as the second than the first, because even those who most firmly adhere to the evaluative use of the phrase 'work of art' will commonly agree that something can be called a 'work of art' which is nevertheless very imperfect.

On the particular point of usage now under consideration, a decision has already implicitly been made. To speak of 'entertainment art' and 'telic art' is to use the word 'art' in a way which includes not only the bad and the good but the serious and the non-serious, which is so far descriptive rather than evaluative. So far, only, because evaluation has come into the picture in that to be counted as art a work must be a member of a class some members of which achieve a certain degree of excellence. Novel-writing is an art only if novels can have excellences which they share with other arts, as distinct from sharing, only, the excellences of those skills which do not form part of the charmed circle – philosophical excellence, let us say. But, of course, from the fact that novel-writing can achieve excellence, or that a novel can be a serious work of art as distinct from being excellent entertainment or excellent

propaganda, it by no means follows that every novel is excellent. It may, indeed, be trash. Excellent or trashy, serious or not, it is still, on my usage, a work of art.

This way of using the phrase 'work of art', and correlatively 'artist', 'artistic activity', is by no means a total innovation, even though it cuts across what is admittedly also a standard usage, exemplified in the contemptuous 'Call *that* a work of art?' Its great convenience is that it allows the affixing of a variety of evaluative adjectives to works of art, thus permitting distinctions which are highly germane to my purposes. To begin from the assumption that there is a class of works – 'works of art' – distinguishable by their seriousness from 'mere entertainments' or 'merely telic productions', which is substantially what many writers do, would be to beg the question. That there is any such class is something which has to be shown. To ask whether within works of art we can distinguish the serious from the merely entertaining and the merely telic permits the central issues to be more clearly raised. Otherwise, too, there is no generic name for those paintings, novels, compositions which do not win the accolade. Trivial poems, trivial plays, trivial music are all of them trivial ... what?

It is sometimes argued, on the other side, that to use the phrase 'work of art' descriptively as nothing more than the class name for paintings, novels, etc. will lead to unbearable consequences, that ducks on the wall, or garden gnomes, or novels written to pre-established formulae cannot endurably be counted as works of art. There are two ways of coping with this objection. The first is to deny that manufacturing garden gnomes counts as sculpture or that writing to a predetermined formula counts as novel-writing. Obviously there can be demarcation problems within each art as there are between art and other forms of skill. There are minimal requirements below which we are not prepared to count a thing as even a trivial example of these art-forms. The alternative is to say that garden gnomes and the like are low-level entertainment art. It does not matter too much, from my point of view, which of these alternatives is chosen.

Vertical questions cannot, however, be wholly set aside. If our discussion is not going to proceed at an intolerable level of abstraction, it will have to make use of concrete examples, examples of works which have at least some claim to be considered serious. Not solitary examples, either. Reading the literature on the arts, or such of it as aspires to be critical, we are constantly struck by the way in which bold generalisations are followed by a 'for example', used as if that were all that was needed to support the generalisation and without the slightest attempt to do what is theoretically necessary, namely to show that this generalisation is true in cases which appear to be clear counter-examples to it. So we find the remarkable, if by now only too familiar, thesis that 'All novels are really about novel-writing,' followed by, 'for example, in *Tristram Shandy*, Sterne ...'. Now although we might wish to question,

even in this case, whether Sterne is writing about novel-writing, *Tristram Shandy*, among older works of literature, is the novel that one would most obviously choose to illustrate the generalisation in question. What we need to be shown is that *The Possessed* or *The Trial* or *Cancer Ward* is really about novel-writing.

There is an enormous number of generalisations which could in this way be exemplified. 'All novelists are symbolists; for example in *Moby Dick* Melville ...'; 'All novels defend reactionary politics; for example in *The Secret Agent* Conrad ...'; 'Every serious novel has a crime at its heart; for example in *The Brothers Karamazov* Dostoevsky ...'. And so on. In an inquiry which purports to be theoretical this will obviously not do; not only does the 'for example' need to be filled out by other, less obvious, examples, but striking counter-examples have to be explored and shown in fact not to be counter-examples. We want not 'for example' but 'even in the case of'. Not then 'Every serious painting is about other paintings, consider Bacon's *Innocent X*', but rather 'consider even the wall-painting at Altamira'. (Which then has to be followed, of course, by detailed argument.)

Then difficulties arise. Both examples and counter-examples can be controversial as examples of serious art. Or they may convey nothing to the reader. I might like to take examples from Australian aboriginal art or from Australian landscape painting, as being immediately available to me for checking. But that would make them uncheckable as examples for quite a few of my readers. For practical reasons, it will be as well, then, to choose examples which are reasonably familiar since, except in the case of very short poems, there is no way of making readers acquainted with the works being referred to. At the same time, it is also sensible to choose works which critics have recommended as being worthy of our serious consideration. For they, after all, have the closest acquaintance with the range of art-works in which they specialise.

Not that we are bound to assume that the Honour Roll set up by any critic or class of critics – or more generally by what is now sometimes called the 'art world' – is infallible in respect of either what it includes or what it excludes. Indeed, unless we have wholly lost confidence in the principle of contradiction, that would be impossible. Critics are deeply divided, particularly, but not only, over time, about what should go into Honour Rolls. Furthermore, like any other occupational group, critics suffer from occupational defects, especially, perhaps, in the contemporary world.

I do not mean, or only mean, the kind of thing Tom Wolfe has exposed – the struggles for power and wealth in a society in which both are attainable within the arts. Neither do I have in mind the nationalistic pressures which sometimes lead critics grossly to exaggerate the virtues of their compatriots, or the determination not to be provincial which, in smaller countries, may have exactly the opposite effect. Even aside from

these factors, critics have violently reacted against the contempt they have endured in the past on the part of artists, against the judgment that they are parasites. Flaubert did not stand alone when he told Louise Colet that:

> Criticism occupies the lowest place in the literary hierarchy: as regards form, almost always; and as regards 'moral value' incontestably. It comes after rhyming games and acrostics which at least require a certain inventiveness.

In reply, critics have sometimes argued not only that they, too, are imaginative, creative – something I should not for a moment wish to deny, in relation, at least, to the better critics – but that they create the works they are criticising. So for Catherine Belsey in her *Critical Practice*: 'No longer parasitic on an already given literary text, criticism constructs its object, produces the work.' Or at the very least, that critics are indispensable guides, so that it was quite absurd of us to suppose that when we read Joyce or Eliot in advance of the more substantial critics, this is what we were actually doing. Such an attempt at aggrandisement can lead critics to place all their emphasis on those works which are obscure to the point of being almost impenetrable, at the cost of works where the critic can enlarge, or explain, our admiration, without first having to elucidate, or complete, what we are admiring.

For that reason it can nowadays be hard to reconcile the two requirements laid down above, to choose works which are both generally familiar and presented to us as serious by critics. For 'modernist' critics have tended to concentrate their attention on works which are seldom read, looked at, or listened to except by modernist critics – let us say the later novels of Samuel Beckett, *Finnegans Wake*, conceptual art, the compositions of John Cage, the films of Straub.

A very different problem arises with a certain type of populist post-Marxist criticism. On this kind of view, only what now has an immediate impact is to be taken seriously. Consider the following from Su Braden's *Artists and People*:

> It must be understood that the so-called cultural heritage which made Europe great – the Bachs and Beethovens, the Shakespeares and Dantes, the Constables and Titians – is no longer communicating anything to the vast majority of Europe's population ... It is bourgeois culture and only immediately meaningful to that group.

I called this 'post-Marxist' in so far as it makes use of a Marxist category. But it can more accurately be described as 'populist' and in fact shares the values of bourgeois Philistinism. There never has been a time when Dante's *Vita Nuova* or Beethoven's late quartets or Bach's *Musicalisches Opfer* or Shakespeare's *The Winter's Tale* – let alone *The*

Phoenix and the Turtle – were 'immediately meaningful' to the vast majority of Europe's population, any more than Marx's *Capital* or books on such topics as 'artists and people' ever have been. Of the artists Braden mentions, Constable and Titian are in a rather different position. Would a European workman, faced with an early Constable, or, let us say, Titian's *Man with a Globe* or *La Bella*, respond by claiming to find it meaningless? That response is far more likely to come from a workman shown examples of contemporary art, in such forms as conceptual art or action painting. Indeed, the number of people who respond to Beethoven's music or to Shakespeare's plays is far greater than it has ever been in the history of Europe. (I was myself recently astonished at the rapt attention of a very ordinary Sydney audience seeing for the first time that notoriously difficult play *All's Well That Ends Well.*)

Why, in any case, should it be regarded as an objection to serious art that it is not 'immediately meaningful'? It would obviously be ridiculous to complain of science or philosophy or economics or sociology in these terms. Of course, it can matter in the case of entertainment art – although many people do not seem to care if the words of popular songs are totally inaudible – and it certainly matters in the case of telic art, where the propagandist wants to make a direct appeal to large audiences and does not want those audiences to look carefully and critically at what they are seeing, hearing or reading. Such art will rely, then, on the kind of immediate impact which forestalls close critical consideration. In contrast, although serious art need not be obscure, as the modernist critic sometimes seems to assume, there is no reason whatsoever for supposing that its obscurity, when it is obscure, is a fatal objection to its seriousness. For these two reasons – the first, that populism exaggerates the degree to which the art of the past no longer speaks immediately to this contemporary age; the second, that even were its appeal no longer immediate this would not demonstrate that past art is non-serious but only that, like much contemporary art, it has to be studied before its qualities become apparent – we can safely ignore the populist demand that we should take our examples only from contemporary art.

There are, however, questions raised by more substantial Marxists which we cannot safely ignore. The arts have always been a problem for Marxists: first because we are able to appreciate works of art which in no way reflect current socio-economic conditions; secondly, because there are artists who set themselves against the society of their time rather than simply reflecting it; thirdly, because it is by no means plain what sort of art should be forbidden and what encouraged in a socialist society, on the assumption that art will have to be controlled.

In the now considerable Marxist literature on these questions, we can detect a number of divergent responses, all of them bearing on the question where we should look for examples of serious art. The first is that the art of the past, however enjoyable, is not fully serious. Marx's

notorious suggestion that Greek art appeals to the child in us is one formulation of this doctrine and an interesting example of the way in which a brilliant thinker can find himself forced by his theoretical assumptions into total absurdities. Some Marxists go even further than this; they tell us – and we shall also meet a similar view in Comte – that to take examples even from the present, to say nothing of the past, is to cite cases of what is not fully serious art. Only in the future shall we know what serious art is like, although we can get some inkling of that future from proletarian novels. Later, we shall be looking more closely at this kind of view, which is wonderfully characterised by Camus in *The Rebel*. For the moment it is enough to say that we cannot possibly accept the demand that all our examples be imaginary.

A second Marxist response is that the works of the past were serious for their own times and are still serious for us in so far as they form the foundation on which we can build. Consider what Lenin once wrote on this theme:

> If we do not clearly understand that a proletarian culture can be built only on the basis of a precise knowledge of the culture created by the entire evolution of humanity and by the integration of this culture we cannot fulfill our task ... All the culture that capitalism has left behind us must be carefully preserved and it is on this basis that Socialism must be built, otherwise it will be impossible for us to create the life of a Communist society.

It was often complained, indeed, that in Eastern European countries the emphasis on the 'cultural heritage', in the form of the great nineteenth-century works, was overwhelmingly strong. To this Eastern Europeans not altogether implausibly replied that if such works are now less read in the West this is not because the West is so creative but rather because the masses have been corrupted by Western entertainment art with its emphasis on immediacy, discontinuous shocks, instant excitement, to a degree that destroys the power of deep concentration. Such Marxists will not object when I take 'classical' works as my examples, but only when I take to be serious what they regard as degenerate art.

A third Marxist response is that artists can deal with perennial issues in a way that gives their work a permanent seriousness. This has its difficulties for conventional Marxists, always suspicious of the view that there are perennial problems or anything accurately describable as 'human nature', finding it easier to hold that an artist working in a bourgeois society – which they take twentieth-century capitalism to be – cannot but be decadent. Nevertheless, the Marxist literary critic Tom Kettle is prepared to assert that Shakespeare is not a bourgeois artist, Ernst Fischer to insist that 'we must not abandon Proust, nor Joyce nor

Beckett and even less Kafka to the bourgeois class', John Berger to defend twentieth-century innovations in painting.

Many Marxist writers, then, would allow me to choose as wide a range of examples as could possibly be hoped for, if others would object to precisely those examples on which modernists commonly insist. If a fundamental challenge to the present project as a whole comes from anywhere it comes from what is sometimes dismissed as 'vulgar' Marxism, which argues that, properly understood, all art is telic, a means of strengthening the social solidarity of the class for which it is written or persuading oppressed classes to accept their lot. Or at most, if we can distinguish within the telic between the serious and the trivial, this will always be a relative seriousness, the serious being that which, in spite of the author's intentions, gives us material the Marxist can use in order to criticise the society for which the author wrote. Balzac is the favourite example. These are views it would be unsafe simply to dismiss, although, as I pointed out, they are not universally held by Marxists and are notoriously difficult to apply to such arts as music, except when it takes the form of opera. But even vulgar Marxists will expect the argument to turn around certain classical examples.

To sum up, we cannot, without stultifying the whole enquiry, begin from the view that either the art of the past or the art of the present is wholly lacking in seriousness, although that is a conclusion to which we might finally be compelled. The safest thing to do, it also seems, would be to refer only to familiar classics, just because by their very nature these are both well-known and generally recognised by critics. But Collingwood rightly argued that this can be misleading, that contemporary examples can be particularly useful in the task of combatting or defending generalisations, as presenting challenges to what we might otherwise somnolently accept as being indisputable.

On the other side, we can be taken in by such examples, wrongly supposing, as modernist critics have sometimes done, that art has permanently taken a turn which at last reveals its true nature when in fact nothing more has happened than that for a time certain 'nonsense experiments' came to be fashionable. Critics, too, can sometimes be so swept away by the novelty of a particular style that they do not notice work of a supposedly out-moded style which is being carried on around them by, let us say, a Balthus. It looks as if the best thing to do is to vary examples, to multiply them, and carefully to avoid saying 'for example' unless we have other examples up our sleeve, in the hope that readers, finding a particular example unconvincing, will readily light on such other examples. Otherwise, we suggested, it is only too easy to lay down generalisations the plausibility of which entirely depends on closing our eyes to all but a few typical examples. Of course, when it is a question of *rejecting* generalisations, one counter-example is, formally speaking, enough. But there is always a risk of misconstruing a particular example.

In any case, we would like to know whether the generalisation has many, diverse, exceptions or whether it could easily be patched up.

Reverting to our main theme after these methodological reflections – tedious and banal, it might seem, but in the light of the critical literature by no means unnecessary – we can sum up thus: to the question 'What is art?', understood as meaning 'What activities count as being artistic?', I have replied: 'Those activities which are either analogous to poetry and music in respect of the kind of excellence they can display or are analogous in this respect to activities which are thus analogous to poetry and music'; to the question 'What is art?', understood as meaning 'What is the cut-off point within these activities at which their products can no longer be described as works of art?', I have replied, 'Nowhere, although there are points at which an activity does not count as one of these activities.' We still have to face the ontological question which philosophers often have in mind when they ask: 'What is art?'

3

The Work of Art

Or must we? Suppose I were to accept the view – as matters stand I have neither accepted nor rejected it – that designing typewriters can be an artistic activity. We all know full well that some philosophers have argued that objects like typewriters are simply bundles of perceptions and others that they are appearances of Absolute Reality. It would be absurd to consider in detail these possibilities before being prepared to embark upon the question whether some typewriters have to be taken seriously as works of art, analogous to sculpture. When I gave as examples paintings by Titian or music by Bach, any reader could catch my point, agree or disagree with it. No one would have waited to see what I had to say about 'the ontological status of works of art' before being ready to decide whether either Titian or Bach still were, or never had been, 'immediately meaningful'. If anything puzzled them it would be that final phrase. Even a more complex statement such as 'In *Hamlet*, Polonius is represented as being a platitudinous dodderer, but in one production of the play he was turned into an efficient administrator, simply by leaving out some of his lines' would not arouse qualms in anyone but a professional philosopher.

Epistemologists, metaphysicians, ontologists have their own special reasons for taking up issues raised by the arts. The arts often present apparent exceptions to the general theories of reality, of truth, of meaning, which they are seeking to establish. Most often, their problem is to find a place for fictions within their theories, although they may also see in music an apt illustration or a troublesome exception. In general, however, the questions which interest them arise as much within entertainment art as within what we think of as serious art. They may prefer such examples as 'What can it mean to say that "Hamlet killed Claudius" when there is no such person as either Hamlet or Claudius'? But the ensuing argument would not be affected in the slightest degree if 'Dead-Eye Dick killed Fast-Draw Sam' were substituted as the example.

At a certain level we shall have to face questions of this kind. But our concern is quite different: we are not engaged in trying to develop a general theory of reality or knowledge or truth. Ontological and

epistemological questions are not our chosen theme; rather they are forced upon us. To explore them in detail would soon burst the bounds of our inquiry. In his *Art and its Objects* Richard Wollheim avoids this difficulty only by telling us at intervals, just when he seems to be moving towards a decision, that 'this problem is too large to be taken up here', leaving us suffering acutely from *intellectus interruptus*. So it would be a relief and, I have suggested, not wholly improper, simply to set aside all ontological issues as not immediately relevant. Such issues can arise, however, at a level at which they influence both critical and artistic practice, particularly in these theoretical days; they can affect the question what is to be taken seriously.

There are, one must begin by observing, two distinct issues involved at the philosophical level in the question 'What is a work of art?' The first of them is to what general ontological category works of art belong. In particular, are they material objects or imaginary objects or processes in somebody's mind? (There is no reason, we should insist at the outset, why the answer to this question should not differ from art to art. Arts did not have to show their ontological credentials before being admitted into the charmed circle.) The second is an identity-problem. In the sentences '*Waiting for Godot* is coffee-stained', '*Waiting for Godot* is a farce', '*Waiting for Godot* was first performed in French', '*Waiting for Godot* was much revised', am I talking about the same thing?

On the face of it, at least three different things are implicated in the existence of a work of art: an artist, a public object which an artist creates, and an audience – using that word in a broad sense to include both lookers and listeners – which receives it. True enough, in a limiting case the audience may consist solely of the artist who destroys, without showing it to anybody else, the created work. But that does not differ in principle from the also exceptional case where a second person destroys a work on discovering it after the artist's death. Receiving the work can still be distinguished from creating the work.

Let us call this, not at all in a deprecatory sense, the 'naive' view. It is the natural starting point. Criticism, one might then conclude, should try to penetrate into the artist's mind, to look with care at what the artist has produced, to consider its effect on an audience. Indeed everyday criticism commonly does all these things. No one would be at all surprised to read something like the following: 'In his late paintings, their colours ranging from grey to black, Goya obviously intends to disturb us and wholly succeeds in doing so', with its references to Goya's intentions, to physical characteristics of the paintings, to their effect on anyone who regards the paintings attentively.

There are theorists, too, who more explicitly accept the 'naive' view. So for Tolstoy what goes on in the artist's mind is an emotion. But Tolstoy at once adds that merely having an emotion does not make a person an artist. Neither does the fact that the artist communicates that emotion to

other people; anyone might communicate sorrow, joy or suffering to others. What distinguishes the artist is the capacity deliberately to express an emotion, either real or imagined, in a public form – whether as a story or on canvas or in marble or in instrumental sounds – so that others are infected by it.

For Dewey, too, three elements must be present, even if they are differently described. The artist sets out deliberately 'to produce something that is enjoyed in the immediate process of perceiving'. The first thing necessary, then, is a particular intention on the part of the artist. (That already involves, however, an anticipation of the attitude of the perceiver, which the artist 'embodies in himself while he works'.) Equally necessary are the making or the doing of 'something visible, audible or tangible' and someone who by perceiving that something enjoys the experiences which the artist sought to communicate.

These are rough and ready summaries of complex views. Still, it will at once be apparent that for both Tolstoy and Dewey, when we judge a work of art to be serious we are, to begin with, saying of a public work which an artist has made that it succeeds in doing what the artist sought to do, namely to communicate something to an audience, and that this differs from non-artistic communication just because what mediates between the communicator and the audience communicated to is a public work of a special character. The difference between Tolstoy and Dewey is only a difference in respect to what exactly the artist seeks to communicate – emotion or a particular kind of pleasurable experience.

Not only philosophers but critics, however, have often hoped to simplify. They then urge that we not only can but ought to ignore one or the other member of the naive trinity. The critic, so it has often been said, ought to refer to nothing but the public work; neither the intentions and character of the artist nor the historical setting of the work has any relevance to its nature when what is in question is its value. Neither does it matter what audience receives it. The true work of art is an autonomous whole, floating free in time and space, and must be thus considered. For other critics, the proper point of reference in discussing works of art is an interpretation it sets going in an audience; that interpretation – or the class of such interpretations – is the work of art, whatever the artist had in mind in creating it. Indeed, the interpreter, not the artist, creates the work. So the third person of the trinity is the only one that matters. For others still, the work of art is what goes on in the mind of the artist, the publicly created object being no more than a medium which lets the interpreter discover that true work of art.

As an example of this third view, consider what Collingwood says in the first book of *The Principles of Art*. I put the matter thus because although what he says in that book reads like an extreme example of the view that the work of art exists only in the mind of the artist, it becomes plain in the third book that both the public work and the audience have roles to play

in the creation of works of art which his preliminary observations would not at all lead us to expect. Indeed, with much of what he there says we can feel the deepest sympathy while not at all accepting his initial pronouncements.

He begins, like Tolstoy, from a position he takes to be unquestionable, that art proper – serious art – 'has something to do with emotion' and more specifically that it *expresses* emotions, as distinct from describing them. But he does not mean by this what we might expect him to mean and what it would mean for neo-expressionist writers and critics – that the work of art must be passionate, rawly revealing the artist's feelings and trying to stir up similar feelings in an audience. Such immediacy Collingwood takes to be characteristic only of what he calls 'magical' – my 'telic' – art, not of 'art proper', serious art. Rather, the serious artist must be able to lift such feelings to the level of consciousness, and that is done by finding a 'language' which expresses them. ('Language' has here the broad meaning it has in 'body-language', which Collingwood takes, indeed, to be the prototype of language.)

Even granting so much, we might question whether such a theory amounts to anything more than this: an artist is a person who has a talent for creating public works which express an emotion in a form much more accurate than anything we could succeed in making for ourselves and which help us, therefore, to comprehend our own emotions. Such a thesis would be an intellectualised version of Tolstoy in which the *comprehension* of emotion rather than, simply, *infection* by an emotion is the outcome of the artist's activities, but still with the public work as central.

When, however, we turn to what Collingwood has to say in his preliminary account of imagination we are startled to discover that on his view there need, in the case of serious art, be no public work whatsoever. As we have already seen, Collingwood draws a very sharp distinction between the artist and the craftsman. The 'magical' (telic) artist is forced, he freely admits, to create a public work in order to produce his intended effect. That is because such an artist is essentially a craftsman, shaping materials into a form in which they will fulfil a preconceived purpose, in a manner not essentially different from a clock-maker. In contrast, what Collingwood calls 'art-proper' – my 'serious art' – need not, on his view, exist anywhere but in the artist's imagination. The 'naive' view that a work of art exists only when the artist creates a public object, he wholly rejects. He takes the case of a musician composing a tune. 'This tune,' Collingwood tells us, 'is already complete and perfect when it exists merely as a tune in his head, that is, an imaginary tune.'

The composer, Collingwood of course admits, will normally want the 'tune' to be performed and that involves bringing into existence what Collingwood calls 'a collection of noises'. These noises are not, on his view, themselves the musical composition: 'they are only means by which the

audience, if they listen intelligently (not otherwise), can reconstruct for themselves the imaginary tune that existed in the composer's head.' 'Listening intelligently' has the force of 'listening in the manner of a musician', which will involve correcting the heard noises. It is not simply a matter, however, of our imagining sounds which are the sounds the musician had imagined. What is imagined is a 'total activity'; that, as the composer imagined it, is the true work of art, whether or not it is ever performed.

Why is not Collingwood content to say that the composer, unlike the rest of us, can imagine sounds which express emotions, rather than introducing all this talk about 'total activity'? Well, the natural way of describing what happens would then be that having heard a lot of tunes, a composer develops a capacity for imagining them – as an alternative to humming them or picking them out on a piano. That would be rather like our being able to imagine going for a walk as a result of having gone for walks, when it would be ridiculous to say that the real, or true, walk is the one we imagine, not the one we actually take, as Collingwood does want to say that the real tune is the imagined tune. It would make the public work prior, reduce the imagined work to the same level as the hummed work or the picked-out work, and leave open the possibility that an actual performance could be better than the imagined performance, as it certainly can be better than a hummed or a picked-out performance.

In the course of elucidating his obscure notion of 'total activity', Collingwood shifts the centre of his attention from music to painting. This, we might think, is a very desirable thing to do, since he is trying to develop a general theory of the arts and by thus switching he avoids the risk that what he is saying may in fact be applicable only to music. But we often find in aesthetic writings that an example-switch operates in a rather different, distinctly less desirable, way. A general theory is developed by concentrating upon the art where it is most plausible until a point is reached where the theory begins to lose plausibility. At that point a hasty switch is made to another art in order to regain plausibility. (I am not suggesting that this is done with deliberate intent, to deceive the reader. Hypothesis-saving is our characteristic *modus operandi*.)

So, in the present instance, it is relatively easy for us to imagine how a composer might have a tune 'in his head', revising it, polishing it, until it is in the form he wants it to have, just as those of us who are writers may do the same thing with a paragraph, perhaps a paragraph in an envisaged book which we never write. Even if many of us cannot get much further than such a paragraph without taking pen in hand we are nevertheless – looking, say, at the near-perfection of Bertrand Russell's logical manuscripts – prepared to believe that some writers can, as they tell us, do more 'in their head' than we can; we know that this is true of mathematical calculators. We cannot rule out Mozart's testimony that he had the whole of one of his symphonies in his head before he wrote it

down – much more, then, than Collingwood's 'tune'. But given the contingencies associated with the flow of paint, we are not easily persuaded that what a painter had in his head could ever be precisely the painting we have before us. Or that it must be superior to it.

Then, too, in the case of music we can at least understand Collingwood's argument that any performance is in certain respects imperfect, that what we take to be serious is something which is in part imagined by us – not in the sense that, to use a common phrase in a rather unorthodox way, the music 'tickles our fancy', setting it going in ways that are purely personal, unrelated to the music except in so far as the music stimulates them, but rather in the sense that we can correct what is heard and thereby respond to what the composer 'had in mind'. In the case of painting, however, the only 'performance' is the painting, and if we imagine a change, let us say, in the curve of a line, we are simply imagining a different painting. There could be no reason for believing that the painter had in mind this different painting.

On the other side, by switching to painting and following Berenson, Collingwood is able to develop a case for saying that our awareness of the work of art does not fall into any single sense-modality and that the appreciation of it, therefore, is an imagined total activity. Conjoining Berenson's views with some observations of his own on Cézanne, he argues that what the spectator 'of a painting experiences on looking at a painting 'is not a specifically visual experience at all'. Neither does it 'consist of this as modified, supplemented and expurgated by the work of the visual imagination'. It incorporates also 'the imaginary experience of certain complicated muscular movements'. So, in the case of a Cézanne painting, 'a bridge is no longer a pattern of colour' but 'a perplexing mixture of projections and recessions, over and round which we find ourselves feeling our way'.

Now, even in so far as this is true – and we might well question whether it is true of all serious painting – it is quite another matter whether, when we listen to music and in the process, as Collingwood says, 'enjoy imaginary experiences which do not belong to the region of sound at all, notably visual and motor experiences', what we see or feel in such an imaginary way is an ingredient in the serious music as distinct from merely being stimulated by it. There is some music, no doubt, which is designed to call up particular pictures or to lead us to imagine ourselves dancing. But it by no means follows that we could construct a Berenson-type analysis which would find these imagined dancings, as distinct from what are actually heard dance rhythms, in the music.

The last few paragraphs have been something of a detour in my main argument because I wanted to develop a methodological point, that we have to beware in anybody's writings about art, including my own, of example-slip. Equally, we have to be wary of analogies. Collingwood tells us that to suppose that what we are listening to as a symphony are the

'noises' the orchestra is making – his choice of the dyslogistic word 'noises' rather than 'instrumental sound' is the sort of rhetorical device which needs watching – is like supposing that what we are listening to when we hear a lecture are the noises the speaker is making. We might sensuously enjoy the speaker's voice but this is very different, he argues, from listening to the lecture.

We can certainly agree with this and, analogously, that sensuously enjoying the sounds made by an orchestra is not the same thing as listening to the music. But beyond that point the analogy does not work. Exactly the same lecture could be delivered in a deep bass or a light soprano voice, in an Australian, an American or a Yorkshire accent, in Russian, French or English. The sounds uttered may be completely different without affecting what we are listening to – assuming only that we can follow the accents or the languages in question. Of course, music can be transcribed, but not to the point of having the soprano role in *I Puritani* sung by Christoff or Boris Godunov sung by Sutherland. It can be transposed, too, but not so as completely to alter the sound-relationships. The sounds, in their relationship, are essential to a piece of music being *that* piece as they are not to a lecture being that lecture, even if they are imagined sounds in imagined music.

One is tempted further to reply to Collingwood by making a series of what we might well suppose to be insuperable objections. The first is that painters often agonise over their painting as they paint, writers over their writing as they write, composers, whether at their score or at a piano, as they compose. Why do they do this if they have already imagined the work and are now simply making it public? In the third book of his *Principles*, while Collingwood still stands by his view that the painting is not itself the work of art, he suggests that in the process of painting the artist and, in consequence, the spectator is helped to see; the act of painting helps to provide the artist with the sensuous basis needed as a foundation for the imagination. (Although Collingwood is properly referred to as an Idealist of the Crocean sort, he constantly refers to the epistemology of David Hume; the imagination, creating the work of art, must on his view have a sensory basis to begin from, or more accurately, since the relationship between impression and idea need not be sequential, it must contain a sensory ingredient as its foundation.) It is not at all clear how this would apply to writing, but Collingwood might argue that by writing the author learns his language. For all Collingwood's opposition to the 'tradesman' view of the artist, he by no means believes that artists need only let their feelings flow. On the contrary, he tells us that 'it is only bad painters who paint without knowing what they are doing' – that every element in the sensory experience of painting 'comes into existence under the eyes of the painter's consciousness'.

A second *prima facie* objection is that many works of art are

collaborative. That is obviously true in the case of a film or an opera, but in a deeper sense it is also true in the case of works of art like *Hamlet*, given its relationship to Saxo Grammaticus and to 'revenge tragedies', perhaps specifically to a play by Thomas Kydd. Collingwood greatly admires *The Waste Land*, where such adaptation of previous works is obvious. (To recognise this does not entitle us, in what was for a time the fashionable manner, either to deny the existence of authors or to conclude that all books are about other books.)

Collaborative work has often been regarded with hostility by those who wish to stress the creativeness of the artist, as Collingwood certainly does. 'Mixed arts' are then regarded as being irremediably inferior. 'Opera,' so it is said, 'is for people who have no understanding of music.' Alternatively, attempts are made to argue that a film, let us say, either is, or ought to be, entirely the product of a single mind, of someone who will direct, write, compose the music, do the camera work and use the actors as puppets, in spite of the fact that most films which come anywhere near to approaching this ideal are hopelessly self-indulgent. The director-worship which has done so much damage to contemporary theatre – under the influence, say, of Tyrone Guthrie – and to contemporary film is a product of the a priori view that a work ought to be the product of one mind, not of empirical evidence to show that it is better when it is.

We should naturally suppose that Collingwood, with his emphasis on the artist, would share these views, demanding absolute originality from artists as a proof of their imaginativeness, and that we could therefore use the collaborative nature of many works as an argument against his view that the true work is in the mind of the artist. We are then quite astonished to find Collingwood ending his work with a diatribe against the Romantic conception of the isolated genius, that artist against society described for us, under French influence, by Symonds, the bourgeois artist turned Mr Hyde. No less surprising is Collingwood's argument that we should entirely abandon the view that plagiarism is a bad thing and his stress on the importance of collaboration not only between composer and performer – the composer leaving room for improvisations – and between director and actor, but even between artist and audience, the artist having to keep it in mind that not only the artist's feelings but wider feelings are being expressed. We may read Collingwood's polemic against the more extreme forms of artistic individualism with complete approval, but the effect is to shift the emphasis more and more on to the public work, as the product of collaboration, and the receiving audience, as something the artist must always have in mind.

At intervals Collingwood pauses to assure us that he still sticks by his view that what he calls 'the aesthetic experience or aesthetic activity' is something that goes on in the artist's mind. We can see how Collingwood might offer some defence of this, arguing that what the artist learns in his collaborative public life is simply the language in which he gives shape to

emotions and, too, that in his relations with an audience the artist only reassures himself that he is genuinely expressing an emotion, not, as a result of 'corrupt consciousness', concealing or falsifying it. But what all this shows is that imagining is itself a highly socialised process; it does nothing to suggest that the only real works of art are imaginary ones. For our purposes, indeed, we have no interest whatsoever in a mute inglorious Milton – who might be, rather, a mute inglorious Samuel Smiles. Our interest is in what is *there* to be a matter of public discussion, whether or not it was under the conscious control of the artist, not simply 'given' to the audience but also not merely imagined by its creator.

We must all the time remember, of course, that Collingwood is working in the tradition of Absolute Idealism, as developed from Hegel at the hands of such Italian Idealists as Croce, not in the tradition of a Berkeley-style subjective Idealism – although, as we have already noted, he does draw heavily on Hume. It is in terms of Italian Idealism that he would reply to a third *prima facie* objection, one we might, at first sight, suppose to be quite fatal. How are we ever to know, listening, let us say, to Mozart, that the work we are listening to is in fact the work in the artist's mind? In some recent theories, as we shall see, it is taken as a starting-point that such knowledge is neither possible nor necessary, that the work of art is what we, responding to the stimulus of the public work, create – or at least what the critic creates for us. Collingwood hopes to avoid any such conclusion.

He grants that we can be mistaken, can suppose a work of art to be other than it is, just as we can be mistaken in supposing that we have understood a sentence. Nevertheless, he adds, it makes sense to say that we can, on later examination, discover our error – just as I might discover, on closer examination, that I have misinterpreted Collingwood – and someone can point out our error to us. There is no question of our not being able *in principle* to discover what is in the artist's mind, of its being hidden from us by being in his mind. For the artist puts not only colours but a mind into a painting, not only notes but a mind into music. That is the importance of Collingwood's view that only the bad artist does not exercise constant conscious control. In his philosophy of history, Collingwood argued that we cannot get into the mind of, rethink the thoughts of, a failed strategist. Equally, an artist who has not exercised conscious control does not give us access to his mind, whereas a good artist does.

But the more Collingwood insists on this point, as the more he insists on the public character of art or on the importance of the performer, of the audience, of other artists, in artistic creation, the less inclined we are to acquiesce in his view that *essentially* the work of art exists in the artist's mind. If the artist puts his mind into the public work what need is there of looking beyond that public work for the 'real' work? To take cases which Collingwood emphasises in the course of arguing that the work of art is

imagined, 'correcting' what we hear, or ignoring the play of light on a painting when it comes from reflections, is the sort of thing we constantly do when we are examining any public object, whether to judge its nature, its utility or its elegance. That we do this in the case of music and paintings by no means shows that we are in these cases going beyond the public object to an imaginary object. It means, only, that to examine an object is not a matter of simply submitting to sensory experience.

Collingwood's is a particularly sophisticated version of the view that the work of art is essentially in the artist's mind, one from which there is a great deal to be learnt. Before leaving this point of view – and, of course, we are in any case merely illustrating it, not considering all its possible alternative formulations – something should be said about an artistic movement of the nineteen-sixties which Collingwood certainly did not anticipate and was lucky enough not to live through: conceptual art. As always with artistic labels, many different kinds of artistic activity have had this label applied to them. My interest, at the moment, is in those conceptual artists and critics who, like Collingwood, insist that the work of art is essentially something which exists in the artist's mind. Reverting, however, to the tradition of German Idealism, they describe the work of art as consisting of 'Ideas' which are themselves the offspring of a 'Concept', rather than as being an expressed emotion. 'Ideas alone,' writes Sol LeWitt in a conceptualist manifesto, 'can be works of art; they are in a chain of development that may eventually find some form.' Or again, 'A work of art may be understood as a conductor from the artist's mind to the viewer. But it may never reach the viewer, as it may never leave the artist's mind.' 'Art', in these contexts, has its narrowest sense; conceptual art is regarded as a substitute for traditional painting and sculpture, not for music and literature.

I said 'as a substitute for', since even when artistic Ideas 'find some form' and in spite of the fact that, as I said, they are artistic Ideas in the narrowest sense of the word 'artistic', it will not be, for conceptual artists, as anything we should normally characterise as painting or sculpture. In fact, conceptual art 'challenges the convention that seems rigidly to govern the form of visual art – that visual art remains visual'. Collingwood still assumed that the tune, made public, would be played by instrumentalists, that a painting would be made public as painted marks. This the conceptual artist denies. The public object may well consist of scrawled sentences of a philosophical or pseudo-philosophical sort. (They are not to count as 'visual'.)

The gnomic sentences of Wittgenstein are often favoured, but the artist's own 'deep thoughts' about art, life and the world may also confront, and affront, the spectator. Or the artist may be content with simple lists. We are not to read such sentences or lists, however, as philosophy or as literature; rather, they are to be seen as art. If words are used, and if they proceed from ideas about art, we are told that 'they are

art, not literature'. Then have all past art critics and art theorists to be recognised as artists? Not so, the reply comes, because they did not put their views forward as conceptual art; it is only statements about art which are designed, or chosen, by artists to reveal artistic ideas which count as art.

What are the motives behind this movement which totally alienated many of us, for the first time in a long and often suffering history of gallery-going, from what was going on? In part, and here it liked to think of Duchamp as a predecessor, conceptual art was a revolt against the art world, an art world in which art is bought and sold, praised or denigrated, with commercial considerations at the forefront, in which, too, critics and theorists are often more highly regarded than artists and may have the power to make or break them – even when, artists often feel, they misrepresent what they are seeing, whether out of ignorance or because it in some way threatens their established reputation. None of this is a purely contemporary phenomenon. The iniquities of the art world are a major theme in Zola's *L'Oeuvre*, written as long ago as 1886.

Very well, the conceptual artists responded, we shall defy the art world by refusing to make gallery paintings or gallery sculptures. (A number of other seventies movements shared this attitude; they replaced traditional art-forms by bodily performances or by wrapped-up landscapes or by constructions in remote places.) More than that, however, we shall get rid of that despised middleman, the critic. The art-work will remain our secret unless we choose to indicate what it is through our writings.

None of this, of course, worked. The art world is too large, too voracious, too competitive to let anything escape its maw. The conceptual artist might express indignation at the way the art world had absorbed Duchamp. Although Duchamp made it plain that his choice of ready-mades for display had not been determined by any aesthetic considerations whatsoever, that he was exhibiting 'a total lack of good taste', critics were soon proclaiming that his choice of work displayed his innate stylishness. 'I threw the urinoir in their faces and now they come and admire it for its beauty' – so he was to complain in 1961. Such protests were to no avail. 'Conceptual artists' soon found themselves artistically respectable, with critical interpretations of their work fastening themselves on what was designed to be its own interpretation.

Other motives lying behind conceptual art are more relevant to our immediate purposes. Conceptual artists wanted to distance themselves as far as possible from craftsmen. In a manner Collingwood could not but have approved, they thought of themselves not as making but as creating; they urged 'the detachment of art's energy from the craft of tedious object production'. But also they wanted to show that they were serious, in a world which takes theorising seriously, by setting themselves up – and here Collingwood certainly would have been at odds with them – as

theorists. Philosophy, Joseph Kosuth tells us, is dead. Art, like mathematics, logic and science, stands above philosophy but, unlike them, in a manner which rejoices in its own uselessness. Thus it fulfils 'man's spiritual needs'.

The disappearance of the traditional public object reached its peak in such 'compositions' as John Cage's 4′33″ where a pianist sits at a piano in silence, leaving the audience to fill the silence with whatever noises arise from such a situation – giggles, whisperings, feet shuffles and the like – or when the French painter Yves Klein put on an 'exhibition' consisting of an empty gallery. Or in a painting where we are told in an appended statement that something is depicted but that it is too small to see, this last hung on the walls of a European gallery. Such 'happenings' we can take as jokes, a relief from the solemnity which has come to characterise both concerts and art galleries. But conceptual art is only too serious, in the bad sense of that word.

Conceptual art illustrates two remarks I have already made. The first is that looking for seriousness in the wrong place can have bad effects not only on the theory but on the practice of the arts. Seeing themselves whether as philosophers or as rising to a theoretical realm above philosophy, artists succeed only in producing verbiage. Conceptual art is the latest stage in a kind of social climbing in which artists deny their craftsmanship and abandon what they can do well, surrendering their concrete intelligence in favour of pseudo-intellectualism, just as the businessman social climber gives up what businessmen can do well to secure admittance to a world of absurd 'socialite' pretensions.

A second point is that a particular ontology, in this case one for which the work of art is essentially in the artist's mind, can give support to this search for seriousness in the wrong places. That is why, I said, we cannot leave ontological issues entirely alone. In spite of Collingwood's efforts to deny this, the 'mentalistic' ontology leads very naturally to the concept of the artist as someone whose distinguishing characteristic is a purely intellectual power or as a personality of such a remarkable kind that we ought to be prepared to accept such crumbs, such public objects, as are thrown to us as an act of grace, without demanding anything in the way of positive achievement. That is something we are certainly not prepared to do in the case of a scientist, a philosopher, a craftsman, a statesman or a member of the professions but may in the case of Royalty or television 'personalities'.

Let us turn now to the second approach. This places all its emphasis on the public work. It may do this to such a degree as to deny that a work of art need be created by an artist at all, as distinct from being simply found. Such 'found' objects can be divided into two classes. The first – 'ready-mades' – are industrial products; the second, to which the name *objets trouvés* is in practice generally confined, are found in Nature, as shells, twisted pieces of wood cast up on the shore and so on. Generally

speaking, the question is whether these are to count as sculpture, although questions could also be raised about whether bird-song counts as music or a cave as architecture – especially if, like the sanctuary of Sta. Rosalia on Mt. Pellegrino near Palermo, it is used as a church or, as in some old salt-mines, as a concert hall or a dwelling place. In the case of sculpture such questions could not arise so long as sculpture was thought of as being essentially representational. True enough, a piece of driftwood can sometimes grotesquely resemble a human figure, but we could not seriously suppose it to be a lost Buddha statue from Japan. We might however easily suppose it to be a wooden abstract.

If it is proper to regard an *objet trouvé* as a work of art, then works of art are maximally distanced from the minds of artists. In this case, there is no artist. On the view that whatever a reputable art gallery exhibits is automatically a work of art, such a conclusion is irresistible, for there have certainly been exhibitions of *objets trouvés*, a notable one in Venice (1960). On a minor scale a surrealist exhibition in Paris (1964) included among its exhibits some of the stranger-looking Australian flora and fauna.

Nevertheless, it is a quite familiar doctrine that natural objects can share properties with works of art without being works of art, properties relevant to judgments on works of art, such properties as 'beautiful', 'elegant'. Both persons and landscapes are commonly described by using such adjectives. There seems to be no good reason why we should not include *objets trouvés* in the class of natural objects which can have such properties, properties which make them comparable with abstract sculptures, without concluding that they are in fact sculptures. Since, unlike persons or landscapes, driftwood lends itself to museum display, we can understand why galleries should choose to exhibit striking examples of it, thus helping us to see more clearly resemblances between natural and sculptured forms. But it does not follow that we have to regard such examples as being works of art, merely because, unlike landscapes, they can readily be exhibited in a gallery.

True enough, they have been picked out by artists, but an artist could in the same way pick out persons, or landscapes, for our admiration or condemnation in the language we commonly use about works of art or, at least, in fragments from such a language. There is a fountain-statue in Canberra which is deliberately designed to look like the sort of driftwood which grotesquely resembles a human figure. That is clearly a work of art. But there is no contradiction involved in denying that if the bronze statue were in fact a piece of driftwood then it would still be a work of art, even though, as we granted, it would be absurd to deny that picking it up on a beach we might apply to it some of the adjectives which we use in praise of a work of art. A question we shall have to face later is which such adjectives we could not use. As matters stand, I shall have to say somewhat arbitrarily that *objets trouvés* are not a final objection to the

view that works of art must indeed be *works by artists*.

I have said nothing about bird song or caves. But clearly bird song can be included in the class of the naturally beautiful – or the naturally cacophonous. And although caves can serve some of the functions of dwelling places, sanctuaries, temples and concert halls I do not think that we have any real temptation to think of them as architecture. There are questions we can raise about works of architecture which we cannot raise about caves, even if the temple grew out of the cave – and not only, as would be obvious, such questions as 'Who made it and when?'

The case of ready-mades is rather different. If we decide that a ready-made object, although originally designed for use, is a work of art, then we are dealing with something which, unlike a piece of driftwood, is certainly a public *work*. The point at issue is whether it is a member of a particular species of public works, those we call works of art. This, as we earlier said, is a demarcation problem. To answer it in the affirmative is to say that an industrial designer can be an artist. The critic – or the artist in the role of critic – then argues that an object is a work of art which was not previously perceived to be such; the object is re-categorised. But there is no question of such objects being an exception to the view that works of art are public works, as *objets trouvés* would be an exception. (In a particular instance, of course, proclaiming the work to be a work of art can just be a piece of mischief at the expense of the art world, as in Duchamp's case.) What they illustrate, only, is that works of art can be created by men and women who have not thought of themselves, and have not been thought of by their community, as being artists. It can still be true that their works display a kind of imagination which we now take to be characteristic of artists, and that they are analogous in the appropriate ways to some of those works we now think of as being serious works of art.

4

Works of Art as Public Objects

I have been arguing that works of art are created only by artists, even if sometimes by people who have not generally been thought of as such – an observation which may sound tautologous but is in fact not so and is quite often denied. Now our attention will shift to the public work. This is often, especially by formalists, taken to be the only thing we need to consider in our judgment of the seriousness of the work. But what then counts as the public work? Let us begin with the view that it is a particular material object. This doctrine is most plausible in respect to the visual arts, especially abstract painting of the formalistic kind, abstract sculpture and architecture. Take the last case. (I shall ignore the fact that architecture occasionally, in a very general way, represents, like the 'sails' of Sydney Opera House.)

A building is clearly an object which we can walk into just as if it were a cave. To judge it, we shall in many cases want to do so, or at least to view the building from a variety of angles. It would be a phenomenalist error to say that the building is therefore a class of perspectives. To judge it, we have to look around it; that is all. Of course, we can also pass such judgments as 'the facade is very elegant', without looking around, just as we can say of a novel 'the first chapter is marvellous' without having read any further. But to judge the building as a whole, as to judge the novel as a whole, we have to carry our investigations further.

So, it would seem, we judge a work of architecture simply by examining closely a particular material public object, namely a building. But need there be such a building? Vitruvius tells us that 'There is an important difference between the architect and the layman; the layman cannot understand what is going to be done unless he already sees it done. The architect, when once he has formed his plan, has a definite idea how it will turn out in respect to grace, convenience and propriety.'

This is only to say, we might be inclined to reply as we did to Collingwood, that the artist can foresee, to a greater degree than the layman would suppose, what a building will be like, can pre-imagine it; the fact remains that the only thing we can consider critically is the public building. Architecture is peculiar, however, in that the projects of

46

the architect are usually set out formally as drawings and models, only a relatively small proportion of which are ever realised as actual buildings. Not only that, these projects, as drawings or models, are often included in histories of architecture and are subjected to critical scrutiny. Projects, too, are often realised in a form different from what was originally envisaged in the drawings or models, perhaps for the sake of economy, perhaps on account of engineering difficulties, perhaps because a new architect takes over, with different tastes.

It is by no means absurd, then, to take a project seriously while dismissing the resulting building. Of course, both the drawings and the models are material public objects, but they are not the objects we are in such cases taking seriously, as we might take seriously the preliminary drawings for a painting, in and for themselves. Rather, they are symbolic representations of buildings, representations we clearly have to *interpret* in order to pass an architectural judgment. We are taking seriously imagined buildings, not actual buildings. A work of architecture cannot always, then, be identified with a particular material object.

When we are confronted only by drawings and models how can we tell, it might be asked, that the building we are taking seriously as architecture is the same building as the building someone else is taking seriously or denying to be architecturally serious? Might we not be imagining quite different buildings? This is not in practice a worry. Decisions about whether or not to construct a particular building are being made all the time on the basis of drawings and models. In competitions, the members of juries take it for granted that they are imagining the same building. After all, drawings and models are very simple methods of representation; we are familiar with them from an early age, even if the interpretation of architectural drawings requires further training. They are made, too, by architects who have been trained in how to use them so as to facilitate the imagining of what they represent; talking them over with the architect we can correct initial errors in interpretation. Of course, we can still get it wrong; we may find when the building is completed that it is not what we expected it to be; we can misinterpret the architect's explanations just as we can misinterpret his drawings. To err is human – epistemologically as well as morally. But it is enough for our present purposes that we sometimes get it right. We can correctly imagine, so we find, what a building will be like, having first seen the drawings and models for it and then the constructed building, and therefore we have good grounds for believing, when no building has in fact been constructed, that we can imagine what it *would have been* like.

Two things emerge from what has just been said. The first is that although architecture seems at first sight to exemplify the view that what we take seriously as a work of art is a material object there are many cases within architecture when what we are taking seriously is not the

material object which confronts us – when it is a set of drawings or a model – but the building we imagine in the light of these material objects. The second is conveyed by the phrase I have just used, 'in the light of'. The imagined building is not a freely imagined building and certainly not just something in the artist's mind. It is a building we can imagine only because we have models and drawings before us and have acquired certain skills in interpreting. These skills are not idiosyncratic. They have been learnt within a particular community; they form part of the public practices of that community. We can discuss the imagined building with other members of that community precisely as if it were an actual building. So we can think of that imagined building as being a public work, distinguishing it thus from a work an architect has simply imagined without making any drawings or models, which cannot therefore be publicly discussed. It is also true that although a work of architecture cannot always be identified with a particular material object it is always either an actual or an imagined material object.

There is another problem which often worries architects and has sometimes led them, or has led critics, to conclude that architecture is really a branch of engineering rather than an art form. Vitruvius sets 'convenience' alongside 'grace' and 'propriety'. Can we really judge a work of architecture without taking account of how well it works, whether as church, library, civic office or dwelling? Don't we then have to take into account not only the material object, the building, or an imagined object, the projected building, but something quite other than this – the wishes and needs of the human beings who are to 'receive' the building, not only contemplating it but using it? No doubt influenced by the Kantian doctrine that art should be purposeless, Adolf Loos gloomily concluded in his *Architektur* (1910) that 'Only a very small part of architecture belongs to art: the tomb and the monument.' On his view 'everything else, everything that serves a purpose, should be excluded from the realms of art' – as 'building' pure and simply. But it is by no means plain why Loos made an exception of tombs and monuments, which certainly serve religious or public purposes.

I have already argued that the fact that an art was designed to satisfy a purpose does not preclude its being taken seriously as art, whether or not it still fulfils its original purpose. A church can be a serious work of architecture even if it no longer serves to arouse or consolidate religious feelings, a dwelling even if nobody now lives in it. We may see a dwelling – a Venetian palace, for example – as very inconvenient to live in and yet admire it architecturally. Should we conclude that Vitruvius was simply wrong in setting 'convenience' on a parity with 'grace', thus introducing into our judgment of the work of architecture a reference beyond the public object to the particular purposes of the particular people who are going to use the building? Institutes of Architects sometimes give architectural prizes to buildings which are daily cursed by those who

have to work in them. They are then adopting the standpoint of art for which, we might say, architecture is simply abstract sculpture on a grand scale. Accepting that view still leaves us free to argue that it would be better if architects did not try to create works of art, to set 'convenience' high on our own requirements, to condemn architects for not paying enough attention to the needs of users.

'Good' architecture cannot be identified, then, with architecture which is artistically serious. At a certain level Vitruvius is right enough; good architecture has to be convenient. But we can take a building seriously as a work of art, and value it highly at that level, even when it is notoriously inconvenient, setting aside such weaknesses, indeed, as being in this context irrelevant, however relevant they may be to our interests as users, to the architecture's being 'serious'.

Turning now to abstract sculpture, someone may criticise an abstract sculptural work on the ground that it does not serve a particular end, as a memorial, say, to the Unknown Prisoner. But that, we might again argue, is irrelevant to the question whether it is a serious work of art, although it would be a quite proper ground for rejecting it in a competition for such a memorial. In general, abstract sculpture lends itself very well to the view that the work of art is simply the material object, to be judged in formal terms, although there are sometimes problems, like those which arise in relation to architectural models, about maquettes. But we can treat maquettes simply as being themselves sculptures, as we cannot treat architectural drawings, or even models, as being buildings. (Moore's maquettes are treated in this way in the Art Gallery of Ontario.)

Like buildings, abstract sculptures are objects of a three-dimensional kind, just as trees are. An abstract painting is rather different. True enough, it is in fact a three-dimensional material object since even acrylic paint has a certain thickness. And sometimes an abstract artist will deliberately thicken the paint or affix solid objects to the canvas as a way of emphasising that what we are looking at is a three-dimensional object, not a two-dimensional representation of a three-dimensional object, thus concentrating our attention on the painting as a material object.

In such cases, it is particularly easy to argue that abstract painting is in exactly the same position as abstract sculpture or as architecture: that what we are to take seriously is a three-dimensional material object with a variety of formal properties. Other abstract painters, however, tried to reduce the material three-dimensionality of their painting to a minimum – as did photo-realists after them: they insisted on the flatness of their surfaces. And indeed we normally do think of paintings, whether representational or not, and however thickly painted they may be, as two-dimensional. So far as that is so, the analogy between abstract painting, abstract sculpture and architecture is imperfect. We cannot walk into an abstract painting or thrust our arm through it without destroying it; if we walk around it, we move out of the space the painting

subtends. We could still argue, however, that the public object, and what we take to be a serious work of art, is in the case of abstract paintings just a material object, in this case taken to have only two dimensions.

A different view has been suggested in respect to what was called 'action art'. In his *The Tradition of the New*, Harold Rosenberg described it in terms which might seem to carry us back to a first-type theory by telling us that 'the ultimate subject matter of all art is the artist's psychic state of tension'. But he treats the public object – the need for which he does not deny – not as an expression or a representation but rather as an *enactment* of those psychic states. A painting, however abstract, is, on his view, not at all like architecture but much more like 'pantomime and dance'.

This analogy fails. For in action painting, as in the case of all other paintings, the only public work is a set of marks on canvas. In contrast, pantomime and dance are not the marks left behind by a performance – as the marks on a stage made by the feet of ballet-performers would certainly count as being – they are performances. So, too, as distinct from 'action art', is 'performance art'; we see, whether in the flesh or on a video, somebody doing something, whether it be smearing himself with mud or washing up, in a manner which carries egoism to new heights and boredom to new depths. The public object, in all these cases, is a human body in motion or at rest.

In contrast, although to paint is to perform, what results from the performance is not someone performing but a painting, not something of which we can ask 'How long does it last?' but rather 'What size is it?' (Consider the difference between a Pollock painting and a photograph of Pollock painting. These, to be sure, are neither *of themselves* performances, but one is about a performance as the other is not.) As for the view that the 'true subject' is the 'psychic tensions' of the painter, that carries us back, as we said, to Collingwood-style views, for which we are judging public objects only as an expression of the painter's mind. So it is not surprising that attempts are now being made to set Pollock in the context of visionary American landscape painting; if we are in search of 'psychic tension' we should look rather at the far from abstract German expressionism. *Blue Poles* shows no sign of it, although of course, Kooning's woman portraits do, but in virtue of being representational. So I see no reason in 'action painting' for denying that in so far as a painting is abstract, it is roughly a two-dimensional material object.

The concept of 'action art' links with a general American tendency to emphasise 'process' rather than product which in turn leads to an emphasis on the artist rather than the work of art. So for Rosenberg 'A painting that is an act is inseparable from the biography of the artist. The painting itself is a "moment" in the adulterated mixture of his life – whether "moment" means the actual minutes taken up with spotting the canvas or the entire direction of a lucid drama conducted in sign

language.' Read at a certain level, this statement – except for Rosenberg's concluding phrase, a distinctly unlucid drama conducted in an unknown sign language – is so platitudinous as not to be worth saying. Any painting, however atrocious, is a moment in the life of the artist. So are Greenberg's observations a moment in his life and my comments on them a moment in my life. But that has nothing to do with the question whether his, or my, remarks are of any value or importance. Nor does it demonstrate that our comments are 'inseparable' from our life.

We have been talking about architecture, abstract sculpture, abstract painting, as being all of them non-representational. We could, of course, add to that list abstract ballet, abstract films, abstract vase-patterns and the like. Ontologically, these are all in the same situation in so far as we do not, in order to judge them, *have* to think of them as representing anything. (I shall for the moment assume this, setting aside the claim of such painters as Mondrian or Newman that they are representing something too deep for words.) They are material or at least public objects with formal properties; their existence encourages an approach to art for which structure is everything, subject nothing.

Whether music falls into this same category is a hotly disputed point. Certainly, it has often been compared to architecture. But at other times it is written about as if it were most closely analogous to painting, or to literature, or, even, to philosophy. For the moment, I shall arbitrarily classify music as non-representational, except on those not very important occasions on which it imitates a bird-call or a steam-engine or some natural rhythm, like the flow of water. What the public object is in the case of music is a question I shall temporarily postpone.

Let us turn now from what is generally regarded as being abstract art to what is generally regarded as being representational. The word 'representational' is anything but a pellucid one. It is sometimes used so broadly that all painting would be representational, the only point at issue being what it represents. So John Marin once wrote that 'although I use objects, I am representing paint first of all, and not the motif primarily'. This is a neat reversal of the traditional view for which paint is used to represent 'the motif'. Clearly, however, the paint is *not* being 'represented' in any ordinary sense of that word. Rather it is being *presented* as the public object, public in a sense in which the 'motif' need not be. At the opposite extreme, 'representation' is identified with picturing, so that literature could be representational only in so far as it goes in for what is sometimes called 'word-painting'. But there is an intermediate sense, which the Oxford English Dictionary places first among still current senses: 'to bring clearly and distinctly before the mind, especially by description or by an act of imagination.'

Insisting on the distinction between 'presenting' and 'representing' I should – and I think this accords with usage – leave out the 'especially' in this definition. If someone introduces a man to me, that man is presented

for my inspection but not represented; someone who describes the man to me, in contrast, is representing him, and so is someone who paints or sculpts or photographs or mimes the man. Abstract art, to be sure, *puts* something before my mind but it does not, in the required sense, *bring* something before my mind – something other, that is, than what is presented to me. (Such language raises fearsome philosophical problems, but let us use the language of the vulgar, at least for the time being.)

As in the case of abstract art, representational art always presents us with a material object. Take first the case of painting. There the nature of that object can vary greatly from case to case. If we use the word 'painting' in its broadest sense, to refer to any kind of pictorial art, the material object can be patches of oil-paint, or water-colour, or mosaic, or crayon, or pencil, on paper or canvas or bark or board, or it can be impressions of marks incised on copper or stone or linoleum. That is by no means a complete list. But in every case, we can discuss it in terms of forms and colours – or, at least, light and shade.

One need not be at all surprised, therefore, to find some theorists arguing that the representational side of a painting is of no consequence, that a representational painting should be judged in exactly the same fashion as a purely abstract painting. So, notoriously, for Clive Bell: 'The representative element in a work of art may or may not be harmful; always it is irrelevant.' Even Bell, however, makes a certain concession, that we regard representational paintings as bringing before us three-dimensional objects, whereas they present us with something two-dimensional. So we may see what is actually a flat shape – with the reservations I mentioned earlier – as a cube. The cube, we might conclude from this, is an imagined, not a public, object.

Then ought we also to conclude that what we take to be a serious representational painting is not at all the two-dimensional material object but rather the three-dimensional object we imagine when we look at it? That leads readily to the third possible view, that the mind of the spectator is the only thing which is artistically important. We might take the skill of the painter seriously, as a maker of effective stimuli, as we might take seriously a scientist who is good at creating hallucinogenic drugs and take the drugs seriously too, in the sense that we have to swallow or inject them to get the hallucinogenic experience. Still, the thing that matters to the drug-taker is the hallucinogenic experience; only chemists would be interested in the structure of the drug itself. Do only painters need to interest themselves in the painted surface, this being of no consequence to the person who is *judging* the representational painting, which is a matter, rather, of judging the seriousness of what the critic is imagining? That is not the way critics of such painting normally proceed. What they take seriously is in fact something quite complex: the picture-considered-as-representing. They talk about the ways in which the swirls of the paint, or the flatness of the paint, bring out particular

features of the subject, as they talk about the ways in which the treatment of the subject draws our attention to the formal relationships in the painting. Quite properly, I should say, the language of critics moves between the painting as marks on canvas and what it 'compels' us to see it as.

I have put the word 'compels' in quotation marks. For it is no doubt rather too strong. Nevertheless, it draws attention to the fact that the painting cannot be regarded simply as a stimulus to imagining, as a drug is or a Rorschach blot. We are brought up in a world strikingly rich in pictorial forms of representation, not only in the special form of television and cinema, but as bill-boards, slides, advertisements in newspapers, comic-strips, illustrated books as well as the representational paintings in homes and galleries. It is assumed that we will see them in particular ways. True enough, what we have before us are photographs more often than paintings, sometimes photographs of paintings where the surface texture is lost and the flatness exaggerated. But for our immediate purposes we can run all of these together, in the sense that we immediately take them to be pictures of persons and material objects of various kinds, real or imaginary.

Indeed, it takes an effort on our part – it is not something that people normally do – to look at what we are seeing simply as shapes on a flat surface rather than as pictures of three-dimensional objects. In general terms, the representational artist is expert in getting us to see the painting as a portrait of a person or a landscape or a bowl of flowers, making use of our habits, our expectations. Sometimes, of course, a representational painter will play upon the regularity of our expectations to puzzle us, as most obviously in the pseudo-geometric drawings of Escher but more subtly in *Las Meninas* or *Bar at the Folies Bergères*, where indeed a critic may have to point out to us just why we feel ill at ease. These we can regard as parasitic cases. To say that is not to depreciate them; in the last two cases at least, to do so would be absurd. It suggests, only, that if we did not normally perceive pictures in a regular way, the special effect of these paintings would be lost.

How exactly does what happens when we see a painting as a painting of a ship differ from what happens when we see a Rorschach blot as a ship? The blot is so designed that we can see it in many different ways; from our response to the question how we see it the psychologist hopes to deduce something about our personal peculiarities. In contrast, the marks on canvas are, in the case of a ship-painting, designed so that we shall see them as a painting of a ship. Only in extreme psychoses would we see the painting in any other way. And how does it differ from what happens when someone takes hallucinogenic drugs and has in consequence vivid images? In that case, although the drug is designed to produce images, it does nothing to determine the content of what is imaged; from all accounts, this can differ greatly.

True enough, a painting, too, can lead us into reveries which are purely personal or only vaguely linked with what we are looking at, as when seeing a stern portrait we recall a stern teacher or unpleasant bureaucrat or But these reveries are not what we are claiming to be a serious work of art. If the painting were anything we can imagine when we look at the canvas, this would differ so much from individual to individual that critical discussion, as distinct from an exchange of confidences, would be impossible. The public work is our discussion anchor, but in a broad sense of 'public work' in which it refers not only to the marks on canvas but to what these are seen as, what the work will persuade us – 'compels' is in fact scarcely too strong – to see it as.

Magritte was perfectly correct when he wrote beneath his painting of a pipe: 'Ceci n'est pas une pipe.' It is not a pipe; it is a painting. The pipe is not the public object; the public object is a painting we see – thanks to our training – as a painting of a pipe, as a two-dimensional painting representing a three-dimensional object.

The boundaries between 'seeing', 'seeing as' and 'imagining' are, however, notoriously insecure. One might say either that we see a painting of Venice, or that we see the painting as a painting of Venice, or that seeing the painting we are persuaded – or compelled – to imagine Venice, and I doubt whether any of these ways of talking can be picked out as the 'right' way of describing the situation. And similarly we might want to say either that the marks on canvas are the public object or that the painting of Venice is the public object. There is nothing peculiar in all this; it does not make the painting metaphysically or epistemologically mysterious. For there can be similar disputes about whether one ought to say that I am now seeing my typewriter, or rather that I am now seeing a particular surface as the surface of a typewriter, or perhaps that I am now seeing something which persuades or compels me to imagine a typewriter. The ontological status of public works is in dispute, as well as what is involved in seeing.

Does anything positive come out of this tortuous and, at many points, indecisive argument? First, representational painters, like abstract painters, present us with a public object which is a material object, in a quite straightforward sense of that phrase. (We can inquire into its weight, its size, its durability.) That can be considered and described in exactly the same terms as an abstract painting. Secondly, the representational artist wants us to see that material object in a particular way – as 'a painting of' – and uses various devices to persuade, or compel, us to do so. The title is one such device, but that normally tells us something we could not see in the painting. It does not read 'a ship' but tells us what ship it was, it does not read 'a portrait' but tells us that it is a portrait of a particular cardinal. Or it may try to persuade us that we are looking not at a naked woman but at 'Prudence' or 'Sacred Love'. (What a relief it is to come across a Renoir entitled 'Woman washing her

right leg' – a title, however, we do not need.) At the level of interpretation I am talking about, the artist's devices are, in contrast, pictorial. That is so even when the artist's object, as in Escher's case, is to persuade us to see the painting as ambiguous about what it is 'of' or when we have to take a lot of trouble to determine what it is 'of', as in some of Clemente's work.

Thirdly, since to those who are habituated to this form of 'seeing as' – and it is not plain how far the artist is relying upon purely physiological mechanisms, how far on some skill which has been learnt – the 'seeing as' is so automatic that it is quite natural to say that the public object is actually what the spectator sees the painting as. (Just as, we suggested, a building imagined in the presence of models is a public object.) After all, by no means all public objects are material objects; habits, customs, expressions, language are all of them public objects – open to direct observation by a linguist, an anthropologist, an artist or each and every one of us. To say that a Canadian flag, as a piece of cloth, is public and so are the shapes on it, but that as soon as we call the shape a maple-leaf or say that the flag is 'Canadian' we are going beyond the public, would be to give a very limited sense to 'public'. 'Pictures of ships are not public objects' would be equally strange, as strange as it would be to say that sentences, as contrasted with strings of signs, are not public objects.

Such objects are certainly what we normally begin from when we discuss whether a work is serious, what in general we presume that the persons we are talking with will have seen – even if in fact we sometimes find that what we presume they have seen they have in fact not seen. Yet of course, in all the cases I mentioned interpreting takes place, even if it is a kind of interpreting which is a regular social custom. The marks on canvas are the only material object we are presented with in a painting, a material object which however represents, and that in a much more intimate way than a Canadian flag represents Canada or a member of Parliament a constituency. The colour of the painting is, in many instances, the colour of the object represented, the shape of its forms is the shape of the objects represented and so is the right-left positioning. Using the phrase 'seeing as' rather than 'being persuaded to imagine' brings out the intimate relation between the two-dimensional and the three-dimensional object.

Finally – although I only touched on this – there can be a second-level interpretation of the painting in which the objects we see the painting as 'of' are symbolically interpreted as standing for something other than what the painting compels us to see them as. To illustrate this point anecdotally: I once walked around the Borghese Gallery with an Indonesian who was totally ignorant of both Christian and classical stories. He could see paintings as paintings of a mother with a baby or of a man on a cross (low-level interpretation) but certainly not as a virgin with a baby or a god being crucified (second-level interpretation) just as we,

most of us, do not see much that a Renaissance painter wanted us to see. (No one who has read Panofsky can fail to realise how complicated this second-level interpretation can be.) But it is not at all plain that in judging a work to be serious, one has to be able to engage in this second-level interpretation; my Indonesian acquaintance could distinguish between what he saw in the Borghese and the oleographs of a mother with her baby he could see in the local shops. Does it matter if a statue which was designed to be of Isis and Horus is taken to be of Mary and Jesus – does it affect the question whether we are looking at a serious work of art? Pater rehabilitated Botticelli, but without connecting *Primavera* with Renaissance philosophical ideals. That is a question to which we shall return later.

Representational paintings have something in common with architectural drawings, with models, or with a sculptor's maquettes, in the sense that in each case we are called upon to consider critically something we are persuaded to imagine. But there is a big difference. While we might, it is true, admire the drawings, the models, the maquettes simply as such, nevertheless we normally think of them as an imperfect substitute for what they represent – a building or a bronze. The painting, I said, is not such a substitute, although admittedly individuals can treat it thus – the icon as a substitute for the saint, kissed as if it were a person, and valued by the worshipper only for that reason. Our artistic interest, however, is in the painting rather than, as in the architectural case, in the building being represented. The analogy is rather between architectural drawings and the sketches which sometimes precede a painting, not the painting itself.

In the case of representational sculptures we do not have the two-dimensional problem to worry about. Nevertheless the 'see-as' vocabulary is still appropriate. Once again, we do not see the sculpture as, let us say, a woman – interestingly enough we are normally less likely to do this with a sculpture than with a figure in a wax-works although we may be temporarily caught out by a George Segal sculpture – but we do see it as a *sculpture* of a woman. It is as such that we take it seriously. Once again, too, the statue is a material object, with all the physico-chemical properties of whatever it is made of. We can calculate the weight of an Elizabeth Frink horse precisely as if it were any other bronze object; placing it off Piccadilly we have to reckon on it suffering from pollution just as we should were it a bronze window-frame. If it were, instead, neon tubes twisted into the shape of Marilyn Monroe the kind of disintegration to which it is subject would be different, but the same general principles apply.

The points at which a statue matches what it represents are commonly different from the points at which the forms in a painting match what they represent. We do not see a bronze bust of a woman as a bronzed woman. These differences do not affect the fact that it is as natural to

speak of the public object as being a statue of a woman as to speak of it as being, simply, a shaped bronze just as we speak of a flag, rather than merely a square of cloth, as a public object. But then it is not just a material object – it is that object seen as representing something. The artist creates the object so that we shall see it thus; we see it thus, partly because human beings see in particular ways, partly because we have developed particular social habits. What we see it as, at the low level of interpretation, will usually be what the artist wants us to see it as, although at the second level of interpretation it may well not be. We may see it as a man on horseback but not as the Great Liberator.

To pass now to literature and for the moment confining it, as etymology suggests, to what is written, the public object is in this case peculiarly elusive. That is a major reason why literary critics have been able, with some degree of plausibility, to argue that they actually create the works they are commenting on – perhaps even that every reader creates what is being read. A building, a painting, a piece of sculpture is substantially *there*, as a specific material object, in a sense in which a literary work is not.

The most obvious candidate for the role of public object is a set of marks, written, typed, or printed on paper or parchment or, even, incised on stone, all of them in a broad sense of the phrase material objects. This at once suggests an analogy with painting. In fact, however, the relation of marks on paper to the work of literature is not at all parallel to the relation between marks on canvas and the painting. The lack of parallelism comes out in a variety of ways. First, we can say things about the literary marks which are quite contrary to what we say about the work. The print, or the writing, may be elegant but the book clumsy or even brutal, the print, or the writing, closely packed although the book is diffuse, the print, or the writing, very legible but the book hard to read. And in all these respects the marks can change completely without the character of the work being affected. That a book is a beautiful visual object throws no light whatsoever on its character as a work of literature. No *particular* set of marks is essential to the existence of the literary work except, as we shall see later, in a genealogical sense. There is no comparable contrast in the case of painting – to change the marks is to change the painting. Even 'multiples' have to preserve marks.

We might nevertheless try to cope with this objection by a manoeuvre similar to that which we employed in the case of painting. Experienced in the use of a language, we might say, we do not see the marks simply as such but rather as a sequence of marks interpretable as a set of meaningful sentences in a particular language. Incised, printed, written marks can all be the same sentence. The public object in the case of a poem is a sequence of such sentences – just as, I have given some reasons for believing, the public object in the case of representative painting consists of the painting taken as being of the three-dimensional objects

the painter compels, or persuades, us to see. But a second difference then emerges. In many cases, a work of literature can be successfully translated; the familiar gibe 'traditore, traduttore' does not always apply. I can read a Russian critic of a work I have read only in English without any sense that he is talking about a work different from the one I have read in English.

True enough, if such a critic makes critical comments on Dostoevsky's use of the Russian language that is not so, and in the case of such a poet as Pushkin I may have to conclude that I am missing so much by having to read him in translation that it is not possible for me to judge *Yevgeny Onegin*. In poetry, the actual sentences, the sound of the words the poet uses, have an importance which is more obvious than it is in the case of novels. Nevertheless a French critic can quite rightly regard himself as having read *Hamlet* and being in a position to judge whether it is a serious work even though he has not read a single sentence of the original work. What he has read are sentences which preserve the meaning and, ideally, some other features of the original sentences.

The original sentences considered as marks, read as being sentences in a particular language, are not, then, related to the work of literature in the intimate way in which the marks on the canvas are related to the three-dimensional objects represented. (Very obviously, of course, the sentence 'Mary is to the right of James' has neither the colour nor the shape nor the direction of what it 'depicts'.) There is no way of judging whether a painting is a serious work except by seeing *that* work – or at the very least a copy of it which preserves the colours and forms in their original relationship. But in the case of literature there is normally no such *that* work, and the copies, unlike prints of paintings, need not match any material characteristics of the original.

One can put this contrast in a slightly different way. In the case of the painting, if we ask what particular marks we have in mind in talking about Leonardo's *Mona Lisa* we can reply 'the marks on the canvas of the painting in the Louvre with the title *Mona Lisa*' or some comparable identifying description. What marks do we have in mind as the material object when we refer to a novel? A novel may exist only as a single manuscript, never read except by the author or someone personally close to the author. In such cases it could be identified more or less like the *Mona Lisa* as 'the work with name *x* in Elizabeth's study'. But it normally exists in a relatively large number of copies and often in translations, none of which has any special claim to be regarded as the work. The effect of these differences is that whereas in the case of paintings and, for the most part, buildings and sculptures we can associate the work of art with a specific material object to which we give a proper name, in the case of original prints and books, in contrast, the name is normally associated, in sentences about the seriousness of the work, with *any member* of a particular class of material objects.

How is it to be decided whether a certain book is, or is not, a member of that class? One particular material object, the copy-text – which may be the manuscript, or a set of corrected proofs, or any member of a class of printed works, if neither manuscript nor corrected proof survives – has priority in determining the identity of the work; whether, that is, the work I am calling 'Joyce's *Ulysses*' is the work which ordinarily goes under that name; whether in trying to judge whether that is a serious work, I can properly rely on the copy I have in front of me. (In the case of an etching, the plate or a print known to be from the plate serves in a similar way as the ancestor.) For what I have in front of me to count as *Ulysses*, it must be a genealogical descendant of the copy-text of that work and must not differ from it in ways which would affect my judgment. The first criterion is the crucial one, but the second criterion rules out corrupt versions or bad translations or parodies as 'not being Joyce's Ulysses'.

The application of these criteria can, of course, give rise to problems. There can be problems in settling on a copy-text; some scholars tell us, for example, that what we have been accustomed to think of as one play *King Lear* is actually an amalgam of two plays. There are problems in determining how much leeway a bowdlerised version or a truncated version or a translation can be allowed without our rightly refusing to deny that a play counts, let us say, as *Hamlet*. But to tighten the identity-conditions, by insisting either that only the copy-text is the work or that any variation whatsoever is a different work would be to produce absurd results, for example that there are as many *Hamlets* as there are editions of *Hamlet*, and that no one has yet written a criticism of *Ulysses* since the only available edition contained a number of misprints. To write in detail about *Waiting for Godot* we should certainly return to *En attendant Godot* and consider the various English acting versions, but broad judgments can be correctly made on the basis of imperfect texts – in Shakespeare's case we know we are doing this – or translations.

Are we to say generally, then, that *Ulysses*, although it looks like a proper name, is in fact the name given to any member of the class of works which satisfy the conditions I have laid down? I have been suggesting only that this is true in the case of sentences in which *Ulysses* is up for consideration as a serious work. There are other sentences, too, for which it works well enough. 'For a long time *Ulysses* was censored in Australia' can become 'for a long time no one was allowed to import copies of *Ulysses* into Australia.' But, of course, it does not work with '*Ulysses* is in the study', where the reference is clearly to a particular copy or, more important, with sentences such as 'it took a long time for Joyce to write *Ulysses*' in which the reference is clearly to Joyce's manuscript. I am describing, only, the way book titles are used in critical discussions of the nature and quality of the novel; in such instances any copy, provided only that it does not substantially differ from the copy-text, can properly be used as the public point of reference, serving as a focal point for critical discussion.

Umberto Eco has described any such 'text' as a 'machine for generating interpretations'. Calling it a 'machine' suggests that it has been designed by someone, the author, with particular purposes in mind, even if, like any other machine, it can in action have characteristics which the designer did not notice and effects which were not expected, and even though it can be used for purposes which were not at all what the designer wanted. Saying that the machine 'generates' interpretations makes it plain that the interpretations are not related in a purely accidental way to the text, that the text persuades us to read it in a certain way, as I suggested in the case of paintings. But the use of the plural 'interpretations' indicates that one cannot say that the text 'compels' as distinct from 'persuading'. And, of course, this fits our experience; critics whom we cannot dismiss as ill-informed about the text may nevertheless tell us quite different things about what the text says.

A much more extreme view is presented, as might be expected, by Foucault. 'The death of interpretation,' he once wrote, 'is to believe that there are signs, signs that exist primarily, originally, really, as coherent, pertinent and systematic marks The life of interpretation, on the contrary, is to believe that there are only interpretations.' I should want to reverse this, to say that the death of interpretation is to believe that there are only interpretations, the life of interpretation is to believe that there are signs that exist really as coherent, pertinent and systematic marks. For interpretation is an essentially relative notion; interpretation has to be of something, just as a child has to be the child of somebody. And in the case of literature, the case which now concerns us, it has to be of utterances in a language. There cannot be a language, in the pertinent sense, except where signs are read in a systematic way – it must be possible to construct a dictionary and a grammar – and given the multiple use of signs, there has to be a notion of 'pertinence', contextual relevance. If the adjectives 'correct' and 'incorrect' can never be applied to interpretations, then there is no such thing as 'interpreting', as distinct from 'being led to think of'. A doctrine which seems to give maximum liberty to critics does so only by making their enterprise totally pointless.

One possible source of confusion is the double level at which interpretation enters into literary argument, just as we noticed in the case of paintings. At the first level, interpretation is necessary to understand the words of the text. Suppose, reading a seventeenth-century work, a boy encounters the sentence 'We were surprised.' Such a reader, if ignorant of the use of the word 'surprised' at that time, might take the speaker to be saying 'We were astonished' rather than 'We were caught in the act.' Then it would be quite proper to say of such a person that he had misread the text. There could be no real argument about this, and many other such examples could be cited. The trouble, rather, is with the large number of cases where we might accuse someone of having misread a sentence although recourse to a dictionary or grammar is

totally useless by way of evidence. To take a simple instance. The sentence runs: 'You don't love her.' We find that someone is reading this with the stress on the 'her'. We complain; the stress should be, we say, on the 'love'. No dictionary or grammar can settle this point, which can be very important in our understanding of the novel. We have to argue by referring to a wider context.

We cannot properly say, I have admitted, that a sentence *determines* how we shall read it. But neither can we properly say that it is the reader, not the writer, who creates the work. Reading is neither a matter of freely imagining, in a way purely personal to us, nor a matter of simply following a set of rules we have learnt. That is why I said that the public object is in this case so elusive. Most of the time, we treat *the sentences as normally understood* – if there were no such thing, language would be useless – as being the public object, but we have always to keep in mind that sentences can be read differently, something that is especially true of poetry and may even be played upon by the poet, who wants to persuade us to reflect, as distinct from simply reading to rule.

If, to sum up so far, the public object is taken to be the marks on paper, this is not the work of art; if it is these marks, read as sentences in a language and interpreted as such, then we can properly regard it as the work of art, as our point of agreement when we are disagreeing about a work, although it is not then a material object, simply, but a set of such objects interpreted in a particular way. It can happen, we granted, that there are disagreements at the level of sentence interpretation; these a dictionary can sometimes settle, sometimes a scholar will have to be called upon, sometimes the point can be settled only by critics. That there can be misreadings, that 'misreadings' is not a meaningless notion, is as certain as anything can be. But misunderstandings are parasitic on understandings, just as lies are parasitic on truth-speaking. If disputes at this level cannot be settled – if someone goes on insisting that when Eliot talks about 'ABCs' he is talking about alphabets and not about the cheap London tea rooms which went under that name – there is a point at which we can only shrug our shoulders. That does not at all demonstrate that there is not a factual point at issue. If he tells us that 'Elsinore' was a town in Scotland or that 'disinterested' always means the same as 'uninterested', whoever is using it, defying the dictionary and all examples to the contrary that we cite, he is in both cases clearly wrong.

There is a second kind of interpretation still to be considered in which we speak not of interpreting the sentences but of interpreting the work as a whole. So I might say that *The Magic Mountain* is 'really about Utopianism' and someone else might allege, as some doctors did on the occasion of its first appearance, that it is purely and simply an attack on the medical profession. At a rather different level, some critics, as Chekhov complained, take his work as tragedies, whereas for him – and for some other critics – they are comedies, or even farces. On the face of it,

this is a confirmation of the view that there is something describable as the work of art, something which all concerned in this dispute have read, and that the only issue is what this common public object is 'all about', just as we might argue about whether a certain painting is a picture of Salome or of Judith while not at all disputing that it is quite certainly a picture of a woman.

At this point, however, the notorious 'hermeneutical circle' raises its head. Admittedly, it may be said, our general interpretation of the work rests on our interpretation of individual sentences, but equally how we read these sentences depends on what we make of the work as a whole, what genre we take it to be, what we suppose it to be all about. Did I not myself say that to know how to read 'You don't love her' we have to move beyond the sentence to the context? We have to be wary, however, of making that leap, which has been so characteristic of philosophy and not only of philosophy, from atomism to monism – or *vice versa*. It is one thing to say that one can often understand a sentence only in a broader context, opposing then the view that each individual sentence must bear its meaning on its face, quite another to say that we have to read it in the light of the *total* context, in the light of our interpretation of the work as a whole. Reading the very next sentence to 'You don't love her' may do the trick: 'It's Mary that you love', or 'You only think you do' or 'It's not love, it's lust.'

Indeed, to argue about the interpretation of *The Magic Mountain* makes sense only on the assumption that there is something we are both talking about. Encountering a different interpretation is more likely to compel us to reconsider the import of certain passages which we had at first dismissed as irrelevancies than it is to reconsider the meaning of particular sentences. So for all the problems this involves I still want to say that there is a public work, even though it is public only because we have learnt a particular language, have particular information and so on; and that it is this that we take seriously, or argue about the second-level interpretation of. I am going to assume, then, that if I mention *Crime and Punishment* and say something about the grounds for taking it seriously, my readers, in whatever language they have read the work, will not reply 'That's only your *Crime and Punishment* you are talking about', and that if they were to say 'You must be reading a different novel from the one I read' that would be a severe criticism, not a simple tautology.

One question I have not touched upon. It is, indeed, of relatively minor importance in the case of literature. Can there be something describable as 'abstract literature', roughly corresponding to abstract painting and abstract sculpture? In a familiar story, when Degas told Mallarmé that he had a thousand ideas for a poem he was met with the reply: 'Poems are made with words, not with ideas.' That is true and reminiscent of what we said earlier, criticising conceptual art. In the same spirit, we might have laid it down that 'Paintings are made with paint, not with ideas.'

Words of course, are not just marks on paper and not just sound-sequences, they are elements in a language. Nevertheless they do have sounds.

Then why should we not have poems in which nothing matters except the sound? There are quite a few poems which approximate to this condition – in English Swinburne wrote some notorious examples as, more consciously, did Edith Sitwell. And if we listen to somebody reading a poem in a foreign language we do not know, there is nothing for us to listen to except the sound-patterns. But that experience, which rapidly becomes boring, may fairly be identified with being present at a low-grade musical performance. We should not judge such a poem to be a serious work of literature merely on the ground that we had heard it read aloud and it sounded nice.

The case where sounds are uttered but they are not words, although they are vaguely reminiscent of words, is even plainer. Indeed, when Kurt Schwitters wrote a work made up of such pseudo-words he called it 'Meine Sonata in Urlauten' – it is often named his *Ur-Sonata*. When read by three voices, it is quite amusing; the sight and sound of three people on a stage uttering pseudo-words with the utmost solemnity has the typical Dada effect of parodying the serious. At this point, however, we have certainly left literature, in the narrower sense, for a performing art. Let us now turn to such arts.

Originally, of course, both poetry and story-telling were entirely oral. Even now there are people who prefer going to poetry readings to reading poems or who prefer 'talking books' or stories read over the radio to printed novels and short stories. Larger still is the number of people who never read plays – let alone film-scripts – and know them only in staged or filmed performances. In all such cases, the public object on which they base their judgment is not marks on paper, read as sentences in a language, but someone uttering these sentences, normally to the accompaniment of gestures. Plato has told us in his *Ion* how a rhapsode would behave, weeping and tearing his hair, when declaiming Homer. He also insists that the rhapsode does not just learn Homer off by heart; he *interprets* Homer. In the case of oral literature, indeed, low-level interpreting is done for the spectator and, as we have already suggested, that will sometimes be in the light of higher-level interpretations. The listener does not have to wonder where to put the accent in 'You don't love her' – that decision is made by the performer. (Although, listening to a play or a poem being read, the audience may disagree.)

Rather than immediately exploring the implications of such facts for our present inquiry, let us look more broadly at the performing arts in search of a generalisation – including drama, music, ballet as performing art, but for the moment excluding film, as raising rather special problems. Such performances may, or may not, be related to a notation-object, counting under that head a written play, a score and – a

much later innovation – a Benesh notation for ballet which includes a musical score but sets bodily movements to it. There are three possibilities: only a notation-object exists, with no public performance; only .performances exist; both a notation-object and performances of it exist.

The first of these possibilities is realised quite often in the case of music and drama; in ballet the notation, so far as I know, always succeeds and records a performance. In theory at least, ballet could now follow in the footsteps of drama and music. The world is awash with unperformed plays, unperformed symphonies, unperformed operas – where, of course, both libretto and music are notated. They are not performed for all kinds of reasons, quite often as being too costly. We commonly presume that it is possible to judge from their notated form whether they are trivial or serious and that judgments whether to perform them may be made on that basis. Of course, we might take a play to be serious as literature but, although it is written in dramatic form, nevertheless conclude that it 'would not work' on the stage. Something similar can happen in the case of music; a serious composition may be unperformable, impossible to play, or so written that its structure would be unintelligible to someone listening to it as distinct from reading the score. (Of course we can be wrong, in both judgments, but we can also be right.) Unperformed, or until performed, the only obviously public object is marks on paper seen as a score or, in the case of songs, as sentences in a language. But that – to repeat our previous argument about literature – is not what we are taking to be a serious work of art. It can be untidy or inelegant when that would not be true of the performed work.

What we judge to be serious, rather, is the work as it would be if it were performed. This is substantially true even if we judge it to be unperformable; we do that by trying to imagine it performed or trying to imagine an audience listening to a performance of it. The name of the work is written on the notation-object but we attach it also to the imagined performance.

Let us turn now to the second of the three possibilities I distinguished, where there are only performances. I shall take ballet as my leading example, because it has only recently been notated and most people have not so much as seen an example of the notation for a ballet, let alone developed a facility in reading it. So it is easy to imagine it not to exist, as indeed it still does not exist in the case of many ballets. Ballet is, however, by no means unique.

In many societies, and in particular sub-cultures of Western society, music has only recently been notated or literature written down. In my earlier discussions I took a work of literature to be any member of a class of works, similar to one another in all aesthetically important respects, and genealogically related to a particular text. In the cases I am now considering, there is no anchoring text. What has to take the place of the

text as anchor is some particular performance. It is through its genealogical relation to that performance, together with its resemblance to it at relevant points, that a ballet counts as *The Miraculous Mandarin*.

In certain cases, the situation, in the absence of a notated-object, is particularly confusing. *Swan Lake* is probably the most admired of ballets. But what exactly are we admiring if we admire it? The first performance was a messy failure, certainly not a serious work of art. Subsequent performances are genealogically related to it, but only that. Later, various choreographers got to work on it, and the ballet seen in Denmark or Moscow is therefore different in important respects from the work seen at Covent Garden. Under these circumstances we have no option but to use such qualified names as 'Petipa's *Swan Lake*', 'Bournonville's *Swan Lake*'. In principle, one could be serious and the other not. In each case, however, there is an initial performance to which we can refer back to justify both the qualified name and the use of the unqualified name within it.

What of the case where we have no possible way of determining when the first performance occurred or what it was like? That is true of oral literature, folk music and so on. Then what we generally do is to select some particular performance at a given time as 'the poem' or 'the song', noting perhaps the major variants in other performances. That becomes the authorised version. Folk-ballets can face a similar problem.

With reservations of this sort, we can stick by the view that, in sentences in which a ballet is up for discussion in respect to the grounds for taking it seriously, any adequate performance genealogically related to an original performance counts as a suitable point of reference. The word 'adequate' must, awkwardly, be there. For there can be performances, claiming to be *Swan Lake*, which are so inadequate, so full of stumblings, falls, grimaces, movements out of time to the music, that we can fairly say to any spectator of these woeful goings-on: 'You have not seen *Swan Lake*.' But it would be too paradoxical to say, 'There can be no such thing as a poor performance of *Swan Lake*; if it is a poor performance, it is not *Swan Lake*.' (Similarly with a piece of music or a play, we have to leave room for being able to say, 'That was a poor performance of ...') So we cannot say that only good performances count as performances of *Swan Lake*; it is only when the performance is so bad that it would be impossible to judge the work from it that we can refuse the name to it. Those of us who live in small cities may well have seen, or heard, some serious works only in what, by metropolitan standards, would count as poor performances. Nevertheless, the performances were *adequate*, not totally disguising the character of the work.

As Collingwood emphasises, we can envisage a performance better than the one we are seeing, in which the work would be fully realised. Directors sometimes do this when watching a rather tatty production of a new play in a suburban hall. They 'see its possibilities' and mount a

better production of it. Of course, judging from such a performance alone it is particularly easy to go wrong. 'Contemporary' composers sometimes complain that their works never receive an adequate performance, whether because the performers are unsympathetic or because there is not enough rehearsal time or because their notation is misunderstood. Part of the attraction of electronic music for such composers is that they can be at once composers, conductors and performers.

When both the notation-object and performances exist, we are more confident in our judgments. Reference to the notation-object permits us to point to gross misinterpretations, to justify our claim that what we were confronted with on a particular occasion was not just a poor performance but a performance which was not entitled to bear the name that had been given to it – was simply not *Jenufa*. Nevertheless, a person can rightly claim to be acquainted with *Jenufa* who has never so much as seen the notation-object. So even when that object exists it is not that we are judging; we are saying of something performed, whether actually or imagined, not of it, that it is a serious work of art.

Even when there is a notation, performances which set out to be true to the notation-object can nevertheless differ greatly. We still, I suggested, say that they are, let us say, performances of a Shostakovich symphony if they are genealogically related to a particular score – or, more exactly, to what we take to be a reliable example of the score – and do not deviate from that score in ways which would affect the seriousness of the work. (In spite of what is sometimes said on this point, if a pianist plays a wrong note, although we might, in the rare cases where this would not be obvious, point out to a friend that the note had been misplayed, it is most unlikely to affect the friend's judgment of the work, which is just as well.)

What, then, is the ontological status of performance arts? It would be more than a little odd to call a ballet performance or a concert or a play 'a material object', whereas paintings and buildings and sculptures, as we remarked earlier, are plainly of that kind. We cannot ask such questions as 'How much does it weigh?' of a musical performance, a ballet performance or a play as we can of the instruments, the settings or the performers. Yet it is not immaterial either; what we are looking at are bodies in motion, what we are hearing are vibrations in the air, in either case a sequence of physical happenings.

Or is that quite right? What we are hearing are not just vibrations but particular musicians playing particular instruments, what we are looking at are not just moving bodies but particular actors or ballet-dancers. We can pass judgments on their performances; some people, indeed, are more interested in the performers, in their display of skills, than in what is being performed. The performer may be much more highly valued, far better paid, granted more public esteem than the composer, the playwright, the choreographer. That is not at all surprising. Like the sportsman – we speak both of actors and footballers

as 'players' – the actor, the musician, the dancer have readily comprehensible skills. But also, the work exists only in and through their performance except for those relatively few who, by reading the notation-object, can construct for themselves a private performance.

The actors and dancers we watch, the musicians we hear, are not, however, doing everything for us. We are called upon to remember what was previously said, played and done, we must have expectations, even if the playwright, the composer, the choreographer finally disrupts them. That is what lends plausibility to the critical theories for which it is the spectator who actually creates the work.

Yet we do not create the work merely because we approach what we hear or see with our memories, our imagination, our expectations, our experience of society, of human feelings, of language, of modes of expression. So far as possible the writer has anticipated these things, and so does the actor. As comes out with particular obviousness in a certain type of thriller in which we are 'led on', they expect our expectations, they rely on our memories. The patterns we end up by perceiving are discovered by us, not, if we are understanding the work, created by us, although it would also be false to suggest that we simply receive them – we have to listen, to watch. We do not simply receive a series of sensations.

Finally, and before trying to sum up, let us look briefly at the case of film. That is extraordinarily complicated at one level, very simple at another. It is simple in so far as there is only one performance to be taken into account, or very nearly so. True enough, films are sometimes 'remade', but no one would have the least inclination to say that the remake is the same film as the original film; indeed, even the name is sometimes changed, as in Hollywood 'remakes' of French films. Admittedly, the new film is genealogically related to the old film, admittedly, too, they are enough alike to let us recognise that we are seeing a remake. But they are not so related that to judge one to be a serious work is automatically to judge the other to be a serious work, any more than, where the same conditions are fulfilled, we must judge *Ran* to be a serious work if we say that of *King Lear* or Polanski's *Tess* to be a serious work if we say that of Hardy's novel.

True enough, too, a film sometimes appears in more than one version, amended for the eyes of a particular country, so that Borowczyk's *La Marge* ends with a suicide in the French version but with a happy ending in the version shown in Austria. In general, however, a film is a one-off. We do not have a variety of directors making the same film over time, or a variety of actors playing the same role in the same film, as happens in the case of plays. A remake like *The Postman Always Rings Twice* may sometimes bear the same name as the original, but we would be more likely to think of the Garnett and Rafaelson films – along with Visconti's *Ossessione* or Chenal's *Le Dernier Tournant* – as different versions of

Cain's novel than as different versions of the same film. Each takes that novel as his source; the common elements between the films, beyond that fact, are relatively slight. Allowing for the possibility of exceptions – it would not be logically impossible for a director to choose a different cast but otherwise to follow line by line, scene by scene, an earlier version – it would be very unnatural to define a film as a class of performances, more natural to say that what we are taking seriously is a single entity, the film, let us say, *Alexander Nevsky*, in any of its copies. (It is in much the same position as a novel, allowing even for translation, if only in respect to what is said by the actors.) And again to identify this with what we see on the screen when a film is run through a projector rather than with that film itself, with 'moving pictures' rather than a set of stills, and with such pictures seen as representing actors who are in turn performing as persons other than themselves. At least that is true of what are sometimes, contemptuously, called 'commercial' films.

The remark ascribed to a film critic in 1947 – he was writing for the London *Observer* and represented an English suspicion of films which has never wholly vanished – that films were nothing but 'bits of celluloid and wire', a view which made him 'ready to declare categorically that films are not art', is a good example of the ridiculous conclusions which can arise out of a failure to get right what counts as a work of art. (We might as well say that painting is chemicals spread on a flat surface, or a poem ink on paper, and conclude from this that they cannot be art.) Equally, it will not do, for the most part, to identify the film with a set of moving images, looked at in and for themselves, although in the hey-day of anti-representationalism there were those who argued that only by so developing into animated paintings of an abstract kind could film hope to be an independent art, as distinct from being 'canned theatre'.

Such films are often called 'experimental', in that curious use of the word 'experimental' in which the 'experiment' is not designed to test but connotes only that the work to which it is applied does not accept the standard conventions. (It is no more curious than the use of the word 'theory' in the phrase 'literary theory'.) They fall into two classes. In one class what is projected is unexposed film, or film exposed to light but not in the presence of objects, which the film-maker has marked in a variety of ways. The intention is to produce on the screen a set of images which will be comparable to abstract painting. No film of this kind has managed to get itself taken seriously by any but very small coteries and there is no good reason why it should.

Slightly more popular with 'art-house' audiences have been films in which coloured images expand, contract, change shape – an abstract form of animation, usually to the accompaniment of a musical score. Unlike 'action painting', such films have genuine analogies with dance, as the shapes twist and turn across the screen, although, of course, in a way that is 'magical', not subject to the confines of what is humanly possible in the

way of movement. But although films by its better-known exponents – Lye, Fischinger, McLaren – are occasionally to be seen, the genre has never established itself. Indeed, the rapidity of the movement takes away from the contemplative pleasures offered by the better kinds of abstract painting and abstract sculpture. For the most part, the films which are taken seriously are representational in character.

What appears on the screen, however, is in all cases moving coloured – or black-and-white – shapes. The American phrase 'the movies' is a less misleading name for this form of art than either 'film' or 'cinema'. For the first of these also means the object in the spool, the second the place of performance. 'Movies' are not the sort of thing we should normally call a material object; as we suggested, there are difficulties enough in extending that concept even to 'live theatre' of one sort and another. I cannot think, indeed, of any general ontological name which we would give to these rapidly moving images. Yet they are not imaginary, as pictures we projected on to a screen as a result of an hallucination would be. The film itself – the object in the reel – is a material object in a quite straightforward sense of the word, but what we see on the screens and judge is a 'public image'.

At the lowest level, seeing the succession of images on the screen as moving shapes is something forced upon us by our constitution, the limits of what we can perceive. Birds can hear as a succession of sounds what to our ears is only a single sound. We can imagine a species which would see a 'moving picture' as a slide show, but we are not members of that species.

When it comes to seeing these public images as human beings, it is harder to be confident about the roles of perceptual tendencies and what is socially learnt. That what we are seeing, except in documentaries, is an actor playing a certain type of human being, who may be not at all the sort of person the actor actually is, certainly has to be learnt and sometimes, it would seem, is not learnt, the characters in a television serial then being treated as real people and the actors playing their role as having the characteristics of these people. Nevertheless anyone setting out to distinguish between serious and non-serious movies will have acquired this learning long beforehand.

In the vast majority of cases, then, the images are seen as actors playing roles in a particular physical and social context – often to the accompaniment of music, an accompaniment first developed in the days of silent movies to relieve the silence but persisting beyond that point. A few movies may fairly be described as 'canned theatre'; in such cases we might well count them as performances of the play in question. In general, however, their seriousness as movies cannot be deduced from the seriousness of the plays to which they are genealogically related, any more than it can be deduced from the seriousness of novels from which they derive – or, for all its importance, of the script specifically prepared for them. The complexity of movies makes them hard to characterise. In

this respect they are like opera; both of them offend aesthetic purists as being 'mixed arts'. Although, again like opera, they can give us great visual delight, to associate them closely, as I have done, with the performing arts is the most natural thing to do.

Now to sum up this unexpectedly, and undesirably, protracted discussion. There are three views I have sought to dispute: the first is that in all cases the work of art is something that happens in the mind of the author, the second that it is to be identified, in all cases, with a particular material object or set of material objects; the third that it is made by the person who appreciates it. Against the first view I have insisted on the primary importance of the public object. On the other hand, I accepted the view that in that public object – as distinct both from 'natural objects' and from man-made objects which are not works of art – we can see an artist's mind at work. On the second point I accepted the view that in certain cases, in architecture and some kinds of abstract painting, what we regard as being the work of art is a particular material object. In other cases, however, the public object is a material object as interpreted in the light of socially acquired habits or biological tendencies on which the artist can safely rely. In the case of the performing arts, it would be greatly stretching the concept of a material object to count performances as such, although they involve the use of material objects. They are sequences of movements set against a background which does count as a material object, or a set of such objects. In the case of film they are 'moving pictures', generally of a representational kind, associated with material objects – films, screens – but not themselves counting as such, except in a very extended sense of the phrase.

On the third point, I happily recognised that the use of such verbs as 'receive' to apply to those who are 'on the receiving end' of works of art is misleading in so far as to treat visual and literary works as works of art, even of the feeblest kind, one normally has to interpret, if in a manner greatly facilitated by the artist's knowledge of how we are likely to react. In the case of performing arts we are called upon to remember, to expect – as well as, in many cases, to interpret speeches, gestures, movements in particular ways. I contested, however, the view that these interpretations are entirely open. There can be a variety of different interpretations, all compatible with a particular segment of the text, but there are also misreadings, misinterpretations, and the variety of possible interpretations can be greatly reduced by scholarship or by considering segments in broader contexts, either within or outside the work. I rejected both the stringent view, that every sentence admits of only one interpretation, and the loose view that it admits in any context of any interpretation, in favour of the tight view that the range of interpretations it admits has boundaries.

So I end up by accepting what I began by calling the 'naive' view that in considering in what a work consists it is quite proper to take into account

what we know of the artist, of the artist's life, times and education, of the public work – whether taken to be a material object, simply, or that object as interpreted in accordance with publicly-accepted habits – and of the anticipated activities of the reader or spectator. For otherwise we may misinterpret the work as habits and anticipations change. In the case of completely banal works, the dismissal of them will not in fact require us to pass beyond the public work, but to demonstrate that a work is serious, it may be very necessary to do so. I also rejected the view that there is an answer to the question 'What is *the* ontological status of *the* work of art?'

As for the identity of a work, what serves as the subject in judgments about the seriousness of the work, I suggested that in some cases this was easily settled: our reference is to a particular painting, sculpture or building. Of course, we may know it only by hearsay or in photographs or some other form of reproduction, but what we are talking about is that individual work. In other cases, the work may exist as a member of a set of substantially identical copies – as in the case of prints or movies. In that case what we are describing as a serious work is any member of that class, provided only that it has the appropriate relationship of descent from, and similarity at all relevant points to, a copy-text, an engraved plate or whatever else is involved as the 'original'.

Performance arts are the most difficult species. Sometimes there exists something of the character of a copy-text – what I called a 'notation object'. That commonly allows, however, of considerable variation in performance. In general, any performance, in such instances, counts as being the work if it is an adequate performance of the notation object, where 'adequate' means not moving outside the world of possible interpretations of the text and letting us judge the work's seriousness. Where there is no notation-object, we may, as in the case of ballet, have to rely on someone's memory of an earlier performance, but that we are then really seeing the same work that other spectators saw – or, in the case of music, hearing the same work – is something we cannot be fully confident about. Of course, we can in the same way be uncertain whether a critic saw an adequate performance; that was not the case, we happen to know, with some performances which bore the name *King Lear* but took great liberties with the text. In other cases we have no way of finding out. Two critics of a performance art may disagree about its seriousness only because one of them has, and the other has not, been present at an adequate performance.

5

Seriousness and Imagination

Asked to offer an example of a 'work of the imagination', most people would respond by nominating a work of art, probably of literature. This is not one of those cases where popular and critical judgments are at odds. That 'imaginative' is a term of praise, that to create works of art, artists, whatever else they have to do, must exercise their imagination – these are nowadays critical commonplaces. Such philosophers of art as Collingwood and Scruton spend much of their time discussing the imagination. I am not here setting out to develop an alternative, all-embracing account of the imagination. The only question for me is whether serious art has some special relation to the imagination – special in character or degree – not to be found in telic or amusement art.

We cannot safely begin, however, from the assumption, current though it is, that at least this much is secure: that serious art stands in some peculiarly intimate relation to imagination. There have been dissidents for whom art can become serious only by shaking itself free from the trammels of the imagination. A notable example is Emile Zola in *Le Roman Expérimental*. Zola freely admits that so long as the novel was regarded as a fabulous romance, it could properly be described as a 'work of the imagination'. But those days, he said, were gone; in the modern novel or drama the imagination has no function. A serious novel will not be a fable but rather a kind of experiment, in which scientific ideas about human beings are tested by placing characters in a set of situations of the relevant kind and showing how they react. It issues in 'an official record, nothing more'. Zola thought of himself, when he made these remarks, not as merely issuing a manifesto with the intent of changing the nature of the novel and the drama but as describing the practice of the best writers of his time. His doctrines were by no means disregarded; he had many disciples, not only in the United States but in such countries as Japan.

Yet, not very long after Zola's death, a standard French literary handbook praised him for his 'luxurious imagination' and for not much else. *Germinal*, indeed, is not at all like a sociological account of conditions in the French coal-mines. It takes liberties which no such report could take. The conditions Zola describes as existing contem-

poraneously were in fact separated by a considerable period of time; he invents dialogue, personal relationships. They may be plausible but they are not 'official records'. A scientific experimenter who did such things would certainly be accused of fraudulent misrepresentation.

Why, then, was Zola so anxious to deny that he had written a work of the imagination? Well, there are certainly senses of the word 'imagination' and its cognates which immediately suggest a lack of seriousness. Consider Molière's *Le Malade Imaginaire*. The very title will serve as an example. Molière's hypochondriac 'only imagines' that he is suffering from this or that disease. When his brother tries to bring him to his senses it is by exhorting him thus: 'Don't give way to your imagination.' Molière's physician is in no better shape. The 'medical knowledge' to which he pays homage is nothing but a 'romance', a fable, just because he is dominated by his 'fine imagination'.

Unlike a real illness, an imaginary illness is one that does not have to be taken seriously, at least as being the sort of illness the patient claims it to be. Neither should the prescriptions of a doctor be taken seriously when they are the product, simply, of the imagination rather than of experience or rational understanding. The imagination, whether of the hypochondriac or the doctor, is represented then by Molière as being something which has to be resisted, not encouraged, since otherwise it issues in worthless speculations and ridiculous conduct.

None of this strikes the modern reader as being at all strange. When we say, 'I heard a knock at the door', we may well get the response: 'Don't be silly; you're just imagining it.' To 'just imagine' is, in this context, to be 'silly'. We are often told that a man is 'the victim of his imagination', 'has a rather vivid imagination' or 'is rather inclined to imagine things' – all this to connote his unreliability as a witness. So we are not at all surprised to be told that an exercise of the imagination will issue in a romance, a fable, as distinct from being a reliable source of information.

That is why Zola says that there is no place for imagination in the novel. He is insisting that his characters, their talk, their habits are not something he 'just imagines', that his novels are not a wild speculation about the way of life of peasants, artists, coal-miners, prostitutes, but are based on serious research. When Henry James, in his *Notes on Novelists*, ascribes *Nana* to 'the foulness' of Zola's 'imagination', it is to James's use of the word 'imagination' that Zola would object. What James should really be complaining about, he would reply, is the foulness of what he has revealed, a foulness which James, by ascribing it to Zola's imagination, is trying to discount.

Zola is clearly right on a central point. It would be a *criticism* of his novels, not a way of praising them, to say that they 'are just a product of his imagination', foul or otherwise, if this is intended to put him in the same class as Molière's hypochondriac or Molière's doctor. So, too, it would be a severe criticism to make a comparable remark about *Hard*

Times, *Bleak House*, *The Possessed*, *U.S.A.* or *A Clockwork Orange*. Very obviously, then, there are senses of the word 'imagination' and cognate expressions in which to apply them to works of art is at once to suggest that those works are not serious. Indeed, there are those who have argued that just because they are inevitably the work of the imagination, representational works of art cannot possibly be serious. That Zola was eventually to be praised for his 'luxuriant imagination', they would see as an illustration of the fact that not even so determined a naturalistic novelist could avoid this defect.

In a world in which mathematics and physics are paradigm cases of serious pursuits we might be tempted to reply that mathematicians happily make use of 'imaginary numbers' and scientists often take very seriously entities which are admittedly imagined, not known to exist. This particular comparison will not work as an attempt to explain how serious works of art can be imaginary in a non-dismissive sense. The mathematician's imaginary numbers greatly contribute to the extension of number theory; Tanguy's painting *Imaginary Numbers* plays no such role. The imagined entities which physicists take seriously are the products of theories, and physicists set out to establish their existence experimentally. Zola's novels, it might be argued, are similarly the products of biological theories about inheritance. But it would be absurd to try to construct experiments in order to see whether Zola's imaginary characters in fact exist; in calling them imaginary, we are saying that any such experiment would be in vain. So we cannot use the supposed analogy with science and mathematics to explain why Molière's comedy, although a product of the imagination, is not to be put in the same unserious class as the illnesses of his hypochondriac and the prescriptions of his doctor. We still have to find a way of replying to those who refuse to take the arts seriously just on account of their link with the imagination.

The most famous of them is Plato, in the tenth book of the *Republic*. The representational artist, he there says, at best presents us with accurate images of natural objects, more commonly with deceptive images which he cheats us into taking as accurate. In contrast, the craftsman makes an actual, useful, natural object, even if it be no more than an image of the eternal Forms, and the philosopher concerns himself with these Forms themselves. Since artists move in a world of reflections, images of images, mere shadows, it is ridiculous, Plato concluded, to take them seriously, except when they deceive us or imitate what ought not to be imitated, when indeed we have to take them seriously as a moral menace but only as that. The imagination, for Plato, has no virtues. It creates, he tells us in the *Sophist* (267d), 'a man-made dream for waking eyes'. Only when we are wholly rational are we fully awake.

Could we communicate with Plato in the Elysian fields and ask him for evidence that artists proceed in the manner he describes, he might well direct our attention to Leonardo da Vinci's *Notebooks* (MS.2038) and

argue thus: 'I said that the artist is like someone who claims to be able to create the Universe, when all he can do is to show it to us in a mirror. Well, Leonardo tells his pupils to paint not what they see in the world around them but that world as reflected in a mirror. "It is certain," he writes, "that if you but know how to compose a picture it will also seem a natural thing seen in a great mirror." And he does all this in an attempt to prove that painting is more scientific than poetry! Did I not demonstrate that science has no interest even in everyday sensory appearances, let alone in deceitful reflections of them.'

Plato was by no means the last to attack the imagination outright. In the seventeenth century, Malebranche described it as 'a fool that likes to play the fool'. Only by reducing it to silence, he tells us in his *Dialogues*, can we 'hear clearly and distinctly the deliverances of inner truth'. Others did not share Plato's and Malebranche's attitudes to the imagination, in the sense that they did not seek wholly to denigrate it. Nevertheless, they have described the imagination and linked it with the arts in a way which is fatal to any attempt to take either of them seriously.

A striking example is that very influential figure, Addison. He agreed with Plato that in everyday experience we do not directly perceive the genuinely real. His metaphysics, however, is not Plato's; he writes in his *Spectator* as a disciple of Locke, and his tone, quite unlike Plato's, is agreeably hedonistic. Whether we like it or not, he argues, we live all the time in Plato's 'man-made dream', when we are walking in the garden as much as when looking at paintings. For the scents, the colours, we enjoy in the garden are of our own making; science has shown them to be absent from the real world. Such enjoyments Addison calls 'pleasures of the imagination'. Art enlarges these pleasures and this, Addison assures us, is a good thing. An obvious alternative, the pleasures of the understanding, involves arduous labour, damaging to the health. In any case, such pleasures are not accessible to most people, for whom the only alternative to pleasures of the imagination is gross sensual pleasure. In W.S. Gilbert's words, the arts are for Addison 'a source of innocent merriment'. Although he by no means agrees with his co-editor, Richard Steele, that 'the pleasures of the imagination are what bewilder life, when reason and judgment do not intervene', the only conclusion we can draw from his analysis is that there is no way of distinguishing between serious art and entertainment.

There are those who would reply to both Addison and Steele, to Plato and to Malebranche, by citing a notorious passage from the fourteenth book of Wordsworth's The *Prelude*:

Imagination which in truth
Is but another name for absolute power
And clearest insight, amplitude of mind,
And Reason in her most exalted mood.

But this is a tactic of sheer desperation, to save the imagination from its critics by re-defining it. We heard more than enough in the sixties of the slogan 'all power to the imagination', but even this slogan did not pretend that the imagination in fact had absolute power, only that it ought to have it. Absolute power can exist nowhere short of God; those human beings who try to exercise it are notorious for their irrationality. Along with Nerval's 'The human imagination has invented nothing that is not true' – for all that a later critic, Marcel Raymond, has described this as 'a fine statement' – the passage from Wordsworth illustrates to what depths of special pleading artists and critics can descend. Goya had better sense. He saw, in *The Sleep of Reason*, what horrors can ensue when Reason is asleep and the imagination reigns untrammelled. To say, in Wordsworth's terms, that this is only Reason in its most exalted sense taking over from Reason in its less exalted sense would rightly have struck him as being insanity.

Then must we grant that so long as the arts are intimately associated with the imagination, they can at best be regarded, in Addison's manner, as entertainment, at worst, in the manner of Plato, Malebranche and Steele, as positive hindrances to clear thinking? Perhaps we can still hope to avoid this conclusion, without falling victim to the extravagances of a Wordsworth or a Nerval, by looking more closely at what is involved in 'exercising the imagination'. For 'the imagination' has been the most Protean of concepts.

Let us begin from what can fairly be described as the minimal concept of imagination. It has its roots in Plato and Aristotle but is perhaps most familiar in the shape it was given by the British empiricists. It runs something like this: 'Whenever we perceive, an image is created in our mind. This image can later be recalled. If we recall it much as we first experienced it, we say we are remembering our experience; if we form a new image by compounding old images, we say that we are imagining. We have the power of shaking our images free from the particular spatio-temporal contexts in which we first met them, we have the power of compounding them, as when we compound a horse and a man into a centaur. But the compounding of images for the most part occurs automatically, as a result of the workings of associative laws. And when we do deliberately create new images compounding is the most we can do; we cannot create images which are in any other sense novel.'

This is an account of the imagination well adapted to the conception of the representational arts as being purely imitative. It overcomes the obvious objection to imitative theories that many of the figures one finds in painting or literature are not actual persons and are often mythological beings – something similar applies to landscapes – by arguing that these imaginary figures or landscapes are compounded out of images rising from the artist's experience. Their *elements*, then, are imitative.

The artist's experience, one should add, includes experience of other

works of art, of folk-lore, of familiar symbols and conventional descriptions. These form part of the world around artists quite as much as do the natural landscape, people, inventions, beliefs, urban structures. To take an example from Wittgenstein, if a painter wants to depict a ghost, the question does not normally arise what colour should be used. Traditions settle the matter, unless the artist wishes to create a special effect by deviating from the conventional transparent white, the ghost-colour of painting, literature, popular tales, and so of the artist's experience. What the artist does, on the empiricist view, is to use skills to present such familiar images on a suitable surface or to express them in literary form. Imagination is involved only at the level of compounding.

It should be emphasised, since the contrary is often asserted, that such empiricists as Hobbes and Hume were by no means hostile to the imagination. Hobbes, indeed, granted it extraordinary creative powers, making it responsible in his 'Answer to the *Preface to Gondibert*' for 'whatever distinguishes the civility of Europe from the barbarity of American savages'; Hume sees in it the means by which we make our way from the isolated sensations which constitute our immediate experience to what we call 'reality', consisting of complex three-dimensional objects, linked by causality. This is despite the fact that for Hume, as much as for Hobbes, imagination is 'decaying sense'.

As Hume's *Treatise* takes shape, however, it becomes apparent that the imagination as he had first described it cannot construct the world. It can play that role only if it has powers which go far beyond the simple capacity to compound; it has to be granted a degree of creative freedom. Something similar is true in relation to the creation of works of art – which are often described, in fact, as miniature worlds. The gap between what artists have experienced and what they put before us cannot be filled by an imagination engaged in a quasi-mechanical process of compounding. Even if artists obviously draw upon their experience of men and horses when painting centaurs, the centaur is not just a compound; it is a particular design. Still less is *Ulysses* just a compound of Joyce's Dublin experience of persons and places.

Recognising such facts, we may be tempted by concepts of the imagination which lie at the opposite extreme from empiricism. Coleridge was well aware of the empiricist doctrines; he had met them, in particular, in the writings of the associationist psychologist, David Hartley, had not only met them but had been deeply influenced by them. When, under the influence of such German Idealists as Schelling, he rebelled against them he did not so much abandon as relegate the imagination of the empiricists. The British empiricists, he tells us in his *Biographia Literaria* (ch. XIII) had been talking about the Fancy – 'a mode of memory anticipated from the order of time and place'. That is very different from the Imagination proper. The imitative artist, the entertainer, is merely fanciful, the serious artist is genuinely imaginative.

Coleridge goes on to divide the genuine imagination into two species, the primary and the secondary. The primary imagination he describes in dithyrambic and scarcely intelligible terms. It is 'a repetition in the finite mind of the eternal act of creation in the infinite I AM'. Even if we despair of explaining quite what this means two things are clear enough. The first is that the primary Imagination, and the artist who exercises this Imagination, is Very Grand and the second is that such an artist is essentially creative, like the deity creating out of nothing except his own existence. (That is if we take the artist to be exercising the primary imagination; of the secondary imagination we shall speak a little later.)

In total opposition to the concept of the imagination as creating out of nothing, the empiricists always insisted that in the long run imagination had its roots in experience, by way of memory, so that when Blake called upon the artist 'to cast off the rotten rags of memory by inspiration' he was demanding the impossible. We can separate this view from the special doctrine that the imagination can do no more than compound memories; once that separation has been made, it seems to me to be incontestable. At one time, Coleridge's own *Kubla Khan* might have been cited as an obvious exception. Livingstone Lowes created a scandal when, in *The Road to Xanadu*, he demonstrated to what a degree Coleridge's reading – which in this context counts, of course, as experience – had entered into his poem. The scandal was created just because that poem had been regarded as the exemplar of a creation out of nothing. Blake's own engravings, with their dependence on neo-classical figure-painting, would have made the point equally well.

The 'death of the author', as sometimes proclaimed, has been greatly exaggerated. I wish I could reply to the critics who complain of my errors and omissions as some 'literary theorists' would have me do: 'I did not write that book: Language wrote it.' I wish I could be convinced that it was Language which, not I who, spent sleepless nights trying to get things right. Merely by an exercise of will, however, one cannot believe total absurdities. But if the view that it is Language, not authors, which writes books can fairly be dismissed as absurd – and the same would be true if some other totality such as Society or Culture were to replace Language in this pronouncement – nevertheless if authors are not dead 'The Author' is, or ought to be. That is, if by 'The Author' we understand a person who creates out of nothing, who exercises Coleridge's primary imagination – now sometimes re-christened as the 'spontaneous imagination'.

Those who have emphasised this point do not always rely on the epistemological assumptions of British empiricism. They insist, rather, on the kind of fact to which we drew attention in discussing Collingwood: that artists, however much they pride themselves on their individuality and originality, have always learnt from their predecessors; that writers inherit a language and artists, architects, musicians, a variety of styles,

which shape, even, the character of their reactions against them; that they are social beings, working in particular socio-economic circumstances, in a particular milieu of patrons, whether in the guise of Church, State or individual consumers. But such critics are making the empiricist point, even if no longer in the language of classical epistemology. There are no authors, no 'auteurs', if this is taken to involve the creation out of purely individual resources of a totally new world, no authors in whose work memory, including memory of other works, plays no part. As Stravinsky once said, 'Only God can create', if, that is, 'creation' has to be *ex nihilo*. (Indeed, in many religions, not even God can create in this sense.)

To say this, however, is not to be forced back on the view that artists can do no more than combine images derived from their experience of events – even if one again insists that the events in question include such events as linguistic utterances, cultural pressures, reading or looking at works of art, the behaviour of other people, the artist's own past reactions. If no work is a pure creation it does not follow that, in Barthes's phrase, it is nothing but 'a tissue of quotations drawn from the innumerable centres of culture'. That is crude empiricism all over again with the elementary experiences re-described, in the contemporary linguistic fashion, as 'quotations'. Let us now look, in this light, at what Coleridge calls the 'secondary imagination'. Perhaps that is what artists exercise.

The secondary imagination is much more modestly conceived than the primary. To be sure, it is said to be 'an echo' of the primary imagination, differing from it only in degree. That must be in the same sense that human beings are said to be made in God's image; the 'image', the 'echo', of omnipotence and omniscience in human beings is faint indeed. So in saying of the secondary imagination that it 'dissolves, diffuses, dissipates in order to recreate', that it struggles to idealise and to unify, Coleridge implicitly admits that it must have something to work upon, that although it can 'recreate' it cannot create out of nothing, that it has to struggle. Nevertheless, the imagination, thus conceived, is by no means confined to compounding. It dissolves, unifies, recreates.

Nearer to our own time Gaston Bachelard formulated a not entirely dissimilar view. Imagination, he tells us in *L'Air et les songes*, is not to be identified with having images – that is the province of perception and memory. Rather, it is 'the faculty of freeing us from the initial images, of *changing* images'. The images must be there to be changed. Nevertheless, we go completely wrong, according to Bachelard, unless we see that the crucial tie is not between imagination and image but between imagination and the imaginary. 'Thanks to the *imaginary*, the imagination is essentially *open, escapist*. Within the human psyche, it is the experience of opening, the experience, even, of novelty.'

We have circled back to our original problem, how the imaginary can be

taken seriously. But our detour has not been a useless one. We now confront a particular suggestion, both from Coleridge and Bachelard, about the imaginary, namely that it is a reshaping, a recreation, of what has been perceived, as distinct either from the Idealist view that it is an entirely fresh creation or the empiricist view that it is a simple or compounded representation of a sensory image. We still have to face the question whether there is any special way of recreating which issues in serious works rather than in mere entertainment or merely telic art.

One particular way of answering this question is now, even in the Socialist world, distinctly unfashionable among critics. The serious artist, on this view, creates an image more perfect that anything that can be derived from experience. Unfashionable this view may be, but it prevailed for centuries and is still widely held at levels closer to popular feeling than the austere heights of 'literary theory'. So the English novelist Angela Carter addressed an interviewer thus: 'Fiction isn't about life, you know ... It's about what we hope for from life. Not about what we are, but what we might be.' In painting, where its influence was particularly strong, perfectionism was a reaction against the Leonardo-style view that the painter set out to imitate, to represent, experience, so that a painter could be thought of as a kind of applied scientist, using a knowledge of geometry to produce something we shall see as an exact replica. The hero is then that Greek painter Zeuxis, who is alleged to have painted flowers in so life-like a manner that the bees took them to be real. What the 'perfectionists' want, in contrast, are paintings and literary works which depict things and people in forms far more perfect than anything we can find in everyday life. In such contexts 'more perfect' sometimes means 'more beautiful', sometimes 'more solacing', sometimes 'more morally attractive', sometimes more 'typical' and quite often a combination of all four of these.

I shall be looking in turn at each of these varieties of perfection. In any of its forms, however, perfectionism is a rejection of imitative art which, through that rejection, replies to Plato. Far from copying the natural world, as Plato thought, the artist, on the perfectionist view, depicts the Ideal. Where does the artist's knowledge of the Ideal come from? Mannerist critics, in particular, often answered that question in what they took to be a Platonic fashion – it is actually, of course, neo-Platonic. Artists have, on this view, God-given innate ideas of the ideally beautiful. They use these rational ideals in order to transform the images they derive from experience, transform them by perfecting them. One could trace this idea from the Renaissance through to Schopenhauer and the symbolists, although it suffered many changes on the way. Art is thus intellectualised, the artist is put on the same footing as a philosopher, Malebranche is satisfied, the imagination is reduced to a minimal role. But only by presuming an extremely implausible metaphysics.

In other forms of the theory, however, the Ideal is constructed by the

imagination, working on the images derived from experience, but now
granted the power not merely of compounding them but of producing out
of them an Ideal type. If Zeuxis still appears as the hero, it is now the
Zeuxis who, called upon to paint Helen of Troy, asked for seven virgins as
models so that he could use their best features to construct an ideally
beautiful form. This involves imaginative selection. Once more, only
non-serious, purely imitative artists are left still subject to Plato's
strictures. Indeed, on this interpretation of perfectionism, serious artists
differ from Plato's philosopher-kings only in so far as they imaginatively
create, rather than dialectically discover, the perfect forms to which they
give expression in works of art, as the philosophers give expression to
them in the ideal State. That is the shape in which the perfectionist
doctrine made the voyage from Bellori's Italy to the England of Addison
and Reynolds, as Panofsky has shown in his *Ideas*.

What is the point of depicting the Ideal instead of the actual? The
assumption of perfectionism, in all its varieties, is that the actual is too
imperfect to be worthy of the serious painter's brush or the poet's pen.
'Nature's world is brazen,' so Sidney tells us, 'the poet's world is golden.'
Let us look first at the case where this is because its beauty is too flawed.
(Whether as a result of the Fall or because the world has degenerated
over time or because the beautiful is inevitably flawed, Platonic-style, by
its presence in the material was a matter of dispute. But not the simple
fact.) So Addison tells us that the poet is 'to humour the imagination in its
own notions' – observe that the imagination now has 'notions', as distinct
from images – by 'mending and perfecting nature' when writing
descriptive poetry or by 'adding greater beauties than are put together in
nature' when the theme is fictional. And Reynolds similarly exhorts the
painter to get rid of 'the accidental deficiencies, excrescences and
deformities of things'. Cromwell, that is, without the warts. (If the 'ideal
type' was often strikingly like the painter's mistress, that is merely
accidental.)

The leading assumption in this kind of perfectionism – and it is, of
course, by no means peculiar to it – is that the serious artist can, and
ought to, produce objects which are purely beautiful. Plato, as we shall
later see, had thought that this could not be done, that pure beauty was
only to be found outside, not inside, the arts, as that very different
philosopher Bertrand Russell was later also to proclaim. Artists,
however, had come to think that it could be found inside the arts, that
indeed the Greek artists had shown how it could be, provided only that
artists were careful to confine their attention to depicting what was
beautiful, describing or painting or sculpting a transformed rather than
the actual world – the world, we might say, as it would have been had the
Fall never occurred.

Fortunately we are not called upon to examine in detail the
psychological apparatus, the theory of abstract ideas, to which this

perfectionist theory appealed in its attempt to explain how the imagination could construct, for the painter to depict, this transformed world, any more than we had to examine in detail neo-Platonic metaphysics. We have only to ask whether we can find in such beauty-centred perfectionism, whether in its intellectualised or in its imagination-centred form, a means of distinguishing serious art from the merely entertaining and the merely telic. And one objection is immediately obvious: it is too exclusive. The Dutch painters are cast into the utter darkness by perfectionists for choosing lowly subjects and not transfiguring them. Bellori entirely rejects Caravaggio. For he once painted a peasant with dirty feet.

Consider what happens when, in his *Laokoon*, Lessing works with a similar view. In fear or pain we cry out, our mouths opened in our anguish. Yet, Lessing tells us, 'the mere wide opening of the mouth – apart from the fact that other parts of the face are thereby violently and unpleasantly distorted – is a blot in painting and a fault in sculpture which has the most untoward effect possible'. One has only to think of Giotto, of Munch, of Picasso, of Bacon to realise just how confining this restriction in the name of perfection would be. The Uffizi is the home of beautiful, perfected art. In the midst of it all one suddenly comes across the Portinari altar-piece of Hugo van der Goes. Here they are, peasants who look like peasants, not like gods come to earth. One begins to wonder what difference it might have made to the world if these beautifully Florentine Madonnas had been depicted as the Jewesses they certainly were.

It would be ridiculous to conclude that paintings and literary works which are inspired by beauty-centred perfectionist ideals can at once be ruled out as obviously being either merely entertaining or purely telic, non-serious, even if many of them do fall into these categories. To clear out everything except the Van Goes from the Uffizi would be as monstrous as to exclude that work, condemning with it the whole Northern tradition. I am simply saying that there are a great many serious works of art which do not satisfy beauty-centred perfectionist criteria and that many works which do satisfy such criteria are either sentimental amusement or telic distortions. How perfectionist works can be serious although they appear to falsify, how non-perfectionist works can be serious although they are far from being beautiful, are questions we shall have to face later. But it is sufficiently clear that any adequate account of serious art has to leave room for Juvenal as well as Ovid, for Beckmann as well as for Botticelli.

The second ground for excluding non-perfectionist works as not being serious is that they do not give us solace. The narrator in Philippe Sollers' novel *A Strange Solitude* writes thus: 'If, as of course I don't believe, the imagination needs excuses, its primary justification would be the solace it provides.' On this view, artists use their imagination to transform the

appalling world we, and they, experience into a world which offers us solace. That serious art ought, through the exercise of the imagination, to offer us such solace has too great a weight of authority behind it to permit us to dismiss it out of hand as outrageous Philistinism.

For Pater scarcely falls into that category. Nevertheless, he tells us in *The Renaissance* that the scholar, the disinterested lover of literature 'will always look to it, as to all other fine art, for a refuge, a sort of cloistral refuge, from a certain vulgarity in the actual world'. Note that for Pater, it is especially the person who loves, and knows, art who will think of it thus. The Japanese novelist, Natsume Soseki, is no less free from any taint of Philistinism. Yet he writes thus in the *Three-Cornered World*: 'Strip off from the world all those cares and worries which make it an unpleasant place in which to live, and picture before you instead a world of graciousness. You now have music, painting, poetry or sculpture.'

Once again, however, much of the art which we are accustomed to take seriously comes off worse, by this criterion, than entertainment art. Gertie MacDowell found solace in her romantic novelettes. So have millions of others, male and female, found solace, according to their taste, in television 'soap operas' or in Rambo-style films or in pious tales. But it would be a rare reader who was solaced by *The Brothers Karamazov* or *King Lear* – I have known someone vomit in the gutter after a performance of that play – or *A Long Day's Journey into Night* or *The Trial*. Of course we might invoke some version of Aristotle's catharsis or German Schadenfreude or Sacher-Masoch's masochism to sustain the view that in these cases, too, we are being consoled. One does not quite know what to do with such hypotheses, invoked to explain how we can take pleasure in what we should normally find painful. I can only reply that I have been as deeply disturbed by serious works of art as was my vomiting friend. At the very least these works are not consoling in the Pater-Soseki sense; they do not offer us a refuge from the world's horrors and vulgarities. Flaubert once said that 'to lose oneself in literature as in a perpetual orgy is the only way of making life bearable'. I am no expert on perpetual orgies. But it would be surprising if reading *Bouvard et Pécuchet* were at all like indulging in one.

Such reflections may, once more, tempt us to fly to the opposite extreme, always a temptation in discussions of the arts, then concluding, in total opposition to Pater, that only non-serious art is consoling, that if a work of art consoles us this is a sure sign that it is either merely entertaining or merely telic. Such a view is assumed by many contemporary critics. It would be nice, at this point in our inquiry, to have hit upon the kind of criterion of which we are in search. But although it may be true, as John Anderson once argued, that 'protective literature, the literature of comfort and consolation, is bad' – true so long as we stress the word 'protective' and take the comfort and consolation to derive from concealment, deception – there is a good deal of lyric verse which

conceals nothing but consoles us by drawing our attention to the joys and pleasures of the world around us. Moving outside literature, to music or painting or ballet, this is more obviously so. If much serious art is critical, some is celebratory. So neither in the fact that it consoles nor in the fact that it disturbs can we find a criterion of serious art.

The transition from Flaubert's 'perpetual orgy' to Socialist Realism is a somewhat sudden one. No one has yet suggested, so far as I know, that reading *The Cement Factory* is an orgiastic experience. Socialist Realists would not want, either, to defend their version of perfectionism by arguing that serious art brings tranquillity into the world or offers us solace. They fall rather into the third of the four types of perfectionist I distinguished, for whom the serious artist imaginatively creates a world which is a *moral* improvement on the world as we actually know it, and that with a particular social aim. Substantially, they agree with what Comte had laid down in his *A General View of Positivism* that art 'should surpass realities so as to stimulate us to amend them'. Rather than solacing us, in the manner Pater suggests, or simply giving us pleasure, as Addison claims, 'true', i.e. serious, art on this view stimulates us to action by indicating to us what the world *would* be like were our attempts to amend it successful. Its seriousness, then, is linked with its telic character; the distinction between telic and serious art has no force. Or, better, serious art is that kind of telic art which has the right kind of purpose.

That is the spirit in which Gorky wrote to Chekhov: 'It is absolutely necessary that today's literature begins to embellish life somewhat, and as soon as it does so, life will be embellished, i.e. people will begin to live more swiftly, more brightly.' The 'mixture', as he described it, of 'realism' and 'romanticism' is substantially what came to be called 'Socialist Realism'. The revolutionary, the worker, the situation in the Soviet Union were all to be presented in a perfected form as an aid to the creation of a perfect society. It was to be the artist's job to use imagination – instructed by 'science' – to show us such a world.

One has to remember, of course, that the varieties of perfectionism I have distinguished often coalesce. If the emphasis has now shifted from perfection as making more beautiful to perfection as moral improvement, moral improvement is by no means totally absent from Renaissance conceptions of perfection and neither Socialist Realism nor the basically very similar art of Nazi Germany totally abjured the concept of beauty. In Nazi art, 'the nude', depicted in a perfected manner, is even more conspicuous than it is in Renaissance art; within Socialist Realist art the noble workman is not only noble but handsome. The ugliness of 'the enemy', however, is not concealed but rather exaggerated. Of course heightened ugliness has a place, too, in Renaissance art, in paintings, let us say, of the Temptation of St Anthony. But in Socialist Realism the effect is achieved, as in all poster art in wartime, not by creating what are

obviously imagined monsters but by uglifying what are depicted as being actual human beings.

Malenkov once justified this practice as a way of revealing the typical, so defending the fourth kind of perfectionism. The 'typical' does not mean, as one might suppose, that which comes nearest to the statistical average. 'Typicalness,' he tells us, 'corresponds to the substance of the actual social-historical phenomenon, and is not simply the most widespread, the most frequently repeated, the usual.' So, 'conscious exaggeration or stressed images do not exclude the typical, but reveal and emphasise it more fully'.

This way of talking suggests that the typical is something actual but none the less not normally apparent; exaggeration and stressed images reveal its true nature. So the true nature of the typical proletariat will be revealed only in a novel or painting in which the proletarian hero and heroine are depicted as being more heroic, more whole-heartedly devoted to improving productivity, more willing to make sacrifices, in peace or war, than the actual workers one normally meets. What this 'true nature' is the artist learns from 'science, with its knowledge of the actual social-historical phenomenon'. The imagination is confined to finding ways of exaggerating, of stressing, making the everyday conform to the 'real'.

Malenkov did not want to admit that Socialist Realist art is purely telic, a kind of propaganda; he wanted to argue that it is truthful, although not depicting things as they are. One cannot reply to him simply by asserting that the use of exaggeration and stressed, heightened images immediately shows that a work cannot be truthful; one must agree, or so I shall later be arguing, that it can be a way of bringing concealed truths to light. The trouble with Socialist Realism was that nothing came to light except what the authorities would like to be the case, and this was already known. There was none of the criticism of received authorities, received doctrines, received attitudes which is the typical use of exaggeration in serious art. And unlike serious celebratory art it consoled only by concealing.

To sum up, however 'perfecting' is interpreted, we have been unable to support the view that it is by perfecting the images it receives from experience that the imagination produces serious art. We have argued, rather, that perfecting is as typical, or more typical, of art which is pure entertainment or purely telic. It then comes out as sentimentality, as art which conceals rather than reveals. To be sure perfecting art can, in certain circumstances, function as a form of exposure, as a Utopia can be a way of exposing the defects in actual societies. But the serious artist, as we shall see, will often want to display things with their defects made more visible, for that purpose resorting to the ugliness of caricature rather than the beauty of perfected images.

There is still another way in which artists might be supposed to modify

the images they derive from experience. That is by using their imagination to transform them into symbols. The difference between image and symbol, in the present context, is that whereas the image is thought of, in however transmuted a way, as pointing to actual or possible experiences, as referring to what is, or might be, the case, a symbol is such an image used to refer to what cannot, in however ideal a world, be sensorily experienced.

Let us begin by distinguishing between the conventional and the innovative way of using images as symbols – remembering, of course, that every conventional symbol was originally innovative. The conventional use is sometimes called 'allegory', in a somewhat extended use of that word; the innovative use is then described as 'symbolist'. (Naturally, the boundaries are not sharp and there can be disputes about the application of these words to a particular work.) Some persons have come, over time, to have conventional attributes; some abstract ideas are conventionally represented by a special symbol; some emotional states are conventionally represented – within a particular culture – by specific gestures. So, on the first point, we can tell by looking at the crossed keys that Goya's painting is of St Peter; otherwise only the title would tell us. On the second point, a woman holding a sword and scales commonly symbolises justice. On the third point, in Baroque painting to look upwards with rolled eyes often symbolises religious devotion. In an Indian dance, in a Noh play, in Renaissance paintings, there are many symbols of each of these three kinds, most of which convey nothing to the uninstructed Western observer but were immediately significant to the audience for which they were designed, as immediately significant as a written word or description.

It can take imagination to make use of such symbols in a way that lets them make their point without being too obtrusive in the composition. Nevertheless, their use does not in itself entail anything more than an acquaintance with the conventions. They now have rather a bad name, except that Paul de Man, condemning symbolism as mystification, praises allegory as a normal use of language – a view not wholly remote from my own.

I remarked that conventional symbols were originally innovative. The fact that they caught on suggests that they were to some degree successful as models. The conventional symbol for justice is a case in point. Here the pictorial analogies are obvious. The judge has to weigh evidence and scales suggest weighing, he has the power to punish and swords suggest punishment, he must not be swayed by irrelevant circumstances and so is blindfold. One can even play ironically on the symbol by making the sword bloody, or by putting a human being on one side of the scales and money on the other.

In one respect, of course, the analogy does not work. Although until very recently the exercise of official justice was a male prerogative, the

figure of justice is female. Femininity is characteristic, indeed, of figures representing virtues. This fact apart, however, the symbol is a natural analogy for justice, one we can recognise as such because we are acquainted with justice as a concrete social phenomenon. Such analogies are regularly pointed to by Freud, most obviously in the case of phallic symbols. But in the case of statues of women labelled Mercy or Patience or Chastity or Reason we should often be at a complete loss were it not for the labels, although an expert iconographer might not be. The interesting thing is how little this matters, as I argued earlier in the case of my Indonesian acquaintance. Iconographers now tell us that we had Titian's *Sacred and Profane Love* quite wrong, that we went completely astray in taking the nude figure to be profane love and the clothed figure to be sacred love, that the reverse is the case. That does not at all affect our judgment that this is a serious work of art. It looks as if the seriousness of works does not at all depend on their success as symbolic models; the images remain and survive changes of view about what they are symbolising. The presence of such symbols certainly does not demonstrate that the work of art is not serious – imagine the slaughter if every painting containing a halo were thus dismissed. Neither, more obviously, is it an indication of seriousness. We have discussed conventional symbolism only to clear the air.

One might well begin the discussion of unconventional symbolism with Kant's *Critique of Judgment*, that remarkable work which foreshadows so much later theorising about art and, more particularly, with what he says there about the 'sublime', defined as 'the use of the sensible in the representation of nature for a possible super-sensible purpose' or, more broadly, with his description of 'the aesthetic idea' as 'that representation of the imagination which induces much thought, yet without the possibility of any thought whatever, i.e. *concept*, being adequate to it'. But given both Poe's enormous influence on French symbolism and the relationship between his essay 'On Fancy and Imagination' to what we have already said about Coleridge, that essay will be a better starting-point.

Poe sums up Coleridge's distinction thus: 'the fancy combines, the imagination creates' and goes on to argue, much in my own manner, that since there is no such thing as creation *ex nihilo*, this is at most a difference in degree. Looking for a genuinely fundamental distinction, he links the 'true imagination' with the mystical. It is, he says, 'the mystic or secondary expression' which 'spiritualises the *fanciful* conception and lifts it to the *ideal*'.

We might put the matter thus: images, so it is said, can be used to symbolise what cannot be imaged, such things as the supersensible, inner states, abstract ideas. Of course, in the case of literature we often have words at our disposal which refer to these, just as in painting, ballet, sculpture and the theatre we have conventional symbols. But they are

often felt to be inadequate, whether because they have gone dead through over-use or because they are insufficiently subtle to express 'feelings too deep for words'. It was often supposed by symbolists that music had found a way of communicating what literature and painting had not been able to communicate; symbolist poets and painters, greatly influenced by Wagner and with a half-understanding of Schopenhauer, sought to imitate music – as, indeed, such composers as Debussy sought to enlarge music's power (or supposed power, for I shall later be writing somewhat sceptically on this point) to capture and communicate subtleties of feeling.

The neo-Platonic theorists on the edge of the French Symbolist movement naturally exhorted the artist to create images of the super-sensible. This, by the nature of the case, presents its problems. Consider what Kant offers us as the most superb example of sublimity, an inscription on the temple of Isis: 'I am all that is, and that was, and that shall be, and no mortal hath raised the veil from my face.' Compare this with, to invent an example, 'I am a Royal Princess, made prisoner, stabbed, while defending my honour against the attack of a Nubian slave.' Any nineteenth-century French historical painter, making use of conventional symbols, could manage that. Painting Kant's Isis, which is the kind of ambition the symbolist painters shared, is quite another matter.

It is easy enough to paint a veiled woman. But how can it possibly be shown, with no conventional symbols at hand, that she is 'all that is, that was and that shall be'? Of course, there are those who have argued that this cannot even be said, since it is nonsense. One might agree that it is metaphysically incoherent. Nevertheless, there is an important sense in which it can be said. The words used, the syntax, form part of the English language, and have been translated from the German language, the Egyptian language, in a way which captures their sense. That sense, however, cannot be shown. Sometimes painters try to cope with such situations by writing on their canvas. Or they might use Kant's sentence as a title. Just what counts as part of a painting is not, as Derrida has emphasised, a question which permits an easy answer. Nevertheless, one can distinguish between showing in a painting and telling in a sentence; the symbolist painters try, without sentences, to paint what they take to be inexpressible.

Even with conventional symbols at their disposal, Christian painters have, however, no way of showing us that the man hung on the cross is the second person of a Trinity which is at the same time a unity, let alone that, as some theologians maintain, the whole Trinity is hanging there. The dove, the crucified man, the elderly bearded figure can only be painted as separate elements. Spanish religious painters delight in painting the Holy Family; that is easy just because they are human figures with conventional attributes. Creating a pictorial image which

will successfully symbolise an unconventional super-sensible entity is quite another matter. Even in literature Yeats's expressed hope that no one would understand his symbolism was only too readily realised.

What to do? Well, the symbolist painters painted women, the typical way out for painters – or poets – with metaphysical pretensions, Renaissance or nineteenth-century. They were women in all sorts of guises, often destructive, sometimes in sentimental attitudes, often naked, or nearly so, sometimes in exotic clothing, but women none the less. Frequently, the painters drew, for their female figures, on Biblical stories, but occasionally on classical myths or the mythical constructions of Wagner, whose work, as I said, they regarded with particular sympathy. But Wagner had, as they did not have, the help of words.

Where the woman was a Judith or a Salome, no particular problems rose. Such paintings were illustrations of a familiar story about human beings. But who, stumbling in the Basle Kunstmuseum on Hodler's oddly posed nude and unable to read the German title, could possibly guess that he was looking at 'Communication with the Infinite' or have any way of judging that this is indeed how people look when they are indulging in that particular pastime?

There is no way, I am suggesting, in which a painting can present us with the super-sensible, except when the painter can rely upon a familiar story where the super-sensible assumes a human or an animal form, with conventional attributes. Yet the attempt to do so can by no means be set aside as of only antiquarian interest. In the 1980s a German painter, Gerhardt Richter, described his strikingly designed 'free abstract paintings' as 'fictitious models' of 'a reality which we can neither see nor describe but which we may nevertheless conclude to exist'. What is this reality we can neither describe nor see? By the nature of the case, we cannot be informed. How are we to tell, then, that the painting is a good rather than a bad model? Had not Richter inscribed on the wall beside an exhibition of his paintings this description of them we should more naturally see them as of – if anything at all – fanciful tropical landscapes. That way of seeing them we could defend by pointing to features of the painting. In contrast, there is, and could be, nothing in the painting to suggest that is a model of an Unknowable Somewhat.

Naked woman or pure abstract, the same problem arises. The painting is there to be studied either as a picture of a woman or as an abstract and taken seriously, or dismissed as merely telic, simply as such. To judge it as a metaphysical model is impossible, although it can be judged as an illustration of a familiar story, myth or legend. It might help the painter if he is able to believe that what is emerging on the canvas is something much grander than a woman or a coloured canvas, but to the critic such psychological aids are irrelevant.

We can, however, interpret paintings – amatory or admonitory, Bacchic or punitive – about the pagan gods simply as strengthened images of

human relationships. Something similar is true of symbolist writings which profess to acquaint us with much more obscurely imagined super-sensible beings or ideas. If we cannot take seriously their supposed latent content we can still take seriously their images of human hopes, human despairs, human weaknesses, human fears. When in Huysmans' *A Rebours* Des Esseintes tells us that Baudelaire 'had succeeded in expressing the inexpressible', he does not at all mean that Baudelaire had given us access to a super-sensible world; what Baudelaire did, according to Des Esseintes, was to draw attention to states of mind which had previously been regarded as too evanescent, too 'fugitive and ephemeral', to lend themselves to literary expression. As in the case of the classical mystics, the reader who is quite unsympathetic to the theological presumptions of symbolist poets can nevertheless take very seriously their depiction of human longings, their criticism of ways of life, their description of the dark night of the soul. The poet exercises imagination to show us what it is like to see the world as a 'forest of symbols'. Too often, however, in symbolist painting and poetry, this does not happen. As Coleridge feared, fancy collapses into delirium, the imagination into mania; we are incoherently preached at, not shown anything. The painter, or the poet, who assumes the role of a seer ceases to be a see-er.

What about such a novelist as Kafka? Does he not succeed in effectively symbolising the relationships between supernatural forces and human beings? Well, if we interpret *The Trial*, let us say, in terms of Christian doctrines of grace and redemption then it falls into the category of those works I mentioned earlier where the author, or painter, relies on the reader already having a set of doctrines at his disposal which the artist can then concretely illustrate. It is interesting to note, however, that these novels have also been read as a kind of prefiguring, based on experience of existing bureaucracies, of what life in Socialist societies would be like. In fact, what Kafka does is to describe a type of situation, what indeed we now call, applying it to situations we actually meet with, a 'Kafkaesque' situation, just as we may speak of a 'catch 22' or a 'waiting for Godot' or a '1984' situation. (It is a striking fact that whereas the nineteenth-century novel created *types of person* who were used in this way as touchstones, as when someone is called an 'Oblomov' of a 'Gradgrind', twentieth-century novels leave us rather with *types of situation*.)

The so-called interpretations of *The Trial* or *The Castle* should be regarded, rather, as different applications or exemplifications of a Kafkaesque situation. In a difficult play like *Measure for Measure*, in contrast, we feel that the play is an application of moral principles and are puzzled about what the principles are. But the concrete detail with which Kafka describes situations – peaking, perhaps, in *Metamorphosis* – and the concrete detail in Shakespeare's linguistic characterisations in important ways speak for themselves, whereas much symbolist writing

and painting is vacuous. Although it is natural to do so, we do not need to try to extract principles from Shakespeare's play or to make applications of Kafka's novels in order to appreciate the seriousness of their work. To try to do so, indeed, may tie them down, where their 'ambiguity' is part of their point – more accurately, their capacity to raise a wide variety of questions.

Were the symbolists serious artists? Where, as very often, their art does not come off, it has the vices which are typical of unsuccessful serious art rather than of unsuccessful entertainment – it strains after an effect which it does not achieve, it is pretentious, woolly, over-stated. One can easily understand the reaction against it, whether in formalistic paintings or in such utterances as T.E. Hulme's: 'A reviewer last week spoke of poetry as the means by which the soul soars into higher regions, and as a means of expression by which it became merged into a higher kind of reality. Well, that is the kind of statement I utterly detest. I want to speak in verse in a plain way as I would of pigs: – that is the only honest way.' In the same spirit, the imagist poets laid it down that poetry should 'present an image', completely eschewing 'vague generalities, however magnificent and sonorous'. Symbols were out, the intensified image, in the manner of a Japanese *haiku* was in; seeing particulars exactly was in, cosmic poetry was out. Yet if, as I said, such a programme was completely comprehensible as a reaction against what had been going on – as indeed impressionism was against vast allegorical and symbolic paintings – the effect can easily be, and in some instances was, shallowness, banality, a turning away from subtle, complex states of mind.

From a quite different direction the surrealists, following Breton, were equally hostile to the vagueness, the obscurity, of symbolist poetry. The poet and painter, they argue, should be concerned with the 'marvellous', not with the 'mysterious', and ordinary concrete things have all the marvellousness one could wish for, once we dissociate them, as in a dream, from their banal context. At a different level again, the 'new novel' of Robbe-Grillet is a reaction against symbolism in the novel, of the kind found in, let us say, some of the novels of Thomas Mann or Patrick White, in favour of concrete description. Yet even if one remains unimpressed by recent attempts to rehabilitate lesser-known German and Spanish symbolists or the mass of minor French symbolist poets, one must still insist that symbolist poetry and painting cannot be cast aside as worthless. This is very obviously so if, as is often the case, such painters as Munch, Gauguin, Klimt, such sculptors as Rodin, are counted as symbolists.

The symbolist movement illustrates, indeed, two things: The first, that interesting work can often be done by artists and writers who are ostensibly working with theories on the reliability of which the quality of their work does not in fact depend – so that we cannot deduce from the

feebleness of a theory the non-seriousness of the work done in its name –
and secondly that the attempt to create works of art which are
intellectually serious most often leads to work which is muddy or
pretentious or stagey. Where symbolist art succeeds, I have suggested,
this is because the images it creates succeed in revealing to us states of
mind which are traditionally concealed or, at least, not clearly recognised.
That is surely what we find in Munch, Gauguin, Klimt, Rodin to say
nothing of the better symbolist poets – or in Ibsen's wild duck, Chekhov's
seagull, Melville's whale, Grass's tin drum.

I have been working so far with the traditional view that imagination is
closely linked with the having and the production of images. But that
view, although still often defended, has been seriously criticised both by
Sartre and by Ryle. It is more than time to look at alternative conceptions
of the imagination. Such an alternative view may or may not deny that
there is any such thing as 'having an image', being content perhaps to
assert, in the manner of Kant and Sartre, that in so far as artists do have
mental images they are extremely vague, whereas artists can *imagine*
very exactly, in minute detail.

One view, often associated with Ryle's name but with a longer history
than this, takes imagining to be a form of make-believe. It does not
matter, on this view, what images are passing through a boy's mind as he
plays with a train or how vague they are. We see, without knowing
anything at all about his images, that he is make-believing that he is an
train-driver and this is exactly the same as imagining himself to be a
train-driver. Similarly, or so it is said, Rodin make-believes that he is
carving a pair of lovers, Constable that he is creating a landscape, an
actress that she is Queen Elizabeth, Jane Austen that a character she has
made-believe to exist would talk to another character she has
made-believe to exist in a particular manner.

Responding to this way of looking at the imagination, Collingwood
objected to it on grounds which are by no means peculiar to him. 'If
imagination were confused with make-believe,' he writes, 'a theory
identifying art with imagination would seem to imply that the artist is a
kind of liar; a skilful, ingenious, pleasant, or even salutary liar, perhaps,
but still a liar.' By no means everyone, of course, would regard this
argument as a *reductio ad absurdum*. Indeed, one of the most striking
features of the history of criticism is the frequency with which the charge
of being liars has been brought against the arts, against literature in
particular. Even more surprisingly, artists themselves have often
accepted this description and even rejoiced in it, although with the
qualification that their lying has a very unliar-like relation to truth.

So, to consider only a few nineteenth- and twentieth-century cases,
Baudelaire in his 'Salon of 1859' expresses in these terms his preference
for old-fashioned theatrical dioramas as compared with landscape
paintings: 'These things, so completely false, are for that very reason

much closer to the truth, whereas the majority of our landscape painters are liars, precisely because they fail to lie.' A book on non-naturalistic Australian novelists is entitled *The Liars*. Oscar Wilde's 'The Decay of Lying' ends with the bold statement: 'Lying, the telling of beautiful untrue things, is the proper aim of Art.' Van Gogh conceded that he was painting 'lies', even if they were also to be 'truer than eternal truth'. The post-modernist architect Philip Johnson tells us that 'Art is artifice, the opposite of truth; it's invention, it's lying, it's cheating the eye.' Plato, it would seem, is thoroughly vindicated.

For all the distinction of its proponents, the view that the representational arts, in and of themselves, lie to us can nevertheless be safely set aside as ill-founded. 'Metaphors,' Hobbes once wrote, 'openly profess deceit.' That very way of putting the matter completely gives the game away. For how can one openly profess deceit? In relation to what one said on a previous occasion or to some other person, no doubt, one can admit to deception, but not in relation to what one is saying now. 'I tell you quite openly that I am lying when I tell you that I am not married' would not deceive the most innocent of maidens – unless, indeed, she were one of those who have never quite mastered the double negative. To write a play, to come on to the stage in order to perform it, is to make an open profession that what follows is not to be taken literally. To take it literally, like Partridge in *Tom Jones*, is at once to be the typical figure of fun, the newcomer who does not understand the conventions, the migrant or the *nouveau riche*. One of the first of British writers on the arts effectively made this point. 'What child is there,' Sir Philip Sidney rhetorically asked, 'that, coming to a play and seeing *Thebes* written in great letters upon an old door, doth believe that it is Thebes?' He was ignored.

Of course, like everybody else, authors may sometimes lie. They may say that their film-script makes no reference to living persons when it in fact does so. They may tell us what we are reading is a document when it is actually fiction. But then they are lying about their book, their film, not lying in it. The maker of a documentary can lie in his work – he can tell us in his film that we are looking at poverty in contemporary Spain when what we are looking at are shots taken many years ago. Generally speaking, in those books which were published by Penguin in blue-covers as non-fiction one had to look out in case they contained lies – although one hoped that such cases were, even so, quite exceptional – but in books published in red covers as fiction no question of lying arose. Creating a fiction is one thing, lying quite another.

Lying is not, however, the only way of deceiving. A magician can deceive us without actually lying. And the comparison of the artist to the magician is a commonplace, with Prospero as the most familiar example. In the *Republic* Plato describes the illusionistic painters as engaging in 'nothing short of witchcraft'. Thomas Mann, two millennia later, was

happy with his family nickname, 'The Magician'. Ingmar Bergman no less proudly assumes the magician's mantle: 'When I show a film I am guilty of deceit ... I am either an imposter or, when the audience is willing to be taken in, a conjurer.'

Are we to say, then, that artists, like magicians, in so far as they make-believe, deceive us? There are two sorts of magician: the magician-priest who deliberately sets out to deceive and the magician-showman who, in the very act of announcing himself as a magician, makes it clear that we are not to take what he does at its face value. Only the magician-priest is subject to moral censure as a deceiver. The last thing such a magician-priest would do is to proclaim himself, in Bergman's manner, to be an imposter or a conjurer. No doubt, an artist, like everybody else, can try to deceive us, can use his ability as a manipulator of verbal or visual images, let us say, in an attempt to persuade us that he is a deep thinker. Tolstoy rightly brought this charge against some of his contemporaries; Bergman might be similarly accused. This, however, is a specific charge against specific artists, not a charge against representative art as a whole.

A liar sets out to make us believe something which it will be to the liar's advantage for us to believe; a boy riding a broomstick is not trying to make us believe that he is riding a horse, although he is make-believing that the stick is a horse. But he would like us to share in his make-believe. Jane Austen is not trying to make us believe that once upon a time there was a girl called Elizabeth who addressed her father in a particular way, as a journalist in a scandal sheet might try to persuade us that a public figure had a mistress who regularly addressed him as 'Dodo'. Such a journalist is trying to get us to believe something, as the author is not, although she may try to make her fiction 'believable'. How these remarks can be squared with the fact that we often describe a novel not only as 'believable' but as actually 'truthful' is a question we shall temporarily postpone. For the moment it is enough to reject the view that make-believing is, as Collingwood suggests, a form of lying.

The question still remains whether if we identify imagining with make-believing and still argue that the arts involve imagining we are not trivialising the arts, whether an artist might not prefer to be regarded as a liar, which is a serious business, rather than as just engaged in make-believing. For how can make-believing, if that is what the artist does, be serious? If what artists present us with, as Kendall Walton suggests, are make-believe truths, is that not to say that they present us with something which it would be absurd to take seriously? Artists themselves have sometimes felt the force of this argument. A sensitivity to it is inherent in Henry Moore's puritanism: 'A stone sculpture should honestly look like a piece of stone since making it look like flesh, hair or wrinkles is descending to the level of a conjurer in a theatre.'

The stage-magician, if no liar, is still a mere trickster, at home at

children's parties or in night-clubs, but not on any serious occasion. The child's make-believing game, no doubt, is serious, in the sense that through it he learns to come to terms with the world around him. When we, as adults, join in we do not think of ourselves, however, as engaging in a serious pursuit except – a consideration which does not apply in the case of our relationship to the artist – in so far as we can, by joining in, help the child. And does not this suggest, as Thomas Love Peacock argued, that the exercise of the poetic imagination belongs to the childhood of our race, and should be put aside, now that we know better?

Henry James thought that because fiction, in particular, clearly involves 'make-believe', many critics were reluctant to see in the play or the novel, as distinct from music, architecture, or even poetry and painting, a form of art. Not all make-believing, however, is, like the child pretending to ride a horse, a simple form of game, a mere imitation. The philosopher make-believes by conducting a thought-experiment, George Orwell by writing *Nineteen Eighty-Four*. In each case, so far like the child, they would have us suppose to be the case what they, and we, know not to be the case. But their purpose is a serious one: to bring home to us, through their make-believing, what we would not otherwise see. Fancy or make-believing is employed in the interest of discovering or uncovering or recovering. It is hopelessly paradoxical to say that artists lie in order to tell the truth; it is at least not so obviously paradoxical to say that they make-believe in order to show us something.

The definition of imagination as make-believing does not, however, work at all well outside the representative arts. Some critics have said that Mozart had more imagination than Haydn, but it would be very odd to say that he was better than Haydn at make-believing. Or again it would be very odd to say that Smirke's greater degree of imagination when compared with other neo-classical architects consisted in his greater ability as a make-believer. Even in the representational arts, while we have tried to make something of it and it is not so obviously a misfit, its use rings rather strangely. Would we indeed happily say that Dostoevsky is better at make-believing than Agatha Christie? Perhaps we might, but it does leave one rather uneasy. We would be even more uneasy at suggesting that Monet is better at make-believing than Gérôme.

Let us turn, then, to yet another way of linking art and imagination, mentioned at the very beginning of this chapter but since neglected. That is through the use of the word 'imaginative'. Unlike the other links this is discriminatory. It is quite generally true of representational works of art, even when they are mere entertainment or merely telic, that they present us with images and very often true that they present us with something imaginary. That they do these things, however, gives us not the slightest reason for taking them seriously.

'Imaginative' is different in two ways. First, it is as applicable to

non-representational as to representational arts; a composer, an architect, can as readily be called 'imaginative' as a novelist. Secondly, there is at least a degree of plausibility in suggesting that it is precisely in virtue of its imaginativeness that we distinguish a particular work of art as being serious – which does not, of course, prevent it from also being entertaining or from having, or once having had, a telic character.

Could this be what we were looking for, a criterion for distinguishing between serious art and art that is merely entertaining, merely telic? That would not entail, I must again insist, that we judge the imaginative highly as art. It could be imaginative and yet suffer from defects which are of a fundamental kind, so that we say of it: 'Yes it is imaginative, but … .' Nevertheless, just because it *is* imaginative, we should bother to make such judgments about it, should not at once dismiss it as trivial.

Two points can be made at the outset. The first is that imaginativeness is not a peculiarity of works of art. I began this chapter by saying that if we were asked to nominate a 'work of the imagination', our mind would almost certainly turn to a work of art and, more particularly, of literature. That is not surprising. Ibsen's *Hedda Gabler*, let us say, is an image of certain types of human attitude, its characters and the narrative are imaginary, the play is imaginative. If, in contrast, we describe an iron bridge as 'a work of the imagination' only the last of these characterisations apply. Nevertheless, that last characterisation does apply, as it can to any invention, theory, plan, proposal. I shall not say that every form of human activity can be imaginative or unimaginative. While cooking can be, I doubt whether the contrast applies to eating, or indeed to walking as distinct from travelling. Its range of application is, however, very wide.

This is something that nineteenth-century poets liked to deny; they wanted to treat imagination as the special possession of the arts. Of course, if we associate imagination with image-making, this is a more plausible view than it is if we think in terms of imaginativeness, since the poet and the painter and the sculptor, to mention only the most obvious cases, do present us with images. But the general Romantic tendency was to deny that science was imaginative, to suppose that it simply describes facts or, at most, generalises facts by 'induction'. That in particular is how poets, regarding it as a threat, tended to see it. They often responded, as we have seen, by conceiving the imagination in terms which distanced it as far as possible from 'the rotten rags of memory', from any connection with facts. Such twentieth-century writers as Apollinaire, however, fully recognised the imaginativeness of science, particularly as realised in technological innovations. Indeed to deny either the inventiveness of Edison or the imaginativeness of an Einstein is totally preposterous. So it is to deny that an industrialist, a policy-maker, a businessman can display, or fail to display, imaginativeness.

A second point is that, in talking about imaginativeness, I can cast off

with relief the psychological assumptions I have so far gone along with, as being intrinsic to the theories I have been discussing. Perhaps it is true that – as the group of French mathematicians collectively known as 'Bourbaki' explicitly assert – one cannot be an imaginative mathematician except by visualising. Perhaps Kant is wrong when he writes scornfully of 'a representation such as painters ... profess to carry in their heads, and which they treat as being incommunicable shadowy images of their creation'. Perhaps there in fact are such representations – although certainly if Kant himself had no such images except as 'blurred sketches' that is enough to rule out the doctrine that clear images are essential to any exercise of the imagination. But I need no longer pay any attention to this hotly disputed question. For in describing something as imaginative, one does not at all have to refer to the presence of images in the person who creates it.

Neither do I have to presume that such phrases as 'calling upon her imagination' have to be taken literally, as if Emily Brontë, let us say, had in her mind a faculty of imagination which remained quietly at hand, until it was called upon, like a good servant. The phrase 'the imagination' is so deeply involved in our language that I could not have avoided using it and did not try to do so. Nevertheless the presumption that the phrase refers to a specific faculty, as distinct from a capacity in some particular field, is not one that can be sustained. A person can be imaginative in a particular area while completely lacking imagination in other areas. This comes out very plainly in such mixed arts as the film in those instances in which one person, as an *auteur*, tries to take undivided responsibility while previously having been, let us say, responsible only for the photography. The photography can be imaginative but the dialogue and the choice of music quite banal. I am not saying, of course, that a person cannot be imaginative in more than one field, that it is totally impossible for an *auteur* film to be imaginative in all respects but only that it can be imaginative in some respects, unimaginative in others – all I need.

It will be best to approach the question in what imaginativeness consists and to generate the vocabulary we require by beginning at the level of practical policies. Suppose a Department of French finds its number of students diminishing and is considering ways of increasing them. A meeting of the staff is called to deliberate how this might be done. Staff-member X suggests lowering standards and is told that this is a banal, conventional suggestion. Professor Y, ever an optimist, suggests that their colleagues in other departments might be approached in order to get them to demand French as a prerequisite and is told that this is a fanciful suggestion. A younger, film-struck staff-member suggests that some famous French film-star might be invited to lecture and is told that this is just a gimmick. Finally a suggestion is made – I wish I knew what it was – which is greeted with acclaim as being 'imaginative'.

Without knowing precisely what it was, I can still say with confidence

that if it has been correctly described as imaginative, it is not banal, not commonplace, not merely fanciful, not gimmicky. These are all negative descriptions but none the worse for that; it is often better to approach a concept by considering what it excludes than by attempting a formal definition. The negative descriptions fall, to think of them pictorially, on opposite sides of the imaginative. The banal, the commonplace – along with the conventional, the academic, the merely derivative – fall on the right hand side of the imaginative. They differ from the imaginative in so far as they do not make any advance on what we normally know, expect, or can arrive at by following familiar rules. When we call a man 'unimaginative' we are usually taking his ideas, his hopes, his achievements to be characterisable in these right-hand ways. Yet this is not the only way of being unimaginative. On the opposite side of the imaginative, the left-hand side, lie such characterisations as the gimmicky, the merely fanciful, the pointlessly innovative, the kitsch. These share with the imaginative the fact that they cannot be described in right-hand terms, although over time particular works may migrate to that side, as having become conventional.

Very obviously, to make any of these contrasts we need a degree of knowledge. Knowing nothing about universities we could not judge whether it was correct to dismiss as merely fanciful the suggestion that other departments should be approached to make French a prerequisite. Drawing on our knowledge of proposals and institutions in general, we do however know that this proposal is being described as impractical, something there is no hope of implementing.

Similarly, in the sciences, without a knowledge of the particular field involved we have no way of knowing whether it is an imaginative hypothesis or a merely fanciful suggestion that life first came to earth in dust from a meteor. But we do know that if it is the first rather than the second it must be in accord with what is known to be the case and must solve what are recognised to be problems. That is, of course, by no means as straightforward a criterion as it at first seems to be; there can be disputes about what is 'known to be the case' and about what constitutes a problem. In a general sense, however, in this case as in the case of practical proposals we know what has to be done to show that something is imaginative rather than fanciful. The arts are in a rather more difficult position.

Take architecture. Are Gaudí's buildings, not only the unfinished Cathedral but smaller buildings like the Palazzo Güell, imaginative or fanciful? Is the Sydney Opera House? Imaginativeness is most easily recognised when what is in question is how to solve a particular problem, or type of problem, let us say an engineering problem in constructing a building. In some Reformation churches – in, for example, Luther's own design in Augsburg – one can see imaginative solutions to the problem how to change church architecture to accommodate the much greater

emphasis on preaching. At the same time, one would not generally take these buildings seriously as works of art.

The whirligig of taste characteristic of architecture, so that at one time or another both Gothic and Baroque have been dismissed to the left-hand side as gimmicky, merely fanciful, and both the neo-Classical and the Modern to the right-hand side as banal, conventional, unduly rational, while being at other times extolled as imaginative, suggests the difficulty in practice of deciding in what architectural imaginativeness consists. It is not just that once imaginative architects establish a new style, unimaginative architects simply imitate them so that the style, once innovative, comes to be thought of as banal; the very style finds itself attacked as being essentially unimaginative.

The 1980s debate between modernist and post-modernist architects illustrates the points at issue. Modernism, according to the post-modernists, falls on the right hand side of the imaginative – and indeed it had emphasised, in its Bauhaus form, reason, order, logic and function rather than imaginativeness. Post-modernism, according to the modernists, falls on the left-hand side of the imaginative.

Consider first the post-modernist accusations. It would be a mistake to take the modernists' claim to be 'rational' at its face-value and to conclude that modernists wholly lacked imaginativeness, a mistake which derives from confusions both about rationality and about imaginativeness. To be sure, the rationality which consists simply in making deductions from fixed rules – for example that the entrance door must be at dead centre in the façade – does not require imaginativeness, but even in such a case the adjustment of that requirement to other requirements may do so. If, as happened in my own case, you had reached a mature age before seeing a modernist building, you were no doubt first struck by its orderliness, by the clean, uncluttered character of its lines. But the broad distinction between the imaginative and the unimaginative ways of ordering space in the modernist manner became apparent with experience. Box-modernism merely piled space on space, in a unity without variety. Imaginative modernists confronted problems, whether in houses, in stadia or in churches – I think of Nervi or of Saarinen, deploying spaces in an imaginative way but without departing from the modernist geometric, uncluttered, ideals. One can agree that modernism gave rise to innumerable buildings which are as works of art banal and as buildings designed to fulfil particular purposes inhuman, impractical, devoid of the functional virtues modernism so loudly proclaimed. The post-modernist reaction is by no means surprising but should not be carried to the point of denigrating as unimaginative the modernist masterpieces.

As for modernist attacks on post-modernism, the modernist claim that *their* buildings are 'true' and 'honest' whereas post-modernist buildings are 'false' and 'dishonest' will not, or so I shall later be suggesting, pass muster. The charge that the post-modernist does have to meet, at least in

the case of many buildings which critics have enrolled under that banner, is that these buildings are merely gimmicky, using trite images – let us say, palm-leaves in a tourist agency – to conceal a lack of imaginativeness, a mere fancifulness, in the actual design. For my own part, I should again want to distinguish, welcoming the imaginativeness demonstrated in post-modernist façades – using that word in a descriptive manner with no suggestion of grandiosity – and roofs while agreeing that many post-modernist buildings use trite symbols in a desperate attempt to demonstrate their imaginativeness, or gimmicks to persuade us to look at buildings which then turn out to be of no architectural interest. It is obviously much easier to make these pronouncements than to defend them in detail.

Let us move then to other art-forms. It remains true that to recognise a work as being, or not being, merely conventional, we have to know what the conventions are. Hearing for the first time a piece of music, we may suppose it to be imaginative, only later – since it so happens that this is the first time we had heard this kind of music – to discover that it is just a series of fragments from Berg. It is, we then say, a 'mere pastiche' – another phrase that fits on the right hand-side of 'imaginative'. But knowing that the work is not conventional we cannot at once conclude that it is imaginative. It may fall on the left-hand side. So seeing Pinter's play *The Betrayal* we might at first describe it as imaginative but then decide that in fact it is banal, the effect of imaginativeness deriving simply from the fact that the story is told in the reverse order. That is when we have recourse to the word 'gimmicky' or such other left-hand side expressions as 'factitious' or 'just a meaningless trick'. Films with wild camera-angles which try to conceal the conventionality of the narrative fall into this category, as do ballets which rely on artificial smoke to make impressive an impoverished choreography, or paintings which, like the paintings of Baselitz, try to attract attention by painting figures upside down.

A pause here, however. This is an obvious allegation against Baselitz and attempts have been made, both by Baselitz and others, to rebut it. One supposed rebuttal, that Baselitz has been doing this over a long period of years, carries no weight. A gimmick can be welcomed as a signature, which lets one more readily say, with an expert air, 'Ah, that's a Baselitz'; it can give comfort to a purchaser as a signal of authenticity. A second reply, this time from Baselitz himself, is that it is his way of drawing attention to the painterly qualities of the work itself, as distinct from raising irrelevant questions about its skill as a representation. To this, the abstract painter would certainly reply that it would be better to have no figures at all, that the figures are simply a distraction. One can see how, in a period when pure abstraction has become distinctly unfashionable, Baselitz might respond: 'Well, I'll give them their figures but not so that they can avoid concentrating on the painting'. The

painting could itself be imaginative, not gimmicky, although attention is drawn to it by a gimmick.

Very obviously, then, the distinctions I have been making do not carry with them rules for their application. They have to be handled with care. Nothing could be more banal, in a religious painting, than an image of Madonna and child. Most such paintings we can safely dismiss to the realm of the merely telic. Yet by no means all. Indeed, the imaginativeness of the work may come out precisely in the way in which it offers us a fresh treatment of a banal subject, through the disposition of the figures, their facial expressions, their relationships to one another, the choice and treatment of the background. Looking carefully at a series of Madonna and child paintings can bring out, with special clarity, the way in which imaginativeness finds a central point between the banal and the fanciful. A work which desperately tries to distinguish itself from the banal by seeking to be novel in all respects is normally disastrous, as we have had plenty of opportunities to observe in recent years. Move Beckett's characters to a science-fiction setting, accompany their utterances by electronic music, have them talk in the manner of *Finnegans Wake* and the effect of his plays and novels would be lost.

It will now be sufficiently obvious that it is very easy to make mistakes in describing a work as imaginative or unimaginative. To be able to distinguish, as being imaginative, gimmicky, banal, between the works of, or particular works of, such post-war composers as Henze, Cage, Boulez, Meale and Glass requires a deep knowledge of contemporary music. To be accurately described as imaginative a work must be, to some degree, unconventional. Yet it may still, in Mozart's manner – or indeed Shakespeare's – accept familiar conventions in very large part; its imaginativeness might come out in its handling of the conventions. The unexpectedness it displays might not reside in any breach of conventional rules – by the use, say, of dissonances or painting people's faces mauve or printing a poem in the shape of a cone – but by unexpected new ways of working within the conventions.

It can be particularly difficult to distinguish between the imaginative and the fanciful. One mode of distinction is that the fanciful is facile, imaginativeness difficult. Being imaginative is a form of work, thinking or thoughtful practice, fancifulness a form of play. Coleridge saw this in his account of the secondary imagination and so did Sidney when he distinguished the poetic imagination from merely building castles in the air. It involves the overcoming of difficulties, the solution of problems, problems which fancifulness – as in day-dreaming – evades. To be sure, it has its roots in fancy but it constrains it, in the light of experience and with a particular rational intent.

Nothing could be easier than to invent fanciful similes. 'She looked at me with the eyes of a frightened sardine', 'with eyes like a holiday at Acapulco' and so on, *ad nauseam*. (There are plenty of real examples in

surrealist poetry, written on the automatic principle. They are not to be excused, in the French manner, by remarking, with an elucidatory air, that 'comme' is not the same as 'tel que'.) To ask whether Eliot's 'like a patient etherised upon a table' is fanciful or imaginative is to ask whether it helps us to see, whether it acts within the poem of which it forms part or does no real work there, whether its ingenuity is 'misplaced'. These are not easy questions to answer. And to be able to answer them in the case of a poem does not carry with it a capacity to answer a parallel question about a painting or a piece of music or a building, any more than being able to recognise an imaginative proposal in the field of accountancy carries with it a capacity to recognise an imaginative proposal in technology.

Looking back on our previous discussion from the vantage-point we have now reached, we can see how Zola could be right in saying that his work was not just a product of the imagination and yet a handbook could also be right in referring to his luxurious imagination. More accurately, Zola was right unless a distinction is drawn between the imaginative and the fanciful and the handbook is right once such a distinction is drawn. Zola's novels are not fanciful. At least, at their best they are not fanciful, for his use of heredity, where he thought he was being scientific, is fanciful. He was imaginative not only in his choice of subject but in his treatment of it; he opened up new paths for the novel. One can see, too, why Bachelard speaks of the imagination as 'open'; to be imaginative is to see possibilities. It is quite another question whether, as Bachelard suggests, it offers us 'escape'. It may do so, I suggested, but that is more commonly the province of the fanciful or the reassuringly banal. This relates to Schopenhauer's dismissal of any attempt to make imagination central in discussions of the arts, namely that it is displayed in escapist novels. If the distinctions with which I have been working are correct, these novels are not imaginative. And it is not imagination in general, conceived merely as that capacity we all possess to form or to compound images, but the rather rare quality of imaginativeness which I am taking to be central.

It is a cliché to say that over the greater part of the present century and, indeed, somewhat further back than that, we have been obsessed by the quest for novelty, for 'break-throughs'. That has, however, never been universally true, unless 'we' refers only to the body of critics. It has come as something of a revelation to critics that through all these years there were artists who worked steadily away, however ignored, in a relatively conventional but by no means unimaginative fashion. Balthus was one of the first 'discoveries' of this kind, but America has by no means been backward in pointing to its own examples – the earlier Marin, let us say – as in traditionalising such painters as Pollock, rather than insisting on the novelties he was introducing. The terms of critical abuse were mostly selected, for a long time, from the right-hand adjectives – 'banal',

'conventional' and the like; critics were so demoralised by their initial failure to recognise the achievements of the impressionists that they have been, on the whole, insufficiently alert to the left-hand forms of disapproval, 'gimmicky', 'fanciful' and their companions.

Things are beginning to change. This is in part a manifestation of what is often called a return to 'traditional values' – although I see no sign that such traditional values as compassion, financial restraint at the personal level, honesty, straightforwardness, mistrust of money-grubbing are now again coming to the fore – but it cannot be wholly accounted for in these terms. The return to tonality in music, the greater directness of post-war poetry, the revival of interest in 'well-made' plays, in figurative painting, in films where the narrative is sequential, all display a sense that there is some virtue in working imaginatively within conventions, as, more notably, does the decline of the more gimmicky kind of 'experimental' theatre. (Not that, I should hastily add, I am prepared to reject as gimmicky the whole range of what has been called 'experimental' but can better be called 'innovatory' theatre. It has sometimes, in my judgment, been genuinely imaginative.) True enough, there is still plenty of gimmickry, and one has certainly to ask oneself in relation to, as I said, post-modern or Deconstructivist architecture – this last with its passion for departing from classical proportions in a Dr Caligari direction – whether they are genuinely imaginative or just a fanciful quest for novelty. (As one has to ask, on the other side, how far the attempted rehabilitation of minor figurative painters has any other ground than the search for fresh stock on the part of gallery-owners, now that so much has been enclosed forever within public galleries.)

Can we say that all serious works, all works deserving of close critical analysis are imaginative, at least in certain respects? To answer this question in the negative, on the analysis I have been suggesting, would have the consequence that a work could be serious although it was in all respects banal, conventional, academic or in all respects gimmicky, fanciful, kitsch, with a misplaced ingenuity. Put thus, the question answers itself. True enough, there are some works which we do not think of as being *particularly* imaginative but still take seriously. Nevertheless, if it could be conclusively shown that they fell totally to the left or right hand side of the imaginative we should, I think, withdraw our description of them as serious works. I have emphasised how hard it can be to decide whether a work is imaginative. That is not an objection. It is hard to decide whether a work is serious. To take only one instance, over the last three decades a number of American novelists have been taken seriously by critics who have now abandoned them, finally recognising that what they took to be imaginativeness was either in fact banal, a banality concealed by gimmickry, or mere fanciful extravagance, in reaction against the naturalistic novel.

Imaginativeness is not, however, peculiar to serious works of art; that

is a point, sufficiently obvious, that I have emphasised. Can we sometimes ascribe it to works which we nevertheless still think of as being purely works of amusement or purely telic? In such cases, we should, I think, carefully reconsider our judgment, remembering that a work can be designed as an amusement or as telic art and yet be serious art, that indeed, as I argued earlier, most serious art over the centuries has originally been designed in one or the other of these ways. Even though we now commonly work with a concept of serious art which distinguishes it from these other forms, we cannot safely assume either that what was designed as serious art has in fact any value except as amusement or as telic art or that work designed to fall within these later categories can therefore be dismissed as non-serious.

Nevertheless, even when this reconsideration has taken place, we may still conclude that there are works which are merely entertaining and yet imaginatively so, or merely telic but in an imaginative way. Some American musicals would fall into the first class, some advertisements into the second. Since I said earlier that there is a great range of human activities which can be performed either imaginatively or unimaginatively, this conclusion should not surprise us. Something extra is needed, then, if we are in search of a characteristic, or characteristics, which distinguish serious art from merely entertaining or merely telic art. Nevertheless, imaginativeness, I have suggested, is at least a necessary although not a sufficient condition of being serious art. That is something, if not very much.

6

The Arts as a Source of Truth

This has been a hard century for the traditional values. Truth has by no means gone unscathed. In an interview with David Sylvester, the painter Francis Bacon nostalgically remarked, indeed, that 'people tend to be offended by facts or what used to be called truth', quite as if dictionaries should now mark 'truth' as 'archaic' or 'obsolete'. Then should we rapidly conclude that the seriousness of certain works of art cannot at all depend on their being a source of truth, since there is no such thing?

Such haste would be premature. We have already observed that even artists who are happy to describe themselves as 'liars' commonly suggest that their lies are, in some mysterious way, in the interests of truth. Bacon himself certainly claims that his paintings, for all their grotesque distortions of the human figure, 'tell us something true about the world we live in'. And he generalises this judgment. 'I believe,' he tells us, 'that art is recording; I think it's reporting.' The concept of truth is built into the concepts of 'recording', 'reporting'. We might suppose that such claims would at least be confined to figurative art. But they are not. There are those who, like Mondrian, insist that their severely geometrical art is a way of conveying deep metaphysical truths.

Indeed, as we saw at the outset of our inquiry, the claims which have been made on behalf of the arts as a source of truth sometimes reach extravagant proportions. Whereas we are just now beginning hesitantly to inquire whether the arts can ever be a source of truth, for Shelley, it will be recalled, poetry, in his very broad sense of the word, is 'at once the centre and the circumference of knowledge'. There can be no question, in his view, whether we might not do better to turn to science rather than the arts if we are in search of truth, since poetry is 'that which comprehends all science and to which all science must be referred'.

To raise critical objections to Shelley's rhetoric, we uncomfortably feel, is to break a butterfly on a wheel, to arouse cheap laughter at the expense of a noble spirit. How, we nevertheless have to ask, can poetry be both centre and circumference without being a vanishing point? And can we really believe either that the theory of relativity is included in poetry or

that Einstein should have referred it to an eisteddfod of bards for their approval?

Sometimes the critic is a shade more modest. Herbert Read, in his *Art and Society*, ascribed to the artist not a unique power of discovery but a unique power of communication. 'Without art,' he tells us, 'we should not know that truth exists, for truth is only made visible, apprehensible and acceptable in the work of art.' Our doubts persist. Surely, the natural protest comes, we know that truth exists the very first time we hear a lie or recognise a mistake, and nowhere is truth made more visible, acceptable and apprehensible than in the writings and diagrams of the scientist, the economist, the historian. If what Read means is that the artist is a sort of superior science journalist, this is simply not consonant with what we know of art.

At the opposite extreme from all this, there are those, now quite numerous, who would cut all connection between art and truth. 'Truth and songs,' Baudelaire wrote in his critique of Gautier, 'have nothing to do with one another.' The artist, we have often been told in the same spirit, is in essence a creator, a world-maker, with the omnipotence and omniscience, in his own world, of a deity. So, to quote Baudelaire again, 'the artist depends on nobody but himself He is his own king, his priest and his god.' The artist's works, on this view, refer to nothing beyond themselves. In so far as they have any reference at all, it is to themselves as art. So a 1960s proclamation demands from painters the creation of 'a pure, abstract, non-objective, timeless, spaceless, changeless, relationless, disinterested painting – an object that is self-conscious ..., ideal, transcendent, aware of nothing but Art'.

Aristotle defined God in a precisely parallel fashion: abstract, timeless, relationless, conscious of nothing but himself. It is certainly a surprise to learn that a *painting* shares its metaphysical qualities with God. More surprising still, not only painting but poetry, the novel, ballet, film have all been defined in a comparable manner as referring to nothing beside themselves as art-forms. If this be so, we cannot hope to justify the seriousness of the arts by pointing to the truths to which they introduce us; if art makes us aware of nothing but itself we cannot without circularity base its seriousness on what it conveys, which would then be nothing but that very art the seriousness of which is in question.

I shall be trying to force a path between these two extremes, neither claiming for the arts those virtues which properly belong, in my judgment, only to history, science and philosophy, nor yet wholly divorcing the seriousness of the arts – or at least of the representational arts – from their capacity for telling us something about ourselves and the world of which we form part. Let us embark upon this project by examining in a little more detail the view that art 'is aware of nothing but art', that it can have nothing to say about 'ourselves and the world around us' – with the exception of works of art – since art is conscious of nothing

but art. That 'all art is about art' is a doctrine which has diminished in popularity, especially in relation to literary works, since around about 1980. For it is scarcely compatible with the most characteristic versions of feminist analyses, the latest forms of Marxism, or the new-style historical criticism. Nevertheless, it would not be safe wholly to ignore it, given the amount of recycling that now goes on. Often enough it has been pronounced as if it were a self-evident truth, even at the hands of those who elsewhere tell us that there is no such thing as truth. (Or is it their view that the only truths are truths about works of art? That would make sense of some of their procedures – if 'sense' is the right word – and carry the aggrandisement of criticism to its apogee, but is scarcely plausible.)

The statement that 'all art is about art' lends itself to several different interpretations. Taken literally, it is a highly counter-intuitive thesis. If in everyday life, we tell a friend that we have just seen a very interesting film, a common response is: 'What was it about?' And only very rarely would we reply 'it was about film-making'. We might do so in the case of Truffaut's *La Nuit Américaine* but certainly not in the case of *Les Quatre Cents coups*. More generally, if van Hecht's *Apelles painting Campaspe* might be said to be, in various ways, about painting, the prologue to *Ariadne auf Naxos* about the composing of opera, Mann's *Doktor Faustus* about biography-writing, these are exceptions rather than the normal rule.

The favourite literary example is *Tristram Shandy*. Since Sterne described a novel as a 'conversation with readers', he felt free to represent his narrator as an *alter ego*, conversing with readers, if in an exceptionally one-sided conversation, about the problems he has in constructing his narrative. But when the Russian literary critic Shklovsky described Sterne's work as 'the most typical of novels', he must have been using 'typical' in the same manner as Malenkov. 'Scientific literary criticism', it would then seem, has discovered what novels ought to be like and *Tristram Shandy* fills the bill. For in any more ordinary sense of the word 'typical', Sterne's novel would be more accurately described as the *least* typical of novels. True enough, Sterne picked up some of his tricks from the novels of now largely unknown predecessors; true enough, too, such is the power of literary theory that it is by now not at all uncommon to come across novels, and films, which take over some of these devices. So the typical, in a Malenkovian sense, is converted into the typical in the sense of the 'normal'. To take three minor examples which are the more striking just because they are minor, in a film by Diane Kurys we see at the end the central female figure beginning to write the script of the film we have just seen; in a Sydney production of Strindberg's *A Dream Play* the curtain comes down – in a manner not at all suggested by the text – on 'the Poet' completing his typing of the play; in a novel by Janet Hospital the central figure is a novelist who goes on to write a novel we then read. But even in his own time and country,

Sterne's novel was, among serious novels, the exception, not the rule – as it even more markedly is if we set it alongside the major nineteenth-century European or American novels.

So far as I know, nobody before the 1920s took *Tristram Shandy* to be about novel-writing. Its readers were amused by its pretence, delighted or shocked by its clerical indecencies, enraptured by the interplay between Walter Shandy, Dr Slop, the widow Wadham, and Corporal Trim, struck, like Bertrand Russell, by its temporal paradoxes. To be sure, by 1941 *The Concise History of English Literature* paid tribute to Sterne as having liberated the English novel, introducing to England the fantasia-novel as distinct from the novel of bourgeois life. It is one thing, however, to say that Sterne liberated the English novel, quite another thing to suggest that his novel is about the liberation of the novel. One could more accurately say that it is about liberation from rules, from the idea that morality consists simply in following rules quite as much as from the idea that novel-writing does so. Or that it is about the power of hobby-horses ... or that it is an informal commentary on Locke's *Essay* ... or that it is about a household of eccentrics ... or that it is about the peculiarities of time.

The 'or' is not exclusive; one can rarely, if ever, say of a serious work of art that it is about just one thing. No single description of it is what the work is *in essence* about. It is about a variety of things. A particular reader at a particular time may well see it in the light of just one of these descriptions; a particular critic may make a reputation by being the first to see it in a particular light. Critics are likely to express their discovery, however, in a claim that they have found out what *Tristram Shandy* is 'really' about, or in such broader generalisations as 'all art is really about art', when all the critics have discovered is that works can be read in this light which were not previously so read – as, let us say, Gide's *Les faux-monnayeurs* obviously had to be.

We have been taking 'all art is about art' very literally; perhaps that is a mistake. Just now, I heard a radio-announcer say this: 'Early nineteenth-century opera was about singing.' He did not mean that the villains, the heroes, the heroines in these operas talk about singing; they sing to us, rather, of their fears, their loves, their hatreds. What the announcer meant was something quite different: that in early nineteenth-century operas the singing, as distinct from the story or the stage-setting, was the centrally important thing. Perhaps the dictum that all art is about art is just a rhetorical way of asserting that the question what a work of art is about is of no aesthetic importance, that the only questions which relate to its seriousness are about its form, its structure, its genre. We have already touched upon this issue; we shall revert to it in a later chapter. So for the moment let us leave it aside. For it does not deny that works of art can be about something other than works of art. It denies only that what they are about is of any importance.

A third interpretation is that art is about nothing at all, so that the question what it is about is not only aesthetically irrelevant but cannot even arise. I shall myself be arguing that, in relation to certain forms of art, this is a wholly correct view. Indeed, it is a tautology to say that non-representational works of art are not about anything, the only question being what kinds of art fall into this category. But suppose someone asks us what a film or a novel or a poem is about and we reply 'Absolutely nothing', that would not normally be heard as a tautology. On the contrary, it would be regarded as a severe form of criticism – unless we went on to explain, in the case of the film, that it was one of the relatively small class of non-representational films.

Oddly enough, it is a remark we are often inclined to make about post-war French films. By no means universally, of course – not about *Lacombe Lucien* or *Jean de Florette*, to mention two very different films – but certainly about those very many French films which reviewers call 'stylish', which persist not at all in the mind and cannot possibly have truly applied to them such adjectives as 'perceptive', 'revealing', 'penetrating', which even considered as entertainment are 'slight'. Perhaps it is no accident that so much contemporary literary theory originates, or has taken shape, in France; it is more applicable to French literature and French films over the last decades than it is to literature and film generally. Elsewhere the answer 'Nothing, really' to the question 'What was it about?' would generally be regarded, as I said, as a severe criticism, not as an answer which follows automatically from the fact that the 'it' in question is a work of art.

Yet a fourth interpretation of 'all art is about art' is that works of art are always about other works of art. On the face of it, this is true, if at all, only of a relatively small class of works. Bacon's painting of Pope Innocent X at once comes to mind; we can see how this might be taken to be not about Innocent but about Velásquez's painting of that Pope. But is Velásquez's painting in turn about some other painting? And do we absolutely have to know Velásquez's painting before we can possibly answer the question what Bacon's painting is about, or is that just an extra bit of art-historical knowledge?

Painting has to be learnt and a painter is at least as interested in other paintings as in the broader world. Quite naturally, too, painters borrow compositions from other paintings. So, to take another very familiar example, one can easily see, if one happens to know both paintings, the compositional resemblances between Titian's *Venus of Urbino* and Manet's *Olympia*. Manet had also studied Japanese prints, and some of the differences between the two paintings derive from that source. Not all of them, however. Manet had also looked around him and the reclining nude is a young Parisienne, in face and figure. That mixture of interests is typical of painters, as it is of novelists. Perhaps we might offer as one description of Manet's painting that it is a satirical comment on Titian's

painting, and is so far 'about art'. But someone who has never seen Titian's painting is not therefore unable to judge Manet's painting to be a serious work of art. It is also about a young Parisienne cocotte and her setting. It is not, incidentally, about Manet's pictorial innovations; if we are prepared to say that the painting is simply expanses of colour ordered in a novel way, then it would be more accurate to say that it is 'not about anything' than it would be to say that it is about these coloured expanses. Not every description of a painting describes what it is about.

In the area of literature, we find Umberto Eco maintaining in his *Postscript to the Name of the Rose* that 'books are made only from other books and around other books' and, in his *Beyond Deconstruction*, Howard Felperin calling upon us to think of Marx as surrounded by piles of books in the British Museum. Here, as so often, there is an exaggeration. Marx was an excellent journalist and had more than a little political experience in Germany. We must not think of that 'experience', of course, as the simple reception of sensations; his reading would have been one of the things that influenced what he saw, as distinct from what he ignored, and under what description he saw it. Nevertheless, it would be absurd to make no distinction between seeing something and reading about it in a book; Marx saw a great deal.

The Name of the Rose is an exceptionally bookish novel, even if most of the books in question are manuscripts, volumes of photographs and the like rather than poems or novels. But although in fact Eco pored over volumes of photographs, he could in principle have moved through the places photographed. Conrad's typhoon, Melville's whale-hunt, Faulkner's South, Joyce's Dublin, Hardy's countryside, Bellow's Chicago, Lawrence's mining towns are not entirely the product of reading books. If we may see the world differently as a result of our reading it is also true that we may come to read differently as a result of our experience. As a counterblast to the view that an artist paints, or a poet writes, or a novelist describes, entirely out of personal experience, the view that paintings are made out of other paintings, literature out of other literature, has its point; artists are not passive recorders any more than they are creators *ex nihilo*. Neither, however, are works of art their sole source of experience – not even nowadays, when their life may be largely devoted to teaching, writing about and practising the arts. They still encounter, in such a narrow world, many of the virtues and the vices, the faces and the gestures, of mankind, even if, in the case of novelists especially, they may be tempted to fall back on fantasy to disguise the limits of their experience, or, if not on fantasy, on bookishness.

In his *Linguistics and the Novel*, Roger Fowler discusses the case of a novel by Christine Brooke-Rose entitled *Thru*. Brooke-Rose draws attention to the fact that what she is confronting us with is a text, not an open window on the world, by a variety of typographical devices. And she also takes very seriously Julia Kristeva's doctrine that 'every text takes

shape as a mosaic of quotations, every text is the absorption and transformation of other texts'. We should note at this point, however, that two quite different doctrines are run together here, since it is one thing to say that every text is 'the absorption and transformation of other texts', quite another thing to say that it 'takes shape as a mosaic of quotations'. Liberally interpreted, we might be prepared to say – with considerable emphasis on 'transformation' – that the first statement is true of *Hamlet* and yet still reserve the right to laugh at the man who said that he did not like *Hamlet* because it was so full of quotations. I do not think it rash to assume that Fowler would himself, or Kristeva would herself, be displeased with a review which said of their books that they were 'just a mosaic of quotations'.

Brooke-Rose does in fact compose a mosaic of quotations or allusions to quotations. But what Fowler says about them is very relevant: that the references are not arbitrary, that they constantly allude to 'linguistics, semiology, structuralism, the *roman nouveau*, and to the styles and situations of a modern academic community preoccupied with such topics'. This brings out two things, first the degree to which such novels are written for an academic audience as an exemplification of theories, the second that even so they are read not as being about other works of art but as being about a particular community with particular interests.

Once more, we have to cope with the effects of over-reaction. It was at one time extremely common for writers on art to argue that each work of art was totally unique – each serious work of art, that is. We can call this the 'monadistic' view of art-works. Nowadays we quite often encounter, in contrast, a 'monistic' view which, in a manner looking back to Mallarmé, suggests that there is one great book, each particular book being something which an author contributes to it or a reader selects out of it. This is the extreme form of the doctrine of 'intertextuality'. We can grant to the monists against the monadists that works of art are not wholly self-contained – I have already written with approval of what Collingwood said on that subject – much in the sense in which no human being is self-contained. An author makes a contribution 'to literature' just as a scientist does 'to science'.

Artists inherit forms, even in the act of rebelling against them; we most easily see the point of much twentieth-century painting by looking at nineteenth-century academic art, of contemporary music by listening to Bruckner, of modern architecture by looking at the Albert Memorial. Sometimes an author will incorporate a discussion of other writers, sometimes deliberately parody a style, sometimes specifically quote or misquote. *Ulysses* and *The Waste Land* are obvious examples of referential works. Composers may similarly quote or parody, in the manner of Stravinsky, and painters do likewise. None of this is very important, however, compared with the less obvious ways in which artists are influenced by their predecessors, not uncommonly predecess-

ors quite remote in time, without actually referring to them. So far one can readily admit 'intertextuality' as against any form of monadism. It by no means follows that we have therefore to accept the 'monistic' view that there is One Big Work, any more than if we reject individualism in general we are forced to conclude that there is something describable as 'the social totality' which is the sole reality, that all individual differences are unreal. Neither, recognising that works of art would not be the sort of thing they are were it not for the existence of other works of art, should we conclude that they are *about* those other works.

However the phrase is interpreted, then, I see no reason for believing that all art is about art, although I have not denied that works of art can sometimes show or tell us something about other works of art. I propose now to return to the question what other truth-claims works of art can make about ourselves and the world around us – which includes, of course, works of art, but is not wholly constituted by them, since it contains, as well, other people, nature, society, science, religion, politics, industry and ideas.

To justify truth-claims for art, and in the process to dispel, once and for all, the suggestion that it is nothing more than solace-offering make-believe, critics have sometimes been tempted so to stretch the meaning of 'truth' and 'falsity' that these words completely lose their normal discriminatory power. In his *Meaning and Truth in the Arts*, John Hospers has amply illustrated the manner in which 'truth' has been thus called upon to take over duties more adequately, if not always pellucidly, performed by 'sincerity', or 'value' or 'sublimity'. Extensions of connotation to the point of vacuity are, for some reason, only too characteristic of critical writings. 'Unity', 'style', 'symbol', 'language', 'irony', 'metaphor' have all gone the same way, if sometimes to be pulled up in such books as Wayne Booth's *The Rhetoric of Irony*.

Hospers does not succumb, by way of reaction, to the characteristic analytical-empirical philosopher's vice, at the opposite extreme from the vice he is condemning, of supposing that 'truth' has only one central use – as a predicate of statements, with 'false' as its contrary – and that every other use is 'merely peripheral'. Admittedly, he somewhat underestimates the range and variety of truth-idioms, but the more idiosyncratic idioms he ignores have often been subjected to precisely that sort of expansive pressure against which he has protested.

Consider, for example, Dorothy Walsh's attempt in her *Literature and Knowledge* to relate 'truth' to 'authenticity', with the help of the idiom 'it rings true'. 'Rings true' has a double application, to coins and to excuses. In respect to coins it means 'that which sounds like a genuine coin', as distinct from a counterfeit, and in respect to excuses 'that which sounds highly plausible'. So we certainly can, without any idiomatic strain, distinguish a 'true' from a 'forged' Vermeer or dismiss an implausible narrative as 'not ringing true'. Walsh, however, thrusts both these cases

aside. With the Heideggerian tradition behind her, she is invoking a much stronger sense of 'authentic', explored if not precisely elucidated in Lionel Trilling's *Sincerity and Authenticity* – according to which, let us say, the poems of Ossian could be 'inauthentic' even if, as Macpherson professed, they were authentically the work of a Gaelic bard.

The contrary of 'authentic', she suggests, divides into the banal and the pretentious. Now we are far removed indeed from the allegedly supportive idiom. A banal and pretentious design on a coin would not prevent it from ringing true; the banality of an excuse, or a narrative, is scarcely a good reason for dismissing it as 'not ringing true' – quite the contrary. Banality and pretentiousness are species of the unimportant, not of the false. The banal is what Walsh herself calls 'the safely commonplace'; the pretentious is what pretends to an importance it does not possess. Perhaps there is a link of some sort between 'truth' and Heideggerian 'authenticity'. But that this is so, the 'rings true' idiom certainly does not suggest.

Before exploring other, more promising, truth-idioms, let us see how far we can get with what, for convenience and with the minimum of ontological commitment, I shall call 'propositional truth' – the sort of truth which attaches to statements, is denied by 'false', is amenable to such logical operations as conjunction, disjunction, contradiction, and can be submitted to critical examination. One obvious point about 'truth' of this sort is that it is very easily secured. Once in possession of a telephone book, and with no other qualifications except the capacity to recognise and count the letters of the alphabet, any diligent person could spend a life-time discovering truths. ('My next inquiry will be into the number of telephone-entries which contain an "e" as the third letter in the entry and an "n" as the tenth letter.') Even if art does offer us propositional truths, they could be so trivial, then, as not to justify our taking it seriously. Art might still be a form of what Samuel Johnson attacked as 'idling' and exemplified by the search for inconsequential truths. Its seriousness, when it is serious, would have nothing to do with its truth claims.

Critics have often claimed on behalf of works of art, however, not only that they introduce us to truths, but that these truths are of the greatest consequence. As a relief from the dithyrambic, let me quote a relatively moderate, metaphysically sedate, but boldly encompassing spokesman for this doctrine, Gotshalk in *Art and the Social Order*, and presume, for the moment, that the 'truth' Gotshalk has in mind is propositional truth.

> The scope of truth in art is very wide. Music can give us amazing insights into the qualities of innumerable nameless emotions as well as into the qualities of innumerable nameable ones: rage, eagerness, love, tenderness, fervour and the like. Painting and sculpture can image for us the most subtle and fleeting as well as the more central and characteristic of outer appearances and reveal to us trenchantly the basic inner bent of a

personality or group. Architecture can give us knowledge ranging from insight into the possibilities of certain materials to an understanding of the aspirations and needs of a society. Literature, even more fully than other arts, can give us literal as well as metaphorical truth about nature and human life.

Gotshalk concedes, admittedly, that the pursuit of truth is not the *central* business of the arts, that if it were, artists would certainly set about synthesising and ordering the truths they proclaim, and would indeed convert themselves into scientists. Nevertheless he does not, in the light of these considerations, withdraw his view that the arts 'give us truths'.

Such phrases as 'give us knowledge' – or Gotshalk's variants 'give us truths', 'give us insights' – are, however, ambiguous. Anything whatsoever, any human action, any social institution, any physical process, can be a source of truths, in so far as by considering it, reflecting on it, we can arrive at truths which would otherwise have been inaccessible. The feeblest pornography, banal songs, amateur water-colours, can, in this sense, 'give us knowledge' about their creators, about the society which supports them, about their form and their defects. So, in the special case of architecture, the towering boxes designed for multi-national corporations, the architectural fantasies created for Californian millionaires, the collapsing walls of jerry-built terraces, can all of them 'give us knowledge about the possibilities of certain materials' or 'an understanding of the expectations and needs of a society' just as much as can King's College chapel or the Sydney Opera House.

We have a tendency to suppose that where there is learning there must be teaching, that what we discover we must in some way have been told. So we describe a visit to Greece as 'telling us a great deal we did not know before about the nature of Greek geography' or 'explaining Greek history to us'. But that tendency must be resisted; what we learn from does not necessarily, or even for the most part, *assert* what we have learnt. So although there are many things we can learn by looking at buildings, and could not so easily learn in any other way – for example, how exposed concrete responds to polluted rain – it does not follow that the building itself asserts what we have learnt from it.

Architectural critics delight in telling us that some enormous skyscraper 'makes a powerful statement'. That is one of those misleading metaphors so common in our communications-oriented society. If the building were indeed a statement then we ought to be able to ask about it a whole set of logical questions, or indeed grammatical questions, which have in fact no possible application to it. What is its subject and what its predicate? Has it a universal or an existential quantifier? In fact 'it makes a powerful statement' is simply equivalent to 'it's so big you can't help noticing it'. That dreadful period in which architectural criticism – one

critic, A.L. Huxtable, has justly described it as issuing in 'pretentious and glutinous prose', the reading of which constitutes, in her words, 'a new kind of cruel and unusual punishment' – went on and on about the 'syntax' and the 'semantics' of buildings is, I hope, now over. It retains its usefulness only as an example of the ways in which the contemporary preoccupation with language can distort the processes of criticism, particularly when it is linked with a determination to apply the predicate 'true' to buildings as evidence of their seriousness.

So two things are now plain: first, that in this sense of 'gives us knowledge' the capacity of architecture to give us knowledge is a function, simply, of the fact that buildings *exist*; secondly, that their capacity to give us such knowledge has nothing to do with their architectural seriousness, however interesting it may be to the engineer or the sociologist. It would be absurd to say: 'that is a serious piece of architecture' and then offer as the ground of our judgment that the building shows us how badly bare concrete weathers or what poor taste millionaires sometimes possess. The *Oxford English Dictionary* is right when it singles out the meaning of 'truth' when it is used in the criticism of architecture as a quite peculiar one; I shall look at that peculiar meaning when I am discussing art and morality rather than art and truth.

In the case of music our doubts run, if anything, still deeper. How exactly does music, as Gotshalk says it does, 'give us amazing insights into the qualities of innumerable nameless emotions as well as into the qualities of innumerable nameable ones'? Precisely what do we learn *about* the emotions by going to a concert? Undoubtedly, as we shall later argue in more detail, music can stir us emotionally. It is natural, sometimes, to describe it in emotional terms. It by no means follows that it offers us theoretical *insights* into emotion. 'Music', so Suzanne Langer no doubt tells us in her *Philosophy in a New Key*, 'can reveal the nature of feelings with a detail and truth that language cannot approach.' This is a self-protective theory; by the nature of the case, we cannot ask Langer to spell out these revelations, for that would entail expressing in language what, she tells us, is inexpressible in language. But remember Frank Ramsey: 'What we can't say we can't say, and we can't whistle it either.' How else are we to check her claims? Presumably by some sort of behavioural test. By these tests it seems to fail. An old-fashioned psychologist might cite as evidence for a theory of the emotions a sentence from a novel, or even reproduce a painting, but would certainly not cite a passage from a symphony. Such of our friends as are tone-deaf we may commiserate with, but we do not avoid them as persons who are bound to be crippled by emotional ignorance.

Our century is as preoccupied with linguistic analogies as was the eighteenth century with gravitational analogies. When the ethnomusicologist John Blecking tartly writes: 'I see no reason to assume that music

is a kind of language, or that it has any special relationship with language, or that language processes are naturally more fundamental than other human cultural activities', he is going against the grain of the last few decades. I should join him in his unorthodoxy. Music is no doubt like language in being rule-governed but so is behaviour in public parks. Not even written music is a language; it is that very different thing, a notation. (It does not contain, for one thing, the possibility of negating.) Still less is it sensible to think of performed music as sentence-making. We can apply to music some of the predicates we apply to people – sentimental, sensuous, sad, cheerful – but not such statement-predicates as true, false, ambiguous.

The exact relationship between emotion and music is, of course, a highly controversial question, which we shall later explore. We certainly do tend to think of certain kinds of music as being emotionally 'appropriate' or 'inappropriate' in particular contexts or in relation to particular literary texts or in ballet to kinds of bodily movement. In his *Symphony 14* Shostakovich sought to write a work which would be, on his view, a musically adequate response to the emotions aroused by death. In respect to death, he argued, composers had emotionally cheated. He cited, as examples, the consoling music which immediately follows the death of Desdemona in Verdi's *Otello* and the major key sequence which follows the death of Boris in Mussorgsky's opera. In each case, he says, the reality of death is being denied. But does *Symphony 14* teach us something new about death? There are complications arising out of the fact that this symphony is a song cycle and that both Shostakovich's examples are from opera, not from music without words. Leaving its words aside, the most we can say is that in the operatic cases the music arouses emotions which are not in that context appropriate – something which even so is by no means uncontroversial – just as at a certain point the Roman Catholic Church decided that masses written by Rossini were not suitable for performance during the ceremony. To say that Rossini's, or any, music teaches false doctrines, or that Verdi is denying the reality of death, is to go well beyond what one is entitled to say. When the violinist Isaac Stern tells us that every time he picks up his bow he is preparing himself to make a statement, we might, could we question him about what he meant by this, find that he has something interesting to say. But it certainly cannot be that a proper response to his own playing might be 'What is his evidence for that?', or any other response which would be quite in order in the case of what we normally take to be statements.

To turn now to painting and sculpture, it is one thing to 'image an object', quite another to make assertions about that object. I do not, in general, assert something merely by handing you a photograph, as I am asserting if I add 'That is a picture of my aunt' or 'Look, the Tower of Pisa does lean'. What the picture does is to show you something. And to show

is not the same thing as to assert, even though showing can sometimes serve as a substitute for asserting. If somebody asks the question 'Does the Tower of Pisa really lean?' it may only be necessary, by way of response, to show the questioner our photograph.

Undoubtedly, however, pictures *can* be used to assert, as in a hieroglyphic language. Then why cannot a painting assert? Let us compare two paintings, one of Jesus suffering on the cross, the other of him as totally calm. Does not the second of these paintings assert, and the first deny, that Jesus, as the son of God, was unable to suffer?

It would be more accurate to say – and this accords with the usage of a great many critics – that the second painting *illustrates* the doctrine that Jesus did not suffer, just as the murals on a medieval church illustrated the teachings of the priest. We might criticise the painter for depicting Jesus thus, on the ground that it will mislead those who look at the painting; we might object that he is misrepresenting what happened. 'That's false; Jesus did suffer' would, however, be a quite inappropriate reaction. If, in contrast, we can properly react to a sentence in hieroglyphics with 'That's false', this is not in virtue of the fact that the hieroglyphs are pictures but because they function as parts of sentences, sentences constructed in accordance with syntactical rules. We can, in principle, translate the hieroglyphic language, without loss, into a word-language. In contrast 'Jesus did not suffer on the cross' is not a translation of the painting, any more than 'Thinking is hard work' is a translation of *Le Penseur*. It would be totally absurd, in either case, to ask for the contrapositive of the work of art, as it would not be absurd to ask for the contrapositive of the alleged translation.

One can, of course, say many true things about paintings, not only true statements about where and when and by whom they were painted but about what they represent. So one might say of Botticelli's *Birth of Venus* that it depicts a naked woman, whom we are meant to take to be Aphrodite, standing on a shell. If, however, this is true of that painting, as it is false of his *Primavera*, we are not to conclude, as is sometimes suggested, that it is true *in* that painting that she is standing on a shell. What is true is *that* in that painting she is standing on a shell. The difference between these two ways of expressing the matter comes out very clearly if we think of the antitheses to them. To say 'It is false in that painting that Aphrodite is lying down' makes no sense. But 'It is false that she is lying down' is perfectly correct. This, however, is a statement about the painting, not a statement made by the painting.

So far, then, I have been cutting art loose from truth, at least from propositional truth. The value of architecture, or music, or painting, I have said, does not lie in its *telling* us something. What about literary works, including under this head such mixed arts as opera, acted drama, films? These certainly contain sentences which are in conventional statement form. Here, if anywhere in the arts, the concept of

propositional truth can be expected to have a firm application. Gotshalk clearly thinks so: 'Literature, even more fully than the other arts, can give us', so he says, 'literal, as well as metaphorical, truths about nature and human life.' (This remark might be taken to suggest, incidentally, that we ought to be distinguishing between two sorts of truths, 'literal' and 'metaphorical'. But it follows from our previous observations about Hobbes that a so-called 'metaphorical truth' is simply a truth conveyed by a metaphorical statement. 'He is extremely hot' does not have a different sort of truth from 'He is an absolute furnace', although it makes somewhat different demands on its interpreter.)

Plato had fought against the view, so prevalent in his society, that poetry could be a source of knowledge. In the nineteenth century, nevertheless, Browning was discussed by philosophers as if he were one of them and 'as Shakespeare says' lent an adventitious aid to many a dubious statement, even when what followed it had originally been uttered by Polonius. The *Oxford Dictionary of Quotations* is a memorial to this practice. In such instances, the truths in question were 'deep thoughts'. However, Chernyshevsky did not stand alone when, in nineteenth-century Russia, he took 'the great importance of poetry for life' to consist in the fact that 'it disseminates among the mass of readers a vast quantity of knowledge and, what is still more important, familiarity with concepts elaborated by science'. In his eyes, that is, it was a major form of self-education, an entrance into the wide sphere of human knowledge.

The reaction when it came was predictably violent. One already finds it in Flaubert's dream of a novel which would be simply style – 'a book about nothing, without external attachments' – for all that the *Madame Bovary* he was then writing was to be widely denounced as 'false' or praised as 'true', for all that he also tells us that he wanted to produce novels so real that we would no longer notice that they were written in language. Baudelaire was by no means unique in claiming for poetry that 'elle n'a pas la vérité pour objet, elle n'a qu'Elle-même'. Indeed, the post-Romantic emphasis on the autonomous existence of the literary work, summed up in Archibald MacLeish's notorious

> A poem should not mean
> But be

seemed to make such a conclusion inevitable. If its sentences have no meaning, a poem can certainly not present us with truths.

But do not these lines themselves 'mean' and derive any importance they may have from that very fact? Suppose, altering nothing but the spelling, we substitute:

A poem should not mien
But bee.

Then the whole point of the poem vanishes. Yet nothing has been lost, at least from the poem as spoken, except the meaning of its words. Poetry which aspires to the condition of music, which attempts, in MacLeish's phrase, to be 'wordless/as the flight of birds' is bent on suicide. A poem, we can happily agree as against those who hold that it must have an external purpose, should not be regarded as a social instrument, as a *means* – in that sense it is indeed autonomous. That is far from being identical with saying that it should not mean. Confusion on this point has been a potent source of obfuscation. Only in so far as it has a meaning does the poem so much as exist, unless it is a member of the very small class of purely 'word-music' poems.

Yet some literary theorists, as I have already suggested, would go much further than MacLeish, cutting all connection between literature and truth by destroying both meaning, in its referential sense, and reality. The background to all this is, of course, Saussure. Although the theorists I particularly have in mind are Anglo-American, they pay no attention to Tarski-based Anglo-American semantics, perhaps because it requires close attention to logical issues, of a sort which literary theorists seldom find congenial. I shall take as a specimen Raymond Federman, for no better reason than that he is unusually succinct. In his contribution to the volume he edited as *Surfiction* he argued from such premises as that 'no meaning pre-exists language' and 'language creates meaning as it goes along' to such conclusions as that 'to write is to produce meaning, and not to *reproduce* a pre-existing meaning' and then finally, and more boldly still, that 'to create fiction is, in fact, a way to abolish reality'.

The confusions in this, as in so much recent literary argument – if argument is the right word – are so manifold as almost to defy comment, at least in any reasonable confine. Federman begins, to be sure, from unexceptional premises. Since the 'meaning' which interests us in the present context is the meaning of linguistic expressions, it is scarcely news that such meaning does not pre-exist language. It is quite another thing to say that what linguistic expressions mean could in no case exist before language, as if fish could not swim before there were human beings to call them 'fish' and to describe what they do as 'swimming', as if it is unintelligible nonsense for evolutionists to say that fish swam before human beings spoke. (That *statement*, of course, could only be made after human beings spoke, but fish swam long before there were fishermen, let alone biologists.) Since new expressions are regularly introduced into languages, one can also freely admit, if no more than this is intended, that 'language creates meaning as it goes along' although this would be less misleadingly put by saying that speakers create new meaningful expressions and change the meaning of already existing expressions.

That way of talking would remind us that there are no disembodied 'meanings', that 'meanings' are always of expressions and have to do with the way those expressions are used at a particular time in a particular language. In any case the antithesis which follows is a false one. For to write is, in the only intelligible sense of these phrases, both to 'produce' and to 'reproduce' meaning.

Let us assume that no one before MacLeish had ever written or said:

A poem should not mean
But be.

Then he has composed a sentence which has a meaning no sentence previously had. So far he has 'created meaning'. But he has done this only by making use of linguistic expressions which already have a meaning in English and by combining them in ways which the English language permits. Otherwise his poem would have been gibberish.

As for Federman's final claim that to create fiction is *in fact* to abolish reality – whatever 'in fact' might mean now that reality has been abolished – one can only gasp at the attempt to derive so remarkable a conclusion from the unremarkable premise that the writer uses new expressions or conjoins them in a new way. The Romantic conception of the artist as a god made flesh reaches its apogee in the notion that by a stroke of his pen the novelist abolishes reality. Reacting against the view that language is, or ought to be, a diaphanous veil, such structuralist critics converted it into a lead sheet which nothing can penetrate, a system of signs which can mean nothing but other signs.

Often enough it is supposed, as by Catherine Belsey in her *Critical Practice*, that the only alternative to this doctrine is what she calls 'the empiricist view' that every word functions as the name of something In fact not even J.S. Mill said this; he admitted that it was not true of such words as 'if', 'or', 'and'. But in any case, in order to claim that human beings use language in order to get around in the world and that one of the ways in which they do this is to offer and receive information, it is by no means necessary to assert that every word is a name. A girl learns that if she says 'Please can I have an ice-cream?' she will sometimes get one. It would be absurd to say that in this sentence 'please', 'can', 'have', 'an' are names for things, just as it would be absurd to deny that 'ice-cream' and 'I' act in this way – making it plain what is being asked for and who wants it. (This does not at all imply that 'I' is the name of a 'substantival self', it identifies a particular body.) The girl learns to use 'please' as an aid to getting things. She might find it better, with some parents or teachers, to say 'may' rather than 'can' but has in either case discovered a source of power from which ice-creams can come, has learnt that 'have' is, in this context, a claim to possess, that if her request succeeds, she has a form of

property, the right to accede, or not to accede, to her brother's request to 'take a lick of it'.

None of this learning is possible unless there is a 'common world' containing ice-creams, other people, satisfied and unsatisfied demands, rights and privileges, givers and receivers, which we explore partly by watching, partly by linguistic trials and errors. It is with a degree of such learning already in our possession that we begin to read. The only question then at issue is whether by reading fiction we can extend, or be led to modify, what we have already learnt, or take ourselves to have learnt. Many literary critics, nowadays, certainly take themselves to have learnt from Saussure, Lacan, Marx, something about a world which is common to all of us – language, of course, itself forming part of that world, as something we learnt by a lengthy process of listening, demanding, being corrected, encountering threats, warnings, promises, predictions. If they can learn from those writers, so, surely, we can also learn from other writers, including their critics, and from our own reactions with other people. Only if there is in some degree a common world can we learn anything about anything from anybody. And that we can do so is sufficiently evident every time we save ourselves by responding to someone's 'Look out!' The only real point of issue, as I said, is whether *literature* can be learnt from.

The attractiveness of Saussure-style epistemology to literary critics is understandable. Language is, after all, their great love; much of the most illuminating recent critical work has drawn attention to the importance of syntax. Furthermore, they can appeal to this theory of signs to settle qualms which have troubled them since Plato – qualms about their relationship to science – without having to invoke Shelley's implausible intellectual imperialism. Art surrenders all claims to tell us what the world is like, but in the process denies to science the right to make such claims; the formal structure of science, the formal structure of literature, are the only possible topics. Semantics is collapsed into syntax.

There are other advantages, too. Like science, or so the argument runs, the artist comments not on reality but on the codes and conventions of his predecessors. The critic, for his part, comments on this comment. Since such conventions are as clearly exhibited in a routine detective story as in *Crime and Punishment*, in a sentimental novelette as in *Anna Karenina*, the critic can avoid the task of evaluation, with the uncomfortable accusations evaluation now brings in its train of elitism, racialism, authoritarianism and sexism. University teachers need no longer trouble their students by forcing upon their attention the great masters; students can continue to restrict their reading to science fiction and thrillers. In such countries as Poland, where formalism flourished, the critic could safely study authors who would otherwise be forbidden; if Dostoevsky says nothing about the world, then a *fortiori* he says nothing reactionary. In Italy, formalistic literary experiments flourished under Mussolini's

regime as a way of avoiding the discussion of social issues. Dostoevsky would not have been amused. Neither are such of us who feel when we read, let us say, a structuralist analysis of Baudelaire's *Les Chats* that if this is all literature has to offer, there is not the slightest reason for our concerning ourselves with it, as we felt in the school-room when we were subjected to the pedantic analyses of poetry once common there.

One does not, however, have to be the wilder sort of structuralist to question whether the sentences of a literary work convey truths, or are meant to do so. Consider the opening sentence of Proust's *Remembrance of Things Past* in its English translation: 'For a long time I used to go to bed early.' True or false? In this context, the question, at least on its most natural interpretation, is out of order, as it would not be if this were the first sentence in an autobiography. (His parent's diaries, we might in principle then argue, show that Proust *never* went to bed early.) Not that this sentence is wholly 'closed towards the world'. To understand it we rely on our experience of what it is to go to bed early; without that experience it would be as if the sentence were in its original French and we knew no French. But we are not called upon to consider whether to add it to our repertoire of general knowledge but simply to imagine it to be true. If propositional truths enter into a novel only as something we are called upon to imagine, that would scarcely be a ground for taking it seriously. For they enter in that way into the trashiest of entertainment novels.

Compare, however, a later sentence from Proust's novel: 'The process which had begun in her ... was the great and general renunciation which old age makes in preparation for death, the chrysalis stage of life, which may be observed wherever life has been unduly prolonged; even in old lovers who have lived for one another with the utmost intensity of passion ... who, after a certain year, cease to make the necessary journey, or even to cross the street to see one another, cease to correspond, and know well that they will communicate no more in this world.' Like the sentence I previously quoted – 'I used to go to bed early' – this sentence contains an indexical word, in this case 'her', which refers to a fictional character. But what follows is the general statement that *all of us* will, if we live beyond a certain age, no longer communicate with those we have loved. We can judge this statement true or false, in a quite straightforward sense, true or false not of fictional characters but of human beings.

Even if this be so, the truth of such statements, it might still be replied, has no bearing on the value of the work which incorporates them. Indeed, if the seriousness of literature rests on the importance of the truths it contains, then, it has not uncommonly been argued, we should be bound to rate its seriousness very low indeed. What we initially envisaged as a possibility, that even if literature can convey truths they might turn out to be wholly trivial, would then turn out to be the actual situation.

In this spirit, George Boas once laid it down that 'the ideas in poetry are

usually stale and often false and no one older than sixteen would find it worthwhile to read poetry for what it says'. There is something in Boas's severe judgment, however, to give us pause. Why should anyone *under* sixteen find it worthwhile to read poetry for what it says? They have no more need of stale and false ideas than have people *over* sixteen. There must be some reason why writers are so often praised for their wisdom, even although they do not have the credentials of scientists. Perhaps we can say of literature what Wittgenstein says of philosophy, that it consists in 'assembling reminders for a certain purpose'.

That might explain why the truths literature conveys can be, in a certain sense, obvious and yet the conveying of them can nevertheless be important. Keats certainly tells us that poetry 'should strike the Reader as a wording of his own highest thoughts, and appear almost a Remembrance'. And in our own century, Robert Frost took a not dissimilar view: 'In literature it is our business to give people the thing that will make them say "Oh, yes, I know what you mean". It is never to tell them something they don't know, but something they know and hadn't thought of saying.' We no longer keep a skull on our desk, as a reminder of death. Yet – and by no means only until we are sixteen – we still need vividly to be reminded of the great commonplaces, not only 'birth, copulation and death' but that, let us say, matters rarely turn out as we had expected them to do, that freedom can never be taken for granted, that loyalties can conflict. T.S. Eliot was certainly not ashamed to tell us once more, if very differently, that these things are so, in that passage from *Gerontion* which begins: 'History has many cunning passages.'

This is the sort of thing that must be said in a way which escapes sententiousness, which is fresh and vivid and alive, if the protective barrier – the barrier of platitude, of euphemism, of evasion – we like to put between ourselves and such terrible commonplaces is to be broken down. For the commonplace, it should be observed, is not only something we might overlook out of familiarity. If we have not thought of saying what the poet says this is not because, at least in the case of any poet of consequence, it is too trivial to be worth saying. We *want* to overlook what Poe called 'the half-formed, the reluctant, or the unexpressed fancies of mankind' or Melville those things which are 'so terrifically true that it were all but madness for any good man, in his own proper character, to utter, or even hint of them'. There are such all-but-mad utterances, as Melville says, in *King Lear* or, at a somewhat more obvious level, in the poetry of Dean Swift. Literature compels us to face them; it forces our attention through its own force, a force essential if the commonplace is not to collapse into a platitude. If, in Frost's own poetry, the commonplace sometimes does so collapse, at other times he calls upon us to face the world's everyday horrors.

The preference, over the last century and a half, for the personal rather

than the abstract mode does not substantially affect the issue. The poet's 'I' often functions as a thinly-disguised universal quantifier. Consider that poem by Borges, translated by Anthony Kerrigan as 'Limits', which ends:

> This summer I complete my fiftieth year:
> Death reduces me incessantly

and begins:

> There is a line of Verlaine I shall not
> recall again

Such a paraphrase as: 'When men reach the age of fifty, their memory begins to fail and their powers are reduced' would no doubt be a mere platitude. Borges' *concreteness* is essential to his reminding – as so often in G.E. Moore and Wittgenstein and Plato. It jolts us, as the familiar generalisation does not. A platitude, in contrast, is a commonplace expressed in a commonplace way – 'we all have to get old sometime'. Paraphrasing poetry into prose is absurd because it loses precisely what is essential to it, its force.

There are, of course, other important distinguishing features of the poetic case; I shall leave them for later discussion. Nevertheless, the seriousness of literature, to a striking degree, derives from the fact that, to quote Wittgenstein, 'the aspects of things that are most important for us are hidden by their simplicity and familiarity' – except that, we should add, they can also be hidden from us by self-deception. Authors, to be sure, do not in such instances *discover* truths, in the way in which the scientist does; rather, they create new forms through which truths can be expressed. Their problem, as Joyce Cary particularly emphasised in his *Art and Reality*, is to write about the commonplace without falling into clichés. The dreadful fact that writers have to face is that even if they momentarily succeed, their very success may create new clichés, a dreadful fact in so far as writers find themselves cast aside by a new generation as prosaic and platitudinous, but heartening in so far as that very casting aside makes possible and stimulates fresh attempts to bring new life into old commonplaces.

And what about the situation when the writer's ideas are not commonplace? It would be foolish to turn to the novel, to poetry, to drama for the kind of sustained argument one finds in Plato or Kant. Between such systematic philosophers and vivifiers of the commonplace, there lies, however, a third group, the Sages. Plato mistrusted them; he rebuked the Athenians for paying such attention, in this respect, to the poet Simonides. Later we shall return to the question why, and when, we might have some confidence in the writer-sage. I need scarcely make the

point that our own age abounds in self-appointed or disciple-appointed sages whose 'wisdom' is sometimes platitudinous, sometimes wholly preposterous. Trying to be 'important thinkers' literary artists sometimes do damage to their works; there are passages in Eliot's *Murder in the Cathedral*, discussions in Thomas Mann's *Doktor Faustus*, which illustrate that defect only too plainly.

It is also true that writers who interest us at a particular time by what we take to be the intellectual character of the discussions their works contain, we often see at some later time as having been, if at a high level, journalists rather than thinkers. Many of the volumes in Jules Romains' novel-series *Les Hommes de bonne volonté* were taken very seriously as intellectual discussions in the 1930s but are now scarcely read, as having 'dated'. Nevertheless, there are Russian novelists who are still read as novelists and whose interest as artists cannot be divorced from their interest as thinkers. Shaw is another case in point. Modern critics tend to pass him over; he does not suit their style of analysis. They prefer elucidation to judgment. The task of winnowing out what has to be taken seriously from Shaw's over-abundant harvest does not appeal to them. Nowadays it is the fate of those who write clearly, rather than opaquely and apocalyptically, to find themselves ignored, while the critics gyrate, in ever more fanciful paths, about the dozen or so esoteric writers who, by their obscurity, offer them endless opportunities for exegesis.

Yet if Shaw is so often described as 'dated', he holds the stage as few dramatists do, even though every successful revival is greeted by the critics with an astonished 'Who would have thought the old man to have had so much blood in him?' One cannot entirely separate Shaw's importance as a comic dramatist from the fact that his characters say things that are intellectually illuminating, the truth of which is worth our serious consideration. This is so even if, what must certainly be insisted upon, his comedies will not be serious works of art, as distinct from being merely entertaining, as they certainly are, or merely telic, unless the ideas circulated in them form part of the intellectual physiognomy of his characters. This is as true of Büchner and Brecht as it is of Shaw.

Notice, however, the phrase, 'intellectually illuminating'. It is not essential that we accept the writer's statements as being *actually* true, before we can admit the seriousness of his work. As has often been pointed out, in an attempt absolutely to separate the seriousness of art from the truth of the statements it contains, we do not have to be an Epicurean to take Lucretius seriously or a Thomist to take Dante seriously. But equally, we do not have to be an Epicurean to take Epicurus seriously or a Thomist to take Aquinas seriously. It is enough that, were it true, what they say would be *importantly* true. So we can allow that the seriousness of literature, like the seriousness of philosophy, does not always depend on the *actual truth* of what is said, while still insisting that it can sometimes at least partly depend on what

is said being, as it were, an interesting candidate for truth. On the other side, too, the intellectual feebleness of the meanderings in many 'left-wing' French films – I have Godard and Lelouch especially in mind – or of the mechanical paradoxes in Eliot's *Murder in the Cathedral* cannot be dismissed as of no artistic consequence. The film version of *The Brothers Karamazov*, by omitting its intellectual debates, emphasised how much they count for in that novel.

There is an aesthetic essentialism at large which argues thus: 'if the factor X is neither necessary nor sufficient to the goodness of works of art in general, then in no case can it contribute to the value of a particular work of art.' So, in the present instance, if there are serious literary works in which nothing is said which is propositionally interesting and merely telic literary works – such as Shaw's novel *The Unsocial Socialist* – in which the characters make intellectually interesting observations, it follows that the intellectual interest of Undershaft's speeches in *Major Barbara* has no bearing on the merit of that play. An everyday analogy will make plain the invalidity of this argument. One can be happy without having intellectual interests; one can have intellectual interests without being happy. But in many cases intellectual interests contribute to a person's happiness. If we praise *Così fan tutte* for its elegance we are not in that process denigrating *Boris Godounov*; we can admire a painting by Pollock without having to conclude that it is irrelevant to a Constable that it shows us something about the English countryside.

Such considerations are particularly important if what is in question is that mythical entity 'the essence of the arts'. Denying that music asserts truths but maintaining that literature can do so and that this is sometimes one reason for taking a particular literary work seriously, I might be taken to be asserting that music is not a serious art, that, as many of the non-musical secretly believe or openly maintain, it is at best a pleasing entertainment. I am not saying anything of the sort, but only that the seriousness of music does not flow from a capacity to assert. Equally, I shall now go on to suggest, this is not always the ground on which the seriousness of works of literature rests, even when their seriousness has something to do with their truth.

First, however, a little more should be said about Chernyshevsky. I have been talking about literature as a source of ideas; for Chernyshevsky its value is as a source of information. Such a way of talking about the arts would shock many contemporary theorists to the core. It is, indeed, easy to dismiss it as Philistinism, and very natural to object that if people are in search of information they would do better to read books, or look at diagrams, graphs and photographs, which are specifically designed to give it to them. Nevertheless, even if we dispute the view that 'the great importance' of poetry consists in its being a source of information about facts and ideas, there can be no doubt that the arts, even poetry as in the case of Lucretius, have often served as such.

Sometimes this has been, as it were, accidental. Works of art are produced at a particular time and place. We can use Etruscan sculpture, Roman mosaics and paintings, the poetry of Homer, as a source of information about classical times, even though for their original audiences they were no more than reminders; an Australian might read an American novel, an American look at an Australian film, partly as a source of information about its country of origin although that is not what it is designed to be read as, or looked at as, and not how it would be taken by its local audience.

In other cases, however, the information is not at all accidental. Historical novels, or novels set in places like Central Africa which the author will assume readers to know little or nothing about, are obvious examples. Many of us got our first information about the French Revolution, or about the British and American Civil Wars, from our novel reading. Nabokov not unnaturally detests Chernyshevsky as one of the critics who were drawn on to justify the official literature of the Soviet Union. In his *Lectures on Russian Literature* he describes 'the admirable reader' in terms which are designed to combat the view that literature can properly be taken as a source either of concepts or information. 'The admirable reader,' he says, 'does not seek information about Russia in a Russian novel, for he knows that the Russia of Tolstoy or Chekhov is not the average Russia of history but a specific world imagined and created by individual genius.' Certainly, it would be unwise to take Nabokov's own novels too seriously as a source of information – he lives up to his own picture of the novelist as rich in 'the magic imageries of the master-forger, the fancy-forger, the conjurer'. Even in his case, he cannot, however, resist teaching us in his *Look at the Harlequins!* a little about the Russian language, and if his picture of academia is very much a 'personal vision' it can still provide us with food for thought – as, surely, does Tolstoy's 'personal vision' of the Napoleonic Wars in *War and Peace*.

It is quite common nowadays for a novelist to draw attention with pride to the extent of research which has preceded composition, as Eco himself does, for all the contemporaneity of his thoughts about literature. There is a whole class, too, of what one might call 'campus novels' which seem to be designed for graduates with a love-hate relationship towards their education. I am not now talking about the comedies of David Lodge – although, as he grants, there is a striking contrast between these somewhat old-fashioned novels and what he has written about literary theory – but have in mind, rather, such works as John Barth's *The Sot-Weed Factor* or Robertson Davies's *Rebel Angels*. From the first, one might acquire information of a somewhat out-of-the-way nature about the intellectual relationship between Newton and the Cambridge Platonist Henry More or about the variety of ways in which the French language refers to prostitutes; from the second about excrement, Tarot cards, the psychologist Sheldon and cultural fossils. (Davies's book,

interestingly enough, has a good deal to say about Rabelais, Barth's novel is very much influenced by him. Post-modernity has no hesitation in looking backwards.)

There is one important difference between Davies, Rushdie and Barth. In Davies's novel the information is given by his characters, part of whose importance in the novel is just that they are in possession of that information, and the giving of the information advances its development. In Rushdie's *Midnight's Children* the information is given in a variety of ways. But again it has a special function; without it many readers would not understand the sequence of events in the novel. In Barth's novel, in contrast, much of it is gratuitous, playing to the academic gallery.

Entertainment novelists, too, often do research, usually in a suitably exotic place, for a new novel. The novelist may in the outcome be praised because the detail is accurate. But such accuracy, which, knowing the region, we can, as it were, tick off against our own knowledge of it has nothing to do with the kind of truth we look for in a novel; it can be found in novels which are banal fantasies at the level of personal relationships, where the detail, in the perceptive words of Pooh-Bah, serves only 'to lend artistic verisimilitude to an otherwise bald and unconvincing narrative'. Something similar is true in a painting where, knowing the scene, we can tick off the painter's accuracies, without, however, gaining from it anything but the revivifying of a memory. That is very different from the case where the painting brings out something we had not noticed, when we feel ourselves to be seeing a scene for the first time, although we believed ourselves to be familiar with that scene or – more often – with that *kind* of scene. We then experience what Edmund Wilson called 'the shock of recognition', which is very different from the mere experience of recognition.

It looks as if we shall have to conclude that the direct giving of general or special information about the world neither detracts from nor guarantees the seriousness of a novel, that a great deal depends on how it is done, whether as intellectual pyrotechnics or as intrinsic to the development of the work. One cannot separate the information-giving of Davies's novel from its seriousness as a novel, for the transmission of information is one of its themes. Neither can we do so in the novels of Mary Renault or Salman Rushdie, for they are about the interplay of social change and individual destiny. Nevertheless, just as the correctness of the ideas which it contains is not essential to the seriousness of the novel in which they are discussed, so too the accuracy of the information it supplies is not essential to the seriousness of the novel in which it is retailed, whether by an unnamed narrator or by a named character. In some cases, that it is *mis*information is indeed essential, as a means of bringing out something about the narrator's or a character's ignorance or bias; in other cases it flows from the ignorance or bias of the author – as it quite often does in novels about revolutions or

wars. Reading an historical novel, many of us like to feel that we are being informed rather than misinformed, as we certainly were misinformed in many of the novels we read when we were young. If our interest is simply in historical information, we shall do better to read history books. If instead we read historical novels this is not because we regard them as being the more reliable source of information but because, as we commonly say, 'they make history come alive'. And similarly literary works can 'make ideas become alive', can show us something about them which we could not so readily see in books where they are more formally developed. What is important is not the information we are directly given but what we are shown about it.

In *The Rhetoric of Fiction* Wayne Booth challenged the view that novelists ought never to tell, but only to show. I have seen it said that he there destroyed the distinction between 'telling' and 'showing', a distinction on which I have been, and shall be, relying. That is by no means the case. What he does, rather, is to argue two things: the first that authors should not be forbidden to tell, the second that it is easy to catch out authors who profess to be simply showing in the use of expressions which amount to telling. These views are defended by the sort of close analysis which makes criticism worthwhile, but they clearly depend on Booth's capacity, and his reliance on our capacity, to see, sometimes immediately, sometimes only with his help, that a passage counts as telling rather than showing. I have myself already argued that writers can do both these things, and are not automatically to be rebuked for telling. At the same time I have suggested that telling, even in literature, is very confined in its range and only loosely related to seriousness.

7

Showing and Seeing

When Engels tells us that he learnt more from Balzac than from all the economists, historians and statisticians put together, his reference is not to what Balzac specifically tells us about Parisian life – although there is so much of this – but to what emerges, is shown through, the stories Balzac relates, perhaps even in a manner which contradicts what he tells us, somewhat as the photograph we pass over to somebody with the remark 'I have five beautiful children' can show that what we are saying is false. Remarkable though it is that in *The Age of Capital*, written in the 1970s, the economic historian E.J. Hobsbawm should still recommend Zola's Rougon-Macquart novels as the best guide to the rise of the bourgeoisie in the mid-nineteenth century, one should not conclude that these novels are in fact a work of history. As history, we said, Zola's *Germinal* is unreliable – the events he describes could not have occurred, all of them, at the same date. It does not follow that Hobsbawm is wrong, that truth can in no sense be ascribed to that novel. Although 'Paris', unlike 'Coketown', is the name of a real city this does not demonstrate that Engels must have learnt more from his reading of Balzac than Marx did from his reading of Dickens. Nor is it just that Balzac and Zola 'give us truths' in the manner in which a work of architecture 'gives us truths' about the strength of buildings. Any novel, as I said, can do this. The novels of Balzac and Zola 'give us truths' in a manner in which a sentimental novelette from the same period does not, even though both their novels and the novelette can be used as historical evidence about, let us say, the prevailing fantasies of their time.

To comprehend such facts as these, we shall have to make a shift to non-propositional truth-usages. There are many such usages. Consider, for example, a 'true copy' of a manuscript. The statements in a 'true copy' need not be propositionally true. If indeed they *are* true, when the original is false, then the copy is – not false but – 'defective' or 'inaccurate'.

A 'true lawyer', to take another case, need not always tell the truth; his opposite is neither a false, nor a counterfeit, nor a defective, nor an inaccurate, but an *uncharacteristic* lawyer. Contrast, too, a man's 'true

circumstances' or 'the true facts of the case', with his *pretended* circumstances or the *alleged* facts. In order to conceal the true circumstances, the true facts, a person need not lie; it may be enough for a woman to assume a new accent in order to 'deny her origins', or a man to wear an expensive suit to conceal his true situation. In a different idiom, when Polonius exhorts Laertes to be 'true to himself' this does not mean, simply or principally, that he is to tell the truth; rather, he is to be loyal to his principles. If he is, then he will not be 'false', i.e. 'disloyal', to any man. ('Truth' has the same Anglo-Saxon root as 'troth'.) Perhaps the 'truth' applicable to works of art lies somewhere concealed in this jungle of usages.

It is a sufficiently familiar doctrine, certainly, that plastic and literary works ought to be a 'true copy' of reality. (One could scarcely say as much of architecture or music.) There are obvious objections to such a view. We can grant that a 'true copy' need not imitate in all respects the original which it copies; a typewritten document can be a true copy of a hand-written original. However, for a typescript to be a 'true copy' of a manuscript there has to be a one-to-one relationship between them, each letter in the typescript matching a letter in the manuscript. Even in the case of a naturalistic or an historical novel there is usually no such match between, let us say, the dialogue in the novel and dialogues which actually took place, although rarely, as in the case of *The Possessed*, remarks may be put into the mouth of one of the characters which, as an actual person, he in fact wrote. In poetry, in the vast majority of novels, it would be wholly absurd to seek for something of which the literary work is a true copy – unless we suspected plagiarism. Only in this last case can a literary work be a true copy of anything at all.

All this is very obvious. But what about a painting and the like? In many instances, a painting can clearly not be a 'true copy' of anything but another painting. It would be ridiculous to ask what a painting by Stella is a copy of unless, again, we suspected plagiarism or, alternatively, that what we were confronted by was not the original work. But what about representational painting? Sometimes a painter claims to be painting a particular scene – say a particular Venetian canal – or a particular building – say the cathedral at Rouen – or a particular person – say a living political figure. Then, although not everyone will be in a position to do so, it is at least possible in principle to 'match', in Gombrich's terminology, the painting against the person, place or building in question. Can we, in such instances, claim that the painting is a 'true copy'? Certainly not in the sense in which a typescript can be a true copy of a manuscript, where every sign is matched by a sign. Even in the simplest case, a portrait, where the obvious difficulties arising out of differences in scale need not arise, the question remains what exactly has to be matched if the painting is to be a 'true copy'. Every pore? A sculptor, working in bronze, can clearly not do this. But neither can a painter.

Indeed, the gap between the most realistic painting and the scene it depicts, between brush strokes and human flesh, let us say, is so great that to speak of the painting as *copying* what it depicts is to attenuate the conception of 'a copy' beyond endurance. A painting cannot copy reality in anything like the sense in which a painter can copy a painting, sometimes with such skill that we find it hard to determine which is the copy and which the original.

With such facts in mind, it became customary to substitute for the notion of copying, or imitation, that of representation – a broader, considerably more flexible, concept. A member of the legislature represents his constituents, Uncle Sam represents the United States, a photograph represents the person of whom it is a photograph. Works of art of any sort *can* represent – so a section of Vivaldi's *Four Seasons* represents a thunderstorm and the roofs of the Sydney Opera House a ship in full sail – but to literature, painting and sculpture representation was for long held to be so essential that they were picked out as the 'representational arts'. And on them we shall concentrate our attention.

How do matters now stand with 'truth'? That attaches to what is represented rather than to the representation. Members of the legislature may accurately represent, or fail to represent, the *true* feelings of their electorate. They may do so by saying what those feelings are, but this is relatively rare. More often, they do so by supporting particular policies, sometimes by making inaccurate, even lying, assertions. If what they say is true this is accidental, just as it is accidental if what Lady Macbeth says is true. To take other instances, Uncle Sam may symbolise, satisfactorily or unsatisfactorily, the *true* character of the United States; literary works, paintings, may depict, or fail to depict, the *true* circumstances, the true facts of the case. 'Truth,' Dreiser once wrote in this spirit, 'is what is; and the seeing of what is, the realisation of truth.'

There is some inconvenience for philosophers in supposing that 'truth' can be a predicate both of circumstances and of statements. But certainly this is a quite idiomatic use. ('Visit the Soviet Union and see the truth for yourself.') Of course, there cannot be 'false circumstances' or 'false facts of the case'. But this is only to say that 'false' is not, in every context, the opposite of 'true'; sometimes, as we saw, the opposite is 'alleged' or 'pretended'. Unless we take account of this idiom, we shall find it very difficult to understand the claims that are made on art's behalf. Our easy victory over Gotshalk was won only by presuming that 'truth' must be 'propositional truth'.

To the view that art in some manner – or, indeed, in any of a great variety of manners – can represent things as they truly are, there are a great many familiar objections. Artists often object to it on the ground that it threatens their claim to be 'creative'. They want, they tell us, to produce 'new objects'. Yet a Renoir is just as much a 'new object' as a

Newman; that the Renoir is a painting of a human being no more prevents it from being a totally new object than does the fact that we have seen stripes of colour before seeing a Newman prevent his paintings from being new objects – unless we suppose that creation must be *ex nihilo*, in which case there are no creative artists.

Another ground of objection, which artists also find congenial, is that to think of art as representing may suggest that it is but a means to the enjoyment of what it represents. Berenson was, in this spirit, once led to wonder whether art 'has a higher function than to make us feel, appreciate and enjoy natural objects for their art value', by which, I suppose, he means their formal values. It is certainly true that we can take an interest in representational paintings not only for this reason but for a great variety of reasons – looking, say, at the Augsburg self-portrait of Angelica Kauffmann as Clio to see how she saw herself, as a contribution to her biography. To avoid this, many twentieth-century painters deliberately design their work in such an abstract form that we cannot look through it, as distinct from at it. On this attitude, I shall comment later.

A philosophically more fundamental objection is Platonic-Galileian. The representational arts, it is then argued, cannot possibly show us how things are. For the poet, the painter, is confined to sensory appearances and is incapable, therefore, of depicting reality. Schiller granted as much in the twenty-sixth of his *Letters on the Aesthetic Education of Man*. The artist, he says, loves and depicts sensory appearances for their own sake. Artists can properly be condemned as liars, illusionists, only if they pretend that their concern is with something other than free, if form-seeking, play with semblances. The honest artist will expressly renounce any claim to be representing reality.

Substantially accepting this view, and with an eye no doubt on impressionism, while not, he tells us, underrating 'the beauty of qualities of appearances', Henri Poincaré advocated in *The Value of Science* the search for a 'profounder beauty' which 'gives body, so to speak, to the iridescent appearances which flatter our senses'. (Note the word 'flatter'.) Without its support, he goes on, 'the beauty of these fugitive dreams will only be imperfect, because it would be vague and fleeting'. That 'profounder beauty', he thought, could only be found in science.

In Cartesian language, an art of appearances can, on this view, never put before us a 'clear and distinct perception'; the best impressionism has to offer is the shifting and unsteady lights of Normandy and the Ile-de-France. In deliberately setting out to paint the ephemeral, in bidding us to look at nature in these terms, impressionism, for Poincaré, is cutting itself off from truth. Cézanne's break with impressionism has behind it a similar impetus. He sought – so he told Bonnard in a letter – to paint on his canvas an image of nature. To do this, he thought, he had to penetrate, if by the use of colour, beyond the surface to 'the depth', to

handle nature, he said, through the cylinder, the cube, the cone. This is the old Cartesian attitude to nature, reflected in Malebranche's preference for a nature wholly constituted by regular geometrical forms and the French landscape gardener's attempt to trim it into precisely such forms.

Some abstract sculptors, indeed, have called themselves 'realists,' just because, in their purely geometrical constructions, they supposed themselves to be concerned with the real underlying shapes of things in contrast with their 'mere appearances', and thus to have overcome Poincaré-like objections. They are still working in the spirit which informed the Futurist Boccioni, writing in 1913: 'It is necessary to proclaim loudly', he wrote, 'that in the intersection of the planes of a book and the angles of a table, in the frame of a window, there is more truth than in all the tangle of muscles, the breasts and thighs of heroes and Venuses which enrapture the incredible stupidity of contemporary sculptors.' But if we take seriously the view that only physics tells us how things 'really are', then the solid cube is as much 'an appearance' as shifting light; the notion that shape and volume are 'real' whereas colour is mere appearance cannot survive, as Kandinsky recognised in his *Reminiscences*, the electronic theory of matter. Calder has no greater claim to be realistic than Maillol.

In diurnal terms, no doubt, the shape of Mt St Victoire survives many a change in shade and colour. Its solid shape is not, for that reason, 'more real' than the light which plays on it. That Mt St Victoire looks so-and-so in certain lights, at certain seasons, is in Wordsworth's phrase, 'as permanent a fact' as that it has a certain structure. As for the view that the intersection of two lines has 'more truth' than the human breast, the human thigh, how can an intersection contain either 'truth' or 'falsity' in any of the senses we distinguished? In the case of any but purely geometrical sculpture, we can, in contrast, distinguish works which truly depict the shape of the thigh or breast – or bring out, perhaps by exaggeration or by simplification, something about them – from works which merely please by satisfying our conventional expectations, which sentimentalise. That such works, Michelangelo's or Rodin's, do not show us the molecular structure of the human body is irrelevant.

Metaphysicians, distinguishing between 'appearance' and 'reality', may cast into the realm of appearances everything we human beings hear, feel, see. But whatever its force in metaphysics – that is not a question I am compelled to discuss – this contrast works very differently both in everyday life and in the arts which concern themselves with that life. No less to metaphysicians than to the rest of us does it matter whether what they see in a desert is water or a mirage, whether the affection of a friend is real or illusory, whether they are being deceived by a mountebank or enlightened by a thinker, whether a floor is actually solid or only seems to be so. At this level, the representational artist can properly claim to have

shown us not merely how things appear at first sight but how they are in truth, showing us that if we look more carefully we shall see as counterfeit many of the beliefs, passions and attitudes which normally pass as genuine, see as mirages many of the ideals with which men and women try to console themselves. Alternatively, we shall come to see as genuine what our culture tries to persuade us is a sham – let us say, devotion to a way of life.

Iris Murdoch does not have to forget that she is a philosopher in order to write that 'the pilgrimage from appearance to reality' is 'the subject of every good play and novel' – even if one questions the generalisation, thinking perhaps of works where what we are shown is how a person can be forced into illusion, as in *Nineteen Eighty-Four*, or can be unable to shake free of it, as in *Waiting for Godot*. To illustrate, if for physics Madame Bovary is an electronic cloud, she is not, all the same, under an illusion when she takes herself, her lover, her husband to be human beings. Her illusions, and those illusions of ours which through his presentation of her Flaubert helps us to discard, lie elsewhere, not to be dispelled by subsequent scientific discoveries. Something important about human beings can be brought out by stories and films in which they are depicted as machines, but what is brought out is not that Hoffmann was wrong to feel disillusioned when his Olympia turned out to be a mechanical doll. So far Wordsworth is correct. The distinctions to which the artist points are indeed as permanent as human life itself.

There is, however, something of a problem here. One can see why we need science, scientific theories and scientific instruments, in order to pass beyond bodies to cells, cells to molecules, molecules to particles. The artist, except that the painter or sculptor may study anatomy or perspective, has nothing to rely upon but everyday powers of observation – as is most obviously true of the literary artist. Why do we need the artist, why not simply look for ourselves? The traditional answer is, I believe, correct: we do not normally look with care.

Why don't we normally look with care? Our normal approach to the world is practical. We see what we need to see for some particular purpose, its function but not its form and colour except in so far as they are a guide to that function. Not only that: there is much that we do not wish to see, from which we avert our eyes, whether out of distaste or by convention. After Kubrick's film of *Clockwork Orange* first appeared, there were many who complained that gangs of louts, and worse, were imitating the film; such complainants had not seen what Burgess and Kubrick had seen in the England around them. At a less spectacular level, the Gogol of *Dead Souls* saw 'things that are constantly before our eyes but which idle eyes do not see – the appalling morass of trifles that has come to control our lives ... the cold, humdrum characters which fairly swarm through our daily life, now bitter, now boring'.

Our feelings, too, are often merely conventional; we love and hate what

we have been taught to love and hate without examining the objects of our love and hatred at all closely. The representational artist compels us to look, and to re-examine our feelings, whether by celebrating the beauty of the world or by forcing upon our attention its miseries, its iniquities, its horrors. So much Constable and Beckmann, Monet and George Grosz have in common, Heine's lyrical verse and the plays of Büchner and Brecht. That is one answer, if only one answer, to those who ask 'Why should I bother with the representational arts when I can look for myself?' Art can concentrate the mind wonderfully. And the conventions of art can enable us to look unconventionally, to look at what we should otherwise not dare or care to see, permitting us, without rebuke, to stare. We can say consolingly to ourselves: 'It's only a story, a film, a painting', as we contemplate what we should normally look away from. Yet we know better.

Some critics have suggested, however, that we no longer need the arts to help us to see, that television news now suffices for this purpose, so that if there is to be nowadays any reason for reading, in particular, the novel – if it is not, as John Barth once notoriously suggested, to be set aside as an exhausted form – it will have to be for some quite different reason – delight, perhaps, in its technical virtuosity. One has to remember, however, that 'teaching to see' is not identical with persuading us to look, as either the news or a commercial can do. If a woman says of some event at which she has been present 'I did not see what was happening', this may be because she was not looking, but it often has the force of 'I did not understand', or 'did not realise'. The real question is whether by looking at television news we acquire that kind of understanding which a novel – or a poem, a play, a film – can offer us. If we can, then indeed novels have lost their point as a way of helping us to see.

It is reasonably plain, however, that this does not happen, that looking at news reports from the Southern United States does not give us the kind of insight into Southern ways of thought we get from Faulkner, that reading Salman Rushdie is very different from looking at the latest news from India, that no news report from England gives us the understanding we get from Stephen Frears's film *My Beautiful Launderette*. This is not only a seeing of what it is like to live in a particular place at a particular moment of time – the most we can hope to get from television news – but, much more generally, what it is like to confront problems over a *period* of time, to believe, feel, act, dream, hope, suffer, recover, in a particular way, not only what it is like for other people to do these things but even what it is like for us to do them. For this is something we may only realise as we read, as in reading Turgenev's *Fathers and Sons* young Russians saw Bazarov as someone who believed what they, until then, had not realised that they believed.

As my earlier examples – Monet and Grosz, Heine and Brecht – should

sufficiently illustrate, artists have many ways of getting us to see: by telling us a story, by the vividness of their colours, the charm of their rhythms, their mastery over invective or irony, by distortion, perfection, simplification, the use of metaphors or symbols, by plain, if far from unsophisticated, literalness or by romantic exaggeration, by abstraction or by loving detail. The painter Francis Bacon was not joking when he called himself 'a reporter'. He is as much a reporter as is the *News of the World*. But he brings out, as that newspaper does not, the vulnerability of human beings, their physical meatiness, without prurience, without compromise.

What, borrowing the phrase from Chomsky, we might call the 'surface structure' of the artist's work is never realistic, not even in the most 'naturalistic' of novels, the most 'representational' of paintings. This is not a defect. To suppose that a neatly rounded plot in a novel demonstrates a lack of realism is quite to misunderstand the character of realism in literature, and in a manner which leads to the destruction of the novel, the conversion of it into a dossier or a set of fragments deliberately linked only by chance. Only when human relationships, as in sentimental stories, are falsified to fit some convention – say, the 'happy ending' – can we rightly complain of a lack of realism. Similarly, it is quite wrong to suppose that a painting can be realistic only if its proportions 'match' the relevant proportions of the objects it depicts; Picasso's *Guernica* can show us what war is like, as much as does Goya. And even Goya 'unrealistically' makes use of a frame and poses his figures dramatically.

After a time, a particular way of getting us to see may no longer work. It loses what Robbe-Grillet calls 'its initial vitality, its force, its violence', it becomes, in his words, 'a vulgar recipe, an academic mannerism which its followers respect only out of routine and laziness'. Then a new path to what Robbe-Grillet calls 'the discovery of reality' has to be sought. Only over years, as the epigoni vanish, does the style regain its force, enable us to see. But the 'new path' will always be at once 'unrealistic', dependent on particular conventions and, if it succeeds, 'realistic' in showing us how things are.

One of the many things we do not normally see is the feelings of other people, how *they* look at the world, their 'ideology', in a perfectly proper, although not the most fashionable, sense of the word. And this, too, the artist tries to show us, as in Antonioni's film *Red Desert*, where we see the world through the eyes of a deeply depressed woman. Not only that: we see more clearly the darker side of industrial civilisation, and the superficial relationships it engenders, by looking both at it and them through her eyes. A different ideology can help to destroy our familiar ideology, in so far as that is a bar to perception. By showing us what we had not seen, it changes our feelings.

If we were to judge solely by the pronouncements of theoreticians, this

familiar view of the representational arts, as showing us what we do not normally see, has had, in recent years, few friends. But there is often a striking gap between the unlicensed metaphysics of the theorist and the actual practice of critics. Here are three examples of critical judgment from the *London Review of Books* and the *New York Review of Books*, read by chance, not discovered by diligent research. From Wayne Booth, 'he makes one feel that [one] has never looked at anyone before'; from Graham Hough, 'she offers us the satisfaction of seeing one's own hazy observations brought into sharper focus'; from John Richardson, 'Picasso forced himself to look at length at whatever was in front of him as if it had never been looked at by him or anyone else before'. Or, in a slightly more complicated case, Kermode writing about Golding's *Lord of the Flies*: 'It is a sharply imagined account, a new clear outline, of what one vaguely knew.' Serious artists are not content to stay where most of us rest, with a conventional way of looking at things or a conventional way of describing them. Of Merce Cunningham it has been said that 'like every great choreographer he is able to strip us of our preconceptions about the way people move and feel' – yet we daily see people move and observe their feelings. So far Ruskin was right when he wrote: 'The highest imaginative faculty never stops at crusts, or ashes; it pushes them all aside and plunges into the very heart.' He was not right, however, if this is taken to mean that the artist somehow 'gets beyond' looking with understanding.

One has to remember, too, that artists cannot, by the very nature of the case, give us *the* look of things, or how human beings *really feel* about them or *the* correct description of them. For there is no such thing. They can only offer us *a* way of looking, *a* correct description, show us how other people *can* feel and we *could* feel. But by doing this they can get us to recognise that the conventional way of looking at things, or describing them, or feeling about them, is not the only way or, more strongly, is an intellectually or morally defective way of doing so. The artist's 'personal vision', we come to see, is not just personal. Indeed, it may come to be ours.

So the early Dutch painters – and the early Australian painters – reflected the conventional view that their native landscape was of no interest, that it was boring, unvaried. In the Netherlands, when they painted a landscape, it contained the hills, the mountains, which in many cases they knew only from descriptions; in Australia they Anglicised the landscape. In each case, later generations of artists – and, in the Australian case, film-makers – taught their compatriots to look again at the landscape, and in the process to abandon their former way of seeing, to feel differently about the landscape, to offer different descriptions of it, a process which is still continuing. American novelists, similarly, have taught at least some of their compatriots to see differently, to feel differently, to describe differently, their relationships with blacks – or,

more intimately, to see differently, to feel differently about, to describe to themselves and to others differently, the kind of life they have been living, or the kind of life other people live. A familiar example of an attempt to do this – one can argue about whether or not it succeeds – is Updike's *Rabbit Redux*.

One can say, if you like, that artists offer us a 'perspective', or in Nelson Goodman's terminology a 'version'. They are conscious of that fact; many novelists return for another look at the same theme, as indeed Shakespeare does to kingship. 'The same subject seen from a different angle,' Cézanne once wrote in a letter, 'gives a subject for study of the highest interest and so varied that I think I could be occupied for months without changing my place, simply bending a little more to the right or the left.' Rembrandt's thirty portraits of the same sitter by no means betrayed an absurd perfectionism. There are very many serious paintings which look at the Madonna-Jesus relationship, at the extreme ends by Boucher as erotic, by Max Ernst as violent, but within the more conventional range in extraordinarily diverse ways. So, too, paintings of Mary Magdalene vary between the highly sophisticated prostitute and a much more rural, simpler whore. Canaletto's look at Venice is very different from Turner's or Kokoschka's. Indeed, as Gombrich points out, a gain in respect to certain sorts of clarity is always accompanied by a loss in another; we see shapes more clearly in Canaletto only at the cost of losing the effects of mist and changing colour, natural energy in Turner at the cost of shape.

There is much about the look and the feel of a thing, one must also emphasise, which cannot be brought out by an attempt to match it. Francis Bacon has to distort to catch human mortality, Michelangelo to capture muscularity, Munch to bring out the grief and terror to which human beings are subject. The pace of films, from Chaplin to Tati, which satirise modern life is speeded up. The characters in *Volpone* are not the less alive for being larger than life.

The representational artist's modes of expression are indeed, as we said, diverse. Such artists – unlike pure formalists – can paint ironically, in symbols or allegorically; they can turn to their purposes exaggeration, distortion, ambiguity. If nowadays artists make more and more use of exaggeration and distortion, to the point of weakening their force, this is partly because they feel threatened by such alternative forms as photography and documentary, partly because they feel that modern life, modern human relationships, are of such a character that only the grotesque can capture them. Victor Hugo's observation that the grotesque is the distinguishing character of modern art has turned out to be prophetic. This is particularly true in the United States, in the works of writers like Heller, Barth, Pynchon, but is not unique to that country, as is sufficiently revealed by the existence in Germany of such novels as Günter Grass's *The Flounder*. German painting and sculpture has, even

in medieval times, at its best generally been grotesque, but now such art is also to be found even in Italy.

One can understand, in these terms, how 'perfecting' can be compatible with helping us to see – a question we raised earlier – if we think of perfecting as the heightening of an object's characteristics, so that caricature is a form of perfecting. As Shklovsky argued as long ago as 1917, the artist helps us to see by defamiliarising the familiar. This can sometimes be done simply by, as it were, turning a spotlight on it. Looking at a Dutch painting of a bowl of familiar flowers, or a familiar landscape, or a familiar type of domestic interior, or people engaged in a familiar kind of work, or considering a more modern painting, or novelistic description, of a war which we thought we knew a good deal about, we can feel that we are looking at this kind of thing for the first time, even when the artist has by no means exaggerated. But that may not be enough, particularly when the object in question is one we so habitually conventionalise that our tendency is to conventionalise such a painting itself, to pass it by as *déjà vu*. Exaggeration, or the kind of devices used in 'magic realism', may be the only way of getting us really to look. Nowadays, many writers, many painters, obviously believe that artists, like show-ground barkers, can only get people to look at what is on show by shouting through a megaphone, leaving us, in both cases, more often than not disappointed if we obey.

The essential feature of realism in art is that it removes bandages from our eyes; its antitheses are sentimentalism, propaganda, fashion-ableness, melodrama, which bind our bandage more tightly. In view of what I just said, we should distinguish two types of realism – 'diurnal' and 'heightened'. Diurnal realism keeps close to everyday life yet throws fresh light on it, even if, as I said, it is a personal, carefully placed light, like a good photographer's spotlight, not, like a searchlight, undiscri-minating. Jane Austen, George Eliot, the majority of English novelists – except, of course, the Gothic novelists – fall into this category, as do most British dramatists from Heywood and Dekker on. Heightened realists intensify, plunging enlarged characters into extreme situations. Of the older dramatists, Webster, Ford, Tourneur, in modern times Eugene O'Neill, Tennessee Williams, Albee are names that come to mind. Like most dichotomies, this is by no means a clear-cut distinction. Where does Dickens fall? Basically, I wanted to get rid of the idea that realism is necessarily diurnal; decisions about particular cases, I have to leave to critics.

Diurnal realists risk banality, when they do not help us to see but merely confirm us in our complacency. The English have a particular fondness for novels or plays or films which profess to be satirical but actually engender self-satisfaction. On the other side, heightened realists run the risk of falsifying by such violence in action and speech that we no longer take them seriously; they collapse into mania. In his *A Short*

Organum for the Theatre Brecht summed up thus: 'Art does not become unrealistic by changing the proportions but by changing them in such a way that if the audience took art's representations as a practical guide to insights and impulses it would go astray in real life.' If that kind of connection with the real is lost do not have heightened realism but, in in its modern sense, melodrama. Whether Brecht's own *Resistible Rise of Arturo Ui* or, let us say, Dario Fo's *Accidental Death of an Anarchist* fall into the category of 'realistic', thus defined, is also a question for critics to determine.

A look, we conceded, is always the way something looks to a particular artist in a particular society, working, one can add, from a particular social place as well as a particular geographical place and, as Wordsworth insisted, with passions as well as senses. One must not exaggerate; one must not be led into concluding, with Corot, that the landscape the artist looks at is but a mood of his own mind. It is still a landscape, which a geologist might alternatively describe, but as seen in a certain mood. A purely spectatorial theory of art, one can fully agree, stands on no firmer ground than a purely spectatorial theory of perception in general. But epistemological Idealism is neither the only, nor a plausible, alternative. Most of the time, we have not created what we perceive although, to be sure, it is not simply given. We 'take it in', in the light of our past experience, our present hopes and fears.

The objectivity of a Flaubert or a Stendhal lies in their capacity for cutting through pretences, their *passion* for truth, their detestation of hypocrisies, of self-deception, not in a mere capacity for looking on. And in and through that objectivity they help us to see how the world looks to those very different people, their personae, informed by very different passions. The artist may enlighten us rather about the diversity of the ways in which a situation *can* look, in the manner of Kurosawa's *Rashomon*, than about the situation itself. Indeed, our interest may be not so much in what is presented as that it can be thus presented – not, in the classical phrase, nature seen through a temperament but rather a temperament seen through nature. But that is possible only because we can compare the artist's look with what we have seen for ourselves.

There is an obvious difficulty in what I have so far argued. We can appreciate a Turner or a Canaletto without having seen Venice. How, then, can it matter whether those painters give us a true glimpse of it? When Venice becomes familiar to us, we do not ignore, as no longer necessary, their paintings, as we might a tourist guide. The 'inexhaustibility' of the work of art – 'the need to see again, to hear again, to experience indefinitely', as Valéry puts it, perhaps with some degree of exaggeration, suggests that the roots of its seriousness must lie elsewhere than in its capacity to help us to see how some particular object truly looks. Often enough, furthermore, the painter depicts something which is either totally imaginary or, like the ways in which Jesus looked,

in no way checkable. In literature, something similar holds. How can Chekhov 'give us the feel' of the life of Russian gentlefolk in pre-Revolutionary days, we naturally ask, when the particular actions his characters engage in, the particular speeches he puts in their mouths, never in fact occurred? He may be *convincing*, but so can a sophist, a charlatan, be convincing.

One can respond to this objection by taking up Aristotle's suggestion that art is not about the actions of this or that person – what Alcibiades actually did – but about what a certain kind of person has it within him to do. In the logical language of our own days, literature and painting, like science, help us to see, although, unlike science, they do not actually assert, the truth of counter-factual conditionals: 'If anybody were to be of that type, he would ...' or, as I put it earlier, they show us 'what it is like to ...'. That is exactly why it is unimportant whether the story of Oedipus has any historical foundation; it is enough that we see in Sophocles how human beings will react in certain types of extreme circumstances.

The truth of a work of art consists, then, not in the fact that it presents us with true circumstances, but in its presenting us with true-to-type circumstances. Did Venice not exist, it might in the same spirit be argued, this would not affect in the slightest our appreciation of Canaletto or of Turner. What is important about these painters is that they show us how buildings will look in certain conditions of light – just as the quite imaginary buildings in Renaissance paintings nevertheless help us to see the colours, to appreciate the spatial relations, in actual buildings, or the ideal landscapes which Carracci created and Claude developed help us to appreciate actual landscapes. Chekhov, similarly, shows us how human beings *would* speak and act, in respect to the general character of their speech and action, in the sort of social circumstances he depicts, although we might be sociologically interested in the question whether these actually existed in pre-Revolutionary Russia.

A work of art, some would wish therefore to say, gives a glimpse of a possible world, not the actual world. Care is needed here. It is sometimes argued, as by Ortega y Gasset, as a counter to even the most liberal sort of representationalism, that the world the artist creates is a wholly independent one with a coherence which is internal to it – a 'small hermetically sealed universe'. Such a possible world would be of no interest to us, nor should we have any criteria by which to judge whether it was, or was not, coherent. (If one of its gentler characters, let us say, suddenly becomes violent with no provocation whatsoever this is incoherent only in terms of our *actual* world.) There must be some sort of cross-identification across the possible and the actual world, not indeed of individuals, but of types of description and relations between them. Otherwise writers would have to make up a language entirely of their own. Alice is a little girl, however odd the things that happen to her; we read *Alice in Wonderland* against the background of our knowledge of the

actual; its absurdities are absurd by everyday criteria. That she is based on Alice Liddell, if she is, is of no importance; that she is a particular sort of girl is not only important but fundamental. Paul Feyerabend once wrote, in his *Against Method*, that we need a dream-world in order to discover the features of the real world. The dream-world can help us in this way, however, only if it refers in some way to the real world.

The suggestion that art presents us with true-to-type behaviour will certainly arouse a critical response from those who question the seriousness of art. The work of art, after all, is about particularised individuals – about, to take a familiar case, a blackamoor general married to a Venetian noblewoman and with a malignant, envious Machiavellian on his staff. Raskolnikov is not the typical criminal, or Porfiry Petrovitch the typical policeman.

No doubt, artists sometimes profess to be presenting us with universals. So Molière writes comedies with such names as *L'Avare*, *Le Misanthrope*; Rodin entitles a statue *Le Penseur*; Botticelli calls a painting *La Primavera* or *La Calumnia*. Yet in fact what we see on Molière's stage is a particular human being, not avarice or misanthropy. Rodin's thinker is *a* thinker, the persons in Botticelli's paintings have individual characteristics. To attempt to present pure universals in the arts, we can agree, is to attempt the impossible – in practice to lapse into stereotypes.

At the opposite extreme, we should however point out, there can be no pure particularity, absolute uniqueness. Othello, for all his individuality, is indeed a jealous husband, Iago a faithless friend, Macbeth a tyrant. What we encounter in a work of art, as not in a generalised psychology, is the very accent and bearing of passion. (Contrast, in this respect, a Freudian case-history with Freudian theory.) We discover what it is like to be jealous, to be faithless, to be tyrannical, with a degree of insight we could never achieve by contemplating formal definitions. Jealousy, of course, has not its unvarying linguistic or expressive form; to try to impose such a form on it is to lapse into the stereotyped cliché, as melodrama characteristically does.

What Othello says out of jealousy is, so far as Shakespeare succeeds, shaped by his special character and circumstances. Yet the suburban husband can recognise in it the clearest possible utterance of what he is himself suffering. It is only if we think of words like 'jealousy' as names for ideal entities rather than as descriptive expressions for wide ranges of complex human conduct that we shall find it hard to understand how a work of literature can 'show us what jealousy is like' or, more accurately, can provide us with 'a look' at jealousy, while still remaining immersed in the particular. There are not two classes of entities – particulars and universals – which we can be aware of and describe separately from one another. There are only things in particular times and places, imagined or actual, which we can describe in general terms or see in action as having general characteristics.

Such a post-Aristotelian analysis will not satisfy the Platonically-minded. It certainly would not have satisfied the Mallarmé of 'Mystery in Literature': 'Why should we perform the miracle by which a natural object is almost made to disappear beneath the magic waving wand of the written word, if not to divorce that object from the direct and the palpable, and so conjure up its essence in all purity?' But this is wholly preposterous. Language is not a magic wand which makes objects disappear; it cannot cast aside those narrative, descriptive, imperative, denotative functions which Mallarmé wants to dismiss as 'vulgar'; language does not permit us to conjure up *essences* in all their purity, if only because there are no such 'pure essences' to conjure up. It is not by such magical means but in and through its depiction of the gross and palpable that literature and the plastic arts acquaint us with 'essences'.

Expressionist playwrights and film-makers have sometimes tried to persuade us otherwise. There is a film of Murnau's which purports to be set 'anywhere' and 'everywhere', with personages bearing such names as 'The Boy', 'The Girl'. But the concreteness of art defeats such pseudo-Platonism. Of necessity, the place, the time, the personages, have to be particularised. This does not prevent the personages from being a *boy*, a *girl*, the places as a *farm*, a *city*; their particularity does not exclude universalisability. Even when what is depicted is a relationship between two rather exotic beings, a North African Venetian general and the daughter of a Venetian nobleman, a suburban husband can still, we said, recognise his own feelings, his own impulses to act. Not, however, in virtue of a metaphysical foray into a transcendental world of ideal forms, but in so far as he recognises them as feelings and actions of a familiar sort.

If literature has a rival it is not, for this same reason, to be found in abstract, generalised psychology or sociology but rather in the detailed, concrete descriptions of ways of life which the anthropologist puts before us, the works of such 'micro-historians' as Ladurie, the case-studies of the psychologist and the sociologist, the penetrating, as distinct from the official, biography, each with the capacity for stimulating our sympathies, helping us to understand human conduct through the exploration of a particular situation in detail. The novelist, the dramatist, the poet, can outdo them in principle, through their greater control over and understanding of language and their greater freedom to explore possible, or even fantastic, situations, as in John Berryman's *Dream Songs* series. This is ever more difficult for the novelist and dramatist, however, in an era in which language is deliberately homogenised – unavailable, then, as a means of characterisation – and we have discovered how fantastic actual lives can be, at home or abroad. Novelists are tempted to compete, as we saw, by engaging in research, trying to involve their readers simultaneously in a documentary and a novel. When, however, they succeed as serious artists it is not because their research has been

thorough but because they are able to display the outcome of their research in and through the interactions of their characters, as the best historical novelists and dramatists have always done.

It was, in part, an unjustified fear of the encroachments of science which provoked another kind of defence of the universalising powers of art in which art is conceived, not as exhibiting more clearly the sort of empirical universals which science can also – as psychology, or sociology – take as its province but rather as supplying us with our means of, if not understanding, then at least encountering, universals which are scientifically inexpressible. (We have already discussed symbolism in connection with imagination, but now our theme is truth.) The work of art, on this view, is not so much, as we have already seen, an image as a symbol – not, even then, as a word is a symbol or as abstract conceptions are symbolised in the conventional iconic devices of medieval or Renaissance painting, or a country by its flag, but a symbol which in some extraordinary fashion carries its meaning in itself. 'True symbolism,' wrote Goethe, 'is where the particular represents the universal, not as a dream or a shadow but as a living momentary revelation of the Inscrutable.' And Carlyle wrote in the same spirit that a 'true work of art' is distinguished from 'a daub of Artifice' precisely because we can discern within it 'Eternity looking through time; the God-like rendered visible'. This capacity for revealing the Inscrutable was later assumed to be particularly characteristic of music. So for Schopenhauer 'the composer reveals the inner nature of the world, and expresses the deepest wisdom in a language his reason does not understand'. Even abstract painters, seeking to make it plain that they are not mere decorators, have made such claims, or critics have made them on their behalf. Mondrian, for whom 'the straight line is the line of truth', belongs to the first group, the cubists; Apollinaire, as their 'interpreter', to the second. (Mondrian also argued that geometrical art was purely masculine, that all externality is feminine. Ironically, he was to become a favourite of dress designers.) They have not been content to cut all connections between art and truth, or unashamedly to engage in non-representational painting. Their work *does* represent, they have wanted to say, but represents something which we are not ordinarily capable of perceiving. Their abstract designs, we are to suppose, are metaphysics in disguise, a route to the transcendental.

The artist's reply to Plato, when couched in these terms, is that the artist imitates nothing whatsoever, whether image, particular or universal, and does not pretend to be a sage. Rather, as Hugo suggests in *Les Mages* and Rimbaud was later to insist, the artist is a kind of priest or a kind of seer. The work of art, in the manner we have already discussed, symbolises, shows forth; the 'wisdom' to which it introduces us can never be rationally specified, spelt out, called to account as the teachings of a philosopher can be called to account. The poet-seer's 'truths' are not to be discovered by patient investigation; they are intuited. In Wordsworth's

phrase, they are truths 'not standing upon external testimony, but carried alive in the heart by passion; truth which is its own testimony'.

What Plato saw as a weakness in poetry, that it depended on inspiration, that it is a kind of madness, is here judged to be its strength; the attack on 'enthusiasm', characteristic of British philosophy from the seventeenth century onwards, is converted into a paean of praise – yet, in England, always with reservations. Wordsworth himself had second thoughts: 'What temptations to go astray are here held forth for them whose thoughts have been little disciplined by the understanding, and whose feelings revolt from the sway of reason.' Like Coleridge, Wordsworth was sufficiently in the English tradition to insist, at least in his more reflective, less rhetorical, moments, on the importance of commonsense and moderation.

Compromise, however, must sometimes be ruled out. This is such a case. One cannot say: 'Trust artists *absolutely*,' and then hastily add, 'but not unless their inspiration is checked by reason and commonsense.' If what they reveal is genuinely inscrutable, then there is no point in our admonishing artists or their audience to scrutinise their deliverances with care; if their 'truths' need no external testimony, if they are self-generating, if like Keats we are ready to accept the principle that 'what the imagination seizes as beauty must be truth', then it is farewell to commonsense and reason.

Here is a point at which the attempt to find a certain kind of seriousness in art – a transcendental seriousness – has in fact issued in solemn idiocies on the part of critics and artists alike. One has no difficulty in understanding Robbe-Grillet's reaction against the concept of 'the great novelist' as 'a kind of unconscious monster, irresponsible and fate-ridden' who 'emits messages', even if, as earlier in the case of the similar reaction of Hulme and the Imagists, we do not see in a bald particularity the sole alternative to pseudo-metaphysics. The 'symbolic' approach *inflated* art, and imposed on the critic the self-defeating function of making plain what particular inscrutability this or that work has as its theme. Not surprisingly, the critic, too, sought refuge in inscrutability, in some particular mish-mash of bad philosophy.

As a critic's parlour-game 'hunt the symbol' had an obvious utility; it gave the critic something to do, and avoided the nasty question: 'But is this work really worth taking seriously?' The effect is to reduce the importance of the work of art as such, as something to listen to, to look at, to read, as an indissoluble union of sensuousness and rational order. On such an interpretation, looking for a meaning *does* involve treating the work of art as a means. One can see this very clearly in a passage Melville quotes from Hawthorne: 'When the artist rises high enough to achieve the beautiful, the symbol by which he makes it perceptible to our mortal senses becomes of little value in his eyes, while his spirit possesses itself in the enjoyment of the reality', or in André Breton's description of art as

a 'lamentable expedient'. Such pronouncements flow from a puritanical under-valuation of sensuousness, sensuousness which is the savour, and the saviour, of both humanity and nature, their guardian against the excesses of the geometrical spirit which, too assiduously employed, can lead, as Plato did not see but helps to show us, only to sterility.

Art – I should be far from wishing to deny this – can, like a myth, have a fascination which we do not clearly understand, the sort of fascination which Freud sought, if inadequately, to explore. We do not know why we are so deeply moved by a particular musical phrase, why a line in a poem haunts us, or a face in a painting, or a play like *Waiting for Godot* or a film like *Last Year in Marienbad*. Sometimes the effect is not long-lasting: on a second view, we decide that we were 'taken in', as we might be taken in by a skilled rhetorician or a charlatan mystery-monger.

The critic can help us to see why we were moved by drawing our attention to the way in which the work echoes an ancient myth or satisfies a familiar aspiration. All that I am protesting against is the doctrine that what moves us in such circumstances is that light is at last thrown on the Inscrutable; that 'truth', in some higher form, is what in such circumstances we are confronting. I hope that we have awakened from this particular bad dream of the intellect, that critics will no longer attempt to persuade us that without their help, *nothing* is clear, that even the simplest serious novel contains level after level of metaphysical significance, that to read any serious novel in the way many of us did as young men and women, without the help of instructions, was to condemn ourselves to eternal incomprehension. Novelists like Kafka, film-makers like Bergman particularly suffer in this way; they use symbols but they are not theologians, not metaphysicians. If we had to regard them as such, we could not rate them highly. This is not, of course, to suggest that there are never levels of significance in a work, that *Moby Dick* should simply be read as an adventure story about whale-hunting. But it is to deplore the sort of symbol-hunting which converts, let us say, Joyce's *Dubliners* into a network of mysteries, the daily habits of an Irish Catholic family into deeply significant esoteric symbols, sherry and biscuits into a communion feast.

Artists help us to look, I have said, only by presenting us with their own look. But why should we take their look seriously? One familiar answer is that they are peculiarly sincere and their look, therefore, authentic. 'Truth' then enters into the analysis of the work of art only in that special sense it has in Polonius' 'to thyself be true' – as 'sincerity' or 'authenticity'. Now, certainly to describe persons as being 'sincere' is to recommend them as being in some respects trustworthy, in respect to their confessions of belief, admiration, liking. They are not hypocrites. It does not at all follow that we should trust sincere people when the point at issue is the *truth* of what they believe or the nature of those things, persons, institutions which they hate or admire. They can sincerely

believe the most monstrously silly doctrines, can sincerely hate only out of ignorance. If we consider, as many of us do, that the beliefs of Pound, Yeats, Eliot can properly be characterised in this denunciatory way, why should we pay any attention to their poetry as a source of truth? They may well have been completely sincere. But that is not a good ground for trusting them.

On the face of it, indeed, its sincerity by no means guarantees that a work of art is worth taking seriously. Oscar Wilde may be characteristically exaggerating when he says that 'all bad poetry springs from genuine feeling' but not too grossly so. It is only if we give to 'sincerity' a rather special meaning that it can be at all plausibly linked with seriousness. That is substantially what Leavis does when he writes in his *The Living Principle* of a passage from Conrad: 'Creative art is here an exercise in the achieving of precision (a process that is at the same time the achieving of complete sincerity – the elimination of ego-interested distortion and all impure motives).'

If we can accept this view then the problem which has been worrying us will have been solved. If artists are really capable of looking at things with no 'impure motives' and without any 'ego-interested distortion' then clearly we should have good reason for giving a special authority to their ways of looking at things and should try to make it ours. They can help us to see and to see through. Even if, reading their correspondence, we can find plenty of cases when they distort out of malice or egoism, that does not settle the matter. Perhaps something quasi-sacramental happens to them when they pick up their chisel, their pen, their paint-brush. Perhaps such moral and intellectual defects as racialism, anti-Semitism, male chauvinism drop away as they work.

That is not so entirely absurd as it at first sight seems to be. It has often been observed that a writer can, in the process of writing, build up a character with a degree of fairness one would not expect, knowing either the writer's, or the prevailing, general opinion. That, I imagine, is what happened to Shakespeare as he wrote Shylock's 'Hath not a Jew ...' speech; in such cases as Dostoevsky's Grand Inquisitor the facts are indisputable. Still, it would be absurd to pretend that this level of objectivity – and Leavis is substantially equating sincerity and objectivity – is guaranteed by the mere fact that what we are reading is serious literature. The question still remains then: why take the artist seriously as purveying or showing us truths? Unlike philosophers, artists do not construct systematic arguments, unlike historians they do not seek out evidence, unlike psychologists they do not interview or experiment, unlike social scientists they do not conduct surveys or engage in statistical correlations or do field work.

One classical reply is that they have an innocent eye. Novelists sometimes proclaim this innocence by taking as their narrator an outsider: a child, an adolescent, even an idiot, or at the very least

someone removed from the action, a disinterested observer, depicted as only gradually coming to see what is happening. But, of course, this innocence is a device and has to be; the artist can see precisely only by not being innocent. Balzac, Lawrence, Conrad are far from innocent. They show us so much not in spite of being, but just because they are, ideologically committed – as is true also of Daumier or Hogarth. (Here, as at other points in this chapter, I find myself, somewhat to my surprise, in substantial agreement with ideas expressed by Althusser in his 'A Letter on Art', an essay I had not read when I first presented my own ideas.) Painters have a 'trained eye', but this is an eye trained in conventions of representation; they are by no means trained to be innocent.

Another way, now quite popular with literary theorists, of responding to our question why artists should be trusted begins by challenging the contrast I drew between the arts on the one side and, on the other side, history, the social sciences, philosophy. Since the early 1970s a number of Anglo-American philosophers have developed positions which can crudely be described as 'idealist' or 'sceptical' or 'anti-realist' and which in various ways threaten such contrasts. Literary theorists seize with particular enthusiasm on the ideas expounded in Richard Rorty's *Philosophy and the Mirror of Nature*, which speaks with an approval few philosophers would share about the style and methods of literary theory. The sociology of knowledge developed by the Edinburgh school and the philosophy of history presented by Hayden White are also admired by many literary theorists – as is Thomas Kuhn's theory of paradigms, for all Kuhn's warning that it applies only to the physical sciences. What is taken to emerge from all these doctrines is that there is no less reason for trusting the writer, including under this category the critic, than there is for trusting the historian, the philosopher, the social scientist or, even, the physical scientist.

This line of argument is sometimes invoked for rather special purposes. So it is employed against the new-style Marxist criticism of Pierre Macherey in France and Terry Eagleton in England, which might roughly be characterised as asserting that literary artists are not to be read as Marx and Engels themselves read them, for what they tell or show us about the society of their time, but rather for what they do not tell us, do not show us, conceal rather than reveal. Traditional Marxism set out to explain why works of art took the form they did by deducing the character of the works from the class relationships of their time. For the sophisticated Marxists, with Althusser's essay on Cremonini as their guide, this is far too crude; it is the fissures, the elisions, in a literary work which Marxism can explain. Nevertheless, such Marxists still have to distinguish between 'the historical facts' and what appears, or fails to appear, in the literary work. This is the point at which critics like Howard Felperin mount their attack. Following Hayden White, he argues that history consists of nothing but a collection of texts – documents which the

historian puts together to form a more or less plausible narrative. To contrast what is said in a novel with the 'actual historical facts' is, then, to appeal from Caesar to Caesar. (I sometimes wonder whether the refusal to distinguish between fact and fiction is a response to the horrors we have lived through in the twentieth century. How consoling it would be to be able to believe that the 1914-18 War, the Depression and its political aftermath, the Holocaust, the Second World War were all of them fictions, my memories nothing more than products of the imagination, the drug-taking and homelessness of the present indistinguishable from an ugly nightmare.)

This is just one of the ways in which some literary theorists – not those, of course, who proclaim that art has nothing to do with truth – seize upon recent intellectual developments to attack the view that as a source of truth art cannot compete with science or history, somewhat as creationists seize upon the phrase 'the theory of evolution' to argue that evolution is just one view among others, with no particular credentials. It is obviously impossible to launch within the confines of this book an all-out attack on the intellectual movements which such literary theorists are now canni-balising. But it might be worthwhile to look briefly at the special case of history.

Suppose an historian wants to discover what size the population of Australia was when the first white settlers landed there. The historian will, of course, make use of personal diaries written by the first settlers, official reports and the like. In a broad sense of the word, these can certainly be described as 'literary' sources. Whereas, however, historical novelists would regard their duty as done if they read such sources, the historian will regard them with varying degrees of suspicion, taking account not only of the actual experience of the authors of these documents but of the audience for whom they were prepared and the likely motive in preparing them. 'To do this', it may be replied, 'the historian will have to use other literary evidence'. Not necessarily so. Historians have had social experience, preparing documents for organisations, reading minutes and the like; this they can draw upon.

Furthermore, they do not simply collect or sum up documents; they set them against one another. They look for evidence which was not in the least designed to provide an answer to the problem they are considering – evidence, let us say, about the location and content of middens, about the death-rate from introduced diseases in communities which had not previously suffered from them. Everything they say is subject to criticism by their fellow-historians. Nobody would pretend that all this secures historians against error, that 'historical evidence' is ever totally unquestio-nable, although there is a great deal it would now be quite silly to question. But if there is a discrepancy between what historians tell us about the date of the Battle of Waterloo and the date we find in an historical novel, it would certainly be foolish to prefer the date given in the novel.

Although, then, it is quite sensible for us to have our reservations as we read the latest historical analysis of the role played by the bourgeoisie in the French Revolution or the latest views about nutrition or cosmology or punctuated evolution as reported in the *New Scientist*, as there certainly is in reading a philosophy journal, and one often has occasion to wish that literary theorists would read, or read about, Saussure, Lacan, Foucault, Derrida in a more sceptical spirit and with some attention to what has been said against them, the fact remains that there are specific reasons for, if never wholly trusting, at least taking seriously what we are told by historians, scientists, even philosophers. Novelists, although to be sure they write in a world of critics, are not subject to ruthless examination in respect to the truth of what they say. So the question still remains why we should in this respect place any confidence in them. Or in the painter, the poet, the dramatist, the film-maker.

After all, we should have to admit – if the word 'art' is used in its broadest sense – that by far the majority of representational works of art deceive us, mislead us, reinforcing the accepted ideologies of our society rather than encouraging the criticism of them, strengthening our illusions. Even works which purport to break through such illusions may in fact do so in a way which reinforces our complacent feeling that we belong to an enlightened minority. They may do nothing to encourage us to re-examine ourselves, our assumption of superiority. Certainly, then, if we 'trust the tale', it ought never be with blind faith, with unquestioning confidence. But if 'trust' is taken to mean total, blind faith, such trust is *never* justifiable. We should retain a residual scepticism even in the case of what we have found to be the most reliable of sources.

'Have found to be?' – well, we have been able to test them in the light of our experience or can at least do so in principle. Perhaps we shall never discover that the *Oxford English Dictionary* cannot always be relied upon when it gives the date at which a word is first used unless we undertake scholarly work in the seventeenth century, never discover that what we took to be a reliable account of Japan is in fact unreliable unless we visit the country. But we have all, I imagine, had some occasion to find unreliable a source of information on which we have been accustomed absolutely to rely, if it is nothing more than a timetable. When we first read novels we swallowed them whole. If the Indians, the Puritans, the French revolutionaries were in those novels always villainous, if the explorers, the Cavaliers, the aristocrats were always models of heroism, that is the way the world was for us. What we learnt over time, in the light of experience, was caution, not to trust every tale.

Critics may sometimes help us to see through pseudo-profundities, sentimentalities, to detect ideology-driven falsifications. Yet critics, too, we have to read with caution. In the long run, we have no defence except our own critical powers and our own experience. Artists, it is often said, can enlarge our experience. That is surely right; they can enlarge it as

well as correct it, put it into focus. But it is only in so far as we can cross-identify art with our other experience that we can judge whether to trust a particular artist, judge whether Daumier is simply malicious, Steinbeck merely a propagandist. As Kenneth McLeish says, discussing Faulkner: 'It is hard at times for non-Americans to believe in the verisimilitude of all these inbred relationships, blinkered and steamy emotions.' A Mississippi reader might have similar problems with the novels of Evelyn Waugh or Anthony Powell. Yet sometimes we do know that what is being enlarged, focussed, corrected, is indeed our experience, that the author has 'got it right' although we have never previously got it right ourselves. Or we see, perhaps with astonishment, that a painter has got a landscape right which we thought we knew, or how unconcerned ordinary people can be with an event to which great significance is normally ascribed, whether it be the fall of Icarus or the crucifixion of Jesus.

How is it possible to sum up the argument of the last two chapters, hemmed in as it has been by reservations, admissions, hesitations? Well, in the first place, I rejected the view that there is any general relationship between the serious arts and 'truth', in any of the manifold uses of that word. I confined that relationship to the representational arts, denying that music or abstract painting give us access to 'higher truths' or that architects, in their buildings, 'make statements'. So far as propositional, or statement-making, truth is concerned, I could also not find it in painting – except, of course, in the case of those painters who scrawl sentences across their canvasses. I did not accept the view, recently expounded, that to pose a scantily clad girl alongside a picture of a car *says that* buying the car will make such girls available, although it does *suggest* this and could be described as 'misleading', just as it is misleading for a man to wear a military medal to which he is not entitled. There are very many ways of misleading which do not involve the making of statements.

Literature does contain statements and some of them are intellectually interesting. I rejected the view that even if this is so their intellectual interest is irrelevant – always – to the seriousness of the work in which they appear. Generally, I however agreed, what is more relevant is what we are *shown through the use of* the statements which appear in the novel, play, poem, or film. Considered in themselves such statements may be banal or false and their being so may be just what makes them important. Or we may not have to consider them at all from this point of view, understanding them, without judging them, being all that is needed for us to grasp what we are being shown. Painting, sculpture, ballet, theatre, have their own ways of showing, which in the case of theatre, or film, may or may not involve the making of statements. Something is commonly shown to us as soon as we see what is on the screen or the stage, before a word is spoken.

Art, I have said, concentrates the mind through its imaginative power, the particularity of its detail, its force. It can show us that what we like to pretend to exist does not exist, that what we like to pretend not to exist does exist, how it is possible to see, and to feel about, the world quite differently from the ways in which we have been taught to see and feel. But we are not compelled to accept the artists' ways of seeing and feeling. They see but are not clairvoyants, have, like us, eyes and minds but not an inner light, offer us, as Althusser has said, grounds for reflection rather than knowledge. Their vision is often fitful, as in the case of philosophers; like the rest of us, they are not all of a piece. They have demands to meet, not only from publishers and audience, but from within. That is the truth which lies behind deconstruction. We have to work to see what they show; it may not be what they are thrusting at us, not, as in Brueghel's painting, the peasant in the foreground but the tiny, falling figure in the rear, not Milton's description of Satan but what Satan says and does, not how Pamela describes her feelings but how she acts.

8

Art and Morality

'Art,' John Dewey once wrote, 'is more moral than moralities.' A fine resounding statement, typical of pronouncements about the arts in the width of its range and the apparently paradoxical character of what it says. Yet, unlike most such pronouncements, it might turn out to have a degree of sense. Of course, it must first be observed that Dewey can only be using 'art' in an honorific sense. For a substantial segment of telic art is devoted to the illustration and encouragement of some particular morality to which it deliberately subordinates itself. And although entertainment art sometimes jokes about an accepted morality and may appear to subvert it, this is not, in any possible sense, in the interests of being 'more moral'. Usually, in fact, the entertainer's joke is like the 'in-joke' which the religious sometimes allow themselves, which is not in the slightest degree subversive of accepted beliefs but is rather a safety-valve, a miniature saturnalia.

One can safely presume, then, that Dewey is talking about the kind of work of art which I have labelled 'serious'. If this be so, and Dewey's claim turns out to be defensible, it will justify that description of them. For to be 'more moral than moralities' is certainly to be worthy of serious consideration. It is scarcely news, however, that the claim of such works to be moral at all, let alone to be supremely so, has been bitterly contested, at least since Plato's time.

Those hostile critics of art who fasten on its immorality fall into three classes. At the extreme point lie those who criticise, in every respect, the artistic enterprise: the way artists live, the nature of their works, the effects of those works. Secondly, and less broadly, there are those who object only to the representational arts – or certain particular representational arts, such as painting or theatre, then sparing music and unadorned architecture and sacred poetry from their strictures. Many seventeenth-century Puritans fell into this category. Thirdly, and much more commonly, there are those whose objections are only to particular works of art, singled out as being morally offensive.

Let us look first at the most general objections, where the defence is easier because the charges are so broad. One such accusation I shall set

aside because this entire book is an attempt to refute it, namely that art is trivial, of no real consequence, so that to make the creation of art, or the criticism of art, or the enjoyment of art, a central part of one's life is immorally to waste time which ought to be devoted to serious matters. Tolstoy says as much in respect to all except a small sub-section of art; it is a by no means uncommon view among practical men of affairs. One cannot hope successfully to respond to it except by showing in detail how art can be serious.

A second objection is in some ways more troublesome, that art is a waste not so much of time and energy as of feeling. It goes back at least to Augustine, to his remark that the spectator at a drama 'is not moved to succour but only to grieve'. In Oscar Wilde's *Intentions* 'Gilbert' uses a similar contrast to argue that from the standpoint of the everyday practical man all art is immoral. For art, Gilbert says, is 'emotion for the sake of emotion', whereas from the practical, as distinct from the contemplative, standpoint, morality admits emotions only 'for the sake of action'. How are we to reply to this?

I do not think it possible to deny that the contemplation of art can sometimes be a substitute for action. This is not necessarily a vice. Only for Fascist Romanticism is action necessarily virtuous, simply as such. Aristotle ascribed to tragedy the catharsis of those emotions which are 'perilous stuff'; he saw in it, in other words, a prophylactic against the more terrible forms of action. Again, although admittedly we can do nothing for Hecuba, the feelings aroused by her plight can pass into action in a comparable case, which we might otherwise ignore. We can be led to realise for the first time through reading a novel, watching a play or film, just what harm we have been doing or just what succour we could offer – realise this through the feelings that have been aroused in us. That this does not always happen is not a strong argument against art. Watching an actual event can also arouse feelings which do not pass into action, or, for that matter that, listening to a preacher.

Finally, if art offers us a respite in a world that is too much with us this is not necessarily a ground for condemning it; the free play it offers to the feelings and the intellect can refresh without drugging. In short, it is not a fatal objection to art that it can arouse feelings without necessarily stimulating us to action. Telic art fails if this is its final effect, serious art does not.

A more fundamental general objection is metaphysical in character. It is summed up in Plato's rebuke to 'the lovers of sights and sounds', a rebuke which still echoes through the western world. We can formulate it thus: the arts remain at the sensory level – I say sensory rather than the more traditional 'sensual' or 'sensuous' because those words are now morally loaded, as one side-effect of metaphysical Puritanism – and it is our task as human beings to escape from the bondage of the sensory, a bondage which art, in contrast, makes more powerful by rendering it in

an attractive form, gilding our chains. On the face of it, this objection applies to music, painting, ballet, cinema far more than to the novel, where the sensory surface of prose rhythm is, if not unimportant, still scarcely as conspicuous sensorily as is the flow of sound in music or of shapes and colours in painting. Nevertheless, the novel certainly concerns itself with sensory particulars – even if, I said, that does not prevent it from showing us something universal. It is set in a particular place and time, whether real or imaginary, whether lightly sketched or described in detail.

One way of responding to a Plato-style critique I have already discussed in more than enough detail: the view that Plato was wrong in asserting, and I was wrong in agreeing, that artists concern themselves with sights and sounds. What is sensory, on this view, is just the surface of the work of art, a ladder which can be kicked away once it is climbed, a means to higher things. Any such approach, I have argued, leads in the end to mystification and to a depreciation of the actual work of art.

What is wrong, I should rather ask, with being a lover of sights and sounds? To enjoy specific places, times, persons, to detest their physical degradation – all this can be a moral protest against the attempt to write the world off as but an image of eternity, an image so deeply flawed that we ought not to enjoy it but only to use it, in Augustine's famous phrase, so often interpreted as meaning that nature exists only in order to be exploited. The painter, the poet, works on the very different assumption that nature is worthy of being celebrated. 'Poets,' Schiller wrote, 'are the guardians of nature.' So they are, or so they can be, the painter as much as the poet. They are the guardians, more generally, of individuals, of Blake's 'minute particulars', of Hopkins's 'dappled things'. The film is from this point of view one of the most morally important forms of art; in its capacity to direct our attention to little things Gabriel Marcel rightly saw its 'redemptive power'.

The arts do not offer us this kind of moral assistance by preaching, as they are sometimes tempted to do. Then one finds exhibitions like the formidably named 'Künstler demonstrieren den Umgang mit der Kunst, ihre Herstellung und Betrachtung', which rightly bored Hamburg in May 1975 with its banal messages scrawled across feeble paintings. It is rather by painting, by writing, by making films which help us to see what the things around us are like that artists contribute to their preservation. Of course, there have been painters who hate all this, particularly modernists. Mondrian set out to denaturalise. He saw in 'denatura-lisation' one of the 'essential points of human progress'. The critic Clement Greenberg told us rather differently that we now have no time for the contemplation of nature and that sensuous art is incompatible with the spirit of our times. I hope we have come to see just how destructive not only to nature but to ourselves such attitudes can be. If the modern world leaves us 'no time to stand and stare', so much the

worse for it. Fortunately, in fact it does this only if we prefer to spend our time in other ways, like 'keeping up' or 'making it'. The love of what lies around us and the art which brings out its sensory quality is not just an ornamental sentiment. It has a moral character.

Except for those who see every particular existent as so irretrievably fallen that to enjoy it is to come to terms with Satan, there is at least no vice in the enjoyment of 'sights and sounds'. (I have put the matter much more strongly than that.) Vice flows more often from adherence to abstractions, whether in the killing fields of Kampuchea, the horrors of the Gulag Archipelago or the Holocaust or, indeed, in everyday life when people are thought of as a 'Nobody', or as 'just a broad'. In virtue of their emphasis on sensory particulars, the arts can help to destroy such abstractions, whether in the form of stereotypes or ideals. Jane Austen does this as surely, in her own way, as Wordsworth does in *The Prelude* or Orwell in *Nineteen Eighty-Four*.

One should however add that, as Hegel saw, the work of art is not just a sequence of sensations, William James's 'blooming, buzzing, confusion'. It is ordered. In virtue of that fact serious art helps us to see that particularity and order, sense and form, are quite compatible. For its order is the ordering of particulars, not the formal, argumentative, ordering characteristic of science and philosophy, which themselves, of course, are far from being identical in the type of ordering they display. Each art, similarly, has its own characteristic ways of ordering, which are by no means fixed from time to time, from place to place.

There is no point in denying, of course, that to devote oneself to art is indeed, from the standpoint of an idealist metaphysician, to devote oneself to a 'passing show'. The Manichaean theologian might, in a deeper sense than is customary, call art 'one damned thing after another'. But this 'passing show' is not, as the artist reveals it, total chaos. And it is after all the life in which we participate as moral beings, making moral decisions, unless we see our sole moral salvation in a life of total withdrawal from the world. Then we shall naturally condemn art as a distraction, but no more so than everyday morality in so far as that imposes upon us the maintenance of human relationships.

So much for the general moral arguments against art. What now for the particular arguments against the representational arts? The most familiar such charge is that the artist is a liar, the work of art a lie, its effect not to educate but to mislead. We have already argued that this is a groundless charge. That does not clear the representational arts of all possible moral accusations, but it does dispose of a principal ground on which they have been singled out for disapproval. (The Muslim objection to both representational painting and to poetry I shall have to ignore, as theological rather than moral. Not that a Muslim would grant the distinction.)

Let us turn, then, to the third, and, as we said, by far the most common,

line of criticism, directed only against particular works of art, condemned as being depraved, corrupt, or, at the very least, morally offensive. For our present purposes, this would not disturb us if the works in question were mere entertainment or purely telic art. In fact, however, works of art about the seriousness of which there can be no real doubt – *Ulysses* is a classical example – have found themselves condemned in these terms. In the 1930s the Australian Customs Department was by no means unique in laying it down that books were permitted to enter the country only if 'the average householder would accept the book in question as reading matter for his family' – the 'average householder' meaning, in practice, the Irish Catholic or evangelical Anglican household. Paintings, films, the theatre were no less restricted; this was substantially as true of Great Britain and the United States as it was of Australia. The Australian Customs rule was established in 1930; in the United States, Dewey wrote his *Art and Experience* in 1934. Is Dewey's 'art is more moral than moralities' just one of those desperate counter-statements to which the beleaguered are sometimes driven? And is that much-banned painter and novelist D.H. Lawrence being hypocritical, or indulging in paradox, when, writing about Whitman, he tells us that 'the essential function of art is moral, not aesthetic, nor decorative, but moral'?

I shall approach that question by considering in what ways we might try to defend serious works which are condemned for immorality without departing from what I shall label 'conventional morality' – as a shorthand for the moral framework from which the 1930s censorship arose and which is by no means dead in our society, in the East, or in the Soviet Union. Sometimes the attacks are directed against the content of the work of art, sometimes against the supposed effects of encountering it, the two being, of course, closely associated in practice.

If the representational arts, as normally the battle-scene between artist and censor, must be our principal concern, such arts as music and architecture have not gone entirely unscathed. In *Measure for Measure*, Shakespeare has the Duke say of music that it

> oft hath such a charm
> to make bad good, and good provoke to harm

where, I take it, 'bad' means 'the bad' and good 'the good'. He would not agree with Dr Johnson, then, that listening to music is 'the only sensual pleasure without vice'. The Duke's remarks are, however, in response to Marina's apology for singing and are prefaced by ''tis good' – good that she had been doing so. The question his remarks raise is whether all music can have a morally malign effect or whether, as Plato certainly thought, only certain types of music 'make bad good, and good provoke to harm' and, beyond that, whether serious music can confidently be placed within the class of morally harmless, or perhaps even morally helpful, music.

Serious opera has certainly been attacked as immoral, where, as so often, we can substitute 'sexual' for 'immoral'. But here the literary associations are strong. One is not at all surprised to find the London *Times* thundering, on its first appearance, against *La Traviata* or even that a New York reviewer should write of Shostakovitch's *Lady Macbeth of Minsk* that Shostakovitch is 'the foremost composer of pornographic music in the history of the art'. For their libretti deal with forbidden subjects. (Even so, Kate Stanley, Bertrand Russell's mother, was permitted to see *La Traviata* at the age of sixteen but was not allowed to read beyond the first two books of *The Mill on the Floss*.)

In most societies music has been indissolubly united with dance or song. In our society, music can exist in a pure form but the connection with words and physical movements is still strong and can spill over into pure music, appearing there as a reminiscence. There is no difficulty in seeing how bodily movements or the words of songs can be offensive to conventional moralists. Once the associations have been firmly fixed between particular musical rhythms and particular dances, or particular ribald songs, the moral objections could be carried over to pure music which makes use of these rhythms. Perhaps that is why Boulez once described Messiaen's *Turangalila* as 'brothel-music'. Or was the suggestion no more than that Messiaen was pandering to the tastes of his audience?

I cannot in fact think of any uncontroversially serious pure music which has been banned on moral grounds. When such music has been banned, it has normally been on nationalistic grounds – as being in the 1914-18 War German, as being in Hitler's Germany Jewish. American dance music did, however, meet that fate, and sometimes as being morally decadent. Gorky once described a jazz-band as 'conjuring up an image of madmen, sexual maniacs, led by a man-stallion beating time with an enormous phallus'. Scarcely a form of entertainment suitable for the conventional moralist!

Still, Plato and the modern totalitarian states might have been right in thinking that even uncontroversially serious music could be destructive of established moral conventions. One of the most striking criticisms of music is put into the mouth of Pozdnyshev in Tolstoy's *The Kreutzer Sonata* and can almost certainly be ascribed to Tolstoy himself. 'In China,' he says, 'music's an affair of state. And that's the way it ought to be.' This was Plato's view, too, but in Tolstoy, the reference is to music which is entirely wordless, Beethoven's Kreutzer sonata. There is no suggestion either, as there is in Plato, that certain specific rhythms ought to be banned, an attitude which may derive, we suggested, from the particular associations of these rhythms. The condemnation is related, rather, to the power of music to stimulate emotions – emotions which, the argument runs, can be deeply disturbing if they are not allowed to flow into action, as they are if a person dances to dance-music, marches to the

music of a military band, takes communion when stirred by religious music. The Beethoven sonata ought not to be played 'in a drawing-room full of women in low-cut dresses', to be followed by trivial talk, but only on 'solemn, significant occasions when certain solemn actions have to be performed'. Otherwise 'the generation of all that feeling and energy, which are quite inappropriate to either the place or the occasion, and which aren't allowed any outlet, can't have anything but a harmful effect'. It is not, then, that the feelings are wasted, as Augustine objected, but that they are positively dangerous.

This would suggest that it is not the music itself but rather its performance on specific occasions which is morally amiss – the modern concert, where people are jammed together to listen to music, would certainly be objectionable on these criteria, perhaps the classical concert even more than the pop-concert. But Pozdnyshev would certainly not want to say that it would be morally better if male listeners made sexual overtures to those 'women in low-cut dresses' he so significantly particularises, appropriate to the music as that behaviour might be. Nor would he approve of juvenile behaviour at pop-concerts. For Tolstoy, at least, going to war as a reaction to military music would certainly be morally objectionable, however appropriate it might be as a reaction to the music. It looks as if he would have to argue that music was morally objectionable either when, although the feelings it arouses are not themselves objectionable, they cannot be acted out on the occasion of the music's performance or when the acting out would be reprehensible in itself.

The implication here, however, is that music is essentially telic, that there is some form of action which it incites us to, which has to be performed if the music is not to arouse in us the feeling that we are being thwarted. There are such kinds of music; one can sometimes see people looking thwarted because they cannot dance and moving in response to the music as a substitute. Or some kinds of music may stimulate humming, as if it needed to be sung. Given the associations of music with dancing and song, with war and religion, such responses are not surprising. But if, in relation to most serious music, we were asked: 'What type of action does that music demand of you?', we should have no reply to offer – or no reply other than 'Listening.' Although Tolstoy is talking about a serious piece of music, the most we can make of what he says, and many would agree with this, is that such music demands a degree of concentration which makes it unsuitable for drawing-room performance. One can add, of course, in terms of what I said earlier, that music can be both serious and telic; we can listen in solitary enjoyment to music which *was* designed for drawing-room, or even dining-room, performance or had a religious or civic function. To listen in such a way has nothing morally perverted about it, by the standards of conventional morality.

Architecture is a very peculiar case. It is, of course, sufficiently obvious

that architects can behave immorally in the practice of their art, can deceive their clients about the way their building will look, how it will work, the durability of the materials, and so on. One can readily imagine, too, objections on moral grounds to buildings, such as some Hindu temples, which incorporate sexual detail whether as ornament or in the actual shape of the building. In no other way, I think, would it occur to an ordinary onlooker to criticise a building in conventional moral terms. Yet at least since Ruskin described Renaissance architecture as 'morally corrupt', architects and architectural theorists have quite regularly done so, as David Watkin has amply illustrated in his *Morality and Architecture*.

This is often linked with their tendency, on which we have already remarked, to use adjectives like 'true' and 'false' of buildings. So buildings are described as 'honest' or as 'sincere' where the idea of truth-telling is predominant. Twentieth-century architects have been particularly given to such moral judgments. James Stirling has, he tells us, a 'deep conviction of the moral rightness of the new building'. And Marcel Breuer particularises that 'the sincere expression' of a building's structure is 'a sort of moral duty'. Why it should be thought 'insincere', to take a case, for a building to use as a façade columns which obviously do not support, which are obviously ornamental, is never made plain. A sort of Puritanism is at work here, except that it was only the weirdest sects who took nakedness to be a sign of sincerity.

Suppose we could find a way of making visible, as we walk around, the workings of all our organs. Would this amount to our becoming more sincere? Are aborigines being insincere when they apply body paints? Surely not. Then why should it be considered insincere to ornament buildings or to conceal their pipes and ducts and wiring? To call the Pompidou Centre 'fun' is one thing, to call it 'honest' quite another. Sincerity, understood as candour, truthfulness, is an admirable quality in an architect when it is in response to a client's question about how a proposed building is to be held together, where space is to be found for pipes, how well the surface will last. It by no means follows that such moral adjectives as 'sincere' can properly be applied to the buildings themselves, that since they have successively been applied to Gothic, neo-classical and 'international modern' architecture we should carefully consider to which of these they in fact apply; that would be a total waste of time. In a 'high-tech' building it can be useful to be able to see where all the pipes are and to be able to replace and repair them without too much difficulty, just as in a severely cold climate it can be useful to protect them. But neither policy serves to moralise the buildings in which they are adopted. When, as happened in the 1930s, local authorities banned both modernist books and modernist buildings, it was not because the books were unconventionally styled or the buildings immoral but contrariwise – except in so far as the conventional moralist sometimes

has a suspicion that innovation of any kind is a threat to morality.

The attempts of architects to claim that their kind of architecture is peculiarly moral sometimes take a form even more absurd than the ascription of 'honesty' and 'sincerity' to their buildings. So, as a contribution to the desperate battle of modernists against post-modernists, I have seen it alleged that morality consists in 'keeping up with the times' and that this is the essence of modernism. In thus identifying morality with contemporaneity, the architect has moved far away from conventional morality, or, indeed, from any morality in the least degree plausible. It would make of the most egregious time-server a moral model.

A more plausible view arises out of the urban conscience which some architects have recently developed, or at the very least, a degree of conscience about what their buildings are like to live in, as distinct from their success whether as a form of sculpture or as memorials to their own, or to corporate, grandeur. A moral building, it is then said, is one which helps those who live in it to live a better life. However 'better' is defined, I certainly should not wish to question that the kind of building an architect constructs can sometimes help those who use the building to live a better life or can make it more difficult for them to do so – just as, another point that has been made, architects can build so as to 'save energy', something we may take to be morally desirable. If in most cases the moral effects of living in one kind of house rather than another are no doubt marginal, they are sometimes significant, as the sorry history of post-war housing schemes has made only too evident. But even when the architect has deliberately set out to construct a building with this in mind, or has on the other hand completely ignored such considerations, it is natural to ascribe the morality, or immorality, to the architect rather than to the building itself. If we regard the Begijnhof in Amsterdam or a London square or a modern garden-suburb development as being places where people could live better lives, it would nevertheless be very odd to look at them and say, 'What moral buildings!' Quite certainly, there would be no reason for what I have called a 'conventional moralist' to say this, but even a Utilitarian would think of architects as acting rightly or wrongly when they design such a building rather than of the building itself as having moral characteristics.

With the exceptions I noted, then, I see no reason for believing that conventional moralists can find anything either to object to, or to praise, in architecture, as distinct from the behaviour of architects. About serious music I am less confident if, as is generally asserted by conventional moralists, the power to arouse sexual feelings is subject to moral condemnation. Certainly, though, conventional moralists do not appear to find serious music at all threatening, except when it is combined with words and actions, as they often do find plastic arts and literature threatening, including under these general heads film, theatre and ballet.

In 'The Art of Fiction' Henry James admirably summed up the

conventional attitude when he wrote: 'There is a traditional difference between what people know and that which they agree to admit that they know, that which they see and that which they speak of, that which they feel to be a part of life and that which they allow to enter into literature.' James goes on to suggest that the willingness of English novelists to conform to this tradition – and he had earlier spoken in the same breath of the novel, painting and sculpture, to which we could more obviously add the theatre and poetry – is a sign of 'moral timidity', a lack of the 'moral energy' which would wish 'to survey the whole field'. In the eyes of conventional moralists, in contrast, silence on these points is precisely what is morally called for.

We can particularise what James wrote in something like the following manner: conventional moralists condemn any works of art, serious or not, which

(a) fail to show vice as punished and virtue as rewarded;
(b) show, describe or suggest what ought to be concealed;
(c) use language or symbols which ought not to be employed;
(d) depict as immoral groups who are *ex officio* moral.

There will, of course, be considerable variations from society to society in respect to what counts as 'virtue' and 'vice';, in respect to what ought to be concealed, what linguistic usages are forbidden; the members of what groups are *ex officio* moral.

In the Soviet Union certain political leaders – Lenin, for example – once fell into this category of the uncriticisable as did, from time to time, other persons and organisations. In the United States, the notion that there are persons, or kinds of person, who must not be depicted as immoral has a narrower range. Nevertheless, the film depiction of Jesus as someone who could be sexually tempted aroused a very considerable outcry and a demand for banning, even if not, as in the Muslim world with Salman Rushdie's *Satanic Verses*, a demand for execution.

My concentration, for reasons of economy, will be on modern Christianity-dominated Western societies. Most often, the forbidden language, symbols, things that ought to be concealed are of a sexual character – although within such societies there are considerable differences in attitudes both to nudity and to obscenity, to take only the most obvious instances, as there are also very great differences over time. Even Tolstoy, although his sweeping moral objections to almost all of what we normally think of as being serious art mainly rest on other grounds, offers us in his *What is Art?* a condemnatory description of a quite normal opera ballet in the following terms: 'half-naked women make voluptuous movements, twisting themselves into various sensual wreathings.' (This is by no means wildly inaccurate, but the luscious tone is very characteristic of conventional moralists, whatever their political or religious persuasion.)

The most uncompromising response to such censures comes from Oscar Wilde, that they have no possible relevance to works of art. For 'the sphere of art and the sphere of ethics', he tells us in 'The Critic as Artist', 'are absolutely distinct and separate'. Confronting art, he adds in the conclusion to *The Picture of Dorian Gray*, we must turn off our 'ethical sympathies'. Conventional moralists are unlikely to be assuaged by this reply. They will not allow that any human action, any human creation, is free from moral judgment, that there is any Alsatia in which Art can find sanctuary from its writ. And why, indeed, should art be thus privileged? In a more moralistic age, critics used to defend Restoration Comedy by arguing that it was neither moral nor immoral but amoral. We could absorb Wilde's utterance into this doctrine. From the point of view of a conventional moralist, however, amorality is worse than immorality. There is hope for the immoral, who may be suffering from no more serious defect than a weakness of will, to which all human beings are in some measure subject. To set oneself above morality, in contrast, is to commit the sin of intellectual pride, Satan's sin.

In the conclusion to his *The Psychology of Imagination* Sartre none the less tried to justify a Wildean position, if on metaphysical grounds. It is stupid, he says, to 'confuse the moral with the aesthetic'. The stupidity lies in the fact that moral judgments relate to what has 'being-in-the-world', they concern 'action in the real', whereas the work of art has no being-in-the-world, as a purely imaginary object. We need not explore Sartre's total view, or consider the difficulties he has in denying that music and architecture have any being in the world. Let us concentrate on the most plausible case, literature. If his theory does not work there it will not work anywhere.

Molly Bloom, we should certainly have to agree, is an imaginary person, with no being-in-the-world; her monologue is not a record of actual events. Do these considerations release her actions from moral judgments, or Joyce's action in creating her, or our action in reading what Joyce has written, or any consequences which flow from that reading? Is it a sufficient reply to the vigilant moral censor: 'But Molly Bloom is a figment of the imagination'? Clearly not, from the standpoint of conventional Christian morality, the standpoint we are at the moment accepting. Even to imagine oneself as doing what one ought not to do, entertaining thoughts of sexual encounters, to take such a moralist's favourite example, is on that view a breach of morality. In so far as Joyce, in order to create Molly Bloom, has to entertain such thoughts, in so far as the reader, in order to interpret what Joyce has written, has to entertain similar thoughts, both reader and writer are subject to moral censure. That Molly Bloom is an imaginary being does not affect the issue. If her monologue were to turn out to be a precise recording, the moral position would be completely unchanged, so far as author and reader are concerned. Even if we were to agree with Sartre that

imagining has no being in the world – and why should we? – the act of writing, the act of reading, the act of painting, the act of looking at a painting can scarcely be so described; we can observe them, place them and date them exactly. On the face of it, they are as subject to moral censure as any other act.

Such a Wildean defence, furthermore, weakens the claim of the arts to be taken seriously. As Henry James observes, it is an insult to literature. The evangelical, the socialist realist, at least take art seriously as a moral force. To suggest that when we read about the actions of a fictional character we should turn off our faculty of moral judgment would rid literature of much of its interest. For that interest often lies in the revelation of some moral obliquity or the depiction of moral conflicts. Sartre's own plays constantly demand such judgments from us, as does *The Picture of Dorian Gray*. Indeed, our complaint about both Sartre and Wilde might well be directed against their too explicit moralism. Of course, there are moral judgments which are inapplicable, just because the situation is fictional, judgments like: 'I ought to stop Hamlet from treating Ophelia in that way.' But such judgments as: 'Shakespeare ought not to have written a play in which a woman character is treated in that way' or 'No one ought to read a book in which a woman is thus treated' are by no means obviously inapplicable, as feminist critics regularly remind us.

This example reminds us that the new moralism, for which the deadly sins are sexism, racism, elitism and the like, can be quite as hostile to what has traditionally been counted as serious art as is conventional moralism. So both *The Merchant of Venice* and *The Taming of the Shrew* have found themselves banned; if ageism is included in the list of sins *King Lear* will have to go. *Othello* is certainly suspect, as, I have suggested, is *Hamlet*. The Bible is clearly sexist and has already, in at least one case, been prohibited for school-reading on that ground. In all, the new-style moralists could wreak greater havoc than conventional Christian moralists have ever done. This is so, at least, if they share the assumption of the older moralists that both the depiction of sin in any but an unfavourable light and the creation of works which might arouse sinful thoughts must be prohibited and if they can attain to positions of sufficient power to make their views politically effective, whether in schools or in the community at large.

A second possible defence of the view that moral considerations, new or old, cannot properly be used to condemn serious works of art is suggested by the now-familiar judicial phrase 'redeeming artistic value'. The concept of 'redeeming' is, however, anything but perspicuous, except in its, here irrelevant, pawn-broker's context. If we interpret it in the light of that dictionary entry which defines 'redeem' as 'to make up for, compensate for, counterbalance (some defect or fault)' then to speak of a 'redeeming value' is to grant as against Wilde that the redeemed work

does have a moral defect or fault, that it is morally wrong for it, let us say, to depict or describe sexual intercourse, but at the same time to suggest that this moral defect is somehow compensated for by the artistic merit of the work within which it is contained. This implies, however, either that there is a calculus within which literary merit and moral defect can be compared or, alternatively, that even a tincture of artistic merit outweighs any kind of moral defect.

Neither of these assumptions will the conventional moralist allow. Moral defects, such a moralist will certainly argue, cannot be outweighed by any sort of artistic merit or indeed by anything at all except moral virtues. For – a view now sometimes taken to be an analytic truth – it is essential to morality that its claims are pre-eminent. If to the statement 'you ought not to steal' the reply is permissible 'but there's a lot of money involved', this is a rejection of morality, not just a decision to let moral considerations be outweighed by pecuniary gain. Kant wrote an essay on 'a supposed right to tell lies from benevolent motives'; he would be even harsher on a supposed right to depict immorality from artistic motives. *Romeo and Juliet*, such a moralist might adamantly say, is a play about premarital juvenile sex. That it contains some beautiful poetry only compounds the offence, lending a surface gloss to the morally indefensible.

The Williams Report on Obscenity and Film Censorship sums up the situation very well: 'Many pointed out to us the assumption embodied in the present law, which they found extraordinary, that there could be a work which tended to deprave and corrupt those who read it, but that, at the same time, it could be for the public good that the work be published – as though it could be for the public good that readers be depraved and corrupted, so long as it was by art.' The conclusion some witnesses drew, that this paradox could only be resolved by prohibiting whatever tends to deprave and corrupt, however striking its artistic merits, is the natural moralistic conclusion. But there were other witnesses who argued, in reply, that 'what was of genuine artistic or literary merit could never be capable of depraving and corrupting'.

Perhaps, in the light of this last comment, we should look again at the concept of redemption. To redeem, it might then be said, is not simply to compensate for fault but to free from fault. 'Redeeming artistic merit' signifies that what would be a moral defect were it not for the fact that what is being judged is a serious work of art ceases under these circumstances to be a defect. Its literary or artistic merit not only excuses its capacity to corrupt but actually abolishes it.

The depiction of, let us say, sexual intercourse in a serious painting or a work of literature, so we are then told, changes the moral character of the act of contemplating it. That was the Schlegels' view and it was restated in D.W. Prall's *Aesthetic Judgment*:

Beauty transforms the surface of what might be in itself merely unclean or unchaste or unholy, into what may be still unlovely in itself, and yet so holds our eyes to its beautiful surface that it seems purified of its evil, as actually happens in a work of art, where it is just this surface that specifies the whole beauty and significance of the object.

Such a statement of the case for artistic redemption more naturally applies to the plastic arts than to prose, where it is not at all plausible to argue that the aesthetic qualities of its surface account for its 'beauty and significance'. (Poetry in an intermediate case.) Prall has his own ways of dealing with this problem, which we shall not explore.

Once more, let us concentrate on the most plausible instance – that what would be, were it not the subject of a painting, unclean or unchaste or unholy is purified by the beauty of the painting's surface. Others would say, to extend this thesis without departing from its spirit, that it is purified by its formal qualities. (I was once looking in Washington at an exhibition of R.B. Kitaj's paintings, consisting to a considerable degree of spreadeagled female nudes, while the guide talked solemnly to groups of mid-Western visitors about the formal values in Kitaj's paintings, entirely ignoring their sexual content. This was by no means a unique occasion.)

Or again, literary and historical values have sometimes been called upon to supplement formal beauty as a redeeming factor. So in nineteenth-century England the taboo against the exposure of the naked figure did not apply to paintings, provided not only that the surface was sufficiently luscious but also that the nudity was justified by its reference to some occasion in history or classical literature, especially a Biblical tale. Any such attempted justification, the conventional, or the feminist, moralist would reply, is just a species of hypocrisy; the formal values, or the beautiful surface, could as well be exhibited in quite other themes. It is not necessary to portray pictorially Lot and his daughters, or Susannah and the Elders, let alone Mars and Venus. Far from purifying evil, the moralist might add, such paintings bestow on it a meretricious attractiveness, offering us a moral holiday, under apparently respectable auspices, to which we are not at all entitled.

To such accusations Samuel Alexander replied in his *Beauty and Other Forms of Value* that 'if the nude ... is so treated that it raises in the spectator ideas or desires appropriate to the material subject, it is false art and bad morals.' No serious work, that is, however nude, could possibly be objectionable on moral grounds. As Kenneth Clark comments in *The Nude*, 'This high-minded theory is contrary to experience.' He takes the quite contrary view that 'no nude, however abstract, should fail to arouse in the spectator some vestige of erotic feeling, even although it be only the faintest shadow – and if it does not do so, it is bad art and false morals'. Can we imagine, indeed, any pictorial treatment of the nude or of

sexual detail in literature which can be completely relied upon not to arouse ideas or desires appropriate to the natural object, whether these be attraction or repulsion? The small boys in Brusati's film *Dimenticare Venezia* who used nudes by Goya and Titian as if they were pinups are scarcely untypical; Shakespeare has long been leafed through for the 'dirty bits'.

The Schlegels no doubt had such facts in mind when, defending the view that 'the adoration of beauty is the most powerful of all counters to base lust', that 'all higher plastic art is therefore chaste, irrespective of its object', they dismissed the 'incidental effects' of works of art, loftily remarking that 'in dirty souls even a vestal virgin can arouse sensual desires'. That reply does not suffice as a defence of Alexander's generalisation that only bad art can possibly arouse in the spectator 'thoughts appropriate to the natural object', or the view that works of art cannot by their very nature deprave or corrupt. One has only to read Victorian critics of Victorian novels to realise that sexual agitation can be aroused at a very low level of exposure indeed. The censor, for that reason, is never satisfied.

We might, of course, wish to distinguish between works which are deliberately designed to be sexual stimulants and those which are not so designed. But, although it would, on the conventional view, subtract from or remove the blameworthiness of artists that they did not mean to create a work which would deprave and corrupt, it does nothing for the members of their audience or for the work itself. If they have accidentally created an occasion for sin it still remains an occasion for sin, and therefore an immoral work, which should be removed from public display or sale, however innocent the artist was in intent.

There is also a second point, suggested in Clark's remarks, and explicitly made in the Williams report. Although there are obviously books, paintings, films, which have but a single intention, that of arousing sexual feelings, or being an aid to masturbation, there are other works, worth taking seriously, which have the arousing of sexual feelings as part of their intention. Some paintings, some novels, some poetry, much sculpture and many films would have to be regarded as failures if we did not respond to them in this way: Rubens, Renoir, Rodin, Wagner's *Tristan*, the poetry of Catullus, the architecture at Konarak, statues of Aphrodite, will suffice as examples. 'The devoted poet,' Catullus once wrote (Poem 16), 'remains in his own fashion chaste; his poems are not necessarily so. They may well be lascivious ..., stimulants, indeed, to prurience.'

The intended responses to the depiction of sexuality may, of course, be adverse as well as favourable. Many writers, many painters, are deliberately 'offensive', as Swift is, or Goya, or the German expressionists. If we do not respond to them with 'the ideas or desires appropriate to the material subject', they have failed. So the German

expressionist painters put before us meretricious sex, both in the etymological and the modern sense of that word; we are to be disgusted by it. From the standpoint we are considering, this would not save them from condemnation. Even the fulminations against sensuality of such Church fathers as Clement of Alexandria were, by the representatives of the moral outlook I have been considering, left untranslated in nineteenth-century English translations of their works – on the odd assumption, scarcely borne out by experience, that anyone who could read Latin was incorruptible. In the same century, Tolstoy's *Kreutzer Sonata* aroused the wrath of censors, anti-sexual though it is. For what is condemned is the depiction of certain aspects of human life, even as something to be condemned.

Plastic formalism and its literary descendant – structuralism – would no doubt have us ignore the subject and thus dissolve the criticism that the subject matter of art is sometimes of a sort that is commonly regarded as indecent. For if indeed painting and literature are about nothing at all, that puts them beyond the reach of censors, although not of those moralists who would condemn art as a waste of time. But the censor is, I have suggested, perfectly in order, from his conventional moral standpoint, in refusing to be persuaded that Henry Miller, let us say, is not talking about sexual relationships in a manner which that morality condemns, that Picasso does not depict them thus, that they are never shown thus on stage or film. Thomas Mann was once asked by a publisher – this was in 1920 – whether he should publish Verlaine's *Femmes* and *Hommes*. After describing the effects on him of reading these poems, the abysses they opened up, Mann wrote thus: 'It would be ridiculous to deny the indecent character of these pages, as ridiculous as for some liberal-minded literary expert to gloss it over by pleading "the grace of form". I certify bluntly that these poems are shockingly indecent.' He said this, he went on to explain, 'in a sense that justifies you as against those who might condemn you for publishing such intimate material'.

Those remarks permit me to sum up my argument so far and to modulate to its next, synthetic, stage. There are, of course, important works of art, for example nineteenth-century English novels, which satisfy, or come near to satisfying, the criteria of the sort of moralist represented in an extreme form nowadays by such organisations as the Festival of Light but not many decades ago by the Hollywood Hays code and the standards of Australian censors. (Although to modern eyes it is extraordinary how many such novels were attacked by nineteenth-century moralists.) Nevertheless, on such principles – or, indeed, on the feminist principles which are now sometimes to be found in an uneasy alliance with conventional moral principles – there is no possible way, I have suggested, of defending some quite serious works of art against the view that they are immoral, let alone of arguing that one reason for taking them seriously has to do with their moral character. None of the

familiar ways, I have said, of defending serious art against the attacks of conventional moralists really work. Art is as subject to moral censure, from the standpoint of that morality, as any other form of human activity. That it is serious art does not serve as an answer to such condemnations; there is no way, for such a moralist, of counterbalancing moral defects against artistic merits. Neither is it possible to argue plausibly that serious art is, by its very nature, incapable of arousing the kinds of feeling which the conventional moralist condemns.

Let us, then, take another look at John Dewey, in search of a more potent defence. 'It is virtually assumed,' John Dewey wrote in his *Art and Experience*, 'that morals are satisfactory in idea if not in fact, and that the only question is whether and in what ways art should conform to a moral system already developed.' That is the assumption Dewey went on to challenge: without challenging it he could not possibly have defended the paradoxical-sounding pronouncement that 'art is more moral than moralities'. How, we naturally ask, can this be so? For conventional moralists, Dewey's proclamation can only be an absurd paradox. To be moral, on their view, simply means to accord with morality, and art can no more be more moral than morality than morality can be more artistic than art. Such a reply, however, ignores Dewey's plural form 'more moral than moralities' – a plural form offensive in itself, of course, to a conventional moralist.

By a 'morality' he means, I take it, a set of principles, codes, prohibitions, rules, which are considered to be binding by a society or a particular group in a society, so that a failure to adhere to them generates, in those who accept their authority, remorse, a sense of guilt or, at the very least, of shame. There can be many such moralities, in different societies or in the same society, even if their contents partly overlap. The adherents of any such morality 'know the difference between right and wrong' in the sense that they know what they are called upon to do or not to do. This does not entail that they have ever reflected on moral issues.

What Dewey is suggesting is that genuinely moral individuals will not be content simply to follow such accepted rules, that their concern will not be with the right thing to do, if that is taken to mean, simply, that which accords with conventional codes, but with what is morally good whether or not the prevailing morality in their society enjoins, prohibits or ignores it. Art, on this view, is 'more moral than moralities' precisely because it encourages us to engage in serious moral reflection, as moralities do not – at least in respect to their guiding principles, as distinct from their detailed application – and as a result of such reflection either to recognise the inadequacies of received opinions or to understand their real grounds. It offers us, then, a moral education.

We need moral education because, as George Eliot remarks in *Middlemarch*, 'we are all of us born in moral stupidity, taking the world

as an udder to feed our supreme selves'. If, to emerge from that stupidity, we had only to learn and conform to a set of rules, rules which could not be in conflict and can automatically be applied to particular cases, then our moral education could be rapidly completed; the sole role of art would be didactic, to remind us of these rules and persuade us to keep them. In short, moral education would be moral training. For conventional moralists that is the ideal situation. But George Eliot's Dorothea, who provoked Eliot's reflections, had been well trained; she knew, let us say, that she should behave towards others as she would have them behave towards her. That did not help her in her dealings with Casaubon. Indeed, it encouraged her to suppose that she knew how he would wish to be behaved towards, when she did not, just as a Utilitarian can do enormous damage by presuming that he knows in what a person's happiness consists. It is the differences between persons and situations which make our moral education an endless process, differences in the descriptions we can offer of them as we see them in this light or that, bringing them into different categories, subsuming them under different principles.

One can fill out this gloss on Dewey by returning to Shelley, who greatly influenced him. Against didacticism, understood as an attempt to use the arts telically for the purpose of persuading people to accept the prevailing morality, Shelley argued in A *Defence of Poetry* that the poet 'would do ill to embody his own conceptions of right and wrong, which are usually those of his place and time, in his poetical creations, which participate in neither'. Right and wrong, on this view, are always relative to a particular society at a particular place and time; in virtue of their seeking universality poets should not make them the assumed starting point of their poetry, as the didactic poet does. That does not mean that the poet is devoid of any moral concern. 'The great secret of morals,' writes Shelley, 'is love; or a going out of our own nature, and an identification of ourselves with the beautiful which exists in thought, action, or person, not our own.' Shelley's linking of goodness with beauty is characteristic of attempts to ascribe a moralising function to art while yet rejecting the view that it is to be judged by the standards of everyday morality, with its central emphasis on wrong-doing. No less characteristic, in its suggestion that this 'going out' involves an exercise of the imagination, is the way in which Shelley continues: 'A man, to be greatly good, must imagine intensely and comprehensively; he must put himself in the place of another and of many others ... Poetry enlarges the circumference of the imagination ... [It] strengthens the faculty which is the organ of the moral nature of man.'

All this, the reply might come, is fraudulent reasoning. Knowing that the poet's life and works are quite indefensible by the standards of everyday morality Shelley is arbitrarily constructing a morality of his own, based not on righteousness but on concepts like beauty and

sympathetic imagination which have nothing to do with morality. The suggestion that there is a moral standpoint from which the established morality of a society can be criticised is by no means, however, an *ad hoc* invention on Shelley's part. Neither are the details of his view. Adam Smith and David Hume had, in Shelley's fashion, made central in our moral thinking the concept of sympathetic imagination, linking it also with our apprehension of the beautiful. Even in the history of Christianity, one finds a conflict between a moralism based on obedience to precept, especially to prohibitions, and a morality in which love is central, a love which has to be caught from examples, or bestowed by 'grace', rather than taught by rules. (Moralism and antinomianism are the two extremes of Christian moral thinking.) Within feminism, too, there is a wing that is primarily protective, prohibitionist, and a wing that is interested in positive freedoms. Only the first wishes to censor.

In Bergson's *The Two Sources of Morality and Religion*, a similar contrast takes shape as a distinction between 'open' and 'closed' moralities, the closed morality looking to rules, as conventional morality typically does, the 'open' morality to exemplars. Such a morality is 'open' in the sense that it implies imaginatively thinking out, in the light of the life lived by exemplars, what is demanded in a particular situation, rather than simply applying a rule. Taking as his point of departure the suppression of *Ulysses* by the Australian censors, John Anderson argued in his *Art and Reality* that 'in professing to speak "in the name of morality", [the censors] assume that their conception of morality is one that all must accept'. 'Their position would obviously be weakened,' he continues, 'if they admitted that they were speaking only in the name of *a* morality.'

More recently, John Cook in an essay on 'Cultural Relativism' has distinguished two imaginary cultures. In the one, he writes, moral tales 'are concerned not so much with passing judgments on actions as with the quality of moral thinking'. The 'villains' are the 'hypocrites, the self-deceivers, the insincere, the prejudiced, the opiniated, the obtuse, the smug, the callous and so on'. The 'tales of virtue' in such a culture are about people who 'manage to break out of their prejudice and callousness, who are brought into a new level of sensitivity and insight, or who triumph over their self-deception or hypocrisy'. Corruption, depravity, are here equated with moral blindness, not with sexuality. In the other culture the main emphasis lies quite elsewhere. The villains are mostly 'thieves, cheats, seducers, adulterers and traitors'; the moral heroes or heroines are those who resist such temptations; self-sacrifice is the cardinal virtue. Our own culture, of course, contains 'moral tales' of both of these kinds, even if for a particular audience within that culture one or the other sort of tale may be pre-eminent.

I shall take over Bergson's terminology although not his detailed theory, with its mystical element. The moral criticisms of art I have so far

been considering come, I shall say, from the adherents of a 'closed morality', or in the case of Christianity from a 'cloistered' version of that religion. What Shelley calls 'morals' and links with being 'greatly good', Dewey's moral standpoint which is 'more moral than moralities', what Anderson calls the 'morality of freedom' and contrasts with the 'morality of protection', the morality of Cook's first culture, I shall group together as 'open moralities'. I do not wish, by so doing, to conceal the quite fundamental differences between them. But they all take as their moral centre good and evil rather than right and wrong, emphasising imaginative enterprise, human affection, an openness to the world, freedom, critical reflection, as distinct from conformity to precepts.

From the standpoint of an open morality, many works of art – at least in the descriptive, non-honorific, sense of the phrase 'works of art' – are subject to moral criticism. These, often enough, are precisely the works which are most pleasing to the closed moralist, as emotionally reinforcing a particular moral code. They do nothing to enlarge the sympathetic imagination, to help us to understand moral conflicts, to encourage moral reflection on our own standards, and in that process to achieve what Lionel Trilling called 'moral realism'. On the contrary, they make moral decisions look easy, simply a matter of following predetermined rules; the difficulty, for them, lies only in resistance to temptation. Such works particularly, not representational works of art in general, are subject to the charge that they deceive us.

The objections to Zola's *Germinal*, Oscar Wilde wrote in 'The Decay of Lying', are artistic, not moral. 'From any ethical standpoint,' he continued, 'it is just what it should be. The author is perfectly truthful, and describes things exactly as they happen. What more can any moralist desire?' Wilde, of course, is being ironical. He knows quite well that closed moralists have no interest in the truth being told. Their concern, indeed, is that certain things shall not be said, certain situations not depicted, certain symbols not used, even when such situations, such language, are essential to the artist's truth-showing purpose. And this, very often, is because the moralists have a particular political stance which they misdescribe as moral. Wilde brings out that fact in a later observation: 'We have no sympathy at all with the moral indignation of our time against M. Zola. It is simply the indignation of Tartuffe on being exposed.'

Wilde's reference to Tartuffe reminds us that the representative artist does indeed, as is alleged against him, often ignore the requirement that the *ex officio* moral ought not to be subject to moral criticism. Such challenging is more particularly the province of comedy. In popular art – for example, the *commedia dell'arte* – the three representatives of *ex officio* virtue – Church, Army and men of property – were regularly exposed as hypocrites; *Tartuffe* is an exercise in the same genre. In pictorial art, Daumier and Rowlandson perform a similar function, as do very many post-war novelists and film-makers.

In so far as the distinction between the way things are officially made to appear and the way we see them when we look more closely is central to the concerns of serious representational artists, they will naturally refuse to grant, except under constraint, that official status automatically confers moral qualities. It is scarcely necessary, nowadays, to say all this. Indeed, there is a somewhat tiresome tendency, crawling into the novel from scandal-sheets, to look for ways of showing that anyone who might conceivably be regarded as a culture-hero has feet of mud, as when, in *The Sot-Weed Factor*, John Barth ascribes pederasty to Newton and Henry More. I am not myself suggesting that the exposure of Tartuffery should be the sole business of artists or that they are obliged to say, or to paint, whatever the closed moralist will find offensive. That would be didacticism in reverse. Closed moralities arise out of the business of living together. It can be expected that they will contain within them some recognition of essential human relationships, even if at other points they are nothing more than instruments of domination.

To revert to Cook's contrast, the artist as moral educator is not obliged to show as praiseworthy 'thieves, cheats, adulterers and traitors'. Such an artist will do well, on the other side, to keep a wary eye on Cook's appeals to 'sensitivity and insight' or to such cognate concepts as 'integrity', in so far as they sometimes serve as covers for cowardice, inaction, the condoning of evil, self-righteousness, moral laziness. In their various ways, Chekhov, Sartre, Camus make this plain to us. In Utopias, many of the precepts of the closed morality characteristic of the society out of which they emerge are rejected. But I do not know of any Utopia in which lying, murder, personal violence, exploitation are extolled, unless one counts de Sade as a Utopian. Evil passions will often find expression in a manner any society, however open, will condemn as wrong-doing; an artist may use that fact as a way of bringing out the power of evil. Consider *Othello* and *Macbeth*. Their central concern is with evil passions rather than wrongful deeds. We do not need a Shakespeare to show us that murder is a nasty business. It is by no means morally pointless, however, to show that we can be driven to murder as a result of moral defects of a subtler kind – defects like jealousy and excessive ambition, about which conventional morality is generally silent.

That does not entail preaching. In the preface to his edition of Shakespeare, Dr Johnson complained that Shakespeare 'seems to write without any moral purpose' and 'omits occasions for instructing'. Tolstoy, too, seems to think that Shakespeare does not live up to Tolstoy's recipe for serious art – that it should teach us to love good and hate evil. But how could one possibly argue that *King Lear* does not teach us to hate evil, or that it does not instruct us morally? Only by presuming that it is the artist's task to lay down explicit rules, rather than to show us what it is like to be evil. After saying that the novel is primarily moral, Lawrence went on to attack didacticism. There is no contradiction in this. Comte,

even Lenin, makes the same point, Lenin in his letter to Minna Kautsky, Comte in *A General View of Positivism*.

What is characteristic of a morally 'open' work of art is that it is not prepared to force the facts in order to satisfy the demands of the closed moralist. In what are genuinely vices, the practice of the vice gives rise to an internal disintegration, a loss of the capacity to love, an inability sympathetically to imagine the position in which others find themselves, selfishness, intolerance, crudity of response. These are the punishments of vice, the punishments Macbeth is suffering well before his defeat and death, just as the rewards of moral development are an enlargement of imagination, affection, understanding. But the closed moralist demands, often enough, that the virtuous, whether it be the Socialist worker or the bourgeois housewife, shall achieve their worldly aspirations – be rewarded or punished in this primitive sense – and display, at the same time, a kind of purity of motive which is wholly inhuman. Serious artists cannot write what Dickens called in *Hard Times* 'leaden little books ... showing how the good grown-up baby invariably got to the Savings-bank, and the bad grown-up baby got transported'. They have sometimes been forced, however, to tack such an ending on to books that tell a very different story.

Education, as distinct from training, encourages criticism, as is as true of moral education as any other. Then shall we agree with Matthew Arnold that poetry – a word he uses very broadly – is 'a criticism of life'? That depends, in part, on what we take Arnold to mean. At its broadest, 'life' means human life in general, the human condition. Such criticisms of life are common in religion – in Buddhism, in Ecclesiastes, in the Manichaean forms of Christianity. One can certainly point to examples from serious art: in Swift, Beckett, the darker passages in Shakespeare, the late paintings of Goya, to mention only a few familiar examples.

The religious criticism of life, in that form in which it insists on the worthlessness of human effort, asserting that, in Calvin's words, 'the whole man is of himself nothing but concupiscence', is clearly at odds with the moral view that some ways of life are better than others. (I have discussed Calvin's attempt to reconcile the two in *The Perfectibility of Man*.) In the novels of Graham Greene and François Mauriac, we are sometimes called upon to admire characters who, whether from the standpoint of conventional or open morality, behave in ways which we should normally condemn; they are, we are to suppose, suffused with divine grace. Two striking cases are Greene's *The End of the Affair* and Mauriac's *Thérèse Desqueyroux*, which Ian Gregor discusses in *The Moral and the Story*. Beckett has a similar religious background. He has remarked that if he were writing a critical examination of his own work, he would begin with a quotation from Geulincz – a seventeenth-century convert to Calvinism from Roman Catholicism: 'When you are worth nothing you should want nothing.' There is no room in Beckett for the

criticism of particular ways of life; if we manage to keep going, in the tragico-comic way of clowns, that is enough of an achievement. (Contrast Joyce, for whom we are called upon to make serious moral decisions, for or against servility.)

Lawrence exalts, rather than criticises, life; for him, the moral villains are those who are hostile to life. Yet in his case, too, life drives moral reflection out the window. Of course, much of his work is in fact a criticism of ways of life, and the same could be said of Greene and Mauriac. Nevertheless, for him as for them we have to get in touch with 'some kind of primal force, which will carry us along in a way that makes moral reflection unnecessary'. For them this 'primal force' is God, for him it is sex – where 'man comes to the limit of himself and becomes aware of something beyond him which surpasses him'. For our purposes, this difference is insignificant. It is not enough, for any of these writers, to do what we can, in the ordinary affairs of life, to show understanding, courage, affection.

Arnold certainly does not defend a Calvinist attitude to life. And one can scarcely imagine that he would have been more favourably disposed to Lawrence. What he has in mind when he talks about 'life' is lives, ways of life. That is what, he thinks, literature criticises. For Comte and the Socialist Realists, in contrast, it is quite wrong to suppose that there is any essential connection between art and criticism. Indeed, Comte specifically argues in *A General View of Positivism* that what he calls 'real art' is incompatible with criticism. He agrees that the criticisms of Byron and Goethe were valuable as facilitating the transition from the age of theology to the positivist age to which he looks forward; the Socialist Realists say much the same sort of thing about Dickens, Balzac, Zola. Nevertheless art as it ought to be, art as it *will* be once the final relics of bourgeois life have been destroyed, will not for Comte be critical. It will be purely celebratory, celebrating and strengthening the unanimous moral feelings of the community.

On that view, then, any connection between serious art and criticism is a sign of imperfection not only in the society that engenders it but even in the art itself – for, as we saw earlier, on the Comtean and Socialist Realist view serious art is concerned with the perfected. This, of course, is the doctrine which dissident Soviet writers so hotly contested. We may well dismiss it, indeed, on the ground that the idea of a perfect society is wholly fanciful and, in practice, always a route to tyranny, as J.S. Mill came to see in the case of Comte. It is nevertheless clear that not all serious art is 'critical', if this is taken to mean condemnatory.

'Criticism', one should therefore explain, has to be understood in the sense it has in the phrase 'literary criticism'. The literary critic does for literature what the novelist, the poet, the dramatist does for ways of life. Literary criticism can celebrate as well as expose; so can art, in relation to ways of life. It can help us to see the moral qualities of ways of life we had

dismissed as worthless, whether it be the characteristic way of life of the puritan, the peasant or the prostitute. Closed moralists, indeed, fear the celebrations of art at least as much as, perhaps more than, its exposures. Or at least, they want the artist to celebrate, in the manner Comte approves, only what is, on their view, worthy of celebration, certainly not the pleasures of the world, of the flesh, as they are celebrated by Rubens or by many a lyric poet.

It is a familiar point, of course, that celebrations easily collapse into sentimentality. Dostoevsky's celebration of Sonia does not come off as successfully as his exposure of Raskolnikov; Fielding is more successful with Thwackum and Square than he is with Mr Allworthy. One can have serious doubts about Joyce's celebration of Stephen Dedalus, and wish he had turned his comic spirit in that direction. Official celebratory paintings are notorious for their banality. On the other side exposure can collapse into melodrama or cynicism. All I wish to insist upon is that both celebration and exposure fall within the artist's province. Celebration is more readily to be found, and is easier to handle, in poetry and painting than in the novel or the theatre, but it is not unknown there and certainly is not in film. Depictions of the beauty of landscape, now rare in poetry, but certainly to be found in the work of Elizabeth Bishop, can, as we said earlier, educate us morally into a love of the natural world. For Arnold himself, indeed, the greatness of Wordsworth's poetry did not lie in its being a criticism of life but rather in its power to make us share Wordsworth's own joy in nature and in 'the simple primary affections and duties'.

It would be ridiculous to say to artists, in the manner of Socialist Realism: 'Celebrate!' Serious artists have to be free to paint and write out of what they see; there is plenty to expose. Ezra Pound is probably right enough: 'Most good prose arises ... from an instinct of negation, is the detailed and convincing analysis of something detestable; of something one wants to eliminate.' But humour, as distinct from the cynical malice which sometimes passes as such, can reconcile exposure and celebration. Courage, affection, joy in creation, natural and man-made beauty, honesty, disinterestedness, just dealings still exist. That we encounter them at all in this chaotic and accidental world is cause for rejoicing.

In recent decades, we have supped so full of horrors that we have been forced, by life itself, constantly to confront our worst side. The real danger at the moment is the depreciation rather than the exaltation of the natural man. (I set aside the false exaltation of mysticism, the exaltation of man to a level beyond himself, which is still a depreciation of human beings as they actually are.) A danger, because we may find in our manifest iniquity an excuse for deeper iniquity.

Let us suppose, to revert to our main theme, that it is possible to criticise received moralities on moral grounds. Why should we turn to the artist as a source of such criticisms? Shelley, as we saw, emphasised the

artist's power of sympathetic imagination. 'If art does not enlarge men's sympathies,' a very different artist, George Eliot, once wrote, 'it does nothing morally.' Precisely in that power, the closed moralist might argue, lies the danger of art. Artists win our sympathy for what we should be condemning. In reply we must, of course, distinguish two senses of sympathy. In the sense Eliot and Shelley have in mind, sympathy is nothing more than a capacity to understand other people's feelings; that is not the same thing as approving of, or seeking to win approval for, those feelings.

True enough, literature can help us to understand how what we were inclined to dismiss as a monster can be impelled by feelings which are all too human. That understanding, however, has an educative force. We come to recognise the banality of evil, that evil passions are not something against which we can regard ourselves as secure, provided that we are not sub-human or psychopathic, but can flow from quite everyday insecurities, desires, frustrations. Reading Grass's *The Tin Drum* we see, for example, how a quite ordinary person could become a Nazi.

Evil, the conventional moralist may reply, is not the sort of thing we ought to try to understand, at least not with the kind of understanding which involves the use of sympathetic imagination. For this is the sense in which to understand is to excuse, and evil ought not to be excused. Although, however, to understand may sometimes be to pity, it is not to excuse. Sometimes it is not even, except in the most general of senses, to pity. That is so unless we are environmental determinists of the most uncompromising kind. For the understanding may lead us into a revelation of darknesses still deeper than those we had immediately recognised. Hugo's detective Javert in *Les Misérables* we may at first see as simply bent on revenge; we are at once more horrified, and reach a fuller understanding of him, when we realise that he is a man of principle, the principle that no human being is capable of reforming. The motivations of Beaver become plainer as Waugh's *A Handful of Dust* proceeds on its way but not in such a manner as either to excuse him or to arouse our pity – quite the contrary. Even in the novels of Zola, where environmentalism is at its strongest, although we may pity, let us say, Nana as her origins and circumstances are revealed to us, there are aspects of her behaviour which this understanding in no way excuses.

What is in some ways a more serious question arises out of the fact that the evil characters in a novel or a play may have a degree of imagination, energy, vitality which arouses our admiration. So the readers of *Clarissa Harlowe* sometimes admired Lovelace; later examples would include some of Dickens's villains, Becky Sharp, and, especially in films, many an ingenious criminal, as in *The Sting*. There is nothing at all strange in this. In the world outside literature, too, if one sometimes finds an admiration for a criminal, such as Charles Manson, which is a form of

moral pathology, in the majority of cases when a criminal is hero-worshipped, this is as possessing qualities we are accustomed to admire – imagination, ingenuity, vitality, independence, courage.

This may horrify the closed moralist who would wish our condemnation to be absolute. But it has never been so. In the folklore of many societies there are bandits who function as heroes, or if not bandits at least tricksters. It is only when brutal criminals are extenuated, or brutal violence excused as 'being in a good cause' or as 'just youthful energy', that our moral condemnation can be totally unreserved. And I do not know of any serious work, as distinct from entertainment or telic art, in which we are given any encouragement to sympathise with such brutality. A possible exception, once more, is de Sade. If his work is simply an exaltation of brutality that is one of several reasons for rejecting its claim to be serious art; it is a question for critics whether that is the correct reading of it.

One has to grant, as I earlier said, that literature and even painting find evil easier to present than goodness. The exposure of that kind of evil which does not immediately present itself as such is, for the most part, the manner in which literature contributes to our moral education. The illumination offered by such literature does not leave us in a state of moral superiority. Its theme, unlike the moral complacency of melodrama, is 'there, but for the grace of God, go I', or whatever secular equivalent we substitute for God – family sympathy, friends, education, or the like. How, we wonder, would *we* have behaved? Just for this reason it can be unsettling: many will prefer to keep evil further from them, as something alien, inhuman, essentially incomprehensible. But its being unsettling is ingredient in its being a form of moral education.

The evils in question, I should add, need not issue in the crimes of a Raskolnikov or a Macbeth. They, and their consequences, may be of a subtler kind; evils such as opportunism, the cowardly sort of respectability, insensitivity, selfishness, self-satisfaction, maliciousness, with as their consequences lives that are emptier, less satisfying, more straitened, less capable of adjusting to misfortune, more friendless than they need be. Of course, a particular book, a particular film or play, may fail to touch us in these moral ways; it has, from the standpoint of moral education 'nothing to say to us'. If we admire it, this is on purely formal grounds, as we might be morally untouched by a film but admire its photography. Or we might simply enjoy it as an entertainment. Or even welcome the fact that the tribulations of its characters have no bearing on our own weaknesses, our own situations. We are talking only about ways in which serious literature *can be* morally educative, not suggesting that any particular work always will in fact be educative for particular readers, let alone that there could be no other good reason for its winning their admiration. And the same applies to painting.

That is just as well. For critical art is by no means the norm. At most

historical periods, representational artists have had to work within the confines of a closed society, in which criticism could be directed only against what was officially condemned and only what was officially approved could be celebrated. True enough, artists were sometimes adept at circumventing these official restrictions, while still ostensibly operating within an orthodox framework. Their Last Judgments may send clerics to hell with a special gusto, their Eves, sometimes even their Madonnas, may celebrate worldly delights. On the other hand, they may firmly adhere to principles which seem to us, on moral grounds, highly objectionable, they may be sincere adherents of closed moralities, closed societies, entirely lacking in moral sympathy for those who rebel against them. Yet their work can still delight us by its beauty, its elegance or its power.

I should make this plain; my argument is of a minimal kind. I am not arguing that all serious art, of whatever kind, helps to educate us morally in the direct ways I have been describing – although it may, to be sure, help us to appreciate in what craftsmanship consists, or disinterested-ness, or how sensuality and rationality can be reconciled or what, in the world, is worth preserving. Even less am I arguing that the only proper reason for regarding a work as serious is that it makes a contribution to our moral education. I *am* suggesting, first, that in the case of the representational arts this can be an important element in our judgment of them and secondly that works can be morally educative which conventional morality condemns.

The question still arises why we should pay any attention to artists as moral educators. (Now one principally, although not entirely, has in mind literary artists.) They are not moral philosophers; they do not stand alongside Plato or Aristotle or Kant or Mill. We do not turn to contemporary novelists in the expectation of finding there the close reasoning of such contemporary moral philosophers as Hare or Rawls. *Their* authority rests on their control over argument; if we reject their views, it is their arguments which we have to question. Serious novelists, in contrast, do not offer us a network of argument. And if they sometimes engage in moral generalities, this is at the level of generalisations about particular types of person or situation, not at the abstract level of a Plato or a Rawls talking about justice. Only rarely, as in Fielding's *Tom Jones*, do either characters or narrators enunciate formal moral theories. There is, to be sure, a relatively long discussion of 'natural depravity' in *Billy Budd*. We might well wish it away; the moral impact of *Billy Budd* does not rest on the truth of these general reflections. It is the sort of thing on which we should seek enlightenment in criminological studies rather than a novel.

Poets have often sought to win authority by claiming to be inspired. That is a natural response, perhaps, to the fact that lines sometimes 'come to them' as ideas may come to a scientist or arguments to a

philosopher. But what thus 'comes' is not, in these last cases, at once assumed to be reliable; the fact that it 'just came' is not put forward as any kind of evidence in its favour. Neither should 'pearls of wisdom' that 'just come' to a poet be regarded as being in fact wisdom only for that reason.

The didactic writer preaches or tells exemplary stories, the didactic painter, like Greuze, paints exemplary scenes. *Their* authority derives from the initially presumed authority of the morality they preach. That is what the conventional moralist expects from art. Serious writers are sometimes tempted to preach, but if it is a Lawrence preaching it is certainly not with conventional morality as his authority. Neither is it by his preaching that, at his best, he educates us morally. Preaching is not, we said, something the serious writer normally *tries* to do.

Our moral education arises out of what a serious novel, a poem, a play shows us about human beings, their mode of life, the society in which they live. Nothing need be said, either by the narrator or by the characters, which is itself a moral reflection. Or if it is, it may, deliberately, be a completely worthless reflection. Recognising that fact may contribute to our moral education, although that education more commonly derives directly from our consideration of the work as a whole.

The artist's work has to be, as we might put the matter, its own authority. In a novel, a drama, a poem, a film 'he takes us through' – to pick up a phrase of John Wisdom's – persons and situations which concretely exhibit a particular style of life, specific moral attitudes, pride or prejudice or sense or sensibility, the pursuit of power or profit or social status or liberty, the quest for religious belief or personal stability or release from the burden of the past. As Goethe puts the point in his *Autobiography*: the writer 'neither approves nor censures, but develops sentiments and actions in their consequences, and thereby enlightens and instructs'. Or in Iris Murdoch's words in *The Fire and the Sun*, 'good literature is uniquely able to clarify evil and to justify the good man's vision; thus enabling us to see misery and evil justly'. So in Thomas Keneally's *A Family Madness* we come to see, with horror, the ways in which patriotic nationalism can blind us to moral distinctions; in his *Schindler's Ark* the difference between heroics and heroism; in Bellow's *Herzog* the crippling effects of a certain kind of intellectualised self-concern: in Jane Austen's *Emma* the no less crippling effect of the self-complacent assurance that one 'knows what is best for people'.

At this point what I am saying about art and morality obviously relates to what I said previously about art and truth; it is not in the slightest degree mysterious that the same art-forms should be implicated in the two cases. To help us to see by showing: that is what art – and above all the novel, film, drama, because they have at their disposal time to show how consequences work out – can do in the field of moral education. Pictorial artists, of course, sometimes try to use time, whether by

painting a series, in the manner of Hogarth's *The Rake's Progress*, or by representing, in the manner of many medieval paintings, a set of events in a single painting which we are to look at sequentially. In both these cases, however, the effect tends to be didactic. Morally educative paintings generally present, like the lyric, but a single scene, something more in the nature of a Joycean epiphany. We may be shown evil at work, as in much Northern painting, or given cause to celebrate, as in much Italian Renaissance painting. We are not shown, we cannot be, how evil arises or how goodness is threatened. *Guernica* shows us nothing about the origins of the Spanish Civil War.

Just because its impact is immediate, pictorial art very easily lends itself to telic purposes, assuming the form of propaganda. We have to judge for ourselves, in the light of our wider experience, whether the powers of the artist are being used to illuminate or to deceive us. Statistically speaking, the odds are very much in favour of the first hypothesis, and by no means only when the deception is in favour of conventional morality; we can suppose ourselves to be enlightened when in fact we are being demoralised.

Are there special areas where the artist may be particularly trustworthy? As I have already suggested, artists can help us to see what it can be like to live a certain kind of life only in virtue of their sympathetic imagination. They have a special interest in unimaginative people, considered from a moral point of view – in the moral blindness which is allied with an inability to look beyond one's own sphere of interest – as in the fantasies of the undisciplined imagination. Since they are intent on seeing things as they are, unmasking the hypocrite, or so we suggested, is a moral task they are likely to undertake with a particular zeal.

It is sometimes said that self-deception is far more common in literature than it is in everyday life. I do not know of any statistics which bear upon this point. Assuming the contrast to be correct, it is by no means surprising. Self-deception is the kind of moral defect which lends itself to treatment in literature. It is by no means an objection to literature that it emphasises particular kinds of vice; the writer is not trying to depict a total moral landscape. To some degree, Bunyan tries to do this in *Pilgrim's Progress* but at the cost of allegorising. To deal with a moral defect concretely, as it arises in a particular individual in a particular society, in response to a certain kind of training when confronted by a certain kind of temptation, is a more properly literary task.

In general, the concern of writers is likely to be with the sorts of moral defects which do not lend themselves to being codified. When Shelley sets out to show that poets, as poets, are 'the wisest, the happiest, and the best' of men, that the greatest poets have been human beings of 'the most spotless virtue', he naturally does not find his task an easy one, given the

biographical facts. He ends up by substantially claiming no more than this: that poets have been free of 'cruelty, envy, revenge, avarice, and the passions purely evil'. And whereas only by drawing a contrast between the poet as poet and the poet as man can Shelley, and even then with the very minimum of plausibility, defend the lives of poets against the attacks of conventional, closed, moralists – as indeed we cannot defend a Pound or an Eliot against the attacks of 'open' moralists – the evils he particularises are certainly not characteristic of artists, even if artists are not entirely free from them. As for novelists; saints do not write novels. Perhaps we cannot claim anything more than what Roger Fry once said about painters: 'I am sometimes inclined to think that honesty is the only one of the moral qualities that affects an artist's work.' But honesty is a sufficiently rare virtue. These are forms of evil to which the writer is particularly sensitive, in so far as they poison human relationships, especially if 'cruelty' is understood in its broadest application.

A familiar example is in Dickens's *Hard Times* where he contrasts the circus women, none of them 'at all particular in respect of showing their legs', untidy, disorderly, but gentle, ready to help one another, with the bourgeois virtues of Mr Bounderby. The artist is no friend to those for whom morality is exhausted by the concepts of order and respectability. One thing Dickens is bringing out is the degree to which this second kind of morality is often a cloak for a lack of any genuine concern for other human beings, any sort of sympathetic imagination. The novelists' own interest in human beings makes them peculiarly sensitive to such forms of moral blindness.

Let me then sum up. I see no way of defending many works which I take to be serious whether against the attacks of conventional moralists or of such moralists as Comte and the Socialist Realists, so long as we accept their moral doctrines. Comte was right when he said that art can weaken fixed moral convictions; the real point at issue is whether this is necessarily a bad thing. The conventional Christian moralist is no less correct. Such art often celebrates a carnality which, on his view, ought rather to be condemned. It exposes what ought, conventionally, to be kept secret; it sympathetically examines what ought to be wholly unseen, unmentionable. If we are going to maintain that nevertheless such art can be morally educative, we must lay the moral stress where it does not fall either in Comte or in conventional morality – on courage, human affection, sympathetic understanding, freedom, generosity, tolerance, in opposition to bigotry, fanaticism, suspicion, avarice, jealousy, hypocrisy, malice. Not, I have argued, that all serious art has these educative effects, any more than all important art is elegant, or unified, or possesses any other virtue we care to imagine. There are very many reasons, I said, why we may take a work of art to be serious. We have to admit, too, that serious art – inevitably – has not always shaken itself free from the moral convictions of its time, and may even sustain them. So far the feminists

9

Beauty

I have made depressingly small progress in my attempt to discover characteristics which would justify our distinguishing, within the arts, between serious and non-serious art. True enough, I did maintain that serious art was always imaginative, whereas non-serious art was usually banal or gimmicky, or exhibited some such non-imaginative characteristics. I found myself forced to admit, even so, that purely entertainment or purely telic art could also be imaginative. It would have been a real step forward had I been able to find at least one sense of 'truth' in which all serious art made us aware of truths. In fact I was able to say this only in the case of some serious *representational* art. A similarly limited connection was all I could find in the case of moral education, even after major revisions to the conventional account of what counts as such.

Perhaps I have been looking in the wrong place. 'Consider what you have done,' a traditional aesthetician might rebuke me by complaining, 'in your discussion you have scarcely said a word about beauty. No doubt beauty is linked with truth and goodness, but whereas their principal home is outside the arts, beauty has its principal home in serious art and constitutes its defining characteristic.' Others, whose attitude I have already anticipated in talking about the view that art is the sole subject of art, might prefer to use some such phrase as 'formal values' rather than 'beauty' but would be still more severe in their criticism of what I have been saying in the last three chapters. 'Your attempt,' they would say, 'to retain at least a vestige of the traditional link between art, truth and goodness is wholly misguided, you are like a wrecked mariner clinging pitifully to a spar in the middle of an Atlantic storm, prolonging the agony of surrender to no avail. In so far as one can properly distinguish a particular work as "serious", this is solely in virtue of its formal values.' 'Furthermore,' both my ancient and modern critics would add, 'we can do what you have failed to do; we can point to characteristics which are to be found in art of every kind, which are not confined to representational art. Indeed, the distinction between art which does, and art which does not, represent, a distinction which led you into a great many difficulties, will turn out to be of absolutely no importance.'

Then, finally, there are those who take a different, sometimes even contrary, line: 'Admittedly you have not been entirely silent about emotions, whether under that name or thinly disguised as feelings or passions. But what you have failed to bring out is the *centrality* of the emotions to any discussion of serious art, not merely as a source of art or an effect of art but as the real content of serious art in each of its forms, architecture and music as much as poetry and painting.' So, again, if I have failed to generalise about the arts, this, it is said, is because I have looked in the wrong place for my generalisations.

Let us consider first the case of beauty. Every possible view about the relationship between serious art and beauty has at one time or another been upheld by influential critics. At one extreme lie those for whom the presence of beauty is a necessary and sufficient condition for a work's being serious. Nothing else, that is, can be beautiful and every serious work of art is beautiful. At the opposite extreme lie those for whom beauty is not to be found at all in works of art or, at best, resides there in an extremely inferior form, by no means helping to justify the view that there is such a thing as serious art. Finally there are various versions of the view that although being beautiful is neither a necessary nor a sufficient condition for being a serious work of art, nevertheless it is a factor to be taken into account in a wide range of cases – in this like truthfulness and moral education.

The doctrine that beauty is a necessary and sufficient condition of being a serious work of art was developed by Harold Osborne when he wrote *Theory of Beauty*. He there admitted, to be sure, that in ordinary life we call a great many things 'beautiful' which are not works of art at all so that, on the face of it, being beautiful is not a sufficient condition for being a serious work of art. A beautiful landscape, let us say, is not ordinarily a work of art and so can scarcely be a *serious* work of art. But in such contexts, he said, 'beauty' and cognate expressions are being used in a 'descriptive' sense, whereas when they refer to works of art they are being used in a 'normative' sense.

Presumably he meant by this that these expressions are used in sentences which judge, evaluate, works of art. However, they are equally used in a judgmental way when we refer to a landscape as 'beautiful' rather than as 'boring' or a bird's plumage as 'beautiful' rather than as 'dull'. Osborne would have replied, however, that to adhere to such usages makes it impossible to develop a satisfactory aesthetic theory. For to develop such a theory, he supposed, we must have at our disposal a property which is common to all serious works of art and is possessed by nothing else. And beauty, he thought, is the obvious candidate, the 'peculiar excellence' of works of art, as distinct from excellences they can share with other things – being, say, an excellent souvenir or going excellently with my furniture.

Now certainly it would be nice to have such a property at one's disposal,

to be able to say by direct reference to its presence: 'Yes, that is a serious work of art', nice unless that property, as Plato suggests in his *Lysis* is true of beauty, turns out to be so 'slippery' that one's apparent advance is only nominal. Nevertheless, there is no good reason for believing that there is any such property and there are good reasons for denying that 'beautiful', in particular, could serve such a function.

It is not only that, as Osborne conceded, many things other than works of art are normally accounted beautiful, it is also true that 'beautiful' is not a predicate we naturally apply to many works of art which we none the less take to be serious. This is a point which Wittgenstein emphasised and many recent philosophers have also insisted upon. An exception is Mary Mothersill in her *Beauty Restored*. She argues, in particular, that adjectives like 'dainty' which are sometimes, as by J.L. Austin, appealed to in order to show that 'beautiful' is only one of the eulogistic predicates applicable to works of art, with no centrality in this respect, can be subsumed under 'beautiful' as types of it. Not only in the case of 'dainty' – as she herself points out – but in the case of such predicates as 'handsome' and 'pretty', one has to grant that she has dictionaries on her side; they are all defined by the *Shorter Oxford* as particular ways of being beautiful. Dictionaries, however, can be misleading on such points. We sometimes say things like: 'The landscape there is not precisely beautiful but it is pretty, pleasing to the eyes.' Mothersill finds such distinctions 'pedantic and fussy'. There may be more to it than that. We shall see.

A more fundamental question is whether there are serious works of art to which not even these beauty-like predicates apply. The examples on which Mothersill particularly relies, the first Rasumovsky quartet and Mozart's comic operas, are works we should naturally describe as being 'beautiful'. As beauty is what she is writing about, that is a perfectly proper choice of examples. More generally, 'beautiful' is a description we often apply to serious musical works. There are operas, however, we should not normally describe in these terms – *Wozzeck*, for example – and it is not in a spirit of rejection that a critic writes of such of Schoenberg's later works as *A Survivor from Warsaw* that 'no one but a fanatic would call them beautiful'. Or that another critic tells us that Mahler broke with the tradition that music must be beautiful: 'For the seamy ugly shapes he found within himself, he offered musical correlatives that might actually sound seamy and ugly.'

Sculpture is another case where it is quite natural to describe a work as 'beautiful', if it is, say, by Giambologna. To many sculptures, nevertheless, this adjective is totally inapplicable. As Henry Moore once remarked: 'When a work has this powerful vitality we do not connect the word Beauty with it.' Michelangelo's *Captives*, Rodin's *Calais Burgo-masters* – these are statues to which we immediately attach such predicates as 'powerful', 'dynamic', 'expressive', not 'beautiful', and in no dictionary are these adjectives regarded as sub-species of 'beautiful' any

more than 'the bland', 'the pretentious', 'the sentimental', are sub-species of the ugly. In painting, if Botticelli certainly paints beautiful paintings, to describe Goya's *Kronos* or Nolde's *Family* or Bosch's *Christ Carrying the Cross* or the paintings of Francis Bacon either as 'beautiful' or by using any of the adjectives Mothersill takes to be sub-species of the 'beautiful' would be to carry linguistic eccentricity to an extreme point.

There are many poems which are praised as being beautiful. But there are other poems – let us say Eliot's *The Waste Land* or Juvenal's *Satires* or Swift's exercises in that same genre – which it would be very misleading thus to characterise. As for novels, when they are described as 'beautiful' this is usually a warning to anyone seriously interested in literature to avoid them, as being sentimental. Some aestheticians, committed to the idea that to be serious art must be beautiful, have been led to conclude, indeed, that novels cannot be serious works of art. For certainly it would be very strange to call *Bleak House* or *Heart of Darkness* or *Sanctuary* beautiful, or a great variety of contemporary novels. And the same applies to many plays and films. 'Beautiful' is not the natural description of *Apocalypse Now* – although it may be of particular shots which that film contains – or of *Ubu Roi* or *The White Devil* or *Volpone* or, for that matter, of Shakespeare's tragedies, although they may contain beautiful passages.

The more natural conclusion from these examples, however, is that serious art need not be beautiful. Mothersill seems to admit as much when she writes that 'a work of art may express feelings so painful or thought so unacceptable as to extinguish the pleasure and with it the possibility of beauty'. Serious art can certainly be of this character. So even if she is right in thinking that we can properly describe rather more works as being beautiful than is commonly done, this will not be of any great help to us in our present inquiry.

So long as we concentrate all our attention on Italian painting, we might be able to persuade ourselves that the older serious paintings, at least, are always beautiful. Indeed, the same is generally true of Italian sculpture. The situation is very different once we move North of the Alps; much German art, both in the period up to the early seventeenth century and in the twentieth century is marked by a harsh realism or by a degree of exaggeration designed to bring out the ugliness of what is being depicted. When German artists set out to produce beautiful art they often, if by no means always, turn out trivial entertainment works, those paintings of which the German critic Ulrich Finke has written that they give the impression of striving to be beautiful rather than of being beautiful, lapsing into a 'languid and dreary elegance'. They are naturally very popular, in reproductions, as decorations for drawing rooms. Perhaps the attempt of German Idealists to turn the grotesque into a sub-species of the beautiful arises out of the difficulty German aestheticians have felt in squaring their classical ideals of beauty with

their actual experience of German art.

It might well be replied, however, that what I have just written rests on an elementary confusion. No doubt, such an argument would run, Italian art often strikes one as being particularly beautiful, Northern art not so, but this because Italians preferred to paint persons and things which, whether they are real or imaginary, we should, were we to encounter them, take to be beautiful, whereas Northern painters have often preferred to paint the ugly. The beauty of what is represented is, however, one thing, the beauty of the painting quite another. There are some cluttered Italian canvasses, or frescoes, in which each item is beautiful but the work as a whole fails to be beautiful. Contrariwise, the argument might continue, Northern paintings can be beautiful, even when they represent something that is not beautiful.

One can see the force of this argument. In everyday life we sometimes encounter persons and places we see as beautiful, others we see as ugly and others still – the great majority – which we do not subsume under either category. Let us call them 'banal'. In the case of paintings we can make the same three-fold distinction. Some paintings we take to be beautiful, some we take to be ugly, some are not ugly but are so banal that we do not give them a second look. But there is not, one must agree, a one-to-one correspondence between members of these two groups.

For most paintings of strikingly beautiful landscapes are at best banal and are often ugly daubs. On the other side, a painter may take something which, in our everyday life, we should dismiss as banal or be horrified by as ugly and represent it in a beautiful picture. In the case of the banal, the Dutch painters did so, and many later painters of everyday street scenes, whether impressionists or photorealists, have followed in their footsteps. This may affect our everyday perceptions, so that we come to see beauty where we had only seen the banal, but that is not the present point at issue. In the case of what we should perceive as ugly, Italian painters often so treat it as to make it seem beautiful. So the Crucifixion may be transformed into a scene of mourning, the cruelty of the event subdued, martyrdoms into ecstasies; a painting of Salome with John's head on a plate may be so beautiful as to lose all sense of horror.

A painter may, however, want to do precisely the opposite of this, to bring out the horror of persons and events which we have come to take for granted, as banalities, or even to admire. So whereas in Italian paintings the martyrdom of Saint Sebastian is commonly an occasion for the display of half-nude physical beauty and Michelangelo's Sistine Chapel Saint Catherine was partly painted over by vigilant censors as being unduly sensual, Altdorfer's *The Beating of Sebastian* is physically horrific, as are the many martyrdoms portrayed in Byzantine art, to say nothing of the Crucifixion by Grünewald, or Goya's *The Disasters of War*, in contrast with 'heroic' war-paintings. Expressionist paintings of Berlin's 'beautiful people', Kooning's women, Daumier's lawyers, will

serve as later examples.

I am not, however, suggesting that such serious works are, like their subjects, ugly – that predicate, applied to paintings, normally suggests daubs. As in the case of Michelangelo's statues, there are many favourable things to be said about them. They are powerful, dramatic, revelatory. But they are not beautiful. Their lack of beauty does not prevent them from being serious works of art. Indeed, even a degree of surface ugliness does not have this effect. It is not in dispraise that an Australian critic, with his eye on the muddy surface texture of its colours, writes of a painting by an aboriginal artist Tjungurrayi that 'one of the strongest impressions is of its wilful and powerful ugliness' – something which might also be said of some collages. (Mahler's ugly 'musical correlatives' are in the same position.)

I have talked about painting at some length, both because this is one case where we use the word 'beautiful' quite freely and because representative painting particularly raises the sort of problem I have just been discussing. In relation to abstract painting – in the form in which it departs as far as possible from the natural world rather than, like Cézanne, bringing out structures in that world – questions about the distinction between the representation of natural beauty and the beautiful representation of nature do not arise. Some of its practitioners, indeed, see in art a refuge from nature and would wholly deny, in Oscar Wilde's manner, that nature is ever anything other than either ugly or banal. Or at the very least, they see nothing in life as it is now lived to be worth representing in a beautiful painting.

Robert Motherwell in his contribution to a Museum of Modern Art symposium on 'What Abstract Art means to me' is a case in point. Abstract art, he explicitly says, is 'a form of mysticism'. It arises from 'a feeling of being ill at ease in the universe'; it is an attempt 'to wed oneself to the universe' through 'felt experience', immediate, direct, as distinct from experience mediated through objects. Such attitudes to the world I have critically explored in a broader context in *The Perfectibility of Man*. All I shall now say is that when we confront a painting by Motherwell, it is as expanses of colour, often on a very large scale, a physical object. There is nothing else to find beautiful. He may feel, in the act of painting in a manner which is not bound in any way by the objects he perceives around him, a sense of liberation, but for us he has added another such object to our world and one we may or may not find beautiful. Of course, some American abstract painters would cast Beauty to the winds, along with History, Style, Europe, and we may equally cast their work aside as neither beautiful nor serious for some other reason. But if we do sometimes find it beautiful it is as sensorily attractive forms. Other non-representative arts, architecture for example, are in the same position. In the case of performing arts, we may find the performers beautiful but that does not demonstrate that the work is beautiful.

Beautiful dancers can perform in a ballet which is not beautiful, whether because it tries, and fails, to be beautiful or because its concern is to show us something ugly, whether about human life or about human movements, rather than to be beautiful.

In the field of literature, I suggested that 'beautiful', when applied to novels, generally has the connotation 'sentimental' and is not commonly used by literary critics except in an ironic manner. Poetry is in a very different position. Although, as I earlier said, there are many serious poems which one would not describe as being beautiful, when a poem is beautiful that is a reason we give for taking it seriously. Films and operas are complicated. They may be beautiful pictorially, their music may be beautiful, their actresses may be beautiful. It can be difficult to know precisely what is being claimed when films and operas are described, compendiously, as being beautiful; particularly in the case of a film, this may turn out, as with novels, to be equivalent to 'sentimental'. Admitting these complications, however, I have been defending the view that serious works of art can be, but need not be beautiful, as against both the view that being beautiful is a necessary condition for being a serious work of art and the view that seriousness and beauty are incompatible.

But why does beauty matter? One can easily enough see why truth matters, or moral education, or imaginativeness. On the face of it, it is not so easy to explain why we should take something seriously, as distinct from simply enjoying it, if all we can say in its favour is that it is beautiful. Yet if, as we shall see, Plato, Plotinus, Russell all refused to ascribe to art any but an enfeebled form of beauty, this was just because they took beauty so seriously. For G.E. Moore, beauty itself was good and the appreciation of it one of the few good states of human consciousness. Go back in time, in any part of the world with which I am acquainted, and one comes across objects, designed no doubt for practical or religious use but with patterns incised on them which have no functional explanation. For human beings, beauty matters, just as discovery matters but with a longer history, it would seem, of its mattering. That is all one can say and all one needs to say.

When Wittgenstein laid it down that 'in real life, when aesthetic judgments are made, aesthetic adjectives such as "beautiful", "fine" etc. play hardly any role at all', he was, I think, exaggerating. True enough, when artists themselves are talking, such sentences as 'he's brought it off' or 'she's got it just right' are more common; they know the difficulties, and see the work as overcoming them. But in everyday judgments, made by those who are not artists, the use of such adjectives is common enough – just as, listening to a politician, an ordinary listener might say 'that was a fine speech' where another politician might say 'he's brought it off'. Both can be correct.

The third possibility remains, however, that while it is quite correct, under certain circumstances, to call works of art 'beautiful', their beauty,

as is also, so we saw, sometimes said of whatever truth they contain, is of such a trivial, such a low-grade, kind as not to be a good reason for taking them seriously. Plato occasionally – he is writing dialogues, not treatises – seems to take this view. If in the *Phaedrus* he extols beauty, he nevertheless relegates the artist to a position below the merchant and the gymnast and not far above the sophist and the demagogue. In his *Symposium* he has Socrates describe as a lesson learnt from a 'wise woman', Diotima of Mantineia, that true beauty is 'pure and clear and unalloyed, not clogged with the pollutions of mortality and all the colours and vanities of human life'. This is a description no literary work and no painting could possibly satisfy, unless we count as uncoloured those plain black or plain white canvasses with which painters since Malevich have sometimes confronted us. To be sure, such platonically-ideal beauty is not to be arrived at all at once; art, one might think, could be at least a major stepping-stone on the route to it. In fact, however, when describing the passage to ideal beauty, Diotima referred Socrates to the beauty of the human form, of minds, of laws and institutions. Not a word about art.

To take another case, Plotinus is included in an anthology of writings on aesthetics under the heading 'Art as Beauty'. This would suggest that he is identifying art and beauty or, at the very least, taking art to be a primary example of the beautiful. When we look at the text of Plotinus we soon see, however, that he has no real interest in the arts. If he grants that both sights and sounds can be beautiful, even at this level he generally refers to natural objects rather than to works of art. In any case, only the sensualist, he argues, will take any lasting interest in beauty of this sort. The true philosopher will move on to contemplate the beauty of conduct, of intellectual pursuits and then, in the case of a chosen few, to catch sight of 'that inaccessible Beauty dwelling as if in consecrated precincts, apart from the common ways where all may see, even the profane'.

Although one seldom has occasion to mention Plotinus and Bertrand Russell in the same breath, in this case there are similarities. In 'The Study of Mathematics' Russell at first, to be sure, claims for mathematics – his equivalent of Plotinus' 'inaccessible Beauty' – no more than that 'the true spirit of delight, the exaltation, the sense of being more than man which is the touchstone of the highest excellence is to be found in mathematics *as surely as in poetry*'. But that concession to poetry is soon withdrawn. Literature, he admits without pursuing the matter further, can present us with universals but never, he says, in their pure form, never without the 'irrelevant trappings' of particular circumstances. Sculpture, it now appears, is the only art which deserves comparison with mathematics. For mathematics, so Russell tells us, possesses 'a beauty cold and austere, like the best of sculpture, without appeal to any part of our weaker nature, without the gorgeous trappings of painting and music, but sublimely pure'. So whereas for Boccioni there is more *truth* in

geometrical forms than in breasts and thighs, for Russell there is more *beauty*. Presumably Calder would satisfy both of them, Rodin neither. Russell's beautiful mathematics is no doubt somewhat more accessible than Plotinus' 'Beauty', but it shares many of its characteristics – eternity, purity and the like.

On this view, then, beauty is possessed only by one variety of art, sculpture which is completely free from irrelevant, gorgeous trappings. For the rest, it can be found only in mathematical relationships in their purely abstract form. This puritanical conception of beauty is by no means confined to philosophers. One of the few segments of twentieth-century verse to be found in the 1941 edition of the *Oxford Dictionary of Quotations* is Edna Millay's 'Euclid alone has looked on beauty bare' – a privilege which earlier generations would have ascribed to the sculptor of the Venus de Milo, a distinctly different matter. And many painters, many sculptors, have tacitly, or explicitly, thought of themselves as geometers or, more fashionably, topologists.

Of course, they are not. A work of art is a concrete, individual thing. So is a geometrical diagram, but that is not what the geometer is talking about; the diagram, for him, is simply an imperfect illustration and its object is to help us to understand a proof. The work of art, in contrast, stands on its own as something to be taken seriously for its own sake. (This is not affected by the fact that it may, like a print, be one example of a class of cases.) A line in a painting has a coloured breadth; a sculpture has a determinable mass and a specific colour, if generally white or bronze or the colour of some kind of wood. None of these characteristics is possessed by the proper objects of geometry. Does this prevent works of art from being beautiful except at a third-rate level?

That would rule out, on the face of it, the view I have just defended – that it is quite proper to appeal to its beauty in urging the seriousness of a work of art. It might, I suppose, be argued that beauty is so important that it lends seriousness, even at the third-rate level, to anything which exhibits it. That would not be very convincing; the more natural conclusion would be that we should confine our energies to those areas where first-rate beauty is to be found, following Russell into mathematics or Plotinus into the contemplation of beautiful conduct or into purely intellectual pursuits. For only there is beauty to be seen either totally bare or, in Plotinus' case, but lightly clad.

It will be obvious from things I have said earlier that I do not share the assumption that the lover of sights and sounds is automatically a poor creature, in whom 'our weaker nature' predominates, or that the 'gorgeous trappings' of painting and music make it absurd to take them seriously. To delight in the life and colours of the world is a virtue, not a vice; those who thus delight will not wish to mutilate either the landscape or the living things to which it gives shelter. Yet if when critics describe a work as 'beautiful', we generally expect to find that it has a direct sensory

appeal, Russell was not all the same wholly out of line with normal critical practice in associating beauty with formal perfection. It is no accident that the Latin word for beautiful is *'formosus'*. Outside the arts, it is on account of its form, too, that we describe a landscape as being physically beautiful rather than as merely 'pretty' or 'attractive'. To be beautiful, when one is using that word in a carefully discriminating way in such sentences as 'not exactly beautiful but ...', a woman must have a certain regularity of structure not to be found in a woman who is merely pretty, let alone a *'jolie laide'*, attractive though such a person may be.

Looking across a room at a painting we may be drawn towards it by the brilliance of its colouring and even say to ourselves: 'How beautiful!' Approaching it, however, we may hastily withdraw that appellation, as its formal defects become obvious to us. A musical work may in the same way strike upon our senses at first hearing but we come later to notice its formal defects and no longer think of it as being beautiful but rather as meretricious. (Orff's *Carmina Burana*, Ravel's *Bolero*, are works of which this kind of thing has been said.) Indeed, our artistic education largely consists in our coming to discriminate in such a manner. The works we abandon may still entertain us; we do not cease to find them pleasing but we do cease to regard them as beautiful.

On this interpretation of the situation, then, 'beauty' and its cognates, as used in critical discriminations whether of the natural or of artefacts, suggest an orderly organisation which is sensorily attractive, a wedding, if you like, of the sensual and the rational. The claim that a work of art, or a person, or a landscape, or a city, or an artefact of any kind is 'beautiful' can be contested by drawing attention either to its lack of sensory appeal ('No, it is murky, frigid, dull') or to its lack of order ('No, it is shapeless, formless, too repetitive, goes nowhere').

One of the important things about beauty in the arts – most conspicuously in architecture, music and poetry – is that it conjoins sensory attractiveness, imaginative enlargement and intellectual satisfaction. These no longer appear to be irreconcilable antagonists. The belief that imagination and intellect are divorced, that sensory and intellectual pleasure are incompatible, that the sensory is so inferior that it contaminates anything with which it is conjoined, that what appeals to our emotions must be condemned if we are to be rational, has caused enormous damage in Western civilisation and can most rapidly be disputed by pointing to beautiful art. We can easily see why intellectualists like Plato, Plotinus, Russell will not allow us to point in that direction.

There are those who would object, no doubt, that to place any stress on sensory qualities is to confuse between the beautiful and the charming. That was substantially Kant's position. He considers particularly the case of colour, which is certainly a prime example of a sensory quality. The charm of colour can be used, he grants, to draw attention to the

design of a painting, as sensorily agreeable instrumental tones can be used to draw attention to the design of a musical composition. Although in both cases that they are attractive can make the work more agreeable to our taste, the beauty, he argues, lies wholly in the design, the composition.

The mistaken belief that the Greeks worked only with bare white marble may have strengthened this attitude to colour, which can, however, scarcely sustain a close look at paintings so far apart in time as the wall-paintings in Livia's house, Venetian paintings, or Monet's late water-lily paintings. There have, of course been great painters who first designed their work and then coloured it in rather than immediately painting on to a bare wall or canvas. Even then, however, although the design is no doubt primary, in time at least, the choice of colours is far from being inconsequential or a mere sop to those who are not connoisseurs. Neither can we think of instrumental colour as merely a charming addition to musical compositions, whether in Debussy, or that austere composer Webern, or in Indian or in Chinese music. Arguments about the growing practice of playing older music on the original instruments turn around colour. Colour is not a mere charming addition to Egyptian sculpture or to many a Roman Church.

In any case, although sensory appeal is particularly obvious at the level of instrumental or pictorial colour, this is far from being its sole point of entry into the arts – shapes, rhythms, sound compositions can all attract us at the sensory level. One cannot ignore them, very obviously in such a poet as Swinburne, whose defence of sensory pleasure finds a reflection in the sensory qualities of his own poetry, when it is at its infrequent best. If lines from Shakespeare cling fast to our minds, their attraction is as much sensual as intellectual. In 'When to the sessions of sweet silent thought, I summon up remembrance of things past', the sounds can scarcely be ignored as doing no more than add charm to such lines, unless we are prepared to deny beauty to all poetry, as being sensorily corrupted. And that can fairly be regarded as a *reductio ad absurdum.*

Sometimes, it is true, we may wish colours away, be glad that we now see Greek temples bare, fearing that they would have been garish, wish that Swinburne had devoted more attention to sense and less to sound, prefer sketches to the finished paintings, black and white to coloured photographs – as indeed most photographers do who claim to be artists – rejoice in buildings or music which are notable for their austerity. But, as I have just been suggesting and as the Platonically-minded have substantially seen, the sensory element remains, as it does when we contemplate a nude rather than someone wearing a magnificent costume. Simply, it takes a different form. The most abstract of paintings, the most unornamented of buildings, still, if we account them beautiful, offer us sensory delight as well as intellectual satisfaction.

I cannot pretend, of course, that my use of the word 'beautiful' wholly

reflects ordinary usage, if only because there is no such thing, as distinct from ordinary usages. If, however, my usage is not faithful to that very common usage which permits people to say of anything whatsoever which pleases them that it is 'beautiful' – the *Oxford English Dictionary* recognises this as 'colloquial' – and if, too, it does not conform to the Platonic tradition for which, at best, anything which is sensorily attractive can have only a very low degree of beauty, nothing of that kind having any claim to be taken seriously, it does, I hope, conform to the practice of many critics. The fact is that 'beautiful' has local usages. In *Little Dorrit* a surgeon tells a patient that he has a fracture and a dislocation, both of them 'beautiful'; I have heard a skin specialist call melanoma a 'beautiful disease'. It is easier to understand why mathematicians call a proof 'beautiful', for at least such a proof overlaps with the formal properties we find in some works of art. (It can be elegant, economical.) Nevertheless this is a different local usage from the language of critics and does not have to be taken as our paradigm. But does my account suffice even in its restricted field?

We must grant – we are not meeting this phenomenon for the first time in our enquiries – that there are those who would respond to Platonism quite differently, not, as I have done, by refusing to accept the denigration of the sensory, by defending what was to Plato the greatest of enemies, the 'lover of sights and sounds'. Rather, they would argue that the sensory element in art is of no consequence, that it is but a ladder which the critic can safely throw away, the true content of art being metaphysical, mathematical or both of these at once, and deriving its beauty entirely from that fact. Where Plato, Plotinus, Russell went wrong, they would say, was in not recognising this; once it is recognised, art can assume its proper place at the summit of any scale of beauty.

So far as metaphysics is concerned, I have at several points expressed my scepticism about the view that we can turn to the arts for metaphysical enlightenment. One of Chirico's self-portraits bears the motto: '*Et quid amabo nisi quod rerum metaphysica est?*' But unless he had told us we could scarcely guess his metaphysical leanings; that other self-portrait in which he proclaims his love of enigmas is much more plausible. Titles apart, who could guess that the painting he labels *Nostalgia for the Infinite* is any different in its subject-matter from that very similar painting he simply called *The Tower*? Or for that reason judge it to be more beautiful? I cannot imagine a philosophy teacher sending his pupils to Chirico's paintings – or to any other paintings or indeed to novels, poems, plays, works of architecture, musical compositions, films, ballets – in order to help them solve the problems set by Hume or Kant. Who but the minuter sort of scholar can take an interest in pictorial illustrations of third-rate ideas, and first-class ideas, as Hegel substantially saw, do not lend themselves to such illustration. Equally, as I have already suggested, to send budding geometers to look

at even the most abstract of paintings would be a waste of time.

This is not to deny, of course, that artists can interest themselves in metaphysical questions or that references to works of art when one is discussing metaphysical questions are automatically out of court – any more than are references to any other form of human or non-human activity. They can offer illustrations, they can raise problems, but they do not contribute more directly than this to metaphysical discussions. Something similar is true of mathematics. If, as Kandinsky argued in his *Continuing the Spiritual in Art*, 'the final abstract expression of every art is number', why not go straight to number theory? As for geometry, visual artists have no doubt been interested in and learnt from such fields as geometrical optics, whether in their dealings with perspective or, more recently, in op-art. Being influenced by geometry, however, is one thing, contributing to it is quite another thing. No doubt, as Bronowski says, some abstract paintings could serve as illustrations in a work on topology. But illustrations is all they could be.

Nevertheless, painters have astonishingly often laid it down that a work of art can be beautiful only if it confines itself, formally, to some particular geometrical figure or small set of such figures. So we were told by Hogarth that the undulating line is the line of beauty, by Mondrian that the straight line is. There has been much ado about the golden mean. In his *The Foundations of Aesthetics* Ossowski refers – unfavourably – to experiments by Fechner and his school which profess to demonstrate that a rectangle with eight-inch and five-inch sides is more beautiful than either a square or a more elongated rectangle. One could write a history of architecture, landscape, gardening or even fashion with some such title as *From the Curve to the Straight Line and Back*; in his *Renaissance and Baroque* Wölfflin told part of this story. There is a living museum of landscape gardening in Hanover's Herrenhausen Gardens where one moves from a garden where everything is cut into conic sections, conforming to the seventeenth-century geometrical spirit, to a baroque garden where there is not a straight line to be seen. Romanesque architecture was gradually transformed into pointed Gothic; there are now abstract sculptors (Deacon) whose works are wholly curved; curves are replacing the straight edges and rectangular entrances characteristic of modernist architecture; Edwardian female curves became the straight-lined 'flapper'. Somewhat more liberally, Bauhaus pupils were taught to confine themselves to the square, the circle and the triangle and engaged in a furious debate about which of the permitted primary colours went with which.

As this last debate illustrates, it was not in any of these cases being suggested that nothing more than a strictly geometrical form was involved. If after 1921 Mondrian eschewed curves, he certainly did not abandon colours. So nothing said at any stage by the Straight-liners or the Undulators was automatically incompatible with the view that the

beautiful is sensorially attractive form. Simply, the form in question was very strictly confined.

Especially in the case of abstract art, the geometrical confinement was often accompanied by metaphysical expansiveness. We have already seen this in the case of Mondrian. One does not have to look far into Bauhaus pronouncements – as in the case of Schlemmer – to find oneself in the shadow of Plato and Hegel. Geometry and metaphysics often coalesce, as if the painters and sculptors felt that they needed to have the seriousness, as distinct from the decorativeness, of what they were doing guaranteed by something other than its geometrical form. One cannot plausibly deny, of course, that serious art has been created by artists who confined themselves within the boundaries set by such rigid formulas, just as it has been created by artists who were rigidly confined to the treatment of a very limited range of subjects, excluding, let us say, the depiction of any human or animal form.

Perhaps, even, it is good for artists to accept such limitations as a way of preventing their fancies from running wild. Picasso once said as much, and in his *The Classical Language of Architecture* John Summerson ascribes a similar function to the complex ratio systems devised by Corbusier and his followers – 'there are types of extremely fertile, inventive minds which need the tough inexorable discipline of such systems to correct and at the same time stimulate invention'. At the hands of less inventive minds, of course, adherence to such systems degenerates into academicism. Modernism began by scorning the academies but the vast majority of modernist buildings are nevertheless, in the bad sense of the word, academic, automatically applying rules. Attempting as post-modernists – an expression which has more meaning in architecture than anywhere else – to abandon such rules architects too often collapse into total arbitrariness. Their allegiance to modernist formulas had concealed their imaginative poverty.

We are not particularly interested, however, in what it helps artists to believe – which may include such highly improbable beliefs as that they are neglected geniuses, as it may help philosophers to believe that they have at last discovered a method which will lead to the solution of all philosophical problems. The point which interests us, rather, is that there is no arithmetical or geometrical formula the satisfaction of which is either necessary or sufficient to determine that a work of art is beautiful. Most obviously, on the side of sufficiency, it can satisfy such requirements and still be banal, academic, unimaginative. On the side of necessity, any such formula rules out too much. Haters of anything but straight lines will have to rule out not only innumerable Western painters and sculptors and architects, but the Islamic art displayed, for example, in the calligraphic shields of the Blue Mosque in Istanbul – to say nothing of comparable Chinese and Japanese art or Indian sculpture. Haters of anything but undulating lines will have to rule out not only Mondrian but

modernist architecture in general, along with traditional Japanese architecture and archaic Greek sculpture. Yet I have suggested that beauty is related to form. What kind of form, if not particular geometric forms? And how is form related to seriousness? Wittgenstein, rejecting the view that 'beautiful' is the central concept in our aesthetic judgments, went on to say that 'the words you use are more akin to "right" and "correct" '. In *The Story of Art* Gombrich makes considerable use of the concept of 'formal rightness'.

There is always a temptation to suppose that we have made an intellectual advance when all we have done is to introduce a new terminology. But 'formally right' provides us with a predicate which, unlike 'beautiful' we can without incongruity ascribe to the witty, the grotesque, the ironic, the powerful – as well as to the pleasing. Is there any satisfactory way of filling out this concept?

10

Form and Formalism

Form is related both to subject and to content. Describing the subject, or 'theme', of a work is, in general terms, saying what it is about. In the case of paintings and statues this is often indicated by a title. That sometimes happens, too, in the case of a novel, a film, a poem or a play. Joyce's *A Portrait of the Artist as a Young Man* will serve as an example, although the reference to a subject is seldom so direct as this; Milan Kundera, with much the same subject, calls his novel *Life is Elsewhere*. Music is a more complicated case. The title is sometimes simply an indication of the general form of the work, as in *Piano Trio in C Minor*, the subject, or subjects, of the work being announced musically. At other times a composition is given a literary title, let us say *Death and Transfiguration*, which is supposed to indicate what the work is about, a claim which even those who admire the work sometimes dismiss as mere flummery.

Two things are, however, sufficiently clear. The first is that nobody would be under any temptation to say that subject and form are identical unless, as might happen in the case of architecture, this is a way of indicating that some works of art, although they may have a title – St Peter's, the Seagram building – do not have a subject but only a form. For not only do innumerable paintings, differing greatly in form, share as their subject the Crucifixion of Christ, but also there are sculptures, novels, cantatas which have this same subject. And that is only one instance of the way in which the same subject can be treated in a number of different forms.

Secondly, there is no fixed relationship between the seriousness of a subject, historically estimated, and the artistic seriousness of a work that has that subject, any more than there is a fixed relationship between the beauty of a subject and the beauty of the work that takes it as a subject. Many Dutch paintings take as their subject what are, by such historical standards, trivial details of everyday life. This fact has sometimes been deplored. So Sir Joshua Reynolds, ardent proponent of the 'grand subject', regretted that Jan Steen, inn-keeping painter of tavern brawls, had not made his way to Rome where by studying the historical frescoes he could have transformed himself, in Reynolds's estimation, into a great master.

But Reynolds could not bring himself to assert – indeed that hypothetical prophecy suggests the opposite – that Steen was anything but a serious painter.

As for literature, Flaubert, one might say, had an historically trivial subject in *Madame Bovary*, an historically serious subject in *The Temptation of St Anthony*, Tolstoy an historically trivial subject in *Anna Karenina*, a serious subject in *War and Peace*. It would be ridiculous to conclude that the novels with historically trivial subjects were artistically trivial works. It is never possible, indeed, knowing nothing about a work except its subject, to deduce that it is, or is not, an artistically serious work.

To turn now to content, when in everyday contexts we use that word, nowadays normally in the plural, it is correlative to container. We speak about the contents of a parcel, a bottle, a purse, a safe, a desk. In each such case we suppose that we could transfer the contents to a different container without their being subject to any but the most minor change, perhaps some very slight damage as we unwrap a parcel to transfer its contents to a drawer or a drop or two lost as we transfer wine from a bottle to a decanter. Of course, not every change from one container to another will be thus content-preservative; sulphuric acid cannot be poured with impunity from a flask into a parcel. The fact remains that there can normally be quite considerable changes in the container with no substantial change to the content.

If we apply these facts about contents and containers to works of art we may be tempted to argue thus: 'In the case of works of art the container is the form. Just as there is a point at which we have in our possession the contents of a parcel before deciding how to wrap it up, so, too, the artist has the content of a work in mind and then decides in what form it will be best to wrap it up.' Now, if we substitute 'subject' for 'content', this is a plausible account of what occasionally happens. An author may think of a subject which 'has possibilities', taking it at first as a theme for a novel but later deciding that it would 'go better' as a play or a film-script, a painter might decide that a particular subject might be better treated in an engraving than in a painting. That the same *content* could similarly be presented in different forms is what Schlegel was denying in developing the concept of 'organic form', which many another took up after him, if not always quite in Schlegel's terminology. On that view, a form is not a pre-existing shape into which a content can be poured, like wine into a decanter; on the contrary, the form is created as part of the process of developing the content, in a fashion unique to a particular work. How far that is so we can only decide after we have looked more closely at the concept of 'form', always with an eye on our main theme, thus only obliquely referring to some of the great controversies of the past.

There are four different levels at which one might refer to the 'form' of a work of art. The first of these is extremely loose. It classifies a work as

belonging to a broad general species. The membership requirements are sometimes tight, sometimes broad, sometimes referring to the fact that the work has a certain structure, a 'form' in a narrower sense of the word, sometimes to its having a certain kind of subject, sometimes to its dealing with that subject in a certain kind of way. So 'sonnet' is a tight formal classification, 'love poem' refers to the subject, 'satire' to the treatment. One is inclined to say straight off that to allocate a work to any such category is to say nothing whatsoever about its seriousness. A 'monologue', after all, can be either a purely telic political sermon or a light entertainment or a serious revelation of character, as in some of Browning's or Eliot's poetry.

Nevertheless, a very long-established theory of criticism regarded such classification of works of art as either deciding, or being an essential step on the path to deciding, their seriousness. So, supporting the stronger of these views, Percy Scholes argued of symphonies that by their very nature they are serious works of art. We might be tempted to say the same of operas, as of sonnets and epics, perhaps of cathedrals. To complete such works certainly requires a considerable degree of technical accomplishment and artistic endeavour. They set themselves up as being candidates for seriousness, as a comic song or a suburban bungalow does not do. The fact remains that such works may totally lack imaginativeness and can then be properly dismissed as academic exercises. The stronger view, then, cannot be sustained, if, as I previously argued, a serious work must be imaginative.

That still leaves us to consider the weaker view that formal classification is a necessary stage in the process of settling whether a work is to be taken seriously. Such a doctrine rests on the assumption that the seriousness of a work involves its adherence to the requirements appropriate to a particular genre, even if – which is all I have so far argued – it can so adhere without being serious. The history of this doctrine and of the chaos it created is set out by Croce in the second of the historical notes which make up the nineteenth chapter of his *Aesthetics*. Authors *would* insist on writing works which could not be set aside as being of no significance but which either did not fit into any of the accepted genres or did not satisfy the requirements of the category into which it was most natural to place them. To overcome this difficulty, critics multiplied genres in the manner satirised by Shakespeare in Polonius' 'tragedy, comedy, history, pastoral, pastoral-comical, historical-pastoral, tragical-historical, tragical-comical-historical-pastoral, scene individable, or poem unlimited' – the last two phrases referring to those works that did, and those that did not, accept the most notorious of fixed rules, the 'unities'.

It is easy to understand, then, how such categorisation came to be wholly scorned. I have, indeed, no desire to defend it. Except this far: there are occasions when we do not know how to take a work and if we

take it in the wrong way we may be unduly dismissive of it. That is one way of misreading a work. And 'taking in the wrong way' is sometimes a matter of generically mis-classifying. At the opening night of *The Seagull*, Chekhov's audience expected a farce – he was then known only as the author of farcical stories – and began by laughing heartily, but ended by dismissing the play as worthless. Later, when he wrote *The Cherry Orchard*, he was to complain that his producer, Stanislavsky, his actors and his audience had wholly misunderstood his play – although to be sure, they did not in this case dismiss it – by failing to see that his characters were comic. 'The critics have type-cast me as a sniveller', he is quoted as having complained, just as earlier they had type-cast him as a *farceur*. In both cases, then, his play was misread by being generically misclassified.

More obviously, if we fail to see a work as a parody or read as a naturalistic novel what is actually a Menippean satire – I shall have more to say about this later – we are likely to criticise it for not possessing characteristics which have no bearing on its seriousness and to overlook properties that do. The same thing can happen if we criticise a Picasso mid-period portrait in terms which would be perfectly appropriate in criticising a portrait by, let us say, Sir Thomas Lawrence. What happens in such cases, it might be replied, is that we 'misunderstand' the author's – or the painter's – intentions. In fact, however, the intentions are, in most cases, revealed only in the work. Only by reading it can we hope discover what Shakespeare 'had in mind' when he wrote that somewhat puzzling play *Troilus and Cressida*. Although it would be silly to set up a special category of 'anti-heroic tragedies' just to accommodate that play, to decide whether to take it seriously, indeed even to read it intelligently or to direct it, we have to consider it in the light of a class of works, 'heroic tragedies', which we may think of it as undermining.

To traditional genre theory is sometimes counterposed, as we saw, the view that each work is wholly unique, to be judged without any reference to other works. That, I am suggesting, is impossible; to 'take it in' we have to see it as a work of a certain kind. We simply cannot get along without such words as farce, parody, comedy, tragedy, or, in the case of paintings, history, landscape, portrait, however vague they might be, and should be left, at the edges. There is no other language in which Chekhov could have protested against the misinterpretation of his plays, except by saying that *The Seagull* is not a farce, that *The Cherry Orchard* contains comic characters.

The Chekhov case is by no means exceptional. We approach a work of art, normally, with a set of expectations, sometimes, as in his case, deriving from our previous experience of the artist's work, sometimes from the fact that we have selected it from a section of a library or a record shop which bears a certain title, sometimes because it is self-described as being of a certain kind, as when Graham Greene calls

Brighton Rock an 'entertainment', sometimes because a reviewer has categorised it in a particular way. That expectation, like any other expectation, may be disappointed, but to demand that we approach a work without any such expectations is to demand the impossible. Human beings are generalising animals; that is the source of our successes as well as of our manifold disasters. If I find myself criticising particular generalisations about the arts, this is certainly not to defend the view that works of art are unique, in any sense stronger than the sense in which every leaf is unique – which does not prevent us from classifying them.

Let me, then, sum up this perhaps rather too obvious discussion. First, to allocate a work to a particular genre is not in itself to provide a ground for taking it seriously – although to call something a 'boulevard farce', for example, may be automatically to reject this possibility. Secondly, such an allocation may none the less be a step towards the critical examination of a work. Thirdly, it is preposterous to suppose that we must have an appropriate genre for every work, although sometimes it may be desirable to invent a new genre, let us say *film noir*. (Indeed, the creation of new genres with their own requirements seems to be inevitable, even when it is by no means deliberate. So Paul Fussell, in the introduction to his *English Augustan Poetry*, points to the way in which 'confessional poetry', whether at the hands of a Ginsberg or a Plath, works with such conventions as that it must not rhyme; its metre 'must be more or less concealed'; it must use everyday language; it must give the impression that it is wholly spontaneous, 'slipping out' rather than being planned.)

Fourthly, genre classifications are generally very uncertain at the edges. In 1943, when a Sydney painter, William Dobell, was awarded the Archibald Portrait prize, a competitor challenged the decision on the ground that Dobell's painting was a caricature, not a painting. The ensuing legal argument was as sophistical as it was sophisticated. For while we should none of us doubt that Sargent and Kauffmann painted portraits, Cruikshank and Rowlandson caricatures, we have no need to define these classes in a rigid manner. The court had to come to a decision; that is what courts are for. We do not have to do so in order to decide whether Dobell's painting was a serious work of art. The editor of a three-volume edition of Shakespeare, with the plays divided into tragedies, comedies and histories has to decide in which of these classes to put *Measure for Measure*. We need not make any such decision, although if we were to see a performance of the play in which Isabella was presented farcically as a hypocritical sluttish nun, we should certainly protest. Fifthly, the view that nothing matters except form has no plausibility whatsoever if by form is meant genre. Neither does membership of any genre guarantee beauty.

To move to a second sense of form, we sometimes refer to a building – or indeed a painting or a musical composition or a literary work – as being in

form Baroque, Gothic, Rococo, Mannerist. Only buildings are normally described as 'International Modern', but that expression falls into the same category. Perhaps the word 'style' is in such instances more commonly used than 'form', but their sense is, in the contexts I have in mind, much the same. Outside architecture or, in the case of mannerism, outside painting, the formal significance of these expressions is often vague; they sometimes convey little more than 'composed, written, or painted during the period when a certain architectural, or pictorial, style flourished'. But whatever we take their precise formal significance to be, our immediate reaction is to say that it cannot be deduced from the fact that a work can be described in any one of these ways either that it is serious art or that it is beautiful.

Equally, I think I can now safely assume, it cannot be deduced that it is *not* serious or *not* beautiful. The contrary has, of course, often been argued. There was a time when 'Gothic' was synonymous with 'barbaric'. Later when, in 1924, Sacheverell Sitwell published his *Southern Baroque Art*, many were surprised that a critic should take such art seriously. As for music, not until the second half of the twentieth century were such composers as Telemann and Vivaldi taken seriously once more. From the standpoint of the past history of criticism, a willingness to grant that serious work can be found in each of these formal styles is, indeed, aberrant. Nevertheless, in our eclectic times, when even 'Victorian' has ceased to be a term of abuse, it is anything but a novelty. I do not propose to undertake the task of defending it, while reserving the right to maintain that in some stylistic forms serious work is distinctly rare. Once more, then, there is no immediate relationship between being of a certain form and being a serious work of art.

In a third, more important, use of the word 'form', it relates to general characteristics which cut across distinctions in style or in genre. In describing such characteristics, we use such words as 'unity', 'balance', such expressions as 'variety in uniformity'. There are many similar language-items; they make up the ordinary vocabulary of critics when they are discussing the formal characteristics of particular works of art. Are there any such formal characteristics which are to be found, and uniquely so, in serious works of art? This is the point, some would say, at which this book should have begun and to which, indeed, it should have confined itself; certainly, to have to face it towards the end of a relatively long book is not a situation one relishes. Fortunately, however, we need not face the task of examining in turn each of these items in the critic's vocabulary. It is enough to ask whether considerations of this general kind can ever properly be appealed to in discussing whether a work is something more than a successful entertainment or a successful piece of propaganda, in a broad sense of that word. This is the natural place to look for the 'formally right'.

One thing can be said with confidence at the outset; there can be no

demonstrative argument of the form: 'This work possesses one or the other of these general formal characteristics, therefore it is a serious work of art.' Once again, a purely formalist approach is quite implausible. For such formal criteria are so easily satisfiable that their presence guarantees nothing. Suppose, for example, that I paint, in however amateurish a fashion, a red isosceles triangle in the centre of a black circle. There is balance, for I could cut the painting into two pieces which would be precisely equal. There is variety, as between the red and the black. Yet at the same time there is unity, in the expanses of uniform colour and the regularity of the geometry. In much purely entertainment music there is an insistent unchanging beat to the music; if someone then sings against that beat, there is diversity; balance could be achieved simply by singing up and then down the scale. In 'the cat bit a dog', there is uniformity in the sense that each word is monosyllabic, variety in that the words are different from one another, balance in the sense that the subject and the object turn around a central verb.

If the presence of such qualities does not, therefore, guarantee seriousness, it might still be true that a work cannot be serious, or beautiful, unless it possesses them. As in the case, or so I have suggested, of imaginativeness, their presence might be necessary although not sufficient. One difficulty we encounter in discussing this view is the manner in which concepts like 'balance' and 'unity' have been unmercifully stretched, precisely in order to preserve such a doctrine. The examples cited above were very naive. They took 'balance' quite literally as involving precise equality on both sides of the painting; there could be no real doubt, either, about what I had in mind in speaking of unity, of uniformity, of diversity. That is far from being true of what is said in many critical writings which make use of these concepts.

Take 'balance'. In architecture, it can be secured in a fashion very much like the way it is secured in my imaginary abstract painting. So there are churches, many of them, which could be cut through from end to end so that the two sides would be precisely similar in dimensions and even, if we imagined them as being in the pans of a great set of scales, approximately equal in weight. Some of the most highly praised façades on Renaissance and Baroque churches have this kind of geometrical balance.

In many paintings, similarly, figures are arranged on a canvas in such a way that there is a clear centre to the painting and the figures on either side of this central figure are equal in number and, roughly, in mass. (In other cases, of course, the 'golden mean' is preferred). So in Renaissance paintings which bear the title *Sacra Conversazione* – I have beside me as I write examples by Ghirlandaio and Gerini – a figure of Madonna and the baby Jesus often lies at the centre, in some cases (Gerini) at such a height as to suggest the pivot of a balance. On either side of that central figure, often so placed as to stand beneath the centre of an arch, there

stand an equal number of saints. This way of describing the paintings suggests something very mechanical looking. A degree of variation is achieved by having the saints face in different directions (Gerini) or by placing the figures at markedly different distances from the spectator (Ghirlandaio). As well, more minor variations – a book placed high on a right-hand table, differences in the size of the trees seen through right-hand and left-hand arches, a tall cross borne by one of the saints – serve to diminish the risk of banality. Nevertheless, the primary balance of Gerini's compositional scheme, deriving from Perugino, is not affected by these slight deviations and neither is the not quite so obvious scheme of Ghirlandaio.

Even in the architectural case, however, the balance is not always of the clear-cut kind I described above. It is by no means universally the case that every serious work has this kind of divisible symmetry, although certainly there are many instances of it whether in domestic architecture, in official buildings, in office blocks or in churches. DeWitt Parker displays some consciousness of this when he writes in *The Analysis of Art* that 'just as equal weights will balance in a scale pan so only elements *that are somehow equal in value* despite their opposition will balance architecturally' (my italics). In the case of actual scales we do not employ anything like this 'somehow' phrase. We say 'equal in weight'. When we can fill out the 'somehow' with 'equal in dimensions' that leaves us reasonably content; but 'somehow equal in value' suggests extensions of a kind much more difficult to justify, without departing so far from the familiar set of scales as not to be saying anything with the degree of definiteness which that analogy suggests.

Is a painting balanced just because it contains two persons, however positioned, both of whom are equal in value, as being saints? We surely demand, if we say that the painting is balanced, something more like a physical balance than this. But at the physical level does the watering-can in Degas' *Dancers at the Barre* serve to balance the three dancers? In mass and dimensions it clearly does not. We can draw attention to the way in which the shape of the watering-can takes up the shape of the dancer's leg. Is this enough to constitute 'balance'? In fact it is. An element in a painting can have, in virtue of its positioning in a scheme of composition, a pictorial weight which is quite different from either the weight of the physical object it depicts or the value-importance of that object. Another historically significant painting is Titian's *Madonna and Saints* where the traditional centrality of Mary is abandoned and her figure is balanced by an immense flag.

'Balancing' is a very crude word to describe the compositional complexity of, let us say, Leonardo's *Virgin of the Rocks*. Nevertheless it can serve as a shorthand for the presence of a regular geometrical scheme. In abstract art, the 'balance' is of geometrical shapes and colour patches. In representational art it is also that, but the 'balance' has to be

achieved in a way which helps to accentuate the figural relationships, as so remarkably in Michelangelo's *Holy Family* tondo. For all the vagueness of Parker's 'somehow equal in value', we may have to accept it as an indication that we are not to think that 'balance' is to be interpreted as the exact equality of mass on the two halves of a painting or a building but rather as indicating a concern for spatial relationships and, where the meaning of 'balance' is much more obscure, colour-relationships. So Picasso, according to Françoise Gilot, was prepared to tell Matisse that to secure balance in a painting he had to use pink rather than blue at a particular point.

There is another Gilot story which may help us here. Picasso, she says, had been working for some months on a series of still lifes turning around a skull and a bunch of leeks. One such still life struck Gilot, so she tells us, as being arranged in a particularly satisfactory way, just in virtue of the fact that the forms and the space around them were so 'nicely balanced'. 'That's just the trouble,' Picasso is said to have replied. 'It's so well balanced it annoys me ... It's a stable kind of balance, not an unstable one. I prefer a more precarious one. I want it to hold itself together but just barely.' We are reminded of a saying by Heraclitus: 'The hidden harmony is better than the open.' In academic, rule-governed, banal paintings the balance is obvious, secured without any special imaginative effort. In serious art it is often precarious; the triumph lies in securing balance where it looks to be impossible, where, often enough, we are called upon to find it rather than having it leap immediately to the eye. But then we see that it is 'dead right'.

More generally, we can program a computer to produce music, sentences, pictures which are formally 'all right'. But the formally 'just right' always strikes us as being at once unexpected and absolutely appropriate. A trained artist, a trained musician does not have to struggle to produce a work which is formally 'all right', any more than any of us has to struggle to produce a sentence which is formally 'all right'. On the other hand, the attempt to produce a work of art, or a sentence, which is formally 'just right' can reduce an artist to despair. The slightest of margins, as Plato saw and Tolstoy particularly emphasised, separates success from failure, 'coming off' from 'not coming off'. The problem is to specify this difference.

In his *The Story of Art*, Gombrich makes considerable use of the concept of balance in describing individual works of art. Like Parker, however, he finds himself in some instances forced back on the phrase 'somehow balances' and in his discussion of Cézanne writes thus: 'This balance and harmony about which artists worry so much is not the same as the balance of machines. It suddenly "happens", and no one quite knows how and why.' Gombrich continues with a word of advice: 'go and look at the pictures in the original' or, when that is impossible, in a good reproduction. I cannot better this by much. It is much easier to see the

way a picture is balanced than to explain, except in the most obvious cases, precisely why what lies on one side of the painting counts as balancing what lies on the other side.

Given both the obscurity attaching to balance and the immense range and diversity of serious painting, I do not see any way of demonstrating that balance is a necessary condition of being a serious painting, unless we make 'balance' so empty of meaning as to be useless. As Gombrich says, however, it is clearly something that serious painters have cared deeply about, often achieving it when they are dealing with subjects which are on the face of it very difficult to present in a balanced composition. (The same is true of photographers.) Its presence or absence is clearly something which has to be taken into account. Nor is this by any means a purely European phenomenon, although in Japanese painting the balance may take a somewhat different geometrical form, with steeply angled verticals. It was, of course, in any case a gross over-simplification when I spoke as if balance was simply between the left and right sides in a painting; to take a very familiar example a side painting of a church can balance the height of a steeple against the length of the church. One way of studying balance is to compare the landscape – natural, rural or urban – which a painter takes as his subject with what appears on the canvas, to look closely, to take an example I used previously, at just how complex considerations of balance explain the changes Vermeer makes in his painting of Delft to what he saw.

Is balance important only in traditional, classical-oriented, painting? Not at all. A concern for it is conspicuous both in expressionist art and in surrealist paintings, however odd their content might be and although we might in these cases expect it to be absent. And this can be said, usually, without any stretching of the concept of balance.

Many would, nevertheless, describe such paintings as 'unbalanced'. For balancing need not be of masses and shapes. We speak of ourselves as balancing options, evidence, possibilities; we assert or deny that someone has a 'balanced personality'. If the idea of 'balance' can be applied to the literary arts, this cannot be because its masses, in a physical sense, or its dimensions, in a geometrical sense, match one another. In practice, if a book is described as 'unbalanced', this is usually with the suggestion that it is not 'fair', or is 'unjust', or does not give us 'the other side of the picture'. So I have seen it said that *Hamlet* lacks balance because it is not fair to Claudius. One might, of course, make similar remarks about German expressionist paintings, considering them now from the standpoint of their subject, rather than their formal pattern. They are not fair to the bourgeoisie. A painter, or a writer, is looking at a type of situation in order to bring out certain features of it; that, as I have already insisted, can involve exaggeration, distortion. We are seeing Claudius as Hamlet sees him, not as Gertrude sees him, or Fortinbras, because the play is primarily about Hamlet; in the paintings we are

having our attention drawn to the grossness often inherent in the concept of 'having a good time'. To be sure, we can object that a particular distortion is of the kind that shuts rather than opens our eyes, that it is designed telically to strengthen our adherence to some conventional attitude, like a war-time recruiting poster, rather than helping us to 'see through' the eyes of someone, like Hamlet, for whom the world is wholly 'out of joint', or, in a different sense of the phrase, to see through some form of pretence.

One can certainly imagine a play in which Claudius is a good king and Hamlet a paranoid fanatic, but that would not be *Hamlet*. Neither would a play be *Hamlet* in which Claudius' marriage was a necessary piece of kingcraft in a threatened Denmark and Hamlet was simply a young man with different views about the responsibility of royalty. It does not count against Shakespeare that he preferred to write a different play; that a play is 'unbalanced' in the sense of seeing a situation only from a single point of view does not demonstrate that it lacks seriousness. Neither, of course, does such singleness of view either guarantee seriousness or constitute a necessary condition for seriousness. A single vision might at one time have been thought essential in order to secure unity, but many twentieth-century novels have shown that this is not so; Faulkner's *As I Lay Dying* will serve as an example. All one can say, then, that it is not a relevant objection to the claim that a work is serious that it is 'unbalanced' in this sense; such objections are in fact most commonly made to works which compel us to face uncomfortable truths.

There are other cases, however, in which such expressions as 'out of balance' are used in criticism of a literary work, or a film, where the accusation is both of a more formal kind and more relevant. Critics may assert that certain sections of the work are developed at too great a length and other sections are too lightly dealt with, so that it is 'thrown out of balance'. What is the criterion here being appealed to in the use of the condemnatory 'too'? The critic is thinking of the work as having a certain subject; the content of the work, the suggestion then is, demands a particular kind of exposition. So, taking the subject to be the corruption of a man by the attractions of power, we might complain that although the effects of that corruption are described in detail, we are told too little about his earlier life to judge whether, say, the corrupt policeman who becomes a Police Commissioner in a corrupt society had it within him to live a different kind of life. So whereas in describing some element in a painting as 'too long' or 'too short' we may be making a purely formal point, in a novel the reference to content is essential if we are to justify our claim.

In music, a critic who uses 'unbalanced' as a condemnatory epithet is usually talking about an orchestral performance in which the brass, let us say, is so loud as not to permit us to hear the other instruments or, if a sonata or song-cycle is being performed, the orchestra overwhelms the

soloist. But one could speak of a musicial composition in similar terms, whether for parallel reasons or because, let us say, one movement in a symphony is inordinately long. By what standards? Here we reach, once more, a highly disputed point, on which we shall have to say a little more later without pretending to be able to resolve it. For some theorists, the 'too long' can be justified only by reference to the formal structure of the work. Indeed, there is nothing else which could justify it. So we might say, perhaps, that in the second movement of a particular Bruckner symphony there is a great deal of repetition, too little development. On a different view, a musical composition has not only a subject – which, everyone admits, may have been named by the composer in a literary, as distinct from a purely musical way – it also has an emotional content as distinct from a purely musical content, and a section of it may be too long, just as a literary work can be, in relation to the expression of that emotion.

One thing is now plain, that even so apparently simple a critical epithet as 'balanced', while in a limited class of cases in the plastic arts it can be invoked with a degree of assurance, has to be stretched even there beyond its normal physical range if it is to have a wide application. In literary criticism, 'unbalanced' is often used to attack serious art; in music its range of application depends on what we take music to be about. At the same time, I have by no means denied that there are contexts in which to describe a work of art as satisfying, or as failing to satisfy, such formal criteria as 'balanced' is highly relevant to its seriousness.

My discussion of 'balance' was designed to illustrate what was previously just asserted, namely that at this level of generalisation the question how relevant formal properties are to the seriousness of works of art is difficult to settle. An exploration of anything that has been offered as such a formal property reveals problems in applying it in a fashion which clearly discriminates. One could readily construct a parallel analysis of such characteristics as 'unity'. This is not to say that such characterisations are too obscure to be of any use whatsoever when they are appealed to in the course of a judgment whether a work of art is serious; their application in a particular case can be sufficiently clear. So, looking at the baroque houses which line the streets of Augsburg – largely the creation of a single man – and wondering why I do not find them monotonous, I may notice that the ordering of the windows is never identical from house to house and then notice other unobtrusive differences as I pass along, or the manner in which unity is preserved even when the road takes a curve. That is a simple example of variety in uniformity. Such formal considerations can carry one a considerable distance in the discussion of streetscapes as a form of architecture.

Difficulties remain, of the sort we briefly explored in the case of 'balance', in so making use of these formal concepts as neither to reduce them to emptiness – this has often been in the case of unity so that in the

end we are left with no comprehension of what it would be like *not* to possess unity – nor, on the other side, to leave no room for formal innovations, of the sort that occurred when the Madonna was no longer placed in the centre of paintings which included her and other figures. But that these questions are difficult is scarcely news.

The problem I have encountered is to offer an account of these general formal characteristics which is not so tight as to rule out what are obviously serious works and yet is not so easily satisfied as to be useless as an aid to discriminating between the serious and the non-serious. 'An aid to' – that is the most we can hope for. There is no way of finding in these formal characteristics – any more than there was in the case of truth, morality, or imaginativeness – the necessary and sufficient conditions for being a serious work. What distinguishes serious work is not simply that it satisfies these formal requirements but that it does so imaginatively, in a way which overcomes problems set by the fact that it has other tasks before it – whether to house people, as in the case of the streetscape, or to tell a complex story or to develop a musicial theme. That it does not satisfy a formal requirement of the sort we have been considering is a *prima facie* objection to the view that it is a serious work. Nevertheless, it always leaves open the possibility of a 'Yes, but ...'.

In a fourth way of talking about the form of a work, the form is not described in general terms but minutely, for the most part by the use of expressions which are peculiar to the art in question, at least in the precise sense in which they are being employed. There is a passage in C.E. Montague's novel *A Hind Let Loose* in which a newspaper critic, unable to attend an orchestral concert, makes use of an unpublished review of an art exhibition, simply substituting the names of orchestral pieces for the names of paintings. He is caught out only because there was a last-minute change in the programme. We all know criticisms of this kind. They sometimes employ the generalised formal characterisations we have just been talking about, sometimes use words like 'metaphor' transferred from such art to another, sometimes convey ill-defined emotional reactions.

In other cases, however, a critic is quite clearly directing our attention to formal properties which are specific to a particular kind of art. Reading that 'her determination is translated by a cut which is even more elliptical than her first exit: we cut from her at the washbasin to the staircase; but this time we see both flights from below in a very deep shot of her running down', we have no doubt that this relates to a film. Just as obviously 'the peculiar character of [his] chord (in which a seventh of E flat is squeezed as it were into the interstices of an E major triad)' relates to a piece of music. This way of talking about form offers us an intimate characterisation of a particular passage in a particular work of art.

Generally speaking, a critic does not engage in an analysis of this detailed kind unless the work in question is up for consideration as a

serious work of art, even if the critic's analysis is going to culminate in adverse comments, perhaps a dismissal of it as banal or gimmicky. One does not have to be told, in the case of the two passages I have just quoted – one in fact referring to a composition by Stravinsky, one to a film by Resnais – that the work of art there described is taken seriously. If I none the less prefaced my remarks with the words 'Generally speaking', this is because contemporary literary theorists may offer similar analyses of works which they take to be sociologically interesting amusement works – not that they would accept my categories – and there is nothing in the nature of the case to prevent this. The presence in a musical work of such a chord or in a film of such a series of shots does not guarantee that it is a serious work of art, although it may strongly suggest as much. We can conduct a formal analysis of 'Mary had a little lamb', pointing out that its first line begins and ends with an 'm' sound, that the 'a' in lamb echoes while not having quite the same value as the 'a' in 'had', that the 'l' is alliterative, that unlike its successor, with its 'as white as snow', it contains neither a simile nor a metaphor and that this is equally true of the third and fourth lines. We can enter into a learned discussion of the poem's rhythmic patterns, contrasting the relative complexity of the first line with the regularity of 'the lamb was sure to go'. But why bother?

The formalist doctrine that nothing matters except form, at which we have now obliquely arrived, might have us dismiss 'Mary had a little lamb' simply because it has formal defects, of the kind we are now considering or the kind we have just considered, which it would then specify. More often, however, formalism is unhappy with literature. So, according to Clive Bell, poetry is inferior to music and (non-representative) visual art because 'the form is burdened with intellectual content'. In consequence, he goes on to tell us in his *Art*, 'it cannot transport us to that remote artistic beatitude in which, freed from humanity, we are upstayed by pure musical and visual form'. In thus linking formalism with mysticism, in its vision of art as leading us to a 'remote aesthetic beatitude' – in short, to a secular heaven – in its rejection as a 'burden' of not only the intellect but even humanity, this statement of Bell's is only too typical of formalism. Not only the artist, but even the art-lover, is indeed a desert anchorite. Art is depicted, very much in Pater's manner, as a consolation, neither celebratory nor critical, as imaginative only in its disposition of forms, as raising us above morality rather than educating us morally. And, as I earlier argued, literature can be subsumed under this category only if it can be thought of as nothing but a set of sounds, a view which is at all plausible only in relation to a narrow set of 'experimental' poems.

Bell assumes, of course, that music is 'pure form' and that the same is true of the more abstract visual arts, under which head one could include architecture. Music and architecture have indeed often been associated, as in Goethe's much-cited comparison of architecture to frozen music –

although I have never heard music described as 'melted architecture'. What they have in common, except on the interpretation of them in terms of emotions which I shall be discussing later, is that if we are asked to give a detailed account of them in terms of content or in terms of form we shall give exactly the same answer. In the case of architecture we can, of course, be asked about the artistic *contents* of a cathedral in the same sense that we can be asked about the contents of a parcel and answer by referring to the wall-paintings etc. But we can no more talk about its artistic content as something in any way distinct from its form, than we can talk about its subject. If we are going to distinguish serious architecture from architecture which is banal or telic – a monument to power – or simple entertainment or merely an exercise in civil engineering, it will have to be, ignoring emotion for the moment, in purely formal terms.

Of course, it might be said – I have already had a little to say on this point – that what corresponds to content in the case of architecture is function so that in judging the seriousness of an architectural work we have to ask whether the form follows the function as well as whether the building is formally attractive, i.e. beautiful. This, however, is a difficult view to maintain. That form *should* follow function was, of course, argued by a group of architects whose own works have often been subject to attack on the very ground that they are quite unfunctional, that they defined 'function' in terms which paid no attention to the fact that the functions were going to be exercised by human beings, or that they supposed there was something describable as *the* function of a building which in fact has to satisfy the needs of very many different human beings who have a variety of different purposes. The view that form ought to follow function cannot, however, be dismissed merely on the ground that sins have been committed in its name; that is true of all views.

The simplest case, perhaps, is a Roman Catholic church. This, one might be inclined to say, has a single function, the celebration of the Mass, and a serious piece of church architecture will be one that creates forms which are best adapted to this purpose. But will this work? Admittedly, there has to be a place within such a church where the Mass can be celebrated, and the churches in Rome, let us say, were obviously designed so that it could be celebrated in the sacerdotal manner current at the time at which they were designed, just as Protestant churches were designed to emphasise preaching and Byzantine churches to ensure that the service was semi-secret. Nevertheless, within a kilometre or so of Rome railway station one can find churches which are basically rectangular, round churches, elliptical churches, churches which remind one of palatial drawing-rooms, churches which are dark and austere. One soon sees, too, that churches are used for many other purposes than to conduct services – for private devotions, consultations, confessions – and that churches are often sought out by the devout for these purposes

which, considered either as architecture or for their artistic contents, have little or nothing to offer. Form and function, then, are related only in the broad sense that the architect, in virtue of being called upon to design a church rather than, say, a private house, has to leave spaces available for particular purposes, for an altar, a pulpit, confessionals, a communion rail and so on. That can readily be done in a church which is completely unimaginative, banal. What makes the difference between the banal and the serious is not a greater degree of adequacy in satisfying such requirements but their satisfaction in a manner which is not immediately deducible from their nature but is beautiful, or is 'just right'.

Music, as usual, is more complicated. There are those who would say of that relatively recent innovation, purely instrumental music, that we can demonstrate its character as serious art simply through an analysis which brings out its formal shape, and that this shape is identical with its purely musical content. For others, music, as we have already said, has an emotional content on which its seriousness rests, a formal analysis simply pointing to what carries or conveys the content. That would mean, on Bell's approach, that even purely instrumental music had to be set aside, along with literature, as failing to 'free us from humanity'. More obviously, such would be the fate of all songs. The visual arts, similarly, would go unless either they are purely abstract or we can train ourselves to perceive them as such, ignoring their treatment of their subject, seeing only their form. Their seriousness would be brought out by a detailed analysis of that form, an analysis in which a depicted person or landscape would be considered simply as an ingredient in an arrangement of shapes.

To accept the view that art is serious only in so far as it is purely formal, to dismiss therefore the claim of literature, obstinate in its humanity, its worldliness, to be serious art, to regard as inconsequential anything about the plastic arts except that they exhibit formal patterns, is surely to declare oneself a fanatic. A religious fanatic is convinced that there is one, and only one, thing – let us say, total adherence to the teachings of a particular book interpreted in a particular way – that is both sufficient and necessary for salvation and that anyone who questions this deserves damnation. A political fanatic takes a comparable view about some political panacea, an artistic or critical fanatic says the same thing about what has previously been regarded as only one feature of serious works of art. Fanaticism is always attractive, because it so greatly simplifies. If we believe that there is only one thing to be taken into account, whether the field be politics or art, if we can bring ourselves to believe, let us say, that in all instances public ownership is best or that in all instances private ownership is best, how much simpler political decisions become than if we believe that in some instances private ownership is best, in some instances public ownership is best, each case having to be separately considered on its merits. Similarly, if nothing

matters in art except form, much of the most difficult sections of this book could be set aside as totally irrelevant. If the consequence is that the whole of literature has to be cast out as non-serious this no more disturbs the fanatical formalist than it disturbs a political fanatic that compassion has to be thrust aside as irrelevant.

The general attitude of the reading, viewing and listening public to formalism can be summed up in a variant on Sir Toby Belch's rhetorical question to Malvolio: 'Dost think, because thou art a formalist, there shall be no more cakes and ale?' In the case of painting, the cakes and ale are representations of natural objects and human life; in the case of music, those 'dance-tunes' which Stravinsky still detected in Beethoven; in the case of ballet, settings and costumes and elegant movements; in the case of architecture, ornament; in the case of novels and films, narratives, personal entanglements, distinctive characters. Fanatical formalism, no doubt, is only one of the factors which account for the gap, already briefly commented upon in my opening chapter, which sunders much of that art which is taken most seriously by critics from the bulk of art taken seriously by the art-interested public. Anti-formalism can work in the same way, when it abandons forms in which the public has taken pleasure, such as rhymes, and so can innovations which increase difficulty in comprehending without necessarily being fanatically formalistic. To be sure, too, there always have been works of art which had a limited popular appeal, as we earlier insisted. If we may be more than a little surprised that the particular play which Hamlet refers to when he says that 'it pleased not the million; 'twas caviare to the general' fell into that category, Shakespeare obviously expected his audience to be quite familiar with that kind of phenomenon. Nevertheless, the conflict between formalists and public deserves some special attention.

Not everybody, of course, saw, or sees, the gap between popular and critical judgment as a disaster. Mallarmé was happy to lay it down that art is for the artists, Huysmans expressed himself as being content if twelve intellectual men, scattered over the face of the earth, could together understand a Mallarmé prose poem. In his widely-read *The Dehumanisation of Art* Ortega y Gasset said of the new art that was going on around him – the date was 1925 and he in fact didn't like it very much – that it provided us with a reliable touchstone for distinguishing between the élite and the vulgar, between those who were capable of having pure aesthetic experiences and those, most of the population, who were 'incapable of receiving the sacrament of art, blind and deaf to pure beauty'.

Most of the great artists of the nineteenth century, as of previous centuries, had been widely appreciated by an audience by no means confined to a select few – until formalism began to set in. The impressionists, to be sure, had at first been despised but that was as much by critics as by the world at large. If they later won over an

immense public this is connected with the fact that they by no means deserted the natural world. Once it was recognised that their paintings had to be looked at rather differently it soon became apparent that they offered the same formalist-scorned sensory delights as traditional paintings and had the same capacity to help us see the world – often segments of the world we had never previously looked at – in a fresh manner. Indeed, changing what has to be changed, one can say of them what M.H. Abrams has said of Wordsworth:

> Either directly or by way of their influence on other painters, they have altered the way we perceive and describe not only the natural world but our own selves and other men and women, as well as the ways in which we respond to what we perceive.

They were, then, far from being fanatical formalists, any more than were those 'new poets', most familiar in the person of Catullus, who temporarily disconcerted a Roman Republic accustomed to a very different, epic, kind of poetry. To be temporarily disconcerted is one thing, to be lost forever to the ranks of lovers of serious art is quite another thing.

There are many other cases in which no such rapprochment has taken place. In music, for the first time in human history, people who regard themselves as listening to serious music are for the most part listening to music written at least many decades ago, often more than a century ago. (I have just been looking at a symphonic programme for the year 1990, which contains nothing written later than 1913). True enough, there are quite a few twentieth-century composers, regarded as being serious, whose works reach a wider audience than the very few who listen to the pure formalists. They are often opera or cantata writers – Britten, Tippett, Janáček, Berg, Prokofiev, Messiaen – but some of these also wrote purely instrumental music, on which some other twentieth-century composers – Shostakovich, Bartók – mainly concentrated while others, like Stravinsky, worked in every musical field. But their audience is still relatively small, and very many music-lovers, if they look beyond the nineteenth century, look back to the eighteenth rather than forward to the twentieth.

Other art-lovers sought refuge in one art form which still, even when serious, offered the traditional cakes and ale – the film. Even then, they ignored its purely formalist experiments although often, without realising the fact, taking in their stride technical innovations which had originated there – as was also true in the case of some of the contemporary musical compositions they found acceptable. Purely formalist art, quite without cakes and ale, they left to an avant-garde who sat waiting for the world to catch up with them, much as English communists waited for 'the revolution'. As for the majority of people of the

kind who wept when Dickens or Verdi died, they turned to the entertainment arts which offered them cakes and ale in abundance if no more substantial nutriment.

If such people are lost to the artist, the fanatical formalist would reply with Ortega, this shows that they were not seriously interested in art. If they read, looked at, listened to serious works, this was for quite the wrong reasons; they were really seeking entertainment and misusing serious works for this purpose. For what they should have been considering in those works was nothing but their form and if this, rather than the human relationships traditional art depicted, were really their concern, they would have rejoiced when irrelevancies were swept aside and they were left with pure form to contemplate. Getting the treatment of a subject 'just right' does not matter; only formal rightness matters.

Any such argument, of course, rests on the assumption, which needs to be demonstrated, that only formal considerations are relevant to the seriousness of a work of art. If, as I have suggested, there is a variety of good reasons for taking a work seriously, the argument clearly has no force. It does nothing at all to demonstrate that the now spurned general public had no interest in form. Simply, they expected a work of art to be satisfying in more than one respect.

Suppose a woman was interested in philosophy as the rigorous investigation of certain topics, and philosophy then changed, either by dropping those topics or by no longer dealing with them in a rigorous way. If in either case the woman in question ceased to be interested in philosophy it would be absurd to conclude that she never had been interested, whether in rigorous argument or in those particular topics; she might indeed turn elsewhere for a treatment of the topics or for rigorous argument, her interest in philosophy having depended on its having offered *both* rigour and a concern for the topics in question. It is no less absurd to suggest that those who were interested in architecture as ornamented form, if they lose interest in architecture when it abandons ornament, were never really interested in architecture.

A striking example of formal fanaticism is, indeed, International Style architecture, especially as exhibited in the office block. It offers very few of the satisfactions one could obtain from earlier architecture, whether Classical, Gothic, Romanesque, Baroque – or even the simpler styles of eighteenth-century England or traditional Japan. One is confronted, in most instances, by a cube with façades broken only by uniformly sized and shaped windows, equidistant from one another. Its entrance can be discerned only with difficulty. The façade is not divided into bottom, middle and top, distinguished by their architectural treatment; it stops, usually at a highly unfunctional flat roof, as abruptly as it starts. It pays no attention to its architectural neighbours – one does not look for beautiful streetscapes in modern cities. To enter is to be confronted, only, by a barrage of elevators. There is no sign of the crafted detailing which

make it such a joy to wander through the streets of, let us say, the bourgeois sectors of Bamberg, admiring both the general look of the streets and the details of doors, windows, locks, gates, let alone to enter such a church as San Lorenzo in Florence, for all that the simple beauty of its form is so central to it.

We have already encountered the view that ornament is crime. We could even understand it as a reaction against the excessive ornamentation of much nineteenth-century architecture which reminds us that an excess of cakes and ale can lead to indigestion, flatulence, drunkenness. Nevertheless, it is fatally confused between ornamentation which is merely stuck on to a building and ornament which adds detail to a building – controversial though this may be, like all such distinctions, at the edges, as Roger Scruton has emphasised in *The Aesthetics of Architecture*.

For my part, I have no wish to deny that there are beautiful modernist buildings, not only in Finland and Germany but also in the United States. (My own house could be a specimen in Tom Wolfe's *From Bauhaus to Our House*, and most of its furniture and fittings are Bauhaus-derived.) Many of them do not wholly answer to the description I offered above. The Seagram building, for example, has a clearly defined bottom and top. Others make use of glass as skilfully as those Gothic churches in which glass and light react to changes in sunlight and passing cloud. Some of them impress us through their sheer thrusting magnitude, as we might be impressed by the towers of San Gimignano. In the case of Mies, such architectural critics as Kenneth Frampton point to the fact that there are details in his work – after all he once remarked that 'God lies in the detail' – which his official principles do not justify and that he operates within a classical tradition which he failed to convey to his pupils.

Nevertheless, the unpopularity of the general run of modern buildings is in no way a revelation, as Ortega's remarks would suggest, of a Philistinism which had in the past been concealed; simply, the seriousness of works of architecture, as of other forms of art, had been taken for millennia to rest on the presence of a number of properties. Now it was being quite arbitrarily asserted that only one of them really counted. No wonder there was resistance to this.

I revert then to my previous assertion that fanatical formalism – the same would apply to other forms of artistic fanaticism, as exhibited, for example, in Patrick Heron's 1962 remark that 'colour is now the *only* direction in which painting can travel' – gave rise to a wholly undesirable divorce between a self-selected 'fit but few' and a very considerable proportion of those who look to art for something more than casual entertainment but are not prepared to accept monomaniac views about what art can *only* be. One effect of this divorce is that when I now write about serious art many people will automatically suppose me to be talking only about 'highbrow', 'élitist' or 'avant-garde' art. I do not wince

at those adjectives. Nevertheless, it should by now be plain that there is a good deal of 'high-brow' art which I do not at all take to be serious art; rather, as I previously suggested, it is entertainment for an in-grown art-world, often quite amusing as such but more often a wholly trivial pursuit. Its proponents may not see it as such; they may be deadly serious, in the bad sense of that word, but 'quite amusing' is the most kindly way of describing it.

Nevertheless, for all the damage that has been done by fanatical formalism, I conceded that there are formalist works which one cannot dismiss as games-playing. Take the case of painting. First, I see no insult in describing some abstract paintings as beautiful; that they certainly can be. Secondly, they are often not so devoid of reference as is pretended; formal art helps us, in my experience, to look appreciatively at scratches on a wall, relationships between the simpler shapes, even – I have Pollock's *Blue Poles* in mind – light through a birch forest or the solitary dead trees of the desert. Picasso saw this. 'Abstract art,' he once remarked, 'is far removed from the random brushstrokes and carvings on a wall. No matter what anyone says, we always imitate something, even when we don't know that we are doing it.' And thirdly, formalistic paintings correspond, in an admittedly loose analogy, to the formal exercises which now fill many of our philosophical journals.

The best of them display such a passion for getting a point exactly right, even when the point itself is a trivial one, that it would be unjust to reject them as merely pedantic exercises; we have something to learn from their passion for accuracy. Equally, however, one would not invoke them in an attempt to argue for the seriousness of philosophy; their seriousness is a second-order seriousness, significant only to those who already take philosophy seriously. Similarly, abstract painting can be serious for painters and can help the educated spectator better to appreciate what is an essential ingredient in the seriousness of non-abstract painters, while yet not possessing the sort of seriousness which is central to painting – painting which tries to 'get right' not only a form but a subject. The seriousness of the best formalist art derives from the fact that it is the work of artists who have a passion for formal rightness and, in the course of developing that passion, help us to see how complex and diversified a concept formal rightness is and how little reducible, as academicians throughout the ages have hoped to reduce it, to a simple set of rules. We can admire their work for its simplicity and strength, as we do a geometric Greek vase or an Islamic tiled surface, while reflecting that art advanced by seeing how human relations and landscapes, as distinct from pure shapes, could be formally related.

11

Mastery over Language

To reject fanatical formalism, indeed, is not to deny the importance of form even in literature, where form is a more contestable concept than it is in architecture or music or painting. Such a rejection might no doubt lead one to regard with a certain initial suspicion the great emphasis on form which for a time marked literary theory, reaching a peak in structuralism, as perhaps being an attempt to respond to the formalist rejection of literature not by denying that only form matters but rather by trying to show that literature, too, casts off the 'burden' of intellect and humanity, an ambition with which, it will by now be only too apparent, I have not the slightest sympathy. One can, however, find formal analyses of literature both interesting in themselves and relevant, at some points, to our present inquiry without succumbing to formalistic fanaticism.

Formal linguistic analysis, of a certain kind, has for a long time past played a prominent part in the critical discussion of poetry. Many of us were the victims of school English classes in which Romantic poetry was analysed by the methods used above in relation to 'Mary had a little lamb'. In recent years, under the influence of contemporary linguistics and Russian and Polish formalists, the linguistic analysis of literature has become a good deal more sophisticated, and has been extended beyond poetry to the novel. Much formal analysis has, of course, been devoted to broader structures in the novel, to narratives or to author-reader relationships rather than to linguistic analysis of the narrower kind. For the moment, however, we shall concentrate on language.

Reluctantly, however, for two reasons. The first is that so many interesting things have been said about language in the last few decades by Anglo-American philosophers and by like-minded philosophers in Germany, France and Scandinavia. I have given a brief outline of their work in *Recent Philosophers*, but cannot hope to deal with it adequately in the present context; dogmatism is the only manageable option. The second is that so many excessively strange things have been said about language by recent literary theorists. Stunned by such 'revelations' as that the connection between the word 'table' and actual tables is a

conventional one, that 'signs are not meanings', that not all words are names, that to explain how a word is used one has to use other words – all of which one might have supposed to be commonplaces – they have been led to conclude, as we have already seen, that language is a totally enclosed system.

So long as one is writing about literature, it may be relatively easy to understand how Bakhtin could come to argue thus in his *Speech Genres*: 'I live in a world of other's words. And my entire life is an orientation to this world, a reaction to the words of others ..., beginning with my assimilation of them ... and ending with the assimilation of the wealth of human culture (expressed in the word or other semantic materials).' For the literary theorist is at any time writing about sentences and often enough is writing about sentences which other people have written about sentences, perhaps, indeed, about the sentences they have written about the sentences which still other people have written about sentences – as when replying to X's criticism of what Y has said in response to Z's interpretation of Beckett's: 'It's better than nothing.' 'Is there any such thing?' A world of words, to be sure. But I have already rejected the view that even architecture, music, painting, can properly be regarded as 'other semantic materials'. Sometimes, no doubt, writing about them will be writing about, or at least in the light of, what other people have said about them. Mostly, however, it is writing about buildings, compositions, performances, objects hanging on a wall – all of this with the aid of experiences which are only partly verbalised. Accidental bumps in a crowd, aches and pains, sights and sounds of every kind, not just words, form part of the world we live in.

In the course of discussing truth, I have already both argued as much and denied that the only alternative is that all words are names. Perhaps I should restate the argument in this rather different context. Suppose a mother, talking to a child, makes so ordinary a remark as 'It's raining; button up your coat.' Then, in the first place, neither 'it's' nor 'up' are names in any possible sense of the word and neither 'button' – in this context – or 'raining' are names of things in the sense that 'button' is in other contexts and 'rain' generally is. It is not the point of the sentence to give a name to something but to help the child to cope with a world which is not a world of words – words will not make the child wet. If this sentence is used by a character in a play or a novel, that sort of thing is what we should normally take the speaker to be doing. If there is in fact no second person present we should recognise the speaker as being engaged in a fantasy – but only because we know the normal use of such sentences.

The illiterate can survive, the deaf and dumb can survive, and survived even before there were regular sign-languages. Nevertheless, to be able to read, to hear, to engage in verbal exchanges makes it easier to act successfully in a wide variety of circumstances. Beyond that, using words

can introduce us to new forms of understanding, new forms of enjoyment, even if it also introduces us to new forms of deception, new forms of confusion. (Blessings are always mixed blessings.) That is why we are now engaged in the exceptional procedure of talking about words, as part of the process of defining the kinds of understanding, the kinds of blessing, we can get from serious literature.

One assumption underlies these observations – not at all startlingly, so I should have thought – that so long as we are operating within our own linguistic group we can generally rely on being understood. Even so little, it would seem, can no longer be taken for granted. So John Sturrock, writing with approval about Paul de Man, describes his view as being that 'language is inherently unreliable in use'. Why so? To take this view, he explains, 'is to say the forms of language are only human, and not unequivocal transcripts of nature'. He adds the comment, very relevant to our present theme, that to recognise as much 'makes language more worth our attention'.

Now it would certainly be foolish to deny that language is only human – who now would suppose it God-given? – and equally foolish to assert that it is an 'unequivocal transcript of experience'. How could 'button your coat' or 'aren't you coming?' or 'that's a lot of nonsense' be a transcription of experience? Or how could one's experience of heavy rain explain why one says 'it's teeming' rather than 'it's tumbling down' or 'it's raining cats and dogs' or 'the heavens have opened up' or 'it's raining buckets' – not to venture outside English. The question is whether language is unreliable, let alone more important, for such reasons. This doctrine is perhaps another example of what I am coming to think of as the critic's fallacy, which consists in drawing general conclusions about language from the practice of literary artists or even from a special sub-species of that class, such as modernist poets.

People, one can freely admit, are not always reliable, so that some statements are lies or deliberately mislead us in some other way. (Not too many, since otherwise we could never learn our language.) The boy who cried 'Wolf!' was unreliable; in consequence 'wolf' ceased to act, in his local society, as a warning. Not, however, because the word was unreliable in itself as, supposing someone was told to warn by a gunshot and the gun did not work, a gun might be unreliable.

I say 'might be' rather than 'would be'. If we are prepared to call something 'reliable' only if it never goes wrong then nothing is reliable. A gun is not unreliable just because when it is misused it may not fire, any more than a car can properly be called 'unreliable' just because it breaks down after we fail to lubricate it. Something is unreliable only if, even when treated with care, it still regularly lets us down.

By this standard of reliability – and more demanding standards, I have suggested, will make the word useless – language does quite well. In our own country, we use it all the time to make requests, to enter into

contracts of a formal or informal kind, to convey information, and we are rarely misunderstood. If we are, it is usually because we have spoken, or written, carelessly. We often have occasion to complain about the unreliability of persons, of machines, of governments, but I have never heard anybody complain about the unreliability of language – the means by which, after all, a rather feeble mammal has spread successfully across the globe. On its reliability, not on the fact that it sometimes misleads us, the chief importance of language depends. If the cases in which we are misled are more *interesting* than the cases in which we are not, this is only in the sense that illness is more likely to be inquired into than good health, a broken-down than a smooth-running car.

There are, so much can be granted, situations in which we are misled by linguistic uses without anybody deliberately trying to mislead us. A small child, listening to adults describe a soon-to-arrive male visitor as a 'real wolf', may be disappointed to find him, when he arrives, not to be a wolf in male garb, the sort of thing she may have seen in an illustration to a fairy tale. Hearing it said that 'it's raining cats and dogs' she may be disappointed to find no such animals falling from the heavens. Over time, we come to take such stock metaphors in our stride; that is part of the process of learning our language.

In a variety of instances, however, sentences can mislead even those who have mastered the relevant language. Somebody says of a hotel that its charges are 'quite moderate' but it turns out that the speaker has quite different standards from ours; by ours it is quite expensive. Somebody utters a sentence ironically, or as a joking exaggeration, which we take to be literally intended. Somebody uses a fresh figure of speech which we wrongly interpret. 'When the evening is spread out against the sky like a patient etherised upon a table.' 'You mean that both the sky and the patient are full of chemicals?' Sentences can use words we know and be syntactically impeccable so that we wrongly suppose them to be informing us when in fact they are totally uninformative. 'Process is not something but it is not nothing either; it is nothing in the process of turning into something.'

Many philosophers, taking mathematics as their model, have been obsessed with the idea of creating a perfect language, one so constructed that it would not permit us to form unreliable sentences. It would not contain any vague words, would make it impossible for us to form any sentences which are syntactically so constructed that they appear to be offering information when they are not in fact doing so, would forbid similes and metaphors and irony. Utopians, too, have often proposed such a language as the language of their ideal society; they want unmixed blessings.

In *The Perfectibility of Man*, I discussed this ideal, with special reference to Havel's play *The Memorandum*. I cannot recall ever before having quoted from myself but shall now do so, with my excuse the

infirmities of age:

> The artificial language of that play, Ptydepe, is so constructed as 'to guarantee to every statement ... a degree of precision, reliability and lack of equivocation, quite unattainable in any natural language'. (In a manner only too characteristic of our age, this precision is in the interests neither, as for Leibniz, of religion, nor, as for Condorcet, of science, but of bureaucracy: Ptydepe is to be the language of inter-office memoranda.) In Havel's eyes, the new language is a symbol of the totalitarian outlook, yet another way of ensuring that it will be at all times clear exactly what every human being is doing and saying. It destroys, in the process, the very possibility of irony, one of the new forms of freedom which a totalitarian ruler cannot be quite confident he has wholly brought under control.
>
> This brings out the fact that the 'imperfections' of everyday language are precisely what permit it to be used as an instrument of human freedom, as a way of introducing new ideas, new attitudes – allowing Freud, for example, to speak of 'unconscious mind' when 'mind' had commonly been *defined* as consciousness, or Wittgenstein to describe as 'senseless' sentences which, judged by ordinary criteria, certainly have a meaning.

Freshly coined metaphors, exaggerated or ironical sentences, sentences which are informative in their syntax but do not actually inform, words that are vague, fuzzy, can all play a part in serious literature. Not all serious writers, by any means, use language of this kind but many do, many poets in particular. That does not necessarily make them more worthy of attention, so far as the common reader is concerned, but it may make them more interesting for critics, in so far as such writers need to be interpreted sentence by sentence.

What does 'interpretation' mean, in this context? It means, I should say, talking in reliable language about what the writer has said in unreliable language, not by attempting to paraphrase it but by exploring it in various ways, bringing out what the language is doing, why the writer uses this particular language. To revert to something earlier said about interpretation, this is possible only if, for the presumed reader, there are sentences which can be read straight off without the help of interpreters. (Otherwise we are caught in a vicious infinite regress; we shall need the help of interpreters in order to read the interpreters and so *ad infinitum*.) Once we are reasonably educated most of the sentences we read are of the reliable kind. We may be held up by technical terms but in technical contexts these are used reliably and a dictionary will let us go on, as it will not help us with 'Multifoliate rose / Of death's twilight kingdom' in Eliot's *The Hollow Men*. Nothing short of a critical interpretation of this in reliable language will help. Interpreters who themselves use unreliable language are abrogating, on this view, their responsibility as interpreters. There is no need, I fear, to specify examples.

If, as I said, serious writers can be called upon to use unreliable

language – while also to use exceptionally reliable language – this is connected with the fact that one thing traditionally expected of such writers is 'mastery over language'. Not only traditionally, but here and now. So, discussing the novels of John Hawkes, a critic remarks that 'nuances of language and clusters of imagery redeem Hawkes's fiction as art', saving it, that is, from the dreadful fate of being read only for its action which, in *Virginie* at least, is somewhat scabrous. In what does such 'mastery' consist? If, in the everyday affairs of life, we refer to somebody as having, say, 'mastered French' we usually mean nothing more elaborate than that this person is able to do so such things as encouraging, dissuading, asking and answering questions, offering and following instructions, making jokes, playing on words, entering into agreements, thanking, complaining, giving information, without feeling at a loss for words, or only exceptionally so, and without making those kinds of error which arise out of an imperfect command over syntax or idiom. Such mastery obviously admits of degrees, but anybody at all likely to read this book will have mastered English at a relatively high level. What else can a serious novelist or dramatist or poet do in the way of mastering English – or any other language? In what respects is such a writer's mastery exceptional?

Before trying to answer this question, let us pause for a moment. Although the phrase is common enough, there is some difficulty in talking about 'mastery over language'. For this may suggest either that language is the writer's slave or that it is a bucking, recalcitrant horse which authors have to learn to control – in either case as something external to them. Sometimes it feels like that. A sentence lies on the page in front of us; for some reason, we want to change it. This may be because, in the most literal sense of that phrase, we 'don't like the sound of it'. Or we may feel that it has to be altered to avoid offence to feminist susceptibilities. Or we may think it could mislead the reader, that it is an unreliable sentence, whether through some ambiguity it contains or because its irony may not be fully apparent. Trying to alter it, we find that every change we make creates in us a sense of dissatisfaction. It is at such points that language seems most alien to us, a horse we cannot persuade to accept the bridle.

Most of the time, however, our relation to our native tongue, or to any language which we might claim to have mastered, is not like that. It comes to us more immediately than the most servile of slaves could do. We learn to love it, not only for the readiness with which it serves our needs, for its being always at hand, but because, like Cleopatra, custom cannot stale its infinite variety. Yet there are writers whose relationship to language does give one the impression of being sado-masochistic, as if they are both suffering from the claims of language as they write and trying to impose their will upon it, to make it suffer.

An early reviewer of Melville's *Mardi* saw in it 'a continual straining

after effect, an effort constantly at fine writing, a sacrifice of natural ease to artificial witticism'. One often finds this straining in American writers, perhaps out of a sense that English – except when, as many choose to do, they write in a local dialect – is not their native language, since it did not arise on their own soil, perhaps out of the feeling that in what they write their individuality must everywhere be exhibited, perhaps out of a sense of resentment that language resists their ideal of a work which will be created wholly *ex nihilo*. These are idle speculations, a holiday from thinking. At least, however, they let me emphasise that 'mastery' over language does not normally involve this kind of linguistic violence, even if it may occasionally be called for as a means of characterising.

A final general point. It is quite absurd, so it might be said, to speak of 'mastery over language'. For in fact language masters us, makes us what we are. To examine this view in detail, in an attempt to discover what it means and what degree of force it has, how far Conrad was remade when he moved from Polish to English, how far a bilingual Japanese is remade with every switch from Japanese to English, is not at the moment feasible. So I freely permit readers who hold this view to substitute 'being mastered by language' wherever I have written 'mastery over language'; the question for them will be whether literary artists are more fully taken over by language than are the rest of us. If this produces some odd results, that might be a good reason for having another look at the view that it is language which masters us.

To revert to the question we asked, how a serious writer's mastery differs from our own mastery, exceptional mastery over language may be exhibited in a number of different ways. It may consist in being able to use a particularly rich vocabulary, in maintaining control over a variety of registers, in creating rhythms and sound patterns, in being able to invent fresh images, in having an eye for the right word. We shall look at each of these in turn.

Aristotle was convinced that the use of a special diction is essential to poetry, which, of course, included tragedy. 'The diction,' he wrote, 'becomes distinguished and non-prosaic by the use of unfamiliar terms, i.e. strange words, metaphors, lengthened forms, and everything that deviates from ordinary modes of speech.' As usual, Aristotle is not talking at large. He refers us to two tragedians – their works are now lost – who used none but words in everyday use and judges their work to be commonplace, to 'lack dignity'. He has to admit, however, that works written in the manner he has advocated can degenerate into being 'mere riddles', unless they are intermixed for the sake of clarity with everyday expressions. That is still a relevant observation; seriousness is at least not guaranteed by the use of such a diction. It is not uncommonly a sign of affectation.

Aristotle by no means had the last word in the controversy over diction. There were Greeks who preferred the straightforward style of Lysias to

the somewhat figurative style of Plato. Longinus specifically defends Plato on this point. But he goes further than this, arguing that the grand style must not be intermingled with references to anything at all trivial. This is a doctrine one can see at work in nineteenth-century paintings and literary work but is far removed from the practice whether of Plato or of Shakespeare, as is sufficiently illustrated by the interpolation of the porter's scene in *Macbeth* and Plato's constant references to everyday trades. Such restrictions, indeed, would unduly limit an author's freedom to use the full range of his language, even granted that in a particular case a writer may deliberately choose to compose a work in a restricted vocabulary.

In England, notoriously, the seventeenth-century Royal Society, at a time when prose at the hands of such writers as Sir Thomas Browne had reached its most elaborate point, came out in favour of that plain, unornamented style which has since characterised almost all British philosophical writing. A century and a half later, equally notoriously, Wordsworth laid it down that poets should confine themselves to a 'selection of the language really spoken by men', a selection excluding the vulgar, the mean, but also not permitting those turns of speech, like the personification of abstract ideas, which are so conspicuous in the writings of, let us say, John Dyer or William Collins – 'Brown Exercise rejoiced to hear / And Sport lept up and seiz'd his beechen spear'. Wordsworth would certainly blanch if he were to read that passage in *The Waste Land* which begins 'When Lil's husband got demobbed', to say nothing of the obscenities in late twentieth-century poetry. Nevertheless, there is not, on his view, any diction peculiar to poetry.

In reply, Coleridge makes two points against Wordsworth, basing them on Wordsworth's own poetical practice. (In *Re-making It New* Lynn Keller has more recently commented in a parallel fashion on Elizabeth Bishop's claim to be considered as an 'ordinary language' poet.) The first is that Wordsworth, as not the everyday speaker, takes enormous care in his search for the best word in its particular setting. The second is that the order of the words in Wordsworth's poetry is not their order in everyday speech. In the course of an everyday speech-exchange, nobody would say 'Proud was I that my country bred / Such strength, a dignity so fair.' A poet is not called upon, we can agree with Wordsworth, to use words and turns of phrase which belong only to a special poetic diction. At the same time, the poet's use of language is not that of the man in the street or of Wordsworth's bowdlerised rustics. We must allow the poet greater liberty than either Wordsworth or Aristotle would allow. There is serious poetry, ancient and modern, in vulgar diction, as also in a diction which is archaic or exotic or word-inventive. To what nevertheless distinguishes the poet's speech and leads us to think of poets as having an exceptional mastery over language, Coleridge has offered us clues.

The older debates are by no means dead, even if they are now often

transposed, in accordance with what has been the spirit of our age, into political terms and, again in the spirit of the age, have moved from poetry to criticism. I earlier mentioned the charge that to ask for clear writing is 'fascistic'. The description of clear writing as being 'essentially conservative' – poor Voltaire, poor Tom Paine, poor Mill, poor Russell – is now so widespread as to arouse no comment. This amounts to a demand that critics use a particular diction, distinguishable from everyday language by its preference for abstract nouns, convoluted sentences, a special way of employing such logical connectives as 'therefore' – not merely by the introduction, which may be inevitable, of an occasional technical term. Such a diction is not, of course, an entirely late twentieth-century phenomenon, in so far as it particularly flourishes in a United States already notorious for the diction of Dewey and of such sociologists as Talcott Parsons. (Not, to be sure, the diction of William James and many other contemporary American philosophers, including that improbable Conservative, Chomsky.)

Perhaps those who associate clarity with conservatism have in mind Sheridan's couplet: 'You write with ease to show your breeding / But easy writing's vile hard reading.' Easy writing, however, is by no means the same thing as clear writing. Clear writing, indeed, is 'vile hard' work, a sign not of breeding but of brooding – as Sheridan himself must have known. Obscure writing, in contrast, is often formula-writing, flowing from a jargonised pen without hesitancy, concealing an intellectual emptiness which clarity would make obvious in what Gibbon called 'the obscurity of a learned language'. Not, once more, that we can allow ourselves, in indignation, counter-generalisations. There are serious obscure writers, obscure because they find it hard to express new ideas in familiar language. Any account of serious literature which has any plausibility must leave room both for Heine and for Rilke. The superior mastery of a writer over language does not necessarily entail writing in a special diction – that is all it is essential to emphasise, and this is as true of critics as of poets.

Even so that remark has its limitations. To master such a special diction is occasionally something a dramatist or a novelist may have to do. In *Love's Labour's Lost*, Shakespeare satirises the affected, exhibitionist, linguistic habits of pseudo-intellectuals. When Armado addresses his youthful page as 'tender juvenal' and explains that he did so as 'a congruent epitheton appertaining to your young days', this is a proper subject for satire. It is Shakespeare, however, who is writing these words and *his* use of them is perfectly appropriate. He can effectively satirise a special diction only in virtue of having mastered it. But he is writing in that diction in a manner which discourages us from using it.

Very occasionally, a writer may even feel it necessary to invent a language or at least a special diction. Anthony Burgess had to do this in the film *Quest for Fire*, a drama set in prehistoric times, and felt he

needed to do so in *A Clockwork Orange* – 'given pretensions above pulp', according to one critic, 'by the extraordinary street-argot Burgess invents to tell it in'. *Finnegans Wake* is another familiar example. For the most part, however, writers are using a familiar language and show their exceptional mastery by the way they select out of it for their special purposes at a particular time. That may, or may not, necessitate the use of unfamiliar, exotic words. Their use may increase that gulf between the serious writer and the common reader on which I have already commented. Nevertheless one cannot say to serious writers: 'That is a topic you must not take up, those are words you must not use', even though their choice of these topics, these words, excludes many readers. That would be populism gone mad. One can rightly complain only when such language constitutes an unnecessary barrier to communication.

In his plays, Shakespeare shows himself to have control over a great variety of linguistic registers. For the most part, that is not true of the ordinary writer or speaker of English. A politician may use obscenities in private talk which play no part in addresses to the public, or pieties in public but not in private talk; speaking to a foreigner, or a small child, we might use a simplified version of English; if we are German we may sometimes speak High German, sometimes use a regional dialect; talking to fellow-tradesmen we may use technical words which we avoid when talking to a wider public. That is about as far as it goes. When people claim to have mastered the English language we do not usually take this to mean that they will understand everything they hear said by someone from Alabama or Glasgow or Calcutta or at a meeting of cosmologists, that they have full control over Australian slang or the technical language of biochemistry or American football or English cricket, or, more subtly, over those differences in pronunciation which are so important in 'placing' people in England – how, let us say, 'one' is pronounced, or the 'g' in 'Singapore'.

Dramatists and novelists can properly be described as having a special degree of mastery over their language when they control an exceptional variety of registers, including the use of unreliable language. To be sure, this does not *guarantee* that they are serious artists. Mimics may possess this same degree of control without pretending to be anything more than entertainers. Nevertheless, it can clearly help a serious writer to be able linguistically to characterise an individual, a place, a time, a social setting.

Must a serious novelist or dramatist possess this kind of mastery? A test case is Dostoevsky. Russian critics generally agree that he does not use differences in register to characterise. Whatever their social origins, their sex, their age, his personae speak in the same way. Tolstoy rebukes him for this reason; Bakhtin defends him; Nabokov refuses to count him as being anything more than an entertainer. Some of Bakhtin's defences strike one as not being sustainable – for example that Dostoevsky does

not want us to think of his personae as being fixed, 'finished', and that to give them individual speech habits would lead us to think of them thus. After all, changes in speech habits can be used as a sign of changes in personal characteristics. *Pygmalion* is an extreme example of this but something similar happens in *King Lear*, if in the opposite direction. Other instances are Mellor's speech-shifts in *Lady Chatterley's Lover*, or similar shifts in novels where an Australian is depicted as becoming Anglicised or a Northern Englishman acquiring Southern speech.

A more consequential defence is that Dostoevsky is writing 'dialogic' novels in which individuals matter only as the bearers of attitudes and ideas; speech differentiations would simply be a distraction from the differences that really count. We can generalise this remark into the observation that speech habits are not the only way of characterising and are sometimes not the most suitable way of doing so. They certainly have the disadvantage of being very hard to translate. Nowhere do language differentiations matter more than they do in Japan; Japanese novels, relying on such differentiations to characterise, suffer greatly when they are translated, as they now often are, into homogenised Californian.

Speech differentiations, too, are not much use to the writer except in social situations where speech habits vary considerably from person to person, as is less and less true in our own societies, at least within a particular dialect group. To take a relatively simple example, the use of obscenity, even of the most virulent sort, no longer distinguishes between persons of different sex or social status to anything like the degree to which it once did. Nevertheless, in describing social relationships in any society where speech differentiations are important, not to be able to have the power over registers which enables one to characterise class distinctions in such situations, or attempts to move from one class to another, is a considerable handicap. (Just how important, of course, will partly depend on how far the writer relies on dialogue, much less in the German than in the English novel.) England is, of course, the supreme example of a society where speech registers matter socially, but in Italy a Neapolitan accent, outside the South, is a great deal more than just a different way of talking.

If Tolstoy is right, then, one can understand why Russian critics often judge Dostoevsky severely. (In the material published in the second appendix to his *Problems of Dostoevsky's Poetics*, Bakhtin seems to be denying that Tolstoy *is* right, as distinct from admitting but excusing Dostoevsky's practice.) To conclude, however, that Dostoevsky is a mere entertainer would be to give this defect too great an importance; there are, as we said, other ways of characterising.

Another kind of exceptional linguistic mastery relates to the handling of sounds and rhythms. In the case of poetry this is sufficiently obvious, so obvious that I do not feel it necessary to say anything about it, even if the degree to which such mastery is illustrated in the works of a particular

writer can be highly controversial. Fortunately, we need not face the issue at what point poetry can be separated from prose, whether, let us say, Eliot was justified in refusing to count Whitman as a serious poet, not on account of what Eliot sees as 'the large part of clap-trap' in what Whitman tells us but because what he wrote was not poetry but 'excellent prose'. Our interest is in whether Whitman was a serious writer. Into what genre he is put concerns us only in so far as putting him into the wrong genre might lead critics to dismiss him on inappropriate grounds.

Eliot's reference to Whitman's 'excellent prose' does, however, give us pause. How far is prose excellence a matter of sounds and rhythms? That, by general agreement, it is far easier to translate prose works with fidelity than it is to do so in the case of poetry – Tolstoy than Pushkin, Proust than Mallarmé – suggests that sounds are less important in prose than they are in poetry. Indeed, this is something we should normally take for granted. Yet a serious writer of prose will certainly try to avoid, in a manner I shall later exemplify, obvious cacophonies, metrical writing and the like. Excellent prose, however, goes beyond that. It secures balance, variety in pace, rhythms which are appropriate to the subject, differentiated accordingly. It is often said that the poet's mastery over language consists in an ability to do what cannot be taught in schools of communication or rhetoric. The same applies to excellence, as opposed to sufficiency, in prose writing.

Nabokov's high opinion of Chekhov in his *Lectures on Russian Literature* is as marked as his low opinion of Dostoevsky. Yet he grants not only that Chekhov had a 'poor dictionary' and was not at all a verbal innovator, as Gogol was, but that he was 'not exceptionally preoccupied with the way his sentences curve'. At the same time, Nabokov suggests that Chekhov 'managed to convey an impression of artistic beauty far surpassing that of many writers who thought they knew what rich beautiful prose was'. For what Chekhov did in his prose style was to capture what he wanted to capture, the greyness of the world against which his characters displayed their eccentricities, their impotent longings. A self-conscious 'style beautiful' would have been as out of place as it would be in a Beckett novel.

'Rich beautiful prose.' That description has an air of *fin de siècle* elegance about it; we associate it with Pater. Or, alternatively, our mind turns further back to Browne, Burton, Lyly. It does not conjure up much in the way of novels, although some have certainly attempted it – Cabell, let us say, or George Moore, or the Joyce of *Stephen Hero*. It can get between us and the content of the work by its sheer conspicuousness. That does not mean, of course, that serious novelists generally write in an ungainly style, although some do (Dreiser). The fundamental question is whether the style effectively displays the development of the author's subject, not whether, read aloud, it sounds well. That is what, I take it, Nabokov had in mind in contrasting Chekhov with the writers of 'beautiful prose'.

Yet another interpretation of 'exceptional mastery' takes us back to the critic's remark that John Hawkes can rest his claim to be a serious writer

on his 'clusters of imagery'. For certainly a writer's imaginative use of language is often particularly related to the power of creating fresh imagery, something which is not ordinarily demanded of us before we can claim to have mastered a language. Poets may use ordinary words and may utter what would be, were they paraphrased, commonplaces, and yet arrest us, as I earlier said, by the force of their expression. That force often involves the use of 'figures of speech' such as similes and metaphors – or rather, for we all *use* these 'figures' – the creation of new figures, whether with the simplicity of 'My love is like a red, red rose' or the complexity of Eliot's comparison in *The Dry Salvages* of a river to 'a strong brown god', developed through a lengthy stanza. This, Aristotle said, is 'the thing that cannot be taught'.

Not all poets, however, create such figures. Some spurn them, for much the same reason that some architects spurn ornaments. That is true of a great many late twentieth-century poets, but it was earlier true of the Imagists and of Hardy. They may be influenced by Hobbes's absurd doctrine that metaphors are lies – compare the view that this is true of architectural ornaments – or they may simply prefer 'reliable' language for their purposes, using a wide variety of rhythms, in Hardy's manner, or an incisiveness in the choice of words to avoid being prosaic. On the other side, vivid, forceful imagery may be created within ordinary speech-exchanges. Australian colloquial speech has a special fondness for freshly-minted similes. Once again, then, we are confronted by a kind of exceptional mastery which it is quite natural, and proper, to refer to in claiming that a person, especially but not only a poet, is a serious writer, but which is neither sufficient nor necessary to establish that fact.

A final interpretation centres around that once familiar notion, *le mot juste*, and the critic's description of Hawkes as displaying 'nuances of language'. In *The Social History of Art*, written in 1951, Arnold Hauser strongly rejected this concept: 'The *mot juste*, the uniquely correct word, no more exists than does the uniquely correct form; they are both the inventions of aestheticians for whom art as a vital function has ceased to exist.' One can easily comprehend, and even sympathise with, this pronouncement, if it is directed solely against those for whom the appropriateness of a word – or, indeed, of a literary form – is taken to consist in some such characteristic as its sound or its elegance, as contrasted with its vulgarity, with no attention to the question whether it is the word or the form most suitable to the circumstances. As writers, we are naturally sensitive to such considerations; we may try to avoid what strike us as being ugly juxtapositions of sounds, or colloquialisms which are inappropriate in the kind of work we are writing. Writers, too, have linguistic policies which may lead them, for example, to prefer verbs to abstract nouns, active verbs to passive verbs. To make a fetish of such policies, even if they interfere with the flow of communication, is certainly to leave oneself open to the sort of accusation Hauser is levelling.

One can agree, too, that in many cases there is no 'uniquely correct word'. If I now write 'he' instead of 'Hauser', that is in no way incorrect. Neither is it if I refer to his 'book' rather than his 'work'. In such a book as this one, our object, most of the time, is to use words which are 'all right', which will make plain what we are saying without offending the ears or the linguistic sensibilities of our readers. I should avoid such phrases as 'my household Hauser', 'a skerrick of sense', 'my interest in disinterestedness' on the grounds either of euphony or of intelligibility. In a novel, however, these phrases might be not only 'all right' but 'just right' in the mouth of a particular character at a particular time. An author can seek, as Flaubert did, to be all the time 'just right' without at all sharing Flaubert's desire to write a novel about nothing. In poetry, especially, to find such a 'just right' turn of phrase is of primary concern. Shakespeare's ability to do this reduces us to a state of impotent envy. That does not imply, however, that a poem should be thought of as a coruscating 'string of jewels'; Hauser's attack on 'aestheticism' is, in general terms, a valid objection to the pyrotechnic conception of literature, now spreading from poetry to the novel.

How are we to show that a word is 'just right' or, more colloquially, 'dead right'? In part, as when the question was whether a painter has captured a scene or a person, we have to rely on our experience, in that sense of the word which includes, but is not wholly comprised of, reading books. A case in point is Lawrence's *Kangaroo*, when he is describing the Australian landscape. Looking out of our window, we realise how 'dead right' is Lawrence's description of the light shining through the top of a eucalyptus tree, how painfully inadequate our own description of it would have been or how imperfect other 'all right' descriptions that we have read now strike us as being. That gives us a degree of general confidence in Lawrence, which extends to our reading of him when he is describing, in the same highly particularised manner, the landscape of New Mexico, which we might not know. But also in *Kangaroo* there are melodramatic descriptions of the landscape which our general literary experience would already lead us to mistrust: 'waiting, waiting, the bush was hoarily waiting'. That mistrust, too, carries over.

In most cases, of course, the relevant experience is more universal than this, less pictorial in character. It is some aspect of growing up, of personal relationships, of feelings, for which one takes the writer to have found the dead-right words. What is common to all such instances is the interplay between personal and artistic experience. We read differently, recognise the 'dead-rightness' of expressions as our personal experience, in the narrower sense of that phrase, extends; we see things differently as our reading experience of the 'dead-right' extends. Phrases we once felt to be 'dead right' our experience – of both kinds – may lead us to see as overwrought, too 'literary', misleading or banal. There is no security here. But why expect security? Anyone who is looking for security would do

well to give up any thought of being a critic.

At a more analytical level, in his *Linguistics and the Novel* Roger Fowler takes over a method already used by Aristotle, comparing what authors actually wrote with what, without its failing to be 'all right', they might have written, thus bringing out the way in which the difference acts as a method of characterising, whether a person, or a mood, or a setting. That method, interesting though it is, still depends on the judgment that some way of characterising is more accurate or more illuminating than another, a judgment not on the words in and of themselves – in itself no *mot* is *juste* – but on how far they tell us what is going on.

That, indeed, is the moral of everything I have had to say about exceptional mastery over language. The fact that the words used are familiar or exotic, belong or do not belong to a particular register, have such and such a sound or rhythm, are used literally or in a figure of speech, does not settle the question whether the person who uses them is a serious writer. The basic difference between the serious writer and the non-serious writer, in respect to language, is that for the non-serious writer near enough is good enough. For the serious writer, in contrast, the language has to be 'dead right'.

The mere fact that a writer 'writes well', in some commonplace senses of this phrase, does not demonstrate, then, that we are now in the presence of a serious literary work. 'The apparent roughness and *naïveté* of *Mauberley*,' so Eliot tells us in his introduction to Ezra Pound's *Selected Poems*, 'are the result of many years of hard work.' So, too, can be smoothness and sophistication. Roughness, on the other side, can be a sign of haste and crudity; smoothness and sophistication of banality, unimaginativeness. The critic's life, as I remarked, is a hard one. Nothing I have just said will make it any easier. It certainly will not be enough to ask, in a schoolmaster's fashion, whether the writer has 'worked hard'; that does no more than dispel any suggestion that the roughness is a result of laziness rather than incapacity. If it is in place still has to be decided. Hawkes obviously works hard at his writing; whether his novels are worthy of serious critical attention is quite another matter.

I have been suggesting, then, that while a capacity to handle language is certainly characteristic of the serious novelist, as well as the poet, if we spell out this concept it cannot be judged independently of the author's capacity for handling his subject. Or, more exactly, if it is independently so judged, as in such sentences as 'Pynchon uses a very rich vocabulary', it does not suffice to show that the work being judged is a serious work, as distinct from an elaborate intellectual game. A very simple vocabulary may be precisely what the subject demands – although simplicity, too, can be an intellectual game. John Barth has told us that the novelist needs 'a way with stories rather than a way with words'. In fact both are needed, a way with the words needed effectively to tell a particular story.

12

Form and Innovation

Before we conclude that fanatical formalism can get no grip on literature, we should look, however briefly, at that broader concept of literary form which concentrates not on individual sentences or linguistic style but on the general patterns of the novel and the drama. There have been a great many formalistic studies of the novel, from a variety of standpoints, sometimes emphasising formal control over the elapsed time of the novel as contrasted with the time taken in reading it, sometimes discussing spatial relationships, sometimes the relationships between the author, the narrator or narrators, and the characters in the novel – and many of these questions can be raised in relation to the film and the play, except that it is only quite rarely that a dramatist uses a narrator. These investigations have brought out many aspects of the novel which were previously concealed and have emphasised just how many formal problems the serious novelist has to face and how variously novelists can try to solve them.

We have witnessed, too, many formal 'experiments' in the novel. Of course, the earliest novels were by their very nature innovations, some of them rarely repeated. Richardson's epistolary novels, Sterne's *Tristram Shandy*, Fielding's *Tom Jones* and *Jonathan Wild*, Walpole's *The Castle of Otranto*, William Beckford's *Vathek* are sufficiently striking examples, for all that diligent scholars have traced some degree of ancestry, even back to classical times. Nevertheless, and in spite of the considerable differences between the ways in which Dickens, Thackeray, James conceived their task in relation to such matters as authorial intrusion, one can say that the novel gradually settled down to a normal form, particularly perhaps, although not uniquely, in the English-speaking world. That form is still characteristic of the vast majority of works written and sold as novels. The fact remains that after such writers as Joyce, Virginia Woolf, Gertrude Stein, there is now a certain expectation, as in the comparable cases of painting and music, that the serious novel will 'experiment' – or, more accurately, for there is no question here of testing a theory, will introduce formal innovations.

Perhaps I should briefly expand this last contrast. When Zola set out to

236

write 'experimental novels' what he had in mind was that they would exemplify a general theoretical thesis about genetically determined degeneration. Here a specific theory was in question. Even so, Zola was *illustrating* a theory, not experimenting. Confusions of this sort sometimes have their source in school science laboratories, when a pupil is told that what the teacher is doing on a bench before a class, or what a class is instructed to do, is an 'experiment', whereas it is in fact, on the one side, a training in certain techniques – which can, of course, later be used to experiment – and on the other side a practical illustration of a received theory. There is not the slightest possibility that at the end of one of his novels Zola might throw up his hands and say: 'So my theory must be wrong.' Only when there is such a possibility can we properly talk of a scientist as experimenting rather than, as in the teacher's case, illustrating accepted theories or, as in the case of most everyday work in laboratories, utilising them.

The most casual reader of Zola's novels can scarcely fail to be aware of his genetic determinism. In contrast, few readers of *Remembrance of Things Past* would have had any suspicion, as they made their way through the earlier volumes of that massive work, that they were reading a contribution to quasi-science. Yet in *Time Regained*, the last of his volumes, Proust explicitly claims on behalf of the artist that 'in his own sphere he is studying laws, conducting experiments, making discoveries which are as delicate as those of science'. Are we to return to the preceding volumes, now in search of Proust's laws? How can the behaviour of, let us say, Albertine be an experimental test of these laws when it is not, like the outcome of an experiment in science, observed by Proust but actually determined by him? Only scientific fakers behave in this way. We may allow Proust, as I earlier did, a capacity to generalise in an interesting way. Experiments, functioning as they do in science, are out of the question.

Indeed, if we do turn back to Proust's earlier volumes in search of laws, we shall find nothing stronger than empirical generalisations, which we accept, if we do, only if they formulate our own experience or seem at least plausible to us in the light of that experience. They are not defended either as deductions from laws or as having been subjected to rigorous testing. The passage in Proust which we might most plausibly think of as quasi-scientific is his long description of homosexual courting behaviour at the beginning of *Cities of the Plain*. Proust presents it, indeed, as an extension of botany. At best, however, this is descriptive, not experimental, science.

Of course, the word 'experiment', and even more obviously, the French 'expérience', can be used outside science, to mean, for example, trying out a form of action to see how it looks or what effects it has on others, as in 'experimenting with a new hair-do'. What is called 'experimental' poetry, or 'experimental' literature in general, is usually experimental only in

this sense. A director decides to set *Much Ado* in eighteenth-century France, a novelist to write a novel which does not contain the letter 'e', a poet to write a religious poem in the shape of an altar – these are experiments which, if they are successful, show nothing more than that it can be done. They are, we say, 'ingenious'.

In another range of cases, of a sort I have already described, literary theorists may assert that all serious novels are about novel-writing and that leads an author to write a serious novel which is indeed about novel-writing. This does not test the theory in any way; it shows, again, that it can be done but gives us no further ground for believing that all novels are of this kind. The theory could be tested, as I earlier suggested, only by showing that serious novels which do not seem to be about novel-writing actually are. To avoid any suggestion that artistic experiments are at all like scientific experiments I shall use the word 'innovations' instead of 'experiments' to cover all the cases I have described.

One question we can ask, however, both about innovations and about experiment, is 'What is the point of doing that?' In the heyday of modernism, the answer to that question, in relation to artistic innovations, was taken to be obvious, namely that they were 'something new'. But they can be new, I have already suggested, and simply be gimmicks, of no interest except as art-world entertainments. An allied, but substantially different, reply carries more weight.

The innovations compel readers, or spectators, to think – as distinct from merely responding emotionally, identifying with fictional characters or putting themselves into particular fictional situations, in the process making the fictional world part of their own world, making it familiar, cosy. Brecht's plays with their emphasis, deriving ultimately from Shklovsky, on 'alienation-effects' are a case in point. The theatricality of the plays is meant to make identification with the characters impossible and at the same time to force the audience to face realities in a way in which a more 'naturalistic' play might not. (In *The Self-Conscious Novel*, Brian Stonehill ascribes a similar intention to novels in which the author finds ways of insisting that what we are reading is a fiction.) If this is set out as an explicit objective then we can go on to ask whether the innovation succeeds in these respects or whether in fact audiences are simply amused by Brecht's impudence or confirmed in their feelings of intellectual superiority rather than compelled to think.

Brecht's innovative plays are certainly an attempt morally to educate people by getting them to see. We have suggested that such concerns are good initial reasons for taking works seriously, but not decisive. If John Willett is right when, reviewing an East Berlin performance (1949) of *Mother Courage*, he complains about Brecht's 'affectations' – what I have called 'gimmicks' – and says that 'the work lacks formal unity and sequence', these are complaints which might lead us to reject the claim

that the play is a serious work of art, although it may be a telic success as a moral tract.

There are some contemporary writers, no doubt, who would wholly reject such lines of criticism, rejoicing in gimmicks as a form of play – or, in a more fashionable phrase, as 'ludic' – and deprecating unity and sequence on the ground that they interfere with the festival character of literature. Not all innovators, however, take this view. Just as, or so I said, we can find a concern for balance even in the works of painters who are otherwise innovatory so, too, there are innovatory novelists who would want to insist that their works do not lack unity and sequence. Simply, these are not immediately obvious. 'Only the best art,' writes Michael Ondaatje in the preface to his *In the Skin of a Lion*, 'can order the chaotic tumble of events ... can realign chaos to suggest both the chaos and the order it will become. The first sentence of every novel should be: "Trust me, this will take time, but there is order here, very faint, very human." ' To cite Heraclitus again: 'the hidden harmony is better than the open.'

Another instance is Perec's *Life: A User's Manual*, although there the point, characteristically enough, is made in a more indirect way through a little prefatory essay on jigsaw puzzles. 'Despite appearances,' he writes, '... every move the puzzler makes, the puzzle-maker has made before.' The combinations he tries 'have all been designed, calculated, and decided' by the puzzlemaker, i.e. the author. Perec is an author of exceptional ingenuity but he is not simply, although he often is, a games-player. His epigraph is from Jules Verne: 'Look with all your eyes, look', and the title of his work suggests an interest in moral education. He would not have been pleased, I think, had he lived to read the reviewer who described his novel as 'a parade of beguiling tales, a festival of clever puzzles'. And yet we may well be bewildered by those enthusiastic reviewers who compared it, in a manner which is becoming tiresome, with *Ulysses*. From that work we carry away a sense of having explored characters, whose names we shall not rapidly forget, as we follow them through courses of action; Perec's jigsaw of interwoven stories gives us nothing of this sort.

Why not make the unity, if there is a unity, more apparent? I said that one reason why innovatory novelists, or a certain class of them, have taken to writing novels which are anything but perspicuous is that they want to force their readers to stop and think. More specifically, they want them to have to read, as distinct from merely passing their eyes rapidly over a page, as innovatory composers want their audience to listen, as distinct from merely letting the music flow over them, and innovative painters want to force gallery-goers to look as distinct from merely glancing. If attention-getting is by no means a phenomenon peculiar to our age, it is practised on a scale which is ever more intense, given the degree of competition to secure it which now exists.

Recent artists, however, have often sought to secure it by means which at first sight seem more likely to guarantee neglect. So novelists may have recourse to an exotic vocabulary and offer their readers distinctly recondite information. These novelistic procedures are defended, if through his personae, in *The Recognitions*, an innovative novel by William Gaddis. His Wyatt directly attacks authors who 'write for people who read with the surface of their minds'. A little less directly, Gaddis explains the enthusiasm of his Mr Pivner for Dale Carnegie's *How to Make Friends and Influence People* in the following terms: it was 'written with reassuring facility', it contained no 'abstrusely long sentences', you did not need a dictionary to understand it, there was no reason to know 'what Kapila saw when he looked heavenward' or 'of what the Athenians accused Anaxagoras'. There was indeed, he concludes, 'very little need to know anything at all'. (This sentence, which in its fuller form incorporates references to 'the secret name of Jehovah', 'who cleft the Gordian knot', and 'the meaning of 666' sufficiently illustrates Gaddis's own, distinctly un-Carnegian, style.)

Without attempting to defend either Dale Carnegie, whose very choice of title is nauseating, or those simple-minded romance writers from whom Gaddis wants to differentiate himself, I should still want to resist any suggestion that a novel is not serious unless it compels us to have recourse to a dictionary or requires us to possess esoteric information. In the past, no doubt, there were poets in Hellenistic Greece and Ancient Rome – Propertius, for example – who liked to think of themselves as 'learned poets'. Pound greatly admired Propertius and both he and Eliot drew, as well, upon their own learning.

This, however, was for a special purpose, to set the present against the past, as was also true of Propertius, even in such a poem as *A Bawd's Advice*. Eco's *The Name of the Rose* is a learned novel and it has to be, as every historical novel has to be. But the learning in Eco's work is carried and explained by narrators. The learning in many other contemporary novels is like adventitious ornament in architecture as distinct from design detail.

Interestingly enough, Gaddis's own novel *Carpenter's Gothic*, written more than a decade after *The Recognitions*, makes no such demands on the reader. What the reader is called upon to do, rather, is to acquire skill in following the uninterrupted flow of Southern colloquial speech. There are other ways of forcing a reader to pause for reflection than filling pages with exotic information, whether that arouses admiration or exasperation. (If it encourages the reader to have recourse to reference books, as some parlour games may also do, that is no doubt a social benefit but scarcely a ground for taking the work seriously as a contribution to literature.) Works can *need* to be learned, can *need* to convey out-of-the-way information, in order to develop their subject. Otherwise the language, the information, is gimmicky.

Another reason for writing 'experimentally' – and this, like much of what I have just been saying applies, with necessary changes, as much to painting, to music and to architecture as to literature – is that this is felt to be essential to serious work, as a way of avoiding academic banality. Of course a serious work has to display imagination, and that entails deviating in some way from conventional patterns. But it need not deviate in respect to established form. Painters can find ways of being imaginative even within extremely narrow limitations. When Caravaggio painted kneeling pilgrims with dirty soles directly displayed to the spectator, when haloes were first painted in an attenuated form, when the Virgin Mary was permitted to smile or the Christ child to be a normal baby, no formal innovation was involved but wide-ranging new artistic possibilities were opened up.

To return to literature, the writer, too, can innovate in a variety of ways. So a poet can innovate by choosing subjects which have generally been felt to be unsuitable for poetry or by using different rhyme schemes or by allowing greater freedom in respect to what counts as a rhyme or by abandoning rhyme or by inventing different rhythms – Hopkins's 'sprung rhythms', let us say – and so on. The novelist, the playwright, the film-maker can be no less innovative – perhaps, like Elizabeth Gaskell, through choice of subject. The novelist may, as well, introduce different methods of characterisation. At one extreme novelists can profess to penetrate into the innermost thoughts of their personages, their stream of consciousness. Alternatively, in Perec's manner, they can convert Feuerbach's 'Man is what he eats' into 'Persons are what they possess' and characterise by offering minute descriptions of the rooms their personae occupy or the books they read, something Joyce had already done as a way of characterising the priest in his story 'Araby'. Often enough, however, such descriptions are an attempt to secure 'realism' when the characterisation is paper-thin, not as part of a characterisation but as a substitute for it.

More fundamentally, authors may break with traditional methods of story-telling. Are there any limits to this? Or can a serious novel or play take any form whatsoever? Let us now take a look at one of the oldest formal requirements, laid down by Aristotle, to be sure in relation to tragedy, but readily applicable to the novel or a film: that it must have a beginning, a middle and an end. Aristotle goes on to define these requirements more precisely. A beginning does not necessarily presuppose anything but requires something to follow it; an end supposes something to precede it, either necessarily or probably, but does not require anything to follow it; a middle both supposes something to precede it and requires something to follow. He draws the conclusion that an author is not at liberty to begin and end where he chooses. To accept his analysis would supply us with a necessary, although not a sufficient, condition for being a serious novel, play, or film.

Aristotle does not define beginning, middle and end in temporal terms but rather in logical terms. In the conventional novel, however, what might better be called the 'initial situation' does normally come first in its general outline although some elements of it often seep out only gradually. That battle of wits between author and reader, the classical detective story, is an exception; it often begins in the middle with a murder and only at the end of the novel do we discover the actions which necessarily preceded the murder. This may serve to illustrate the general point, much insisted on by recent analysts of the novel, that the beginning, middle, end of the story as told need not coincide with the beginning, middle, end of the story told.

The cinema, with its use of flash-backs, accustomed us to making this distinction – although Conrad, for one, had already employed movements back in time in a less staccato form. We are suddenly made aware of something we need to know in order to understand the behaviour of a person at a certain point but were not told at the beginning. Yet, interestingly enough, film versions of a novel sometimes prefer to tell a story in chronological order which was in the novel told in flashbacks. A case in point is *The Unbearable Lightness of Being*.

It is not uncommon nowadays to read critics who use 'linear' as a term which is sufficient to indicate that the work to which it is applied cannot be taken seriously, just as I have seen it said that nobody will ever again write a novel which tells a single story. (No doubt there were art critics in the 1950s who said that we should never again see painters painting objects as distinct from patterns.) This is linked with what I said earlier: it is often now demanded of serious authors that they should 'experiment' with forms. As usual, however, such properties as linearity and non-linearity neither guarantee seriousness nor demonstrate its absence. Non-linearity, as I earlier suggested in talking about Pinter and as a large number of pretentious films sufficiently illustrate, can be no more than a gimmick; if one has qualms about Peter Greenaway's *Drowning by Numbers* this is by no means on account of the linearity of what is in other ways a quite innovative work. Many modern films – even in France *Lucien Lacombe* and *Jean de Florette* – are strictly linear.

Genuine difficulties, however, arise out of the Aristotelian conception of form. They are important for the question we raised earlier, whether literature can convey truths. 'There is no such thing,' Christopher Ricks confidently tells us, taking this to be what Sterne shows us, 'as a beginning, middle or end.' A beginning, on this view, is nothing more than the point where a writer decides to begin – this as against Aristotle's doctrine that an author is restricted in this respect – and the end is simply the point where the author decides to stop. As for the middle, that can be constructed as the author chooses, perhaps by the throwing of dice; no question of 'probability' arises, since that is a concept which exercises a grip only outside the author-created world of the novel.

Now, we can certainly grant that there are in the world around us no absolute beginnings, if we take that to involve coming into existence *ex nihilo*, and there are no absolute ends, if we interpret that in a sense which is inconsistent with the conservation of energy. But when such writers as Ricks tells us that there are no beginnings and ends in reality, they presumably have in mind something stronger than this. If nothing arises *ex nihilo*, however, any thing or situation, characterised in a particular way, comes into being only at a certain time and passes out of existence at a subsequent particular time. A person is born at a particular place, at a particular time and into particular social circumstances, lives through a variety of situations – each of them, again, arising at a particular time and place – and dies. Again, a boy goes to a particular school at a particular time; his school-life ends at a certain time, to whatever degree its effects live on. A woman marries at a particular time; the marriage may last until her, or her husband's, death or may 'die' before that time, as may her career. All this is obvious.

Novelists have to decide what story, or stories, they are going to tell. So far they are free where to begin. They can choose, too, whether to begin their story at the beginning or to begin in the middle of things or even at the very end. So for Ovid, the story should begin in the middle of things. The poet, he rightly says, 'does not trace Diomedes' return right back to the death of Meleager, or the Trojan War to the twin eggs of Leda'. Stories may seem to have more than one beginning, taking up, as George Eliot does in *Middlemarch*, first the story of one character then, considerably later, the story of another, the initial situation not being fully revealed until the two characters meet. The initial situation is defined as such only in its relationship to what grows out of it, somewhat as the themes of a musical composition are themes only as being what is developed. If the author begins by having in mind what story is to be told the initial situation is no more an arbitrary decision than it is wholly arbitrary what form the first chapter of this book takes. The author's decisions interlock, just like any complex decision in our own life.

There are older novelists, no doubt, who irritate the modern reader by appending to their story a brief account of the 'subsequent life' of their personae, in order to satisfy the demands of their readers for what are conventionally regarded as terminal points, 'natural endings'. So, in the 'conclusion' – a significant word – to *Barnaby Rudge* Dickens marries off six of his characters in the first paragraph. In a later paragraph he kills off three of them, and in separate paragraphs does the same for two others. The rest are described, sentimentally, as having settled into a marriage which, in the years before divorce was readily available, rivalled death in its permanence. Dickens knew his audience and in what their sense of an ending consisted. If, in attacking 'closures', in praising 'open-ended works', critics are simply opposing this sort of thing, or those many other novels in which the course of events is distorted in order to

secure a happy ending or, as in many Jacobean dramas, the maximum number of deaths, one has no quarrel with them.

To abandon such conventional 'conclusions', however, is not to surrender the claim to have reached an ending. Conrad once wrote of Henry James that 'his books end as an episode in life ends'. An episode only: 'You remain with a sense of life going on.' Nevertheless, an episode with an end. 'She walked him away with her, however, as if she had given him now the key to patience.' The conventional 'conclusion' has gone; the modern novelist, one might say, has taught us to see that there are ends other than death or marriage; we may have to read carefully to see that they are ends, that 'It's all over', even when the story is no more than an epiphany.

Novelists have often written trilogies – playwrights, too – and the film sequel is far from being a novelty. Each chapter in a novel is sometimes capable of being read separately, without the 'cliff-hanging' effect of a serial, and yet the stories turn out to be linked in a way which makes it possible to read the whole work as a novel, as it is possible to read Ovid's *Metamorphoses* as a single poem, continuous in a sense in which Chaucer's or Boccaccio's tales are not. A case in point is Frank Moorhouse's *Forty-Seventeen*. Commercial considerations may partly explain this structure, as they did Dickens's serialising. Nevertheless, the fact that each story has a beginning, middle and end as a distinct episode does not prevent the work as a whole having a beginning, middle and end. ('The night has been long – ditto, ditto, my song – and thank goodness they're both of them over.')

The presence of Fortinbras on the stage at the end of *Hamlet* reassures us; life goes on. Nevertheless something has ended, the struggle between Hamlet and Claudius. One difference between literature and life is that in life we can always ask such questions as 'What happened next?' or 'What happened earlier?' and in principle an answer can be given. Such questions can also be asked, to be sure, if we happen to see only a mid-episode in a television mini-series, or read a novel or play which forms part of a trilogy, but in general they do not admit, in the case of literature, of an answer. 'Did Marvell's coy mistress relent?' That is a foolish question. The end of a literary work is so far absolute but no more absolute than the end of a particular life-episode. Hearing that a girl has left school we cannot sensibly enquire into what school courses she will take next year. School is over, for all that what she learnt at school, people she met there, teachers and pupils, may reverberate throughout her life. And some day her life will be over, too. If she is remembered for some time after that, if her behaviour has influenced others, that can also happen to fictional characters.

We might be led, reflecting on these facts, to conclude that the formal rightness of which we have been in search is simply the means by which the artist reveals to us orders inherent in nature. (This is an answer, of

course, which could have application only to the representative arts.) So the painter, let us say, in trying to get the balance in his painting 'just right' attempts to bring home to us the formal balance in that segment of the world he is depicting. The obvious objection is that there is normally more order in the work of art than in anything else we find around us. Then are we to take it that the artist *imposes* order? 'Balzac's collected works,' Harry Levin tells us, 'are a titanic attempt to impose a cosmos on the chaos of everyday life.' 'Impose a cosmos on the chaos' – does not this suggest, once more, that the novelist is a liar, pretending that there is order where there is in fact only chaos? And we may well feel confirmed in this interpretation of the situation as we read on, to discover that Balzac wrote 'in the light of two eternal verities, religion and monarch'. For this strongly suggests that Balzac distorted the realities of nineteenth-century society in the interests of an 'order' which is nothing more than the particular social hierarchy to which he would have it to conform.

One must certainly admit, indeed, that the world of the artist is often ordered in terms that we cannot accept. This is as true, in very different ways, of Aeschylus, Hardy, Ibsen and Zola; we are prepared to accept neither Zeus nor the President of the Immortals nor hereditary disease as having the sort of ordering power which these writers ascribe to them. It is very difficult to order one's material without such crutches – or the more conventional crutch of an often absurd story – and only too easy to understand, therefore, why Kermode has argued, very much in Coleridge's spirit, that we have now to accept the transition from a literature 'which assumed that it was imitating an order to a literature which assumes that it has to create an order unique and self-dependent and possibly describable only after a critical process that might be called decreation'. But this is a false antithesis; the writer or the painter can *discover* an order, and then present it to us in an intensified form, as distinct from either imitating or creating it.

To describe the novelist as *imposing* order on chaos is, therefore, highly misleading if it suggests that his subject is in itself totally without order, that the novelist's imagination, like the imagination in Kant's metaphysics, imposes order upon what would otherwise be a wholly unordered sensory manifold. An order that human beings once supposed to exist, a providential order, many can no longer accept. But there are other orders, as science long ago discovered. Sartre's *Huis Clos* has no ending, but it certainly has an order. Indeed, the artist's position resembles, in certain though by no means all respects, that of the natural historian; he presents us with schemata of the perceived world and contributes to our knowledge just by doing so. *Macbeth* is a schema of tyranny; Shakespeare's simplification of Scottish history in the interests of a tightly woven formal pattern serves that end. Schematisation concentrates the attention – it prepares us, in the Macbeth case, to understand Stalin. We understand better in and through a simplification

– which is not a lie, any more than the diagrammatic plant in a botany book is a lie, just because it does not pretend to be true.

Such a schema neither imposes order on the wholly unordered nor, on the other side, simply copies an order. It brings out one of the orders in a certain kind of thing, a certain set of relationships, by a process of simplification. And this same simplification enables the artist to get his *formal* relationships 'just right'. Looking at a mountain, we can now see the sort of order Cézanne found there, the interplay of plane surfaces and lights. But a Cézanne landscape by no means copies what we see. In his *Lost Illusions*, Balzac has D'Arthez – his persona – describe art thus: 'And what is art? Nothing more than concentrated nature. But this concentration is never formal; on the contrary, it is the greatest possible intensification of the content, the social and human essence of a situation.' Such an antithesis between form and content is, in this context, as misleading as Hauser's contrast between form and 'vital function'; the form is the method of concentration. But certainly the concentration is there in the work and not *merely* as a formal fact; through the concentration we see the object, grasp its vitality. And this is the sense in which art 'perfects nature' – in and through its concentration of nature. It offers 'essences' only in the sense in which we speak of essence of lemon. The classical doctrine of the 'unities' saw this but was too narrow in the forms of concentration it allowed.

I spoke of finding orders, not of finding an Order. 'The sad truth,' Harold Bloom tells us, 'is that totality is a lie, that form is an arbitrary method.' I can substantially accept the first part of this statement, not for a moment wanting to suggest that the serious writer has to show us that the chaotic, messy world in which we seem to be living is, when properly understood, seen to be just a misleading appearance of some total scheme, whether designed by History or Providence or by the President of the Immortals. Indeed, such totalising is characteristic, rather, of telic authors. Any writer who distorts courses of events in the interest of such a Total Scheme can quite fairly be accused of 'imposing' an Order.

I have not the slightest desire to defend what Lyotard calls 'meta-narratives'. Indeed, most Anglo-American philosophers had rejected all such meta-narratives by, at the latest, the 1930s. That Lyotard should suggest that 'we' had accepted such meta-narratives – whether in their theological, Hegelian, Marxist, Freudian or 'progressive' forms – until 'we' were emancipated by post-modernism is just another illustration of the fact that during the calamitous occupation of post-war French thought by pre-war German thought and its no less calamitous and extraordinarily prolonged Stalinism, the more notorious French thinkers, like their 'literary theory' epigoni in the United States, had known nothing about what was going on in the philosophical world outside France, or indeed even the arguments of such thinkers as Bouveresse and Vuillemin within France itself. Rejecting meta-

narratives is not rejecting narratives; one can, indeed, find important narratives in Marx and Freud. A narrative is not an 'arbitrary method'; it is a natural way for human beings, everywhere in the world, to describe what has happened, might have happened or still might happen. What serious literature does, as what history and that part of science which is narrative do, is to place critical constraints on narratives.

To reject a total Order, then, is one thing, to reject ordered sequences quite another. That is, indeed, a form of superstition, according to which all we can say of a sequence of events is that it is 'lucky' or 'unlucky'. I am not denying, as believers in a Total Order would, that there is any such thing as luck. If Mary Jones wins a lottery then, unless the lottery has been rigged, she is simply lucky. If she believes that some action of hers – over and above simply buying a ticket – had any part in securing her win she is simply being superstitious. Unless she chooses to travel on a notoriously unsafe airline to secure a cheap fare, she is simply unlucky, too, if she boards a plane which develops engine-trouble. She did nothing to bring it about, she could do nothing to prevent it from happening. These, however, are special cases. When I say I have had bad luck, this is in most instances a poor excuse for my own foolishness. To say of someone 'he brought it on himself' or 'she knew quite well what was likely to happen' is to refuse such excuses. Although in a particular case this may be unjust, only if there is no connexion whatsoever between actions and consequences do such responses, universally, have no force.

Serious writers are not interested in luck as such. An author who gets a character out of a difficult personal situation by invoking a lottery win or the sudden death of a rich uncle in Waikikamukau is generally, and rightly, accused of falling back on melodramatic devices. That a man always thinks of what happens in terms of bad luck, never seeing anything as his fault can, of course, be an important fact about him, as it can be that a woman blames herself for what is not her fault but sheer misfortune. But if no one was ever responsible for, or at least powerfully contributed to, what happens, the novel, drama, films would lose much of their interest.

In life, a critic has recently suggested, there is nothing but 'and'; I am arguing that there is also 'because'. Putting the critic's point differently, Hayden White says that the world presents itself to us in the form of chronicles, annals. Now, to be sure, it may well present itself to the *historian* in this fashion; the historian has to begin, often enough, from chronicles and annals and has to create a narrative. Nevertheless, he hopes in so doing to get connexions right, to discover them. Otherwise history would lose its point.

What gives the historian the idea of writing a narrative? We are all brought up in a world of stories; if there are societies where no story-telling takes place they have never come my way. And these stories contain 'becauses' if only in the form 'the gods were angry because'. So do

such mini-stories as excuses. The Old Testament is by no means just a chronicle and neither are the Homeric epics. Moreover the historian, like the rest of us, has lived through histories, personal and social, has experienced continuities and discontinuities, has heard explanations and explications, remembers the past, can imagine alternative pasts, wonders how declines and falls have come about.

It seems absurd to have to say all this. We live, however, in an age when a great many people, whether former Christians or former Communists, have lost faith in Order. It is too easy to pass from the rejection of Order, understood as total Order, to the rejection of orders, from the view that everything is prearranged to the view that no one can arrange anything, from the view that there is a logic in history to the view that whatever happens happens by chance. But I do not simply drink too much alcohol and later have a hangover as I might catch a bus and later have a hangover; I have a hangover because I drink a lot of alcohol. I do not simply interrupt people and then find them becoming irritated; I make them irritated by interrupting them.

These are very simple cases. It may be over a long period of time that a man's conduct breaks up his marriage or provokes his child to run away from home. He may be quite bewildered by this outcome. These are the more interesting examples for literature. Nevertheless, the interest still lies in the fact that the story the writer tells is not, like the story told by some young children, just a string of 'ands'. The writer does not invent, although perhaps getting us to see for the first time, the factors that make the difference – how a ruler like Macbeth, a decent enough soldier, becomes a bloody tyrant. Or, at the level of a more ordinary life, helps us to see clearly for the first time, now as being not just a succession of incidents but as having a shape, that daily round, by no means free of horror and terror, of passion and joy, which makes up the principal texture of our lives. We can think of the novelist, too, as doing what Warrender says of poetry in the poet-novelist David Malouf's *The Great World*: 'giving shape to what we too have experienced and did not until then have words for, though as soon as they are spoken we know them as our own.' This, of course, is not the first time I have said as much.

Nothing in what has so far been argued demonstrates that the seriousness of a work of art follows from its having a beginning, middle and end, defined in Aristotelian terms. Simply, I have been arguing that the two are not incompatible, that a work which satisfies these criteria does not automatically falsify, that there is no good reason, either, for treating 'linear' as a contemptuous dismissal-term. If we do now look at the more fundamental question, we can scarcely deny – indeed I have already suggested as much – that both entertainment and telic literature normally have what looks to be a beginning-middle-end structure.

This, however, requires a little further consideration. To satisfy an Aristotelian-type criterion, the middle has to flow from the beginning and

the end from the middle, not, to be sure, as the conclusion in a valid argument flows from its premises – there is no formal implication here – but in such a way that we see what is happening, in the light of our experience, as a likely consequence. In telic and amusement literature, in contrast, the end determines the middle; that end *has* to be reached – the hero *has* to marry the heroine, virtue *has* to be triumphant and vice punished, the villains *have* to be thwarted, the hero *has* to be triumphant, at whatever cost to plausibility. So the beginning-middle-end temporal structure does not satisfy Aristotelian requirements; it only superficially seems to do so. Sometimes we are prepared to accept an artificial end as merely a concession to a literary convention, as with the traditional happy ending. It is when that end is not simply tacked on but arrived at by a kind of *force majeure* which infects the whole of the literary work that we can no longer take it seriously.

Of course, in a serious work, too, we can often see the end coming, sometimes to a degree that is almost unbearable; if we do not know the precise character of what is to come we at least know, as we may know in ordinary life, that 'it must end in disaster'. Some people prefer to read the end of a novel first; in the case of an historical play or a work founded on a 'real-life incident' we may know not only the ending but the general course of events before we begin reading. In Lean's film *Lawrence of Arabia* the script-writer Robert Bolt begins by reminding us how Lawrence died and what was the official response to his death. If the outcome is inevitable, this is not, however, because the genre demands that kind of ending. From a serious work, as not from a pure entertainment, we expect to obtain a deeper understanding of, a deeper feeling for, the course of events which led up to this outcome. Aristotle's readers were accustomed to a literature which began from what were already familiar myths. Their dramatists took them inside, humanised, these myths, as the writers of modern 'faction' also attempt to do, when they begin from persons and events which have in our society a quasi-mythical status. Entertainment novels, too, are often based on popular myths, but they merely repeat them in a disguised form, reinforcing but not illuminating them.

Even granted, however, that the beginning-middle-end structure in a serious novel demands more than simple temporal sequences – indeed may not be linear, although there is nothing against its being so – and demands relationships between sequences which although they are fictitious are not factitious, it does not follow that serious novels, serious plays, serious films must have this structure. They may wish to emphasise the repetitiousness of particular forms of life rather than the possibilities of change they may contain. Sartre's *Huis Clos* – commonly translated as *No Exit* – is a case in point, as is Beckett's mime play *Acts without Words 2*. In these instances, however, what is repeated has a sequential form. Each of Beckett's tramps rises in turn and goes

schematically through his daily round, the two rounds differing greatly in character. Only when the second tramp begins again is the repetition emphasised.

What about works where the idea of orderly structure is totally abandoned? Let us look first at music. As we listen to familiar music we have a sense of a beginning, middle and end; if we are Westerners we may be disconcerted by a classical Indian musical composition precisely because its ending strikes us as being unexpected, sudden, unprepared for. Nevertheless, it would be a mistake to conclude that Indian music is nothing but an unrelated series of improvisations, any more than jazz is. We have to learn to listen to it. An approaching end, in Western music, may be marked in a variety of ways, which differ from time to time, from place to place, from form to form. So the end's approaching may be made plain by the fact that we hear again a passage from which the composition began, separated by a period of development, or by a conventionalised winding-down, not very different from a printed 'The End' in a novel. Nothing in our experience outside music can tell us that the end is nigh; we learn that by listening, just as we learn the inflexions and the stock phrases which in our society suggest that a speech is coming to its end.

Twentieth-century serious music moved in three different directions. With serial music, it laid down new, very rigid, rules for musical composition, even more rigid in the compositions of his Californian disciples than in Schoenberg himself; with Webern it moved towards compositions of extraordinary brevity; with Cage and many other composers in America and Europe it took the form of chance or 'aleatory' music in which the composer presents the performer with musical fragments without predetermining the order in which they are to be played. Serialism by no means deviated from the view that a musical composition should have a firm structure. On the contrary, at a time when composers were abandoning tonality and found themselves at a loss to discover a method of organisation to substitute for the key-based system, Schoenberg developed a new method of organisation – the tone-row – which did not involve a reversion to tonality but was firmly structured. If formal inventiveness guarantees seriousness, there can be no doubt about Schoenberg's seriousness as a composer. This is equally so if formal regularity suffices.

A new form, however, may fail to work; it may take away the interest of the art in question, or diminish rather than expand it, or simply act as a gimmick. And allegiance to a predetermined ordering system can be encountered – indeed is generally encountered – in work we dismiss as banal, academic. If we raise objections to 'International Modern' architecture this is not because it failed to present us with a new architectural form but rather because it issued in the creation of a great many academic, banal buildings, which did not give us the kinds of

satisfaction we expect from architecture. That is what many listeners feel about serialism; whether they are right or wrong, it is at least *possible* that they are right. Thus it is not enough to say in defence of the seriousness of a composer that he adhered to a strict system of composition. So he might have done and yet his work could properly be dismissed as academic, even if another such composer is clearly to be taken seriously. There is nothing surprising in this; there are purely academic works in every artistic form, as I earlier remarked.

There is a remote resemblance between serialism and Joyce's *Ulysses* in so far as Joyce deliberately imposes formal requirements on himself, in a work which, given its scope, could easily collapse into being a succession of vignettes. We know that his novel is approaching its end as the day ends – another 'natural ending'; there is a rigid unity of time and place. But there are also those correspondences to Homer which Joyce deliberately imposed upon himself and those other non-formal requirements set out by Stuart Gilbert, who had a great deal of close discussion with Joyce, in his *James Joyce's Ulysses*. So each segment of the novel is governed by a particular part of the body and by a particular art, most segments by a particular colour.

The Jesuit-ridden Joyce may have found himself sustained and disciplined by these formal requirements – of which the ordinary Joyce-reader is no more conscious than is the ordinary listener of the inverted reversed tone-rows in serialist music. That does not in itself matter; in the serialist case what the listener does not specifically hear as such is none the less essential to the ordering of any strictly serialist music. To suggest, however, that the seriousness of *Ulysses* as a novel in any way depends, except genetically, on the satisfaction of these self-imposed requirements would be absurd. It is not just, as it is in the serialist case, that the uninstructed reader is not specifically aware of the ordering principles; it simply would not matter if they were not there. That Bloom so greatly relishes kidneys matters; it does not matter that kidneys are the part of the body that dominates the segment in which we first meet him. The essential form is the grand design which interweaves Stephen and Bloom. We are quite prepared to believe Gilbert when he tells us that many people who found themselves unable to comprehend *Ulysses* returned to it with interest after reading his book; he has much to say that helps even those of us who had taken *Ulysses* seriously before he wrote. I hope, however, that they did not return to it as to an intellectual parlour-game.

To turn now to brevity, the most striking musical instance is Webern whose works – in total but four hours – Stravinsky described as 'diamonds'. Mallarmé, too, had described each of his poems as a 'diamond', but a very queer sort of diamond indeed which 'reflects everything but which has no existence in itself'. 'Queer', since an actual diamond reflects only in virtue of its structure and to speak of it as

'reflecting everything' would at once suggest that it is a fake-diamond, a glass mirror. In contrast, Webern's miniatures, like a real diamond, are structured and are in no sense mirrors. They are diamond-like because we experience them as a flash of brilliance, in consequence of their structure. Something similar is true of a Japanese haiku or a Wildean epigram.

The effect of sudden illumination is also sought after in 'epiphanies', short stories of the type developed by Chekhov, Joyce and, more recently, by Barthelme and many another, presenting us not so much with a slice of life as with a crumb, from the texture of which we are to deduce the slice or which is particularly revealing to the agents. Whereas, however, the haiku and the Webern pieces are strictly rule-governed, these stories, like the comparable imagist poems, have a loose structure. The effect is too often flaccid, desultory, faux-naïf. Nevertheless such stories can be held together by a central image, coupled with the strict relevance Chekhov always insists upon.

The third type of innovation, aleatory music, is a greater challenge to Aristotle-like musical structures. For in so far as it offers choices, it suggests that there is no kind of formal pattern in the structure of its compositions; any sequence in any order, at least among those offered, will do. The throw of a dice may determine what will happen next. All this is in direct opposition to the tendency of serious composers over the preceding century, jazz apart, to leave less and less freedom of choice to the performer. Such aleatory music was taken up not only by Cage but by Boulez and Stockhausen although, as was often true of serialism, in a modified fashion.

In his *Modern Music* Paul Griffiths suggests that aleatory, or 'chance', music arose partly out of despair, as serialist-style composers began to realise that it was never possible to achieve the total compositional control they were seeking. We noted earlier that electronic music interested some composers because they saw in it a way of exercising total control, with no performers intervening. Even tapes, however, could not wholly be trusted. So composers sought, in response, deliberately to introduce chance into their compositions, as a paradoxical way of gaining control. One difficulty then was that the aleatory element could not be heard by the listeners. Listeners can learn to recognise that what they are hearing is a jazz improvisation or a cadenza, but they cannot hear that the order of a piece could have been different. In so far as the composer tries to overcome this problem by composing in a manner that is obviously random, listeners lose interest.

'When anything is possible, nothing seems to matter any more.' That dictum could be used in relation to such music, but was actually invoked by a Sydney critic talking about some recent novels. In a serious novel, if the critic is right, some things have to be impossible. (The same applies to films and plays.) The impossibility in question, once more, is not *logical*

impossibility; it is the empirical impossibility that the characters as they have been described to us or have been shown to us, whether reflecting or in action, could, given our knowledge of their social and geographical position, have acted as they did. We have been introduced, let us say, to a respectable nineteenth-century household. A daughter returns from her boarding school to announce that she has become pregnant by a married teacher. Her father responds by saying: 'Oh good, when is the baby due?' That counts as an impossibility – only, of course, in virtue of what we know about human societies and the way in which people behave in them. (Literature, as I previously argued, is not a closed world.)

One has, of course, to be careful. We might be reading a parody or a fantasy. The author has been misleading us; the paternal remark may be the first sign that this is so, that in this household things are not at all what we assumed them to be. However, such a response is, as I earlier remarked, parasitic. We thought we were reading a straightforward novel; we found we were reading a parody. We were temporarily caught, as some people have been caught by *Cold Comfort Farm* or by that parody of Bergman's films, *The Dove*. Such a work we have to take reflexively, as a comment on other works. In Bakhtin's phraseology, it is a 'carnivalised' work, allowed liberties which are not generally permitted, liberties at the expense of established authorities.

The Bakhtin reference is to his *Problems in Dostoevsky's Poetics*. In that work he discusses 'the adventure novel' in terms which are at this point in our argument highly relevant. In such a novel, he says, the hero 'has no firm image', since any such image would 'weigh down the adventure plot, limit the adventure possibilities'. Such a hero is 'not a substance but a pure function of adventures and escapades'. Thinking of Richard Hannay and James Bond, we may well question this as a generalisation about adventure stories. Indeed, in British adventure stories it is usually the case that the adventurers are so socially placed or so individualised that there are actions they could not possibly perform. We know in advance, let us say, that attempts to bribe them are certain to fail. Even American 'tough-guy' investigators have compunctions and loyalties which, not uncommonly, lie near to the heart of the events in which they are involved. Indeed, such adventure heroes are often used to characterise. 'A bit of a Sherlock Holmes' conveys as definitely as 'a touch of Socrates'.

Nevertheless, there certainly are adventure stories – and romantic tales – of the type Bakhtin has characterised. Much science fiction is of this kind. The human beings are in the novel only to provide continuity to the episodes. They are not shown as suffering from internal doubts and the dialogue allotted to them does nothing to distinguish them. Sometimes the computers display more individuality than the people. Such works provide us, indeed, with a useful point of contrast to serious novels, with which the British-style adventure stories have much more in common.

Even science fiction of the mechanical sort just described still, however,

formally resembles the serious novel, if perhaps with the reservations I previously mentioned about whether their beginning, middle and end fully satisfy Aristotelian requirements. For all the technological innovations characteristic of the stories it tells, such fiction is not usually innovative in its structure. Like an adventure story, it does not enlarge but rather diminishes the novel's scope. Lending libraries and bookshops often use such expressions as 'thriller', 'romance', 'science. fiction', 'detective story', rather than 'novel', to indicate books which are unambitious entertainments, read solely as narratives and favourably described by the use of such adjectives as 'exciting', 'lively', 'ingenious', without pretending that the work in question enlarges our experience, contributes to our moral or intellectual education, or delights us by its mastery over language. If it does these things then we should reconsider our description of it – just as, in reverse, Nabokov wants us to reconsider our description of Dostoevsky, to read him not as a serious novelist but simply as a writer of thrillers.

In contrast, many fictions of the late twentieth century, emanating particularly from South America and the United States, are extremely ambitious. So a reviewer of Carlos Fuentes' *Terra Nostra* is moved to describe it thus:

> A whacking great affirmation of fiction as the only proper vehicle for poetry, speculation, prophecy, surmise, heroic optimism and most of the more worthwhile human preoccupations.

As it stands, this is a fine specimen of the nonsensical over-claims which ought to bring critics into intellectual disrepute. But if we excise 'the only proper' and substitute 'a proper' we have a claim that might win rather wider acceptance. One can scarcely deny that there are novels which contain all these things – as indeed they can be found in the plays of Shakespeare, but in a manner subordinate, like the witches' prophecies or Hamlet's speculations or Henry V's heroic optimism or Othello's surmises, to the development of the drama.

When, in contrast, they are presented for their own sake, two things happen, as they do when we are reading – if anybody still does – the later novels of H.G. Wells. First, the flow of the narrative is so disrupted that we lose interest in it, and secondly the discursive material is so divorced from the characters, so obviously a direct expression of the author's views, that we begin to turn our attention to it simply as such, when its intellectual shoddiness is too often apparent. Novels from South America or from Eastern Europe when it was under Communist control may, to be sure, be politically and socially revealing, as North American novels now seldom are, but their literary interest lies in what they show us about people under stress – either directly or more circuitously by the use of a variety of literary devices. Trying to make of the novel a gather-all can be

as attenuating as being content to make of it a light entertainment.

In his *Partial Magic*, Robert Alter has described a set of novels dating from the 1950s onwards in the following terms:

> In this vehemently contemporary fiction, there is a cultivated quality of rapid improvisation, often a looseness of form; love of pastiche, parody, slap-dash invention; wilful neglect of psychological depth or subtlety or consecutiveness of characterisation; a cavalier attitude towards consistency of incident, plot, unity, details of milieu and underlying all these a kind of despairing scepticism, often tinged with hysteria, about the validity of language and the very enterprise of fiction.

The novels he has in mind as he writes these words are the very same novels which other critics have listed, for all their length, as '250 pages' books, which once set down are not picked up again. Their verbal tricks, their thumb-nosing at authorities, their fun and games may amuse us, even impress us by their cleverness, much as we might respond to an undergraduate revue. But once again nothing in them matters; if we do not actually put them down we do not pick them up again – as we might leave such a revue at intermission, with no sense of loss. Neither characters nor story engage us. Being engaged is not simply a matter of wanting to know 'what happens next'. Re-reading a novel, re-seeing a film – as many of us regularly do – we already know in general terms, as I earlier remarked, what happens next. Re-reading, re-seeing, we are appreciating more fully the intimations of these happenings, seeing more fully the point of utterances. We want to do this, however, only because we care about what is going on, the author having succeeded in making us care, and because the texture of the work stands up to this closer examination. The connexions are there to be found. The novels Alter is talking about contain no such connexions. They carry the rejection of form to an extreme point.

One particular phrase in Alter's criticism may arouse protest: 'wilful neglect of psychological depth or subtlety or consecutiveness of characterisation.' This protest is not a denial that what Alter points to as a characteristic of many contemporary American novels in fact exists; that would scarcely be plausible. The argument would rather be that the phrase 'wilful neglect' suggests that something which ought to be looked after is not being looked after – like a child, let us say – whereas in the present instance what ought to be in question is precisely the value of what is allegedly being 'neglected'.

In defence of this view, it may in the first place be argued that there are no people in literature. This is true in the same sense in which Magritte could properly deny that his painting is a pipe. Rather, it is a representation of a pipe. So, too, what I have been calling the 'characters' or the 'personae' of a literary work are not people, they are

representations of people, with the proviso that they are generally not representations of any particular person, except in the mixed case of historical characters. Only in historical novels is it sensible to ask questions about the character which the text does not answer, questions about how many children Napoleon had as distinct from questions about how many children Lady Macbeth had. Saying that characters are not people is saying that there are some questions we can ask about people which we cannot sensibly ask about literary characters.

Nevertheless, when the characterisation is consistent and has a measure of depth and subtlety, we often find ourselves, quite properly, asking questions about personae which we might also ask about persons, now expecting the text eventually to answer them. Of course, we can also ask such questions while reading adventure tales, in the form 'How is the hero to get out of this predicament?' In the film serials of my childhood the end of every episode was designed to raise this question. In a modern video game it might rather be 'How can I get myself out of this predicament?' but the narrative-game is in this case, too, designed to force this question upon us. It is to be answered by a display of ingenuity, depending not at all on psychological insight.

When we ask such questions as 'Will she see through him?', 'Will he sign that petition?' the situation is very different. To be sure, in this case, too, the question may be whether someone can be rescued but it will not be by a swift cut through binding ropes but rather by an emancipation from servility. We then expect to be shown, in a serious novel, how this happens, whether by gradual attrition or a sudden realisation that one no longer believes, no longer cares or, as in *The Unbearable Lightness of Being*, can no longer collaborate. In stories in which anyone can do anything, except under physical constraint, these questions cannot arise.

That, it might be replied, is just how it should be in the contemporary novel. Two grounds might be alleged for this somewhat remarkable conclusion. The first, the weaker view, is that nowadays persons do not have the kind of individuality which such questions presume, the second, the stronger view, is that we have come to realise that persons never did have it. Novels which encourage us to ask any question except (of authors) 'What will they think up next?' both, then, depend upon and help to sustain a myth, so far as the personae are taken to represent persons. We are now too enlightened to be able to accept the view that either now, or at any other time, individuals can stand up against collectives.

On the weaker view, we live in a collectivised, computerised society, in which there are no longer individuals. So for Robbe-Grillet:

> In fact, the creators of character, in the traditional sense, can now do nothing more than present us with puppets in whom they themselves no longer believe. The novel that contains characters belongs well and truly to the past, it was peculiar to an age – that of the apogee of the individual.

Such passages emerged out of a post-War France which, as we earlier said, was obsessed by Stalin's Soviet Union, with an allegiance to it for long unshaken. The collectivist passion culminated in structuralism, most obviously in the Marxism from which Althusser sought to remove every vestige of humanism, at a time when many Marxists elsewhere were seeking it out with relief. In the age of Walesa, of Gorbachev, of Havel, it is scarcely plausible.

In every society, one cannot only admit but insist, there are forces at work which attempt to destroy individuality, which seek to enforce uniformity whether in the name of religion or of national unity or simply out of a fear of difference. In our society the emphasis on being 'with it' or 'keeping up', with commercial roots but often manifesting itself in art criticism, has been one powerful factor in securing uniformity, as has been the emergence of such concepts as 'teenager' and the peer pressures that go with it. Computers have latterly become a factor, compelling us to change individual habits in order to conform to their technical demands. Nevertheless, the battle between the forces of conformity and individual dissent has been vigorously fought in Central Europe, Eastern Europe and Asia as well as in the West. One might take Robbe-Grillet himself as an example; he can scarcely be regarded as a conformist.

Those who say that there are no individuals any more, that we are all collectivised, are either trying to persuade us that this is what ought to be the case or else are exaggerating a collectivism which is sufficiently terrible of itself and in need of the author's skill to bring home to us both how it works and how it is resisted. True enough, it was easier to do this on the European continent under totalitarian rule, where the foe, and the methods used to secure uniformity, were more obvious than they are in the United States; the McCarthy regime came, in this respect, as something of a blessing, as is most obvious in Arthur Miller's *The Crucible*. Nevertheless, in American Jewish novels the traditional inter-family struggle between individual and pressures towards conformity is still fought out. If the late twentieth-century novel often contains puppets rather than characters, this is sometimes as a protest against the conformist-making tendencies of our age; sometimes, I fear, the result of a strange lack of capacity to get beyond faces to minds, in societies in which personalities are 'developed', identity sought rather than expressed.

We have yet to dispute, however, the view that individuals not only are now, but always have been, mythical creations. On that view, the classical concern with individual relationships is not only unsuited to our times – the refusal of writers in countries outside France and the United States or even of many novelists in the United States to admit as much being then set aside as a gross failure to be 'with it' – but at all times involves an ideologically motivated falsification of the facts. Such a doctrine is acceptable, I should argue, only if we think of it as being

directed against certain classical notions of individuality and associated views about the nature of the self.

In the modern world, such doctrines are particularly associated with the name of Descartes, in relation to whom French thinkers always place themselves. To express his views crudely – and some such thinkers will have been particularly conscious of Descartes in the form in which they met him in their high school philosophy courses – Descartes treats human beings as having an animal body, certainly, but above that a mind, which although somehow united with a body is totally different from it in character. The mind can know itself through and through but other things, including the minds of other persons, it can know only imperfectly through the body. Each mind then is essentially isolated from every other mind, a view we often find expressed in late nineteenth-century and early twentieth-century poetry. We may fairly call this the myth of Individuality. It is not just that, as Adam Ferguson argued, capitalism isolates us, and at the same time generates the Individualist myth of the self-made man; our human nature on this view isolates us.

That is not the way in which personae appear in serious plays and novels. Rather they are depicted as living in closely described places and times and as being profoundly influenced by the mores, the codes, the social habits, the current beliefs, the illusions and the prejudices of these places and times, as by their parents, their friends. True enough, writers are often particularly interested in rebels. Rebellions make for more interesting narratives than unquestioning conformity; collectivising institutions are most readily put under the spotlight when they attempt to deal with obdurate rebels. But, to use once again a typographical device, rebellions are not made by Cartesian Individuals, they are made by individuals, in a manner profoundly influenced by how and where they have been living. Descartes thought he could begin his thinking afresh, from a starting point without assumptions; his thinking is in fact riddled with scholastic assumptions. Stephen Dedalus is a rebel, but unmistakably an Irish Roman Catholic rebel, not the Jewish rebel depicted by a Roth or a Bellow, just as the heroine of *My Brilliant Career* is unmistakably an Australian rebel. There can be rebels without a cause but there cannot be rebels without cause. Neither classical Individualism nor theoretical collectivism can do justice to such facts.

Some critics of literature complain, as I earlier remarked, that self-deception is too common a literary theme. Self-deception is impossible on the assumption that our own minds are things about which, uniquely, we have complete knowledge, a common assumption in classical philosophical Individualism. It is by no means characteristic of serious novels, either, as it often is of adventure novels, that its personae have undivided, unchanging, intentions. Characters in serious novels are often depicted as deeply torn, divided between different allegiances, as Stephen is torn about his behaviour by his mother's death-bed.

In his *Innocence and Experience*, indeed, Stuart Hampshire tells us that literature taught him how divided people are, something which in their ordinary dealings they often manage to conceal, presenting to the world a united front which is in fact never anything more than a patched-up coalition with a powerful opposition. Serious literature gives the game away. In short, serious novelists are not committed to the philosophical myths associated with classical Individualism – far from it. To be sure, they are novelists, not sociologists, not competitors with Max Weber or Althusser. They are not concerned with abstract relationships between social forces and social structures; they are interested in the ways individuals behave within, and rebel against, such structures. What is wrong with that? Nothing, unless they presume that any rebellion can ever be total or wholly self-initiated. Serious writers do not make that presumption.

The novel bound by formal considerations, carried over from drama, is one of the great Western innovations, comparable in this respect to modern science. There are those nowadays who would blur the concept of science, refusing to distinguish it from astrology, prediction from prophecy, just as there are those who try to blur the distinction between that other great Western achievement, critical philosophy, and the utterances of sages and prophets. We still, fortunately, have words at our disposal which allow us to insist on these distinctions, as I have just done by contrasting prediction with prophecy, the sage with the philosopher and have elsewhere done in more detail. The situation in respect to the novel is more difficult. 'Novel' has often been used indiscriminately, as I have so far used it, to refer to any kind of lengthy prose fiction, although to be sure such historians as Ian Watt have conventionally and I think correctly dated the novel back no further than the seventeenth century. Although Bakhtin, I shall suggest, casts his net far too widely, I should be happy enough to use his phrase 'Menippean satire' to categorise the writings of Lucian, Petronius, Rabelais and the so-called novels which Alter characterises, distinguishing them thus from the novel proper.

Bakhtin sets out some fourteen characteristics of the Menippean satire – for short, the menippea – although he grants that they are not all to be found in every work he wants to include under that heading. Among them the most relevant for our present purposes are its freedom from verisimilitude, from any boundaries on invention set by either life or legend; its formal justification of the extraordinary situations it creates by the fact that they act as tests – not, as in legends, of a hero, but rather of 'an *idea* or a *truth*'; its 'slum naturalism'; its stripped-down discussions of 'ultimate questions' in which complex argumentation has no place; its abrupt transitions; its fondness for abnormal mental states; its scandal scenes; its use of inserted genres – poems, short stories, for example; its concern for contemporary issues.

It will be obvious that most of these characteristics are by no means

peculiar to the menippea, even if they could be historically linked with it. In *Measure for Measure* there is plenty of slum naturalism; there is more than one scandal scene. A song is inserted and prose is intermingled with verse. Ultimate questions are raised, but not argued, in such speeches as Isabella's 'But man, proud man'. Ideas such as 'chastity' and 'authority' are tested. Verisimilitude is not a strong point in the play; there is an abrupt transition in the character of Angelo. The difference, of course, is that we care about the characters of the play; the switches in genre have a dramatic point; actions do not simply follow one another but to some degree *follow from* the characters being in particular situations. We are at no point in fairyland.

Measure for Measure is a play, not a novel, but there is some point in referring to it – as there would be in making similar remarks about *The Beggar's Opera*, both in Gay's and in Brecht's version – because the original menippeas were in dialogue form. But *Tom Jones* and *Little Dorrit*, to mention only familiar English novels, have many of the characteristics Bakhtin has set out. Precisely where they differ, however, is the crucial respect. It is not true that in these works anything is possible. They do not at all resemble legends; they do not, for example, allow supernatural intervention. That distinguishes them not only from, say, such a Roman work as Apuleius' *The Golden Ass* but from the great bulk of those Chinese 'little' tales, *Hsiao-shuo*, translated as 'novellas' and, indeed, from most of the prose literature in Oriental countries before its close contact with the West. Bahktin takes Petronius to be a prime example of a Menippean satirist, but that relatively complete section of *Satyricon* we know as *Trimalchio's Feast* is, interestingly enough, sometimes seen as more closely allied to the modern novel than is Apuleius' work, precisely because it is interested in building up the character of Trimalchio.

When we read a Menippean like Lucian, our mental set is not at all like that in which we approach a novel. At most, we have in his *Alexander* something which approaches to 'faction', a journalistic exposé of a man whom Lucian saw as a charlatan. To call his *The True History* science fiction, even, would be misleading. To call it a menippea – as later *Gulliver's Travels* but not *Robinson Crusoe* – brings out its character as something which does not attempt verisimilitude, delights in grotesque fancies, and has a satirical intent.

In an earlier chapter I remarked that genres ought not to be multiplied beyond necessity and could not expect to be sharp-edged. A novel may have Menippean elements in it and yet still be a novel in respect to its interest in persons, its concern for verisimilitude, its relative tightness in form. I should not, with Bakhtin, count Dostoevsky among the Menippeans. But it is the right characterisation for writers otherwise so different as Lucian, Rabelais and many contemporary writers, especially in the United States. Sterne and Peacock would be other plausible candidates.

The classical Menippeans, like the American writers, quite commonly wrote in a convoluted, literary style. They had been trained, too, to imitate, where that did not signify 'the imitation of life' but rather the imitation of earlier writers whom they sought to improve upon, as Apuleius sought to improve upon the *Ass* ascribed to Lucian. They take intertextuality for granted. If they are deeply concerned with contemporary affairs, that concern is not expressed directly but through the use of some familiar or freshly coined legend, as Lucian makes use of the Olympian stories, Apuleius of the man-ass.

A comparable twentieth-century example is John Barth's *Giles Goat-Boy*. Written in 1966, this is a many-faceted allegory, which can be simultaneously read as a satirical account of Universities, of Christianity, of the Cold War, of human ways and of technology. I remarked earlier that a work can be realistic without being naturalistic; this is another case in point. One doubts whether, as a University teacher, Barth could have written so freely without a disguise. Nevertheless, much of the time one is so busy feeling clever as one penetrates disguises – recognising, let us say, the YMCA in the name 'Junior Enochist League Inn' or feeling thwarted when one cannot do so – that the point of what is going on is lost. A familiar phrase comes to mind with a new force: 'too clever for words'. What does his Menippean parody of *Oedipus Tyrannus* actually do? One does not similarly wonder what Lucian's parodies are doing. These criticisms do not show that Barth's work is not Menippean; they illustrate ways in which we might differentiate critically within that category.

To suggest that one ought not to think of these works as novels is not, then, at once to pass an adverse judgment on them. Most novels are failures; some Menippean satires are successful. What, however, are we to say about them, in a critical mode? For certainly we cannot judge them as we judge novels, in quasi-Aristotelian terms. And it is not as if we could claim now to be living in a post-Aristotelian age. Very many of the novels now being written, the films being made, are quite properly judged in the familiar Aristotelian-style language.

We do, however, have to reckon with the possibility that the menippea is nothing but an entertainment. 'I think it is still very difficult,' writes his translator Paul Turner, 'not to be entertained by Lucian.' Probably so, provided one has intellectual interests. Are modern Menippean satires, perhaps, simply what I earlier called 'art-world entertainment'? Looking around in the 1920s Ortega y Gasset concluded that the new art of his times was 'appreciated precisely because it was recognised as a farce', that modern artists ought not therefore to be compared with the serious artists of the past, belonging as they do to a completely different category. They have recognised, he says, that their society is one whose dominant interest is in sport and games; they have simply decided to join in, that being the most rapid path to public recognition.

A good deal had been going on when Ortega wrote which might fairly be described as games-playing, sometimes directed against the very idea of there being any such thing as serious art. At a later stage, how else to describe Cage's professed preference for the natural sounds we hear when there is relative silence as compared with music? (Although we might well share his feelings in a muzaked supermarket.) Or, for all its darker overtones, what Beckett himself called his 'farce in five acts', his thirty-five-second-long *Breath*. The menippeas, however, cannot all of them be thus regarded.

One can, indeed, ask some of the questions about a menippea which we can ask about many other kinds of literary art. It can display, or not display, mastery over language, as distinct from mere exhibitionism; for all its lack of verisimilitude, it can help us to see, can educate us morally, as Swift does in *Gulliver's Travels*. It may, indeed, contain a great deal of verisimilitude, in spite of its fantasies. The narrator in *The Golden Ass* is a man turned ass. In that guise not only does he have access to a great deal which would not be available to a purely human narrator but also, when the man-ass reports something at which he could not have been present, Apuleius goes out of the way to explain how this happens. It is not surprising, in an age perhaps slightly more superstitious than our own, that he was sometimes taken literally. Even Augustine was uncertain whether Apuleius had in fact spent part of his life as an ass.

What is peculiar to the menippea, and what makes it popular with contemporary American writers, is first of all the elbow-room it leaves writers. It has been said of Apuleius that he discovered the popular, largely oral, story as the medium which would make his moral and religious ideas available to a much wider audience than would ever turn to formal treatises. This is not unconnected with Ortega y Gasset's comment on the way in which modern artists have discovered that to become famous it is necessary to become a games-player. Also the Menippean is not compelled to work ideas out in detail, a considerable advantage.

Distinctions ought not to be multiplied without necessity. But lending libraries, bookshops, have found it necessary, as we saw, to distinguish within that wide class of works which are sometimes described as 'novels'. For their readers, their purchasers, may have not the slightest interest in works which are concerned with personal relationships as they develop over time. They want adventure stories, whether in the form of science fiction, thrillers or detective stories, in which people are broadly characterised but are thereafter important only as bearers of actions, the actions being the crucial thing and personal development not being allowable as a disturbance to the reader's action-expectations. (A supposed hero may turn out to be a villain in disguise, but a hero cannot be allowed to turn villainous, under whatever provocation.)

The works I have just referred to are written as, and are seldom

anything but, either entertainments or telic works or some combination of the two. The critic who complains of a lack of depth in the characterisation is treating them as being what they are not – an attempt to contribute to serious literature. As in all such cases, however, a serious writer may take the outline characteristic of such stories and transform it into a serious novel. We may not accept Graham Greene's description of *Brighton Rock* as an entertainment; we may reject this description of Dostoevsky's novels while admitting their 'thriller' framework; we may put up a case for John le Carré as being a serious writer. But the general character of the distinction is as clear as such distinctions can ever hope to be.

To say of a literary work that it is, in distinction from other prose fictions, a novel is not equivalent to taking it seriously. It may be totally banal, completely lacking in imagination, clumsily written, wholly devoid of penetration, designed to confirm the prejudices of its readers, vicariously offering them wealth and power while at the same time consoling them with the reflection that the wealthy and the powerful are never 'really happy'. Yet it is still a novel in so far as personal relationships lie at its centre, however feebly they are depicted. Many serious novels, as distinct from entertainments, which have this centre are still being written, even in the United States and still more in England, Germany, Australia, Italy – although, reading some literary theorists, one would scarcely guess that this is so. (Personal relationships, one should perhaps emphasise once more, are not relations between classical Individuals, they are relations in a society between social beings.)

All this is reasonably obvious. What is much more controversial is the way in which I took over from Bakhtin, if not in a quite uncritical way, the concept of a 'Menippean satire' and applied it to some recent American works. This, it might be said, is the last refuge of post-Aristotelianism. I save the traditional modes of criticism, without using them to cast these works aside as 'high-brow entertainment' – an admittedly tempting alternative – by denying them to be novels, criticisable as such, and putting them rather in the same class as Lucian's dialogues or Swift's *Gulliver's Travels*, as successful or unsuccessful satires, possessing verisimilitude only in the sense they bring out the nature of what they are satirising, or at least some characteristics of it, morally educative for much the same reason, but not displaying the direct realism characteristic of the novel, including, as it does not, legendary elements.

The boundaries, once more, are insecure. Marquez has complained that some critics describe as legendary what is just the stuff of daily life in his own country; I earlier remarked that British critics may respond in much the same manner to Faulkner's South. But the difference remains. In the menippea neither person nor place have the significance they have in Conrad, in Lawrence, in Forster – to mention only twentieth-century

British novelists – as well as in a multitude of feeble block-busters. Or indeed in *Don Quixote*. Their literary lineage is different; their masters are not Richardson or Austen or James but Arabian tales – to which in his critical writings Barth constantly reverts – Burton, Rabelais, Petronius. We have never known quite what to say about these writers, more often browsed through than read. American Menippean satires may equally leave us at a loss and suffer the same fate. They certainly will if we approach them as novels.

I should perhaps make it plain that I am not dichotomously dividing longer prose fiction into novels and menippea. If one turns to Japan, for example, one finds not only *gesaku* fiction, which Japanese critics describe in terms which largely assimilate it to menippea, but *shosetsu*, which, to be sure, have been influenced by the Western novel but of which Masao Miyoshi has correctly said that they 'might be found quite at home alongside the oral tales of the third world rather than the Western novel'. It would certainly be absurd if, seeking to generalise about the form of the novel, we ended up with the multiplication of genres satirised in *Hamlet*. But, as I said earlier, I do believe that the Western novel is a particular achievement, rich in serious works, about the form of which we can generalise, as we certainly cannot interestingly generalise about prose fiction as a whole. And the same is true of the menippea and the *shosetsu*, which can be regarded as having 'picaresque' members outside, as well as inside, the Western tradition. As soon as the Japanese began to read European literature, not until the last quarter of the nineteenth century on any considerable scale, they recognised that they were confronted with something quite different from their own, or Chinese, prose fiction. Nowadays, of course, there are Japanese novels, such as Tanizaki's *The Makioka Sisters*. But the pull of the older, looser, form is still strong, as in Soseki's *I am a Cat*. Once we make these distinctions, but not otherwise, we can generalise about serious novels in classical terms.

13

Emotional States

The imaginary critic who, four chapters ago, complained that I had been so silent about the emotions, was not entirely fair. I have in fact said a good deal about the emotions, if in a somewhat scattered way. Indeed, in the present chapter I shall have to repeat myself more than I have so far done. It seemed desirable, nevertheless, to bring together my earlier remarks into a more systematic shape, expanding them somewhat and taking up some issues about which I had rashly promised to say something in the sequel.

How should such a chapter be titled? 'Emotions' might seem to be the obvious answer. As currently used, however, that is rather too narrow; moods, as distinct from emotions, have to come into our story. 'Feelings', in contrast, is too broad, employed as it is to refer to simple sensations ('a funny feeling in my finger') and to presentiments ('I feel that she will not come'). So 'emotional states' will have to do. True enough, that too is sometimes used rather narrowly; 'he's in an emotional state' conveys being in an agitated condition. In contrast, it is here to be understood in such a way that to the question 'What was her emotional state?' one can quite properly reply, 'Calm.' 'Emotional states', that is, should be taken to include, whether they are calm or violent, emotions, passions, moods, along with feelings in the sense in which that word is used in Mackenzie's *The Man of Feeling*. If it is thus broadly understood, we always are in an emotional state, or in emotional states. They partly determine how we see the world and how we see the world partly determines what they will be. Our question is about the relationship between serious works of art and such emotional states.

This relationship occurs at three points: artists are in emotional states as they create their works; their works may depict emotional states; they can arouse particular emotional states, whether or not of intent, in those who read or hear or look at them. Let us begin with the emotional states of the artist. Our concern is not purely phenomenological; we are only asking, in respect to each of the three relationships just set out, whether by considering them we can throw light on the peculiarities of serious art.

Some of the emotional states of the artist will be directed at, and

aroused by, the work being created. These may include exasperation, hope, confidence, despair, jubilation. Others have their source in the life the artist is living; they are directed at, and aroused by, wives, children, critics, lovers, publishers, friends, enemies, whatever is happening in the political and social and artistic life in which the artist participates. In the case of any work except those which are dashed off at a white-hot speed, both of these kinds of emotional relationship can vary greatly during the period in which the work is completed. There was plenty of opportunity for a Tolstoy who took four years to write *Anna Karenina* to be elated or depressed by the work he was composing, by what was happening to his personal relationships or in the social and political sphere. There are, of course, persistent moods. An artist may be depressed or elated over months at a time or sustain a particular hatred, a rancorous envy, a desire for revenge. Never, however, to such a degree as to exclude all other emotional states. In respect to most works the question: 'In what emotional state was the artist in the course of composing this work?' will not admit of any but a grossly over-simplified answer. Even in the case of a lyric which flows directly from a poet's love of a particular person, the effort of composition will arouse emotional states which are not included within the state of being in love.

Under Derridean influence and in reaction against the absurd doctrine, fervently defended by *Cahiers du Cinéma* new wave film critics, that it was impossible for a director who had made good films ever to make a bad one, that indeed an individual work could be serious only as a segment of a total output, it is sometimes now denied that we should ever say of any two works that they are by the same author, since the author will have changed between the time the first book was written and the time the second book was written. This, I suppose, is in the same spirit as Heraclitus: 'You cannot step twice into the same river.' But just as Cratylus responded to this with 'You cannot step even once into the same river', so one could respond to 'no two books can ever be written by the same author' with 'no single book can ever be written by the same author'. For the changes one undergoes in the course of writing a single book can be as great as, or greater than, the changes undergone between writing two books.

I do not in fact want to defend either of these two theses about authors. They rest on criteria of identity so rigorous that they would make it impossible to use proper names at all. I continue defiantly to assert that although both 'I' and 'New York' have changed greatly over time, I have made several trips to New York and that, equally, I am the author of several books of which this is one – as Derrida does implicitly by putting his name on the cover of a book and allowing references to his other works. My sole reason for raising this particular question is that if one did regard it as a criterion of identity for a work that it was written in a particular authorial emotional state, the conclusion would have to follow that no book has a single author.

Only very occasionally, to turn to a different point, do we have any more evidence about the artist's emotional state than what we can deduce from the work. And such deductions, we know from those cases where we do have independent evidence, can be quite erroneous. Works which we automatically described as being cheerful can turn out to have been the product of a deep depression. If the suicidal comedian is now a stock figure, he is not a mere figment of legend.

When we do have additional evidence about the emotional states of an artist, furthermore, this is generally, in the cases that interest us, only *after* the decision has been made that we are dealing with a serious artist; that is when biographers get to work, letters are sought out and published. Biographies are written for many purposes, but not to demonstrate that an artist is to be taken seriously – that is the province of criticism. Just occasionally, however, biographical evidence about their emotional states has been used, negatively, to cast doubt on the seriousness of artists. How does this happen?

Consider two such instances. When Samuel Johnson discovered that although Abraham Cowley wrote love lyrics he had been in love just once and had then been unable to tell his love, he took this to show that Cowley was a liar and hence not a serious poet. Johnson's assumption was that if a poet writes a love-lyric, with its almost inevitable reference to what 'I' am feeling, the 'I' can only be taken to mean the poet. So if Cowley was not in fact in love he is misrepresenting the feelings he is depicting.

That assumption was by no means revolutionary. It is echoed in Joyce's description of the lyric as a poem in which 'the artist presents his image in immediate relation to himself'. The trend of modern criticism, however, is against any such view. The 'I' of lyrics, it is argued, is as much a literary construct as are the personae of Browning's dramatic monologues. The fact that in the lyric the constructs are called 'I' and in the monologues they are given such names as 'Bishop Blougram' is totally irrelevant. It would be absurd to object to *Gerontion* on the ground that it begins 'Here am I, an old man, in a dry month' although in fact Eliot wrote it at the age of thirty-two, as absurd as it would be to object that the month in which it was written was an unusually wet one, if some biographer were to discover this to be so.

Remarks of this kind are often bound up with the view that a poem is a world of its own, with no contact with the world around it. They do not, however, entail it. We might criticise Cowley's poems as being insincere not because they do not represent his own feelings – indeed they might do that, as telling a love he has never been able to find an alternative way of expressing – but rather on the ground that the way in which they are written, the locutions they use, are characteristic of an insincere rather than a genuine love. He fails, that is, to depict the emotional state which the structure of the poem leads us to take it to be depicting; his work is 'inauthentic'. In making such a point we should be relying on our

extra-poetic experience of insincerity, which we ought to conjoin, to avoid injustice, with a historian's knowledge of those shifts in usage which can convert a locution from being a genuine expression of feeling into being a merely conventional utterance. (In North America 'have a nice day', 'take care' were once genuine wishes, genuine warnings.) The only thing that matters, it would so far seem, is whether a certain kind of emotional state is successfully depicted, in a way that confirms and builds up our initial impression of its nature – or revealingly dislocates it. And that only our experience of the world, in the broadest sense of 'the world', can tell us.

The second case is of a different order. In the Cowley example, we were concerned with his relation to women. But, as I earlier emphasised, a writer can be in emotional states which arise out of his relation to the work being created. When Trollope revealed his writing habits, his business-like attitude to his work, his apparent lack of creative agony, there were those who, however high their previous opinion of him had been, at once concluded that he could not be a serious writer. Those, like myself, for whom writing is a constant struggle, a matter of revisions and revisions, daily discontents, rare moments of satisfaction, find it very hard to believe that there are others who work with facility. The evidence is against us; there are those who do not agonise, and they include serious painters, writers, composers. The seriousness of Trollope's novels cannot be ruled out by these biographical revelations.

A very different example is provided by Wyck Brooks when he writes of Whittier thus: 'He had no pride of artistry. When editors revised his manuscripts, he accepted their changes without remark.' That does not apply, certainly, to all writers who work with facility. Bertrand Russell wrote with facility but by no means took kindly to editorial changes. Indeed it is reasonable to look with suspicion on anyone who accepts such editorial interventions with total indifference. What Veblen called 'the instinct of workmanship' is here involved, and for that reason Russell was a relevant example; such an instinct is not peculiar to artists. It carries with it a caring about what one is doing, a dissatisfaction with anything that one takes to be less good that one can make it, a determination to get it 'dead right'. Developed to an extreme it can degenerate into the perfectionism Zola critically depicted in *L'Oeuvre* – perhaps as a way of excusing his own too great readiness to be satisfied by the imperfect – where a painter's attempt to perfect his work issues in its destruction. Nevertheless, that 'instinct' is an important factor in the creation of serious art. It is not incompatible with taking into account editorial, or friendly, suggestions for change, as Eliot did in the case of Pound's criticisms; indeed, if artists are intent on making their work 'dead right' to do so is only sensible. Whittier's complete indifference to editorial changes does nevertheless suggest that his claim to be a serious, rather than a purely telic, poet has to be regarded with suspicion.

That serious art involves such a spirit of workmanship is no doubt

sometimes now denied. The old feeling of artists, essentially anti-populist, that they are too superior to be called workers has curiously combined with the populist doctrine that the possibility of being a serious artist must lie open to everyone, so that the 1990 Sydney Biennale, with Duchamp as one of its patron saints, had as its bannered motto 'ART IS EASY'. Philosophy, too, is easy if you do not take it to demand argument; science and history are easy if you do not take them to involve testing against evidence; literary theory is easy if you do not take it to require testing against examples; criminal justice is easy if, as I have just been solemnly informed, 'a woman can tell whether people are guilty just by looking at them'. But then also they have ceased to exist as distinctive forms of human activity, involving the use of imagination as distinct from fancy. So much is also true of art.

I took up two cases in which biographical evidence about the absence of emotional states is taken to suggest the absence of seriousness – I rejected the first of them, in so far as it rested on the assumption that the 'I' of a lyric poem, like the 'I' which begins this sentence, must refer to the author. We might grant that if Cowley knew about the expression of love only by reading love poems, there is a high chance that this work will be academic. But nothing more conclusive. In the second instance, if we have evidence that a writer is quite unconcerned with the structure or language of the emerging work, is not troubled by anything except a determination to finish as quickly as possible, at all costs to write so many words a day, and is quite indifferent to editorial changes, then this is certainly ground for suspicion that we are confronted by a pure entertainer – not that every such entertainer lacks the instinct of workmanship. We had to admit, all the same, that serious artists do not always agonise over their work.

If we ask more generally whether there are any emotional states which make serious work impossible we might, I suppose, point to a depression so deep that the artist cannot create or a mania so advanced that the artist has lost all power of self-criticism. As for states which make it possible to write a particular work, we might say: 'She must have been very angry when she wrote that' or 'he must have been very angry when he painted that' where the 'must' entails that the writing or the painting could not have been done by someone who was not in such a state. Such deductions, I have suggested, are very chancy and in any case do nothing, of themselves, to help us to determine whether the work is serious or purely telic.

So much for the view that in order to construct a serious work an artist must be in a particular emotional state. Everything we have so far said suggests that the crucial thing is the depiction, rather than the experience, of emotions. Yet we cannot lightly set aside the doctrine that what really matters are the emotional states the work arouses. We normally take it for granted that arousing such states is something

artists can do and are particularly good at doing, and it is certainly a plausible view that this is only possible if the artist is at least good at feigning the emotions thus aroused in us.

That was certainly Pope's view and he can scarcely be dismissed as an extravagant Romanticist, a voluptuary of the emotions. In one of his imitations of Horace – 'to Augustus' – he suggests that the power of arousing emotional states is precisely what distinguishes the serious poet from the mere versifier. (I have slightly modernised the spelling.)

> To know the Poet from the Man of rhymes:
> 'Tis he, who gives my breast a thousand pains,
> Can make me feel each passion that he feigns:
> Enrage, compose, with more than magic Art,
> With Pity, and with Terror, tear my heart.

Notice Pope's phrase; 'each passion that he feigns'. He is not saying, as Tolstoy and Dewey were to do, that a serious poem communicates to the reader a passion felt by the poet. It is the depicted passion which is communicated, *to* a reader who really feels it *by* a poet who only feigns it. Yet, to generalise beyond the poet, is it really necessary for a writer to feign a passion in order to arouse it in a reader? In the performing arts, to be sure, the actor, the dancer, is feigning emotions. When in *Tom Jones* Partridge, witnessing *Hamlet*, is terrified by the ghost, he explains that this is because the actor on the stage is so obviously afraid. This would illustrate Pope's thesis: the feigning actor produces real fear in Partridge. Shakespeare, however, is neither feigning nor feeling fear; he is depicting a particular fear, as the writer of love lyrics depicts a particular love. Shakespeare has to be capable of imagining what it is like to be afraid, but we have already rejected the view that this is equivalent to pretending that he is afraid.

To 'enrage' us, then, a writer does not have to pretend to be angry; to 'compose' us – to make us, that is, calm and tranquil – a writer does not need to pretend to be in that state, any more than actually to be in it. Indeed, even an actor's feigned anger may compose us – it was the reaction we were waiting for – and feigned calm may anger us. There is no fixed relation between the depicted emotion and the emotion felt as we read.

In the *Tom Jones* example, the emotion depicted by Shakespeare, feigned by the actor, felt by Partridge is in each case fear. Outside the performing arts, the feigning actor is absent; between author and reader there lies only the text. Interpreting the text, the reader can sometimes experience, by sympathetic induction, the feelings which are depicted in the text as being experienced by the personae, can share the fear experienced, let us say, by a persona in one of Poe's short stories, just as Partridge shares the actor's fear. Such an identification with the feelings

of a persona is, however, far from being the standard way in which a work arouses emotional states in us. In the classical tradition, Pope speaks of poets as arousing pity and terror in their readers. These emotional states are not normally depicted in the work which gives rise to them. Rather, they arise out of reflection on the course of events depicted.

Take the case of dramatic irony. We may see on a stage two young lovers plighting their troth and looking forward to a happy future. We may know what they do not know: that they are shortly to be forcibly separated. We feel pity for them, a pity that may nowhere be depicted in the drama. So, too, we can feel terrified when no one in the work is terrified. The personae may go ruthlessly ahead, in the manner of *Dr. Strangelove*; it is we, the spectators, who are terrified. In *Volpone*, although greed is extensively exhibited, it does not incite greed in us, quite the contrary. Our emotional reaction, to sum up, may be at odds with rather than sympathetic to the states of mind of the personae. And even when it is sympathetic, this may be in the sense in which we feel for people rather than with them. We can sympathise with the love of the young lovers but not with their anticipation of their fate. They have no such anticipation.

Rejecting, then, the view that in order to arouse emotional states in us the author must either feel or feign or depict those particular states, can we still say that, however it is done, not only the poet but the artist in general has a peculiar power of arousing emotional states in us and that the serious artist displays this power to an exceptional degree? That would still leave us with what is essential in Pope's view.

Even within what are clearly representational arts the capacity for arousing emotional states varies a great deal from art to art. It is strongest in the cinema and fades away in the case of painting. One can often see people weeping in a cinema but never standing before a painting weeping although, admittedly, I have known them to be so horrified by a painting – of, let us say, the flaying of Marsyas – as to feel ill. 'I started off life,' the director Peter Greenaway tells us in a *Cinema Papers* interview, 'as a painter and I have always been very aware that when you stand in front of a painting you do not emote. You don't fall around on the floor in laughter, crying your eyes out or jumping up and down in anger.'

True enough, sophisticated audiences do not behave quite in this way in cinemas, either. But Tornatore's *Cinema Paradiso* depicts a Sicilian audience as reacting to silent films with such exuberance, as we all did as children in Australia. And there are people, even now, who wept at that particular film and who were also free with their laughter, to a degree not to be witnessed in an art gallery. Greenaway also tells us that in his film *The Cook, the Thief, his Wife and her Lover* he set out to arouse purely contemplative experiences, of a gallery-like kind. In fact, although he devoted great attention to pictorial composition, his film provoked intense

emotional responses arising as antipathetic reactions to the emotional states and the course of events he depicted. The medium, one might say, was hostile to the effect he wanted to produce, just as the nature of the theatre defeats alienation devices. (Brecht had to live, however indignantly, with the fact that audiences were deeply moved by the 'heroine' of *Mother Courage*.)

One thing is reasonably plain: we cannot deduce from the fact that Greenaway's film, in Pope's words, 'gives my breast a thousand pains' that it is a serious work of art. Both pure entertainment and purely telic works can have such an effect. Even in peacetime, but notably in time of war, attempts are made, and often successfully, to fill us with horror at the mere thought of some nation or group coming to power or remaining in power. In commercial advertising, we have the least controversial example of an artist 'who can make me feel each passion that he feigns'. As for entertainment art, few works, if any, have ever aroused such excitement in me as did the cowboy films of my childhood, such laughter as Buster Keaton and Harold Lloyd, such fear as Lon Chaney in *The Phantom of the Opera* or episodes in Ingram's *The Four Horsemen of the Apocalypse*. Some of these works we might perhaps judge to be serious films as well as being entertaining, but others, for all their emotional impact, were certainly not.

Of course, emotional responses are extremely various. People in a cinema audience often laugh at violence which horrifies others. Ever since *Lucky Jim*, some of us have been extremely depressed by novels which reviewers have described as 'very, very, funny'. Taking these facts together we might well conclude that it is quite impossible to draw any conclusions about the seriousness of a work by examining the emotional responses of those who are exposed to it. The important thing, it would again seem, is whether the artist succeeds in depicting emotions, as distinct from simply reproducing clichés. The clichés may well be successful in arousing emotional states, more often so, perhaps, than depictions which penetrate more deeply and stimulate reflection, re-consideration, rather than immediate response. That does not recommend them to the serious artist.

Yet there are critical descriptions of works of art, intent on pointing to their seriousness, which make use of words and phrases we naturally take to refer to effects on our emotional states – let us say, 'powerful'. No doubt that adjective is also used of works which are merely violent, but such contamination can occur in the case of almost any discriminating adjective. In literature, it is regularly used of such works as *King Lear, Wuthering Heights, Who's Afraid of Virginia Woolf?, Antigone, A Long Day's Journey into Night*. It is often applied in music, to composers as different as Bach and Mahler, quite commonly to films, occasionally to paintings, sculptures, buildings, ballets, performances. It suggests that the work in question 'grabs' us, stirs us, dominates us, not necessarily

provoking any particular emotion but rather a 'welter of emotions'. At the same time, however, it can be a way of pointing to disputable features of the works in question, permitting a denial of its powerfulness which is not a denial that it does have, in some people, such emotional effects.

To reflect further on this fact, we must remember that emotional states can be aroused by works of art that do not themselves depict emotional states. And even when they do depict such states, the states they give rise to may not be created in the manner I have so far described, as reactions to depicted emotional states. Rather, they may be generated by the formal structure of the work considered as a whole. So a film distributor, or so it is said, was so angered by Peter Weir's *Picnic at Hanging Rock* that he hurled an object at the screen, this because it raised problems to which it did not offer any solution. One can easily imagine a similar reaction to Resnais's *Last Year in Marienbad*.

There is nothing at all out of the way, purely aesthetic, about such emotional states. The spectator simply feels frustrated, angry. But the frustration, the anger, is aroused by what is taken to be a defect in the film, finding verbal expression, perhaps, as 'it's worthless, arty, rubbish'. And this might be in spite of the fact that, or even in some measure because, the spectator has sympathised with the feelings depicted in the film, of the quest for freedom, let us say, of the young girls in *Picnic*.

Anger of this kind is by no means confined to cinema audiences. It may be aroused by a building which, so a spectator thinks, ruins a streetscape, by a piece of music heard as 'getting nowhere', by a sculpture seen as 'rusty junk'. Indeed, the capacity of works of art for arousing anger, whether among people who think of themselves as being, or people who do not think of themselves as being, particularly interested in the arts, is one of the most cheering things about them. Unfortunately, it by no means guarantees the seriousness of the work in question.

Such anger, indeed, many would describe as being 'purely subjective'. If this simply means that it is somebody's anger, that does no harm. But if what is meant is that it must by the nature of the case be a mere gut-reaction, so that it would be quite unprofitable to seek out its justification as distinct from inquiring into its cause, this need not be the case. The projectile-hurling distributor would offer such defences as 'it gets you nowhere' or 'it leads you up the garden path'. These, however informally expressed, are formal criticisms, presupposing arguable theses. One might in principle – I do not know that I should actually care to take the job on – try to explain to the distributor that there are various ways of ending, depending on what one takes the principal theme to be, that the present ending, however unsuitable it would be were the film thought of as being a detective story, is quite appropriate in a film about freedom and its risks, a theme to which Weir returns in *Dead Poet's Society*. Or one might, with the distributor, deplore the element of mystification but still argue that the violence of his reaction was

unjustified, since the film should really be thought of in pictorial terms, that Weir is rejecting 'the primacy of the narrative'. Under these circumstances to call the angry reaction 'purely subjective' is either tautological: 'that view is somebody's view'; or false: 'there can be no arguing about that view'; or uninterestingly true: 'there is no way of strictly demonstrating the truth or falsity of that view' – uninterestingly, because the distributor had never supposed himself to be making a contribution to logic or mathematics.

To revert in this spirit to my earlier example, when critics describe a work as being 'powerful' this can be a way of drawing attention to features of the work, a way of recommending it to our attention, not simply a description of the critic's emotional state, his feeling of being overwhelmed by it. Argument can begin at this point. So supposing the work in question to be Mahler's *Symphony No. 8*, then it is at least possible, if not very plausible, to make such replies as: 'You are mistaken. The size of the resources Mahler employs is so large that it is easy to persuade yourself that his symphony is musically powerful; in fact it is bluster and rodomontade, full of sound and fury but in musical terms signifying nothing.' And from that point on, the argument can proceed at a somewhat closer level of musical analysis. So the anti-Mahler critic might draw attention to passages which, the critic says, contribute nothing to the musical development of the symphony, as distinct from making an assault on the senses. A powerful, as distinct from a noisy work, will, he might say, admit no such passages. Concentration is of its essence.

Similarly, if what is in question is the powerfulness of such dramatists as O'Neill, a hostile critic might allege that O'Neill uses melodramatic tricks, that his larger than life characters are purely theatrical creations, one-dimensional, never analysed, whereas the power of a genuinely powerful play lies in its revelations, not of guilty secrets but of character. Here the powerful is contrasted with the melodramatic. So in painting it might be contrasted with the merely lurid, in architecture with the merely large, in ballet with mere displays of physical strength, with *Spartacus* perhaps the controverted work. A critic might ask of a satire whether it is really powerful or only seems so to a complacent bourgeois audience, congratulating itself on its capacity to 'take criticism', or whether Updike's novels offer us a 'powerful' analysis of contemporary American life or are merely an entertaining superficial record.

The point of these remarks is that what might at first sight appear to be statements about individual feeling-responses can be ways of drawing attention to features of the work being referred to, features relevant to its seriousness. We are then treating the emotional response as being, at least in some instances, a rational one, capable of being supported, controverted, discussed. One should not, however, ignore the contrary doctrine that it is impossible thus to respond rationally to a fictional

work, at any rate, from which the further conclusion is sometimes drawn that one cannot even respond to it emotionally, that what are commonly described as emotional reactions are only simulacra of emotions.

That view has been espoused by a number of philosophers, who have found that their general theory of the emotions does not allow for there ever being emotional responses to fictions. It is at least suggested in Hume's *A Treatise of Human Nature*, even if it is not easy to reconcile what Hume says in that work with what he writes in his *Enquiry Concerning the Principles of Morals*, where he takes the great importance of poets to lie in their capacity to provoke the passions, even if 'from a mechanism of nature not easily explained'. His earlier view, reiterated and developed in the Appendix to the *Treatise*, was that the passions aroused by poetry, as compared with those aroused by history, are 'different to the *feeling*'. 'There is,' he there sums up by saying, 'something weak and imperfect amidst all that seeming vehemence of thought and sentiment, which attends the fictions of poetry.'

His reason for arguing thus is that on his general view passions derive their liveliness from their association with 'impressions' which we may roughly translate as 'direct experiences', and in the case of poetry, as compared with history, these are only fictional, without the liveliness of the actual. He says nothing about architecture or music, where what moves us is, on the face of it, not fictional. But music would have meant for him song, and both painting and ballet, of course, representations. Only architecture would have represented itself as wholly actual – a form of art he might rather have thought of as a craft. So for the Hume of the *Treatise*, one can generalise by saying, the arts cannot arouse in us genuine emotions.

In Hume's philosophy of mind, the passions are central in the sense that 'reason is, and only ought to be, the slave of the passions'. Some post-war philosophers have taken the exactly contrary view; they have set out, not for the first time, to intellectualise the emotions, to treat them as the slave of reason. Emotions, they have argued, must always have a specific actual object, their relationship to which explains the effect they have on our conduct. So fear is always fear of something, which we then take precautions against, or run away from, in a perfectly rational manner, and love must equally be love for someone or something. To be sure, it may not, for practical reasons, be sensible to love a particular person, but our subsequent actions are rational in relation to our having that particular love. Works of art, it is agreed, can affect our mood, can disturb us or cheer us up, but we cannot, so it is said, be aroused to emotions by them because they are not putting actual objects before us.

We have already seen what difficulties there are in determining what is to count as 'actual' in the case of works of art. But consider again the distributor who threw an object at the screen because *Picnic at Hanging Rock* comes to its end without resolving the question what had happened

to the girls who disappeared in the course of their picnic. I described him as angry, frustrated. Surely that is right, even if his response is foolish – in so far as he is venting his feelings rather than doing something about what angers him – whereas refusing to distribute the film might be a rational reaction. The 'movie' he has seen is an actual object, even if the events it depicts are fictional, and one could scarcely demand better evidence than his conduct that he was angry, as were those many other people who have defaced paintings or, as with the iconoclasts, destroyed statues.

It seems, indeed, impossible to deny generally that we can be angry with, bored with, love or hate, works of art. Such emotions have – with the reservations I previously discussed – actual objects and can be invoked to explain why, let us say, we want, or do not want, to revisit a particular gallery, to re-hear a particular piece of music and so on. So they are not ruled out by the intellectualising theory of the emotions. I see no plausibility in the view that our love for a painting differs in character from, is bound to be nothing better than a simulacrum of, our love for a natural scene; it may, indeed, influence our emotional states in a greater variety of ways.

If there is a problem, it arises in that class of examples from which the present discussion began in which, I said, we respond sympathetically to the fictive emotional states of fictional characters, whether grieving or becoming angry when they grieve, being attracted by them or repelled by them. Such reactions, I suggested, are particularly common in audiences for the performing arts. If it is in such instances simply a matter of falling in love with or being angry with a performer, no problem arises. Admittedly, the distinction between the performer and the fictive persona the performer is feigning to be is often not made by unsophisticated audiences. Yet if a person will go to see a particular performer whatever the role, seeks out portraits and so on then we can reasonably assume that it is the performer who is the object of attraction, not the persona the actor is playing.

Taking the example of the novel in order to side-step this particular problem, can one properly be said to love or hate a fictional character? Were those who wept at the death of Little Nell really sad? Can one be afraid of Quilp? Or is it just that we experience feelings which have a pale resemblance to these emotions, as David Hume seems to be suggesting?

I do not see any plausible way of denying that people can in fact experience emotional states which are provoked by what they are reading, and that authors quite often anticipate that response. When people weep, as they certainly do at films, this is because, in any of a number of possible ways, what is happening to the personae in the film saddens them, and that is not, usually, because they believe that they are watching actual, as distinct from fictive, events. After all, as we previously argued, they are watching not only a particular scene but a

certain kind of scene, which they may recognise as being one in which they could themselves participate. Indeed, it is the *reductio ad absurdum* of any theory of the emotions that it would lead us to conclude that no one could weep over Little Nell or be frightened by Quilp.

We might wish that these reactions did not occur, might wish that Dickens's readers could see that Little Nell is being sentimentally depicted and Quilp melodramatically. We might even wish, whether on Augustine's grounds or because we are puritanical formalists, that people never did react to works of art in these emotional ways, but that they do so one can scarcely doubt. It is just because Augustine wept over Dido's fate in the *Aeneid* that he raises the question whether this was a morally proper thing to do. The most that we could say is, in Augustine's manner, that these are emotional states which involve grief but not the offering of relief, indignation but not action. Even this, however, need not be always true. Such novels as *Uncle Tom's Cabin* and *Max Havelaar* were not entirely without effect, to say nothing of Dickens's works. And on the other side, outside the arts, one often encounters emotions which are not expressed in actions. People can be as horrified by news, or by casual encounters with misery, as by works of art and to as little practical effect. But if for such reasons to abandon the view that works of art can arouse emotions is quite uncalled for, what I have not so far considered is whether there are some emotional states which are, uniquely, brought into being by serious works of art, as distinct from merely telic or entertainment art.

If we are looking for works of art which set out to arouse active emotions, i.e. emotions which will lead to action, then we shall have to turn to telic art. Purely amusement art, in contrast, sets out directly to arouse emotions, whether horror, cheerfulness, excitement or self-satisfaction. It fails if the emotional state it sets out to arouse is not in fact aroused – if, that is, no one shudders at the horror film, no one laughs at the farce, no one is excited by the pop video, no one is sexually aroused by the pornography. Telic art no doubt also seeks to arouse emotions, but only as a path to action. It is not enough that someone laughs at the advertisement if they still feel no inclination to buy what is being advertised, not enough that they weep at stories, or paintings, about aborigines in Australia, Red Indians in North or South America, Laplanders in Scandinavia, the Ainu in Japan unless they are moved to political action. In contrast, Fitzgerald does not necessarily fail in *The Great Gatsby* if we do not at once determine to destroy the kind of society it depicts; understanding it better, if we do, would suffice to make his study of emotional states, actual and pseudo, successful.

It is again necessary to emphasise, of course, that over history the great majority of works of art were paid for by the powerful and were intended to increase the power, whether secular or religious, of their patrons – or at the very least to advertise that power. So a work can be both serious

and telic, not, since it is serious, losing its power when its patrons lose *their* power, as a purely telic work does. That is far from demonstrating, however, that it retains its seriousness in virtue of giving rise to peculiar emotional states which are not accessible by way of purely telic or purely amusement art. That is a very difficult question to settle. Such emotions, if they exist, are likely to be elusive, and we may well not have a name for them; the emotional states which have names are likely to be those which are more prevalent and of greater practical significance. One would have to speak, too, of the emotions produced by *successful* serious work; where it is clearly designed to be a serious work of art but is a failure, the central emotional state is disappointment, which can equally arise if an entertainment is a failure.

It is very hard to describe the feelings that come over one on entering a great work of architecture or even seeing such a work from a distance, at least in such cases as Chartres Cathedral. Perhaps a 'feeling of awe' comes nearest to it, something one may also experience in the presence of natural scenes, but not in the course of merely being entertained, however successfully. (There is a link between what I am saying here and classical doctrines of 'the sublime'.) Should we perhaps think of this, however, as a sign of telic success, since such buildings are often monuments to power, to riches, or to religion? Even if we do not share the religious beliefs which inspired the creation of Notre Dame or the political beliefs which led to the building of the Palace of Versailles, our feeling of awe, it might be said, is still a momentary obeisance to religion and power, essentially atavistic, of no consequence to our present inquiry except as leading us up a blind alley. I should be hard to persuade, however, that in Istanbul or Granada I am temporarily converted to the Muslim faith, in the Canadian Rockies to pantheism, in Kamakura to Buddhism. One can, I am rather persuaded, experience a feeling of awe in the presence of some serious works of art which is not reducible to a purely telic effect but may partly explain why art has often been regarded as a kind of religion, particularly by Romantics.

Not all serious works of art, however, provoke this feeling. *Moby Dick* might but *Pride and Prejudice* does not; a Beethoven symphony might but a Vivaldi concerto does not; a Michelangelo statue might but a Donatello statue does not. To arouse it a work has to have a super-human scale. And awe can be experienced in encounters with scientific, philosophical, historical writings as well as with serious art, whenever we are confronted by work which has a magnitude, a sweep, which is, as we say, 'breath-taking', but does not lose the control without which it would be merely grandiose, like Nikko in Japan or a variety of buildings and memorials in Washington D.C. or the intellectual wastelands of many large-scale attempts to develop grand theories.

Is there any way of distinguishing between the feeling of awe which the trained scientist, artist or philosopher experiences in the face of major

works from the awe felt by the inexperienced in the presence of the merely grandiose? We can certainly say that it has different sources, one arising from the serious, the other from the mock-serious, the grandiose, But that does not 'assist us in our inquiries', as we pursue our detective-like search for the distinguishing marks of the serious.

The grandiose, we might however add, discourages criticism. What it calls for, and this alone, is worship. In our relation to a serious work of art, in contrast, we are not, as I earlier argued, called upon to worship, however awe-struck we might be, but to look, to read, to listen, in a fashion which is careful, discriminating, question-raising, the 'we' in question being experienced enough to be able to respond in such ways. Are we to conclude that the awe which the general public might feel at the very name of Newton or Einstein – 'sublime geniuses' – is very different from the awe felt by a mathematician, the awe felt by most of us in the presence of a great cathedral or a great bridge very different from the awe felt by an engineer or an architect? The awe is in the latter cases, certainly, an element in a complex of feelings and attitudes. Is the awe itself different? I have no idea how to answer this question or whether I have already answered it, so far as it can be answered, in what I have just written. It is sufficiently plain, however, that while some serious works of art arouse feelings of awe in us this is true only of a limited class of such works and is not unique to them.

The exploration of other emotional states would, I think, produce similar results. An exception might seem to be 'aesthetic emotions'. Since these are defined as emotions always evoked, and only evoked, by serious works of art, there can be no question whether they are being confused with emotions which derive from the fact that most serious work was originally designed as telic art. Neither can one raise the question whether they arise only from a sub-section of serious works, for their arousal is taken to be, by definition, characteristic of all such works. There is circularity here, however, if we then go on to define serious works of art as those works which produce such emotions, just as there would be if we were to define fear as the emotion produced by threats and then defined 'threats' as those features of our environment which frighten us. To make the arousal of 'aesthetic emotions' a useful method of distinguishing serious art, we need to be able to offer an independent characterisation of them and I do not know of any such characterisation which is at all satisfactory.

The most we can say, as I have already substantially suggested, is that in the case of serious art, the emotional reaction can be to the formal properties of the work and not just to the subject. In the representational arts, this can be hard to demonstrate. How are we to show that our reaction to the beauty of Botticelli's *Birth of Venus* is different from the reaction we might have to a beautiful woman? The existence of non-representational painting and ballet makes that demonstration

easier, because there may be nothing there to react to except forms, colours, movements. Such art, as formal decoration on vases, as architectural decoration in Muslim mosques, as dances which do not tell a story, is as familiar in older art as for a time it was in modern European art. It is at least a plausible view that there is nothing else but form to react to in the case of architecture and music. Well before the emergence of twentieth-century abstract art, too, critics were analytically distinguishing between the effects of a work's composition and the effects of its subject. If by aesthetic emotions is meant nothing more than the reactions that can be evoked by formal patterns of shapes and colours, one can scarcely deny that there are such emotional states.

Yet, first, they can also be aroused by patterns in nature, including under that head the human body. Secondly, much contemporary amusement art entirely depends on the spectator's emotional reactions to forms and colours and sounds. These are, the reply might come, quite different in their arrangement from the forms we find in serious art. To say this, however, is to distinguish serious art not by its power of arousing special emotions through the use of shapes, sounds and colours but by the way in which these last are arranged in serious art. So we are driven back upon formal structures, not emotional effects, as the distinguishing factor of serious works. Unless, that is, we can show that the emotional reactions to the shapes and colours in a serious non-representational painting are qualitatively different from the emotions experienced at a pop-concert light show. That, once more, I do not know how to do. Let us leave emotional effects at that unsatisfactory point and look at the many emotional states that can be displayed in, as distinct from caused by, works themselves.

I have several times talked about depicting emotions and have strongly suggested that this, rather than the artist's emotional states or the emotional states to which the work gives rise, is the crucial point of contact between serious art and emotional states. The word 'depicts' suggests pictorial arts, so we shall begin there. How can a painting depict emotional states? Well, it is in the first place obvious that facial expressions and body behaviour serve as the principal signs of how a person is feeling. Of course, they can be feigned, as they are by actors, by confidence men, by wide classes of people, whether politicians or seducers or even teachers, who may find it profitable to pretend to feelings they do not really have. Such feigners, such pretenders can, however, only be successful because, in most cases, the behaviour they feign is a reliable sign of how people feel, a sign on which the painter, at least within the culture for which the painting is being executed, can therefore rely.

Whether the painter will *want* to do so is quite another matter. There is a great deal of painting, as there is a great deal of sculpture, which eschews the depiction of emotion. The painter's or the sculptor's interest, perhaps, is in creating quasi-geometrical patterns, or in that variety of

religion which insists that the gods – who may or may not also be secular rulers – are beyond emotion. Or artists may want to perfect what they find in nature and think of themselves as doing that by taking away from their figures, whether human or divine, any trace of the disturbance emotion brings with it. Their object is to represent perfect equanimity, the Stoic ideal, or perfect justice. That the emotions are what make us animals is a recurrent theme in human thought; it was easier to 'take' the emotional rallies of the Nazis, as conforming to this stereotype, than the technical efficiency of their cremation camps.

Even poets may weary of what they see as excessive emotionalism, to the degree of seeking refuge in unemotional Byzantine-style art. A poem by Thom Gunn makes that plain. He has been reading – and in this case the poet makes it reasonably clear that the poem's persona can be identified with the poet himself – the 'confessional' poems of 'his juniors', on the model of Sylvia Plath. He finds them, as he ironically puts it, 'very poetic poetry'. He makes his way to the Art Museum looking for something, without being sure what it is. He finds it in an early Italian altar-piece in which 'Solidly there, mother and child / stare outward, two pairs of matching eyes / void of expression.'

The attempt to depict emotions through body language can, indeed, easily lead to a decline in formal powers. There is a side-by-side illustration of this in a church in Crete, at Kritsá. The three naves that make up the church were built and wall-painted a century apart. The first of them was painted in a pure, severe, Byzantine style. It is obviously intended to produce emotional effects on the audience – awe, even fear – but the religious figures are aptly described in Gunn's poem; they are indeed 'void of expression'. The second nave is insecurely venturing into the depiction of emotional states. In the third nave, the insecurity has vanished; the religious figures plainly display feelings. What has happened is far from being a total loss. Nevertheless, there is loss; the vivacity of the most recent painting does not have the formal grandeur of the earlier work, as later Greek statuary loses something which was present in the archaic period.

Another example is in the twelfth-century mosaics at Monreale near Palermo. Here both physical and emotional realism are creeping in; after the laborious work of creating the Universe, God is depicted as being physically exhausted. The techniques come from Ravenna but now we are beginning to enter the humanised world of the Renaissance. One begins to see why the Sienese clung for so long to a Byzantine style and why in the history of both painting and sculpture there have been such remarkable swings between an art which depicts emotions and an art which does not – so from archaic Greek sculpture to Hellenistic sculpture, from Bernini to neo-classical sculpture, from Rodin to Calder. Consider, too, the revival of interest in Bernini and in baroque art generally at the very height of formalistic modernism.

This is not just a wholly irrational whirligig of taste; the fact is, as I said, that something is lost, something gained, when a sculptor tries to depict emotional states directly, by the use of facial expressions or bodily gestures. And the same is true of painting, as we readily see by comparing Byzantine, Gothic, Renaissance, Northern European and Mexican depictions of the same religious theme, say the Crucifixion or Jesus on Mary's lap. What is diminished in the more emotional versions is formal beauty, what is gained is the direct revelation of human feelings. That would trouble us if we were determined to lay down sufficient and necessary conditions for being a serious work of art, but we have come to abandon that as a hopeless task. It is enough for us if we can distinguish the depiction of emotions in serious art from its depiction in purely telic art with, in religious examples, their heavenward eye-rolling, their sentimentalised faces, in political examples their empty gestures, their firmly set jaws on vacantly handsome faces. Such works lose both the formal and the relevatory power of serious painting. But that one of these is missing is not a fatal flaw; it may be an inevitable cost.

There are ways, one should add, of revealing mental states pictorially without actually depicting them. A rather special example is Oriental art where the calligraphy can be beautiful and emotional states are conveyed by the associations of the ideographs used. To those who are ignorant of the language, of course, only the formal beauty is accessible. In European art, modifications in the way in which the subject is depicted can be used to convey emotions towards it. In such paintings as Munch's *Anxiety*, not merely do we see a variety of anxious faces but the distortion of the landscape in swirling lines, the strange colourings, help to convey their anxiety. We see the landscape as it might look to them. Van Gogh is another familiar case; colours and forms are chosen and distorted so as to reveal feelings.

Such distortions naturally came as a great shock to those who took accurate drawing to be the sine qua non of painting, the more particularly so as Van Gogh painted flowers, buildings, portraits, interiors, landscapes – the traditional subjects of those who set out to imitate nature. (Indeed, he is very much a Dutch painter, if in Provence.) And it certainly could not be said that he deviated from imitation in order to perfect or even, in the impressionist manner, to reproduce appearances more precisely. That he 'couldn't draw' was, given the expectations of the time, far from being a wholly monstrous judgment, absurd though it may now seem to us. Even so, it is van Gogh's flower-paintings which are sought out by wealthy corporation owners to decorate executive suites rather than those more disturbing paintings in which distortion reveals a state of mind, shows how the world, how people, how oneself, can look.

In films, and to a slightly lesser degree in novels, there are very many different ways of indicating emotional states – by showing us how people act over time, in a variety of situations. What kind of people and

surroundings they seek out and avoid, what they own (pictures and posters on the wall can convey a great deal about those personae who have selected them), how they exercise, make love, use language, eat, or walk through a street – these are a few of the endless ways of getting us to see how a persona is emotionally related to the surrounding world, stimulated or made anxious by it. And I do not think one needs to argue at length that its capacity for bringing home to us the revelatory force of such forms of action is an important factor in any decision to regard a film or a novel as a serious work of art, rather than as a pure entertainment or a work which, to be sure, asks to be taken seriously but is quite hollow. If it is not conventional by everyday standards, it is at least conventional in its particular way of being 'daring' or 'different', in its use of the clichés which are at a given time regarded as being 'deeply meaningful', although in fact, like this phrase itself, they are only suitable for inclusion in a contemporary version of Swift's *Polite and Ingenious Conversation*.

Music is a much more controversial case. It is easy enough to understand why we are disturbed by Camus's *The Outsider* or sentimentally moved by the fate of the characters in *Elvira Madigan*. But why does Mozart's music seem so suitable to the director as an accompaniment to that film or Verdi to the film of *Little Dorrit*? How can, as Shakespeare wondered, the soul be drawn out of us by 'a piece of catgut'? Another set of problems arises in relation to Indian music, where different musical intervals are emphasised in order, so it is said, to convey particular moods. 'For compassion the minor seventh and minor third; in disgust and fear the sixth; in peace the fourth.'

In his introduction to Robert Craft's *Stravinsky*, David Drew describes the doctrine that emotional states can be thus depicted in Indian modes as 'an obvious fiction', adding that 'our own impoverished modal theory – the 'tragic' minor and the 'bright' major – is not only a fiction, but also something that is contradicted by the fact of innumerable masterpieces (and folksongs) of all periods'. The logic here may be somewhat puzzling, but the general thrust of Craft's argument is plain enough. Does it admit of any reply? Taking the Indian example we might suggest that the 'fiction' is simply a useful convention. Given that Indian music is so often used to accompany danced narratives, the music, thanks to these conventions, can be used to supplement facial and bodily gestures, helping to indicate the mood of what is being danced. But why these particular intervals for these particular moods? Similarly, if the exceptions are so many and so obvious to the doctrine that minor keys are tragic and major keys are bright, how does this doctrine get established? We had better explore these questions a little further, however inadequately, before we conclude that music cannot depict emotional states.

First, however, let us return to an earlier problem by considering the power of music to rouse emotional states. There is less controversy than

in the case of fiction about its having that power, nothing corresponding to 'What's Hecuba to him or he to Hecuba / That he should weep for her?' There is quite as much controversy, however, about precisely how music affects us and whether serious music arouses emotions which are peculiar to it, at least in the field of music.

Sometimes an explanation of music's emotional effects is offered to us in physiological terms. Consider the case of Kant. Kant's observations about music take him very far from Addison's description of music in his *Song for Saint Cecilia's Day* as 'the greatest good that mortals know / And all of heaven we have below'. He sets it high among the arts, but only in virtue of its charm and agreeableness. Considered as a contribution to culture, music, as merely play with sensations, comes bottom. Kant considers it as a member of a trinity, of which the first is games of chance, the third is wit. In each of these cases, we are concerned with a form of activity which, according to Kant, 'stimulates the vital functions of the body', stirring 'the intestines and the diaphragm' in a manner which gratifies us, the beauty of a harmony being only what, in this instance, is the vehicle of our gratification, as jests are in the case of wit and the game in the first case.

Writing about rock in the *Independent Weekly*, Michael Duffy shifts his physiology somewhat higher, from bowels to heart. Rock, he says, 'is a sort of aural mirror which plays our heartbeats back to us, usually at a faster rate'. This, he thinks, is one reason why it is so attractive to the young; it gives them a sense of wellbeing. A sense of ill-being can also be aroused by music. I have known people take ill at performances of Orff and Xenakis – and this not as a form of criticism but as a purely physiological reaction.

Although Duffy had long associations with it, he ends up, however, by denying that rock is music, on the ground that the only things of any importance in it are the beat and the vocals. And in the other instances we might argue that the physiological effects are simply a product of such facts as that musical tones are sounds and music contains rhythms. Both sounds and rhythms, unlike melody, harmony, counterpoint and the like, are natural phenomena to which we can respond as such, reacting to their physical properties, as we might react to the 'song' of a 'fever bird' or to the howling of a wind or, in this case favourably, to the surging of the sea or the rustling of leaves. ('The English,' Sir Thomas Beecham once remarked, 'might not like music but they absolutely love the noise it makes.') Yet on the other side, although much twentieth-century music seems to be designed to inhibit such reactions, it would be absurdly puritanical to suggest that their presence is a sign that we are *not* listening to serious music. Dance tunes, as Stravinsky grumbled in the case of Beethoven, are to be found in what is clearly serious music as are other marked rhythms, as in Brahms's *Variations on a Theme by Haydn*, of a sort that encourage a physical reaction. If, indeed, fast music elevates

and slow music lowers the blood pressure, that will be true whatever kind of music it is. If there is a physiological reaction provoked, uniquely, by serious music, it has still to be discovered. The presence of such reactions does not serve as an indication that we are, or are not, listening to serious music, any more than the fact that it sets our feet tapping or our heads nodding in time.

At other times, our attention is drawn to the purely emotional effects of music, without any reference to physiology. Writers, especially, are liable to describe music in that way. Sometimes it is praised in telic terms without any reference to physiology. So Martin Luther tells us that 'music is a discipline, and a mistress of order and good manners', and that 'she makes people milder and gentler, more moral and more reasonable'. Music does this by acting as a tranquilliser, a 'downer', by being 'the only art that can calm the agitations of the soul'. Shakespeare abounds in similar passages. In *The Tempest* there is Ferdinand's 'The music crept by me on the waters, / Allaying both their fury and my fear.' One is not surprised to find Eduard Hanslick sardonically remarking in his *The Beautiful in Music* that 'the soothing effect of music on the human passions is always affirmed with such emphasis that we are often in doubt whether music is a police regulation, an educational rule, or a medical prescription'.

Hanslick goes on to observe that there is no good reason for singling out music as a source of emotional refreshment, whether, in my earlier terminology, as an 'upper' or – as is sometimes, but surely in error, presumed to be universally the case – as a 'downer', since all the arts can have such effects. A more crucial difficulty for our purposes, and this is a special case of what is generally true in the arts, is that the power to raise such emotional effects is by no means peculiar to serious music. Noël Coward, no innocent in this field, drew our attention to the emotional potency of 'cheap music'. True enough, such music is often the accompaniment to words and it is impossible completely to separate the effect of the words from the effect of the music. Even when it is played without a singer the music can recall the song. All the same, that people can be both soothed and excited by music which no one would claim to be serious scarcely admits of denial. 'Bedtime music' and 'martial music' will serve as examples.

Perhaps, however, we can find other emotional effects, as distinct from the power to soothe or to arouse, which are peculiar to serious music. There are two, very different, approaches from which such a conclusion might emerge. The first insists on the intellectual structure of music, which is then taken to arouse in us emotions of a contemplative kind which purely entertainment or purely telic music is powerless to evoke. The second, to which we have already briefly referred, is that music can not only arouse but can depict emotions, in the case of serious music with exceptional subtlety. The first view relates music to architecture, the second to poetry.

The view that the emotional satisfaction derived, uniquely, from serious

music is of a primarily intellectual kind is sometimes resented, because it is taken to imply that only those who are trained in the recondite language of musical analysis and can analyse musical compositions by calling upon this language can fully appreciate serious music, that otherwise they will only get the sort of emotional satisfaction from it which they might alternatively get from entertainment music. Now this could in principle be true and we might have to live with that fact, just as we do with the fact that although we can all in some measure use mathematics, the intellectual pleasures of mathematical discovery are closed to most of us. But the relative accessibility of music, serious or not, however little the technical description of music is accessible, makes one hesitate to draw upon that analogy.

After all, what technical analyses describe are features of music which we can contemplatively enjoy without having a language, or any but the vaguest language, in which to refer to them. We can listen carefully, admiring transitions, variations, unexpected changes in pattern, quite as we can contemplatively enjoy a work of architecture without knowing the technical terms of architecture. With greater knowledge we may learn to enjoy what do we not now enjoy, but that is true in relation to all the arts. It is in this contemplative way that Hanslick calls upon us to enjoy serious music. We have still to consider whether, granted that this is one way of doing so, there are also other ways, which derive from what, against Hanslick and Stravinsky, is taken to be the emotional content of music.

Film music is an interesting case. First, because it was from the earliest days of silent films felt to be necessary. Secondly, because it did not disappear with the advent of sound. True enough, in the earliest sound films, music was used only as song, but as soon as 'mixing' was perfected it returned as an accompaniment to action. Why so? After all, spoken plays are not accompanied by music; when they are not talking, actors move in silence across the stage.

The first of these questions has been amply discussed by Siegfried Kracauer in his *Theory of Film*. His theory is in a broad sense physiological, involving the difficulty we should have, sitting in a dark and silent room, in seeing the moving silent shapes on a screen as a representation. That applies, of course, to all films, serious or not. But even if Kracauer is right this does not explain why music is used in sound films, which is particularly odd, considering that the film is normally taken to be so largely committed to realism. (This discrepancy is deliberately brought to our notice when at the end of a love scene on a Greek beach, Shirley Valentine comically asks: 'Where did that orchestra come from?' We had taken it for granted.) What is the music doing and what determines the choice of music, as in our earlier example Mozart for *Elvira Madigan*, Verdi for *Little Dorrit*? Obviously there must be some sense on the part of the director that the music matches the film. How?

Opera libretti produce similar problems. But there the music has to match the tone and length of sentences, as in China the tone of words. In the case of films that does not happen, except, of course, with musicals. The only things to match are emotional states, whether scene by scene or in the film as a whole, and courses of events. In early silent film days in country cinemas the pianist simply glanced at the screen, modulating from scene to scene as a horseback chase was followed, without undue precipitancy, by what counted as a love scene. The chase was accompanied by music with a galloping rhythm – no problem there in matching. But what about the love scene? The country pianist had no more doubt that her familiar, unpretentious music – I have an aunt in mind in this nostalgic example – emotionally matched the emotional states on the screen than did the many later arrangers and composers who wrote fixed scores for films, some of them with a subsequent history on the concert platform. Kracauer's pianist who paid no attention to the screen was certainly an exception. The general assumption was that the music strengthened the emotional appeal of the film whether by making more powerful the emotional states depicted in the film or – these are not exclusive alternatives – by making more powerful the audience's reaction to the events depicted. So Joseph Korma is described in the *Oxford Companion to Film* as *underlining* 'the bitter-sweet, romantic quality in many of Renoir's films' and the use in *Elvira Madigan* of Mozart's *Piano Concerto No. 21* along with violin concertos by Vivaldi as '*heightening* the poignancy' of the story there told. The use of Gluck's *Orfeo ed Euridice* in a film about the loss, and attempt to regain, a love and of *Traviata* in a film about a prostitute's love are more obvious examples. We could sensibly discuss whether Verdi's music is 'too emotional' for *Little Dorrit* while not taking that view about its use in *1900*.

I earlier questioned whether music can be said to teach us about the emotions. Does not this talk of 'matching' at least suggest that music can depict the emotions, leaving open the possibility that by doing so with exceptional subtlety a musical composition, like some literary works, displays its seriousness? We often refer to music by the use of such adjectives as 'cheerful', 'lively', 'sad', and in general terms, we expect sad music to accompany sad scenes, cheerful music to accompany cheerful scenes. Surely this implies that music can depict emotions?

Let us turn aside from art for the moment to consider that subject of perennial concern – the weather. We speak both of a day and of persons as being 'gloomy', both of a barometer and of a person as being 'depressed'. It might be supposed in the first case that we call things 'gloomy' – whether a castle, a wood, a room or a day – because they make us feel gloomy. Then we should be transferring our feelings to what gives rise to them, by what Ruskin called 'the pathetic fallacy'. But in fact 'gloomy' was used of woodlands, if the *Shorter Oxford Dictionary* is to be trusted, before it was used of faces and moods, 'depressed' of barometers

before it was used of persons. Equally, 'storms' was used to describe meteorological events before anybody thought in terms of using 'stormy' or 'tempestuous' to describe emotional states, as when Fanny Burney's 'Cecilia' is 'in a tempestuous state'. What lies behind such transfers must be a recognition of certain analogies, however hard it may be to define them precisely. That is equally the case when the linguistic transfer runs the other way, as in a 'miserable day'. Or, at least, we are now prepared to recognise that this might not simply be a shorthand for 'a day which makes me miserable'.

Returning then to music, we might also be prepared to recognise that just as a day can be 'gloomy' without either depicting or expressing 'gloomy feelings', this can be true also of that music which is described as being 'sad'. Its sadness has some analogy to sad moods, just as a 'low-key' speech has some analogy to low-keyed music, and a book which is 'joyous in tone' to joyous music. It will be noted that our examples are of moods rather than emotions. One can perhaps understand in these terms the oft-cited case of Handel, with his habit of re-using music, often transposing it from a secular to a religious setting. In Hanslick's example, the music from a love madrigal becomes, without any change whether in melody or key, the music for the chorus 'For unto us a Child is born' in the *Messiah*. For moods can persist, as mystical literature makes very plain, from the secular to the divine – although given the wording of the original poem in this case, one might feel inclined to give even less credence to the analysis of music in emotional terms than I have done, if this is taken to involve the depiction of emotional states.

To sum up, it would be ridiculous to deny that music can affect us emotionally and physiologically – to make a very crude distinction. I do not think music would play the part it does in everyday life if that was not true. The effects can be very generalised; the shops and restaurants which use Muzak presumably hope that it will 'put us in a mood to shop' or to order a more lavish meal, unless they are simply trying to use it to block out other forms of noise, which they regard as being less desirable. It does not seem that there are any musical effects peculiar to serious music, except those which arise out of admiration for its structure. But I should not wholly rule out the view that there are such effects, which run deeper than the effects of purely entertainment music. I find it hard, indeed, to explain otherwise the centrality of music in the lives of so many people – with the complication that rock can also play such a central part, even if most entertainment music is something that people can 'take or leave'. Hanslick refers to our being misled by the emotional fervour of the performer; that element can still be important but most music, of course, is now listened to in the absence of performers. So that cannot be a *crucial* factor.

What I could not find any ground for claiming is that music depicts emotions, as distinct from conveying moods, let alone that the

distinguishing feature of serious music is that it does this with exceptional subtlety. The moods that music conveys are of a very generalised kind, being no more than schemata of directly experienced moods, with similar rises and falls, degrees of intensity, surges and insistence. If we are interested in subtle differences between emotional states, it is to literature that we must turn or to the performing arts. To generalise, all forms of art affect us emotionally, but this can be true whether or not they are serious. Literature's power of depicting emotions is plainly linked to its general power of depiction, to its link with truth and morality. In formal beauty, however, music, like architecture, reaches exceptional heights, and it is not true that this beauty is accessible only to the learned.

Envoi

If the supplementary volumes to the *Oxford English Dictionary* are to be trusted, that use of the word 'serious' which has been interesting us, in which it is used to characterise certain works of art, dates back only to 1901. George Bernard Shaw was then moved to apply it to a class of literary works as part of his protest against the triviality of the British stage. The first reported use of it in a manner now very common, surrounded by quotation marks, was in 1942. Only more recently, however, has 'serious', with the quotation marks almost a convention and applied beyond the dictionary examples of music and literature to all the fine arts, come to be omnipresent in the reviewer's stock-in-trade. If to take seriousness as the central concept in the philosophy of art is certainly not traditional – beauty for long played that role – it is by no means, nowadays, a quite arbitrary decision.

My argument has deviated from dictionary definitions in a number of ways: first of all, by maintaining that serious works can be amusing, highly entertaining. Shaw would have had no doubt on this point; indeed, in that very preface to *Three Plays for Puritans* in which he introduced the phrase 'serious literature' he argues that there is only one way in which a serious writer can concern himself with sexual entanglements – as comedy. Whatever one thinks of this by no means outrageously implausible doctrine there can be no denying that Shaw's preface is at once serious and entertaining. I have suggested, however, that a serious work is never *merely* entertaining.

The situation in respect to 'requiring considerable thought' is not quite so straightforward. There is a degree of ambiguity here: thought on whose part? It can take, I pointed out, very considerable effort on the part of an artist to compose a work which is easy to read, to look at, to listen to. At the same time, the mere fact that a great deal of hard work has gone into something by no means guarantees its seriousness; the hard-working artist may be incompetent or not capable of rising above the level of the academic. On the side of the recipient, the fact that a work is hard to understand by no means guarantees its seriousness. Neither does the fact that it has an immediate impact demonstrate its triviality. Most serious architecture, to take only one instance, has such an impact. 'Difficult' works, I have suggested, are often no more than a form of highbrow entertainment, not unlike cryptic crossword puzzles but with the added

290

pleasure that one can argue interminably about the correct solution.

There is, then, no possibility of generalising on this point. Some serious works are the product of a great deal of hard work; so are some incompetent, or merely pretentious, trivial productions. Some serious works require considerable thought if they are to be understood, others have an immediate impact, even if an impact which can be greatly enriched by later experience. (The impact of the Pantheon is immediate, but every return to Rome demands that it be revisited.) When an artist has developed, by hard work, a great deal of facility, a particular work is sometimes 'tossed off' with a quite bewildering rapidity. What I substantially did, in the light of such facts, was to replace the concept of hard thought by the concept of imaginativeness or, perhaps better, imaginative thinking. This, to be sure, requires effort but that is not its central feature.

Nevertheless, in a formal sense I have not transcended the dictionary, have not offered either a classical definition or a set of synonyms for 'serious'. Simply, what took the place of the dictionary definition is a different set of antonyms – 'not merely entertaining, not merely telic'. What then had to be done was to spell out this 'not merely', asking what else a work has to be. At this point, the argument not unnaturally turned for help to those concepts which have traditionally been employed in criticism, even if not with this explicit intent, to distinguish serious art from what is, artistically speaking, trivial–imagination, truth, beauty, form, emotion. This proved to involve very considerable difficulties, for a number of reasons. In the first place none of these concepts is pellucid; it was necessary to distinguish a number of different usages, even within critical practice. Secondly, whereas writers on the philosophy of art have often been content, once a usage has been settled upon, to presume that what they have had to say about its importance in one art will automatically apply to other arts, the present argument always explored each of the arts in turn, inquiring to what extent, and with what, if any, modifications the relevant concept can be usefully deployed within that art as an aid to distinguishing between the serious and the trivial. For example, even if there are senses of the word 'truth' which make it relevant to the critical consideration of literature, I have by no means immediately concluded that the same must be true of music and architecture but have rather asked whether other usages are relevant there or none at all.

The structure of such an argument can scarcely help being somewhat complex and untidy. This is not as a result of some peculiarity attaching to the arts, although it is no doubt accentuated by the fact that the criteria for admission as an art are anything but tight. Philosophy of science and philosophy of history, so I have elsewhere suggested, have often gone astray by not recognising that both science and history come in various shapes and sizes and that to generalise over them as if physics

were the sole science or narrative history the only kind of history leads to gross over-simplifications.

Even in the course of what are relatively speaking side-lines, my argument has constantly challenged wide-ranging generalisations, as by contending that there is no such thing as the ontological status of works of art, that this status varies not only from art to art but even within particular art-forms. It is easy to sympathise with those readers who will find this line of argument messy, untidy. But that, I should reply, is the way the world is, especially in anything which relates to human affairs, including the arts. Only a fanatic could possibly suppose otherwise. Still, the world is never short of fanatics.

This is not to say that this book contains no generalisations, that its impact is wholly destructive. (Although if what is destroyed is nonsense, destructiveness is far from being a vice.) Indeed, part of its object is to produce generalisations which will permit critics to describe works of art as being serious, without employing the shamefaced compromise of quotation marks, now with the confidence that there are considerations to which they can appeal if their judgment is questioned. But for the most part these will be considerations which apply only to a particular art-form and admit of countervailing considerations, of such shapes as: 'Yes, it does show us something about what life was like in the Bronx, but it is quite formless and the writing is full of clichés.' Anyone in search of a simple way of determining whether a work is serious will not find it here; the criteria suggested are always themselves disputable. 'It is part of the point of that novel,' the reply might come, 'that it is written in clichés.' I am not trying to make life easy for critics, except by suggesting considerations to which they can properly have recourse, and so, perhaps, making it a little easier.

I should claim, too, that such generalisations have been subjected to critical examination. This will certainly disturb, probably bore, readers who are unaccustomed to anything but dashing *ex parte* statements. In particular, they may resent the testing by examples which runs through the book. Examples, so I have been told, are 'distracting', 'confusing, 'untidy'. This is rather as if someone were to describe an historian's references to archives or a scientist's to experiments in these terms. Examples are the only evidence one has in writing about the arts; statements of the form 'as X has said', where 'X' is the name of some currently fashionable pundit, are not satisfactory substitutes. They can, no doubt, be used in misleading ways. That is why their proper use was described at some length. Were I writing for eternity, I should be troubled by the fact that some of the works mentioned as examples will no doubt be wholly forgotten in a relatively short period of time. That I mention them does not at all imply that I regard them as serious works; it is enough that they have sometimes been taken to be such. If I can help to dissipate contemporary fogs that is the most I can hope for.

Index of Names and Key Terms

An unusual feature of this index is that references to a particular work are indexed under the name of the author, painter, architect, composer, or director of that work even when the name is not cited on that page. The names are those in general use, often pseudonyms.